MOVING TARGETS 2

MOVING TARGETS 2
A USER'S GUIDE TO
BRITISH ART NOW

LOUISA BUCK

TATE PUBLISHING

Cover:
Martin Creed
*Work No. 201: half the
air in a given space*
1998 (detail)
Collection Jack and Nell
Wendler, London
Courtesy the artist
and Cabinet Gallery,
London

ISBN 1 85437 316 1
A catalogue record for
this book is available
from the British Library

First published in 2000
by order of
Tate Trustees by
Tate Gallery Publishing
Limited, Millbank,
London SW1P 4RG

Editor: Melissa Larner
Designer: Stuart Smith

Printed in Great Britain
by BAS Printers,
Over Wallop,
Hampshire

ACKNOWLEDGEMENTS

Yet again, I'm grateful to Tate Publishing for their flexibility and forebearance in extending dead-lines and tolerating a mass of last-minute alterations. My thanks to Celia Clear and Judith Severne for their good humour and commitment, and to Daniel Scott for his energy and enthusiasm. Richard Humphreys first approached me with the idea for a guide to British contemporary art, and his support has been invaluable throughout both versions of this book.

For both editions of *Moving Targets*, I have been fortunate to have Melissa Larner as my editor. Her contribution to this book goes way beyond exemplary copy editing, picture researching and fact checking, and the experience of writing – and reading – the books would have been very different without her patience, generosity and rigour. Thanks also to Stuart Smith for his lucid and inspired design, and to my agent Cat Ledger. In order to update and expand *Moving Targets*, I have bent a multitude of ears and received invaluable advice and information. To all those on the receiving end, apologies and heartfelt thanks.

Once more, I dedicate this book to Tom, with my love.

PHOTOGRAPHIC CREDITS

Illustrations supplied courtesy of: Acquavella Contemporary Art Inc., New York (18); Anthony d'Offay Gallery, London (23, 30, 41); Anthony Wilkinson Gallery, London (121); The Approach, London (133); the artist (35, 82, 125); the artist and Anthony Reynolds Gallery, London (139); the artist and Anthony Reynolds Gallery, London and Miriam Goodman Gallery, Paris/New York (79); the artist and Anthony Reynolds Gallery, London (102); the artist and Anthony Reynolds Gallery, New York (93); the artist and Frith Street Gallery, London (115); the artist and Lisson Gallery, London (86); the artist and Sadie Coles HQ, London (77); © Arts Council / Catherine Yass (155); Christian Boltanksi and the Henry Moore Sculpture Trust, Leeds (245); Cabinet Gallery, London (119, 123); © The Condé Nast PL/British Vogue (221); © The Condé Nast PL/GQ (173); Delphina Studio Trust (25); Entwistle (69); Entwistle and Hales Gallery, London (136); Frieze (166); Hales Gallery, London (253); Imprint 93 (239); Jay Jopling, London (27, 48, 60, 74, 95, 100, 112); Laurent Delaye Gallery, London (131); Lisson Gallery, London (37, 44, 51, 107); © Locus+ (235); Maureen Paley / Interim Art (97, 104, 127); Matt's Gallery, London (46, 53); Milton Keynes Gallery (21); Marlborough Gallery (33); Modern Art Inc., London (116, 129); Orchard Gallery, Derry (267); The Paragon Press (240); Pier Arts Centre, Stromness (187); Saatchi Gallery, London (200, 259); Stedelijk Van Abbemuseum, Eindhoven (11); Tate (264); Tramway, Glasgow (186); Victoria Miro Gallery, London (4, 58)

INTRODUCTION: MOVING TARGETS AND ALTERED STATES 6

THE MAKERS

PRESIDING FORCES 10

CURRENT CONTENDERS 43

NEW VOICES 111

THE PLAYERS

THE GUARDIANS OF THE FLAME 140

THE PRESENCES 160

THE DEALERS 170

THE PATRONS 186

THE OPERATORS 204

THE COMMENTATORS 216

THE GEOGRAPHY

ART SCHOOLS 226

ORGANISATIONS

Funders and Facilitators 227

Independent Exhibition Organisers 232

PRIZES AND EVENTS

Prizes 236

Events 238

PUBLICATIONS

Specialist Publishers 239

UK Art Magazines 241

International Art Magazines 242

UK VENUES

England

Towns from Berwick upon Tweed - Liverpool 243

London: Artist-run Spaces 247

London: Commercial Galleries 250

London: Public Galleries 257

London: Public Museums 260

Towns from Lymington - York 262

Northern Ireland 266

Scotland 267

Wales 271

Outdoor Galleries 272

INDEX 273

INTRODUCTION: MOVING TARGETS AND ALTERED STATES

Since the publication of the first edition of this book, the hothouse has cooled down, the palpitations of the 1990s have calmed, and the pulse of British art at the beginning of the twenty-first century feels strong and steady. These days, the art coming out of the UK is viewed not so much as an isolated national phenomenon, but rather as a vigorous and multifarious strand within an interconnected international art world. The era of so-called Young British Artist is over.

There's no doubt that the Goldsmiths class of '88 produced an exceptional line-up of talent and an energetically entrepreneurial attitude; but while Damien Hirst and many of his contemporaries continue to play a prominent role in current British art, the landscape and the climate has changed. Subsequent generations of artists are emerging with a different approach and attitude to making art. Many new venues continue to open and the result is an environment that is richer, more pluralistic and less easy to categorise. It is this revitalised and expanding British art world, its makers, its players, its organisations and its venues, that is the subject of *Moving Targets 2*.

It is no surprise that *British Art Show 5*, the five-yearly barometer of the state of British art that is touring the country throughout 2000, consists of over fifty artists of all generations, from their twenties through to their sixties. For, as I noted in the first edition of this book, the best and most challenging art that is being made in Britain is not restricted by age, art school or agenda. The artists featured in *Moving Targets 2* are therefore of all generations and backgrounds. Francis Bacon and Helen Chadwick, both now dead, have been hugely inspirational to younger generations. Paula Rego – a grandmother – is currently making some of her most challenging and provocative paintings. Susan Hiller, who started in the 1970s, using a multitude of different media to tap into our collective subconscious, continues to do so in ways that are inventive and challenging. Others are in the middle of their careers, while some are only a few years out of art college. Those barely beyond their twenties, such as Darren Almond or Keith Tyson, are making works of impressive scope and ambition.

It is still true to say that the most distinctive feature of the artists who are defining British art in the 1990s is the fact that they do not share a common style or medium. They produce figurative and abstract paintings, readymade and handmade sculptures, photography and text, videos, installations and CD ROMs – sometimes simultaneously. Rachel Whiteread, Cathy de Monchaux, or Michael Raedecker, for example, make radical artworks using traditional skills. Mat Collishaw and Christine Borland employ cutting-edge

technology from other fields to ponder notions of memory, value and nostalgia. Some work in isolation, others operate within interconnected communities, and many are loath to be given any label, whether personal, artistic or national. Indeed, for a number of artists – Michael Raedecker, Tomoko Takahashi, Angela de La Cruz, to name but a few – Britain is not their country of origin, but their adopted home.

What the artists selected for inclusion in this book (as well as many others besides) do share is the desire to use whatever means are at their disposal – paint, celluloid, ballistics, needlework or forensic science – to make work that speaks of what it is to be human and to live in this world. This is what the best art has always attempted to do. And just as the world has changed, so, inevitably, has the way in which artists express their experience of it. The art that this book singles out for scrutiny reflects our contradictory, uncertain times with a refusal to take anything at face value. Messages are mixed; art practices – and the role of art itself – come under continuous interrogation. In the three years between the two editions of *Moving Targets*, an increasing number of younger artists have eschewed high production values and big-budget spectacle in favour of an approach that is lower key, more reflective and self deprecating. Whether Martin Creed's balloons, balls of paper and blobs of Blu-tack, the dystopian pencil drawings of Paul Noble, or the perverse pots of Grayson Perry, there's humour and absurdism in the air, and the ability to be acutely serious without pomposity.

The art world that both sustains and has grown up around this scene is equally shifting and ambiguous. The entries in *Moving Targets 2* confirm that boundaries are permeable and categories seem to exist only to be breached. In these hybrid times, the roles of artist, curator and critic are no longer mutually exclusive and often one person – Martin Maloney or Matthew Higgs, for example – can be all three. Many of today's artists, young or old, as well as some of our leading curators and commentators, also play a crucial role within the best of Britain's art schools, as part of a unique educational system that has done much to nurture successive generations by adhering to a widespread policy of exposing the artists of the future to the leading figures in the current scene.

Central to the character of the British art world is the way in which artists continue to be increasingly adept at organising their own exhibitions. Over the past few years, this practice has evolved from an ad-hoc (if highly professional) enterprise into an ongoing, vital process. Artists' collectives, whether in London, Glasgow, Manchester, Belfast or Reading, are running purpose-built spaces attached to their studio complexes, and individual figures display

works in a multitude of off-beat and unofficial venues, including their own homes, or in the case of Matthew Higgs' Imprint 93, send them through the post in an envelope.

However, while artist-run shows may provide an important testing ground, it is still the commercial sector that has mainly been responsible for taking up many of Britain's brightest and best, and for presenting them to a wider audience. A number of private galleries have taken on the appearance of mini-museums in their own right: several leading art dealers, including Nicholas Logsdail and Maureen Paley, originally began their professional life as artists, and now put together exhibitions with the status of institutional shows. The next few years will also reveal the impact of Britain's first national museum of modern art, Tate Modern, which opened in May 2000, as well as the relaunch of Tate Britain and a slew of Lottery-funded arts centres across the UK, from the Baltic Centre for Contemporary Art in Gateshead to the Milton Keynes Gallery. Add to this the presence of a collector such as Charles Saatchi, whose holdings in current British art of all generations continue to expand, and whose private gallery enjoys the unofficial status of an institution, and notions of public and private, official and alternative tend to melt, merge and become increasingly irrelevant.

Of course, the artists, individuals and institutions scrutinised in *Moving Targets 2* make up only part of the contemporary art world in Britain. Just as there are artists who choose not to respond to the edgy spirit of the times, so there are a great many dealers, curators and critics who do not venture out of their appointed places. However, the subject of this book is the art that sets out to make us look at the world – and ourselves – with new eyes, along with the infrastructure that supports it. It must also be stressed that this is a highly selective and subjective view. *Moving Targets* is intended to be an indication, rather than an exhaustive representation, of what is taking place at the moment; it should be seen as a way in, rather than a definitive view. The fifty-seven artists singled out for close examination are only a small sample of what is taking place, as the multitude of artists' names that crop up throughout all the sections of this book confirms. Inevitably readers will – and should – dispute my choices and substitute their own. For what is so dynamic about British art today is its rich variety, its refusal to be pinned down and categorised. This very slipperiness is evidence of its vitality. *Moving Targets 2* aims to help negotiate the diverse range of moving targets that make up British art now.

THE MAKERS:
PRESIDING
FORCES

FRANCIS BACON

b. 1909 Dublin, d. 1992 Madrid, Spain
Tony Shafrazi, New York/Gerard Faggionato

Towards the end of his life, Francis Bacon declared: 'The greatest art always returns you to the vulnerability of the human situation', and certainly no one has made human life look more nasty, brutish and short than this maverick self-taught painter. While the debate rumbles on as to whether Bacon's later work was infused with serene stateliness or had lapsed into repetitive formula, the screaming popes, snapping Furies, contorted portraits and convulsive figures that he painted up to the mid-1960s have established his mythic status as the quintessential painter of our fragmented, contradictory and morally ambiguous existence.

However, Bacon himself totally denied any such ambitions. With characteristic evasiveness he repeatedly insisted that he was a reporter rather than an interpreter; a rigorous realist whose images deliberately short-circuited any narrative reading in order to work directly on the nervous system. 'One brings the sensation and feeling of life over the only way one can', he once said, and apparently it was this quest for an immediate human essence that gave rise to the bloody scenarios of writhing bodies and mutating forms that he doggedly chose to discuss in terms of artistic problem-solving.

Perhaps Bacon's own tongue was somewhat in his cheek when he claimed that his obsession with the screaming mouth had less to do with horror and more to do with its 'glitter and colour' – his declared ambition

Fragment of a
Crucifixion
1950
Oil and cotton
wool on canvas
140 × 109 cm

was to paint the mouth 'like Monet painted the sunset'. But this refusal to provide any solution, resolution (or redemption) both sets him apart from his contemporaries, and anticipates an ambivalence that is now common in much of today's art. Bacon's victims do not ask you to pity them. They are presented for our clinical scrutiny in transparent tanks, laid out on plinths or pinned to mattresses in the controlled vacuum of an empty room. To increase this distance, Bacon liked even his largest canvases to be shown behind glass, their energy trapped. In the face of this sensational (some say sensationalist) objectivity, in an art that is so immediate but also so detached, it comes as no great surprise to learn that Bacon is one of the few specific influences consistently acknowledged by Damien Hirst.

The bloody carcasses and bodies that morph into raw lumps of meat in

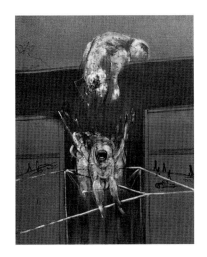

such works as *Three Studies for a Crucifixion* (1962) are there because, according to this artist, that's what we are. But, with a characteristic reluctance to be committed to any philosophical standpoint – another quality that Hirst was to pick up on a couple of decades later – Bacon could flip from a breezy nihilism ('of course we are meat, we are potential carcasses. If I go into a butcher's shop I always think its surprising that I wasn't there instead of the animal') to a tender profundity ('when you go into a butcher's shop and see how beautiful meat can be and then you think about it, you can think of the whole horror of life – of one thing living off another').

Bacon set himself apart from much of twentieth-century art by citing grand, art-historical influences. However, although he might not have been eager to admit it, in 'the pulverising machine' of Bacon's imagination, film and photography were as prominent as Velásquez, Rembrandt and Picasso. Photographic material ranging from Eadweard Muybridge's studies of bodies in motion, to medical textbooks and newspaper cuttings, provided both reference points and triggers for ideas; and Bacon again showed himself to be ahead of his time in his early awareness of the challenges posed to the artist by the mass media. His obsession with films went beyond individual images, though his most commonly cited source is Sergei Eisenstein's *Battleship Potemkin* (1925).

Throughout his life, Bacon steeped his canvases in the language of film: the still, the zoomed-in detail and the panning shot. His *Triptych Inspired by T.S. Eliot's Poem 'Sweeney Agonistes'* (1967), for example, is charged with the

way in which the experience of cinema can simultaneously engulf and distance the viewer. (Later on, the movies were to repay the compliment: Bacon's paintings of the 1940s were a direct source for the designer H.R. Giger's nightmarish monster in Ridley Scott's cult 1979 movie *Alien*; and the caged, muzzled Hannibal Lecter in *The Silence of the Lambs* (Jonathan Demme 1991) owes more than a passing glance to Bacon's boxed-in popes.)

Unfortunately, however, in the last two decades of his life, the complex friction between knowing and feeling that Bacon had generated in his work occurred less and less. The distortions became increasingly predictable, and the settings too slickly theatrical – bringing to mind his previous career as a designer of art deco rugs and furniture. At the same time, the introduction of bizarre new imagery – such as the series of truncated figures in cricket pads – found him veering dangerously close to kitsch. But Bacon's weary replays of his earlier creations, and his increasingly frequent lapses into schlock horror do not detract from his unequalled achievement in fusing art-historical tradition and utter modernity in order to speak of how we live today.

PATRICK CAULFIELD

b. 1936, London
1956-60 Chelsea School of Art; 1960-3 Royal College of Art
Waddington Galleries
Lives and works in London

Patrick Caulfield's paintings are deceptively simple. For over three decades, he has presented our most mundane surroundings with deadpan clarity. Whether he's using thick, black outlines, flat blocks of colour, immaculate photo-realism, or dense patterning, Caulfield's emblematic interiors and arrangements of objects are always immediately recognisable. This impersonal style and choice of everyday subjects, along with his training at the Royal College of Art in the early 1960s alongside David Hockney, Allen Jones and R.B. Kitaj, may have led to Caulfield's categorisation as a Pop artist. But his roots lie more in traditions of European art than in transatlantic mass-production. Even the 'comic-book' outlines that characterise much of his earlier work stem from postcards of Minoan frescoes, upon which crude black lines had been added to enhance the divisions between flat areas of colour and to heighten a sense of 'reality'.

Mothers Day
1975
Acrylic on canvas
76 × 91.5 cm

No subject is too commonplace or banal to receive Caulfield's meticulous attention. In fact, with his Mediterranean-style bistros, flock wallpaper, quiche-serving winebars, Artex plaster finishes and scarily over-garnished salads straight from *Abigail's Party*, it's almost as if Caulfield has wilfully sought out subjects that fly in the face of accepted good taste (although, inevitably, some of his objects have come full-circle back into fashion). Yet there is nothing crude or commonplace about these paintings. Their picture-book straightforwardness is simultaneously a foil and a vehicle for something altogether more complex and subtle.

At the core of Caulfield's work is an abiding concern with how painting can be made to represent, manipulate and reinvent our notions of 'reality' at every level. Two of his art heroes are the coolly precise Cubist Juan Gris, and

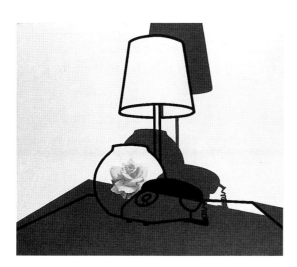

the Surrealist subversive René Magritte. With the elegant, formal rigour of the former and the impassive mischievousness of the latter, Caulfield plays audacious perceptual games that both build on and depart from the art of the past. Beneath their laconic surfaces, his paintings quietly seethe with pictorial tricks, puns, illusions, and allusions. In works such as *Café Interior: Afternoon* (1973) he fuses together an awesome composition of emphatic black outlines and areas of saturated puce, red and blue to present a completely believable and evocative empty table for four, sliced by shafts of afternoon sun, but at the same time his flatly painted bars and blocks cut through and cancel out the illusion of space that they have just created. *Pipe on Shelf* (1995) presents one of twentieth-century art history's most loaded symbols with Cubist clarity, but on a real built-out shelf and against a background redolent of cheap DIY plaster texturing.

By the mid-1970s, Caulfield was further complicating and extending readings of pictorial 'truth' by combining often wildly contrasting styles and techniques on one canvas. *After Lunch* (1975) introduces a luridly illusionist scene of a Swiss chateau into an otherwise uniformly executed restaurant interior. *Town and Country* (1979) presents a cacophonous composition of jarring 1960s geometric wallpaper patterns, fake woodgrain, pointillist-style

lino and schematised stonework, all of which frame a garishly ersatz woodland scene and cause notions of 'real' and 'synthetic' to collapse and collide in a dizzying explosion of surface effects. By the time he came to paint *Trou Normand* (1997), Caulfield had completely abandoned what had by then become his irksomely characteristic outlines, to conjure up a hokey heritage pub interior out of crisp, floating planes, blocks and shadows, in which a realistically painted Victorian oil lamp hovers in space, and leaded window panes are in fact made from raised bumps of paint that seem to have been applied directly from the tube.

Not a flashy artist, Caulfield has aways doggedly restricted himself to the strictures of easel painting, but his subtly inventive negotiation of the area between abstraction and representation has earned him the admiration of fellow artists of all inclinations including Gary Hume, Julian Opie and Fiona Rae. A number of younger figures such as Paul Morrison, who paints crisply graphic black and white landscapes comprised of scaled-up, cartoon-style plant forms, or David Thorpe, whose meticulous paper cut-outs present shabby modernist buildings in uncanny urban and mock-heroic rural landscapes, have also taken note of Caulfield's simultaneous sampling of styles, his immaculate formal rigour, his flirtation with kitsch and his ability to communicate complex information with acute economy.

Caulfield's canvases owe their impact not only to how they act on the eye, but also to what they are made to say. He is all too aware that, for several centuries, still-life and genre painting have functioned not just as representations of our surroundings, but also as symbolic meditations on more profound human realities: our vanities, our frailties and the inexorable passing of time. Caulfield doesn't choose his raffia-seated barstools, breaded chicken wings and mass-produced William Morris wallpaper simply to give a contemporary spin to his meditations on Juan Gris, Fernand Leger & Co – his images are also selected and combined for the messages they send out. Of course, these messages are always mixed in Caulfield's work. The glasses of wine, picture-postcard scenes and lurid plates of paella signal aspiration, escapism and fantasy – but it's up to us to decode exactly what they are saying. Using appropriately garish and synthetic colour schemes that confound all expectations by managing, almost magically, to harmonise, Caulfield chronicles the items that we consume and the environments we create. He doesn't sneer at the images that he paints with such care. Nor does he celebrate them. And nor are his pieces of kitsch relegated to the status of amusing details – they are vital players in his compositional jugglings and complex indicators of the often paradoxical considerations that motivate us.

It is this deadpan creation of such profound and psychologically rich work from the basest of subject matter that makes Caulfield chime with so much art of the twenty-first century. His centres of human activity, pleasure and leisure are almost always empty, and, as we occupy them in our own heads, they reverberate with an intense atmosphere, sometimes melancholic, sometimes full of possibility. We've all been there, mentally transporting ourselves to the South of France via a mussel salad and a checked tablecloth; or taking comfort in the fake homeliness of a hundred pubs with their dark wood, ye olde leaded panes and leatherette banquettes. For, as in the hovering, mirage-like wine glass, the ruddy glow and the uncompromising EXIT sign of his 1996 *Happy Hour*, Caulfield reminds us that what we see, what we want and what we believe are not necessarily the same thing.

HELEN CHADWICK

b. 1953 Croydon d. 1996 London
1973-6 Brighton Polytechnic; 1976-7 Chelsea School of Art
Zelda Cheatle Gallery

When Helen Chadwick died unexpectedly in 1996, she was working on *Cameos*, a series of sculptural photopieces that continued a career-long quest to investigate every aspect of who and what we are. From the sculptural clothes she made as a student in the mid-1970s by painting latex onto women's bodies, through to this last – uncompleted – series, in which photographs showing medical specimen heads of a chimpanzee and a deformed 'cyclops' human foetus were mounted into circular, three-dimensional settings, Chadwick's work splices the provocative with the profound in order to probe scientific, subjective and spiritual notions of identity. Using fur, flesh, offal and melted chocolate, her art makes a point of questioning traditional categories of beauty, normality and acceptability, and the way in which she challenged conventions and stretched possibilities has fed into the work of many of today's most progressive artists.

It is now commonplace for artists to take whatever means or medium they can in order to express themselves, but it was Chadwick's fusion of unconventional materials that helped to open up these artistic options. As far as she was concerned, everything was up for grabs – and her influences spanned art history, myth, science and anatomy, and extended to grooming, gardening and cooking. Whether she was casting a tower of lamb's tongues

Self Portrait
1991
Cibachrome
transparency,
glass,
aluminium,
electrics
45 × 51 × 13 cm
Photo: Helen
Chadwick and Edward
Woodman

in bronze (*Glossolalia* 1993), photographing flowers clustered on the surface of domestic fluids (*Wreaths to Pleasure* 1992-3), working with cutting-edge digital technology, or commissioning specially woven carpets (*Rachel/Jude* 1995-6), Chadwick prodded the boundaries of art in order to give physical form to the complexity of human experience.

The internal human landscape, bodily fluids and the preserved carcasses of animals now all make regular appearances in the world of art, and Chadwick was among the first to employ such visceral artistic material. She was also an early exponent of the use of one's own body as a means to investigate subjectivity. *The Oval Court* (1984-6) is an extravaganza of collaged photocopies of the artist's body, set adrift amongst a mass of animal and vegetable matter, first shown alongside *Carcass* (1986), a vertical glass compost-heap containing their rotting reality. Later, references to self became more oblique but no less immediate: in their exquisitely photographed arrangements of meat and offal, *The Meat Abstracts* (1989) and *The Meat Lamps* series (1989-91) remind us what we are really made of, while the twelve hermaphrodite blooms of Chadwick's *Piss Flowers* (1991-2), which she made in collaboration with her partner, audaciously turn male into female and vice versa by casting in bronze the stamen and corolla-like patterns made by male and female urine in the snow.

Chadwick's celebration of physical decay and entropy as an intrinsic and positive part of life reverberates in the work of a number of younger artists including Anya Gallaccio and Damien Hirst; as does her practice of arranging volatile and potentially chaotic materials within a rigorously formalist framework. Whether in the hard-edged rectangular geometry of *Carcass*, or the circular white tub that houses the bubbling mass of *Cacao* (1994), her fountain of molten chocolate, it is the tension – and friction – between these opposing images of order and chaos that gives her work much of its impact and metaphorical richness. Chadwick also pre-empted today's toyings with good and bad taste by her frequent use of a sheen of kitsch: the round, metal

frames enclosing her *Wreaths to Pleasure* are the synthetic colours of cheap confectionery, while the knobbly cast stalactites of her *Piss Flowers* are cut into the shape of Mary Quant daisies and mounted on bulbous white stalks more appropriate to plastic 1960s table-bases than plinths for sculpture.

However, Chadwick used unexpected and engaging forms as a vehicle for ever more serious concerns. In the months just before her death, her repeated scrutiny of the mystery of the life cycle and its processes of growth and decay had literally taken her to the very origins of our existence – as well as to the forefront of medical ethics. *Unnatural Selection* (1996) is a series of photopieces created during a residency at the Assisted Conception Unit of King's College Hospital in London, which used non-living, human, pre-implantation embryos that would otherwise have been left to perish. With a characteristic lightness of touch, Chadwick juggled and made complex our notions of nature, artifice, individuality and interdependence by arranging these jewel-like microphotographs of human embryos (still at cell-cluster stage) into glittering Perspex settings that took the form of a necklace, a ring and a brooch. In this last completed series of work, Chadwick confirmed her national and international status with a highly topical image of our many-faceted human potential, set within a permeable world where nothing is fixed or finite.

LUCIAN FREUD

b. 1922 Berlin, Germany
1938-9 Central School of Arts and Crafts;
1939-42 East Anglian School of Painting and Drawing, Dedham;
1942-3 Goldsmiths College
Acquavella Contemporary Art Inc., New York
Lives and works in London

The human body may be at the forefront of art today, but the jury is still out on the painted studio nude. Several art schools have discontinued their life classes, and the practice of working directly from a live model is regarded by many younger artists as an antiquated activity, no longer valid as a legitimate form of artistic enquiry and useful only as the focus for theoretical debates around paradigms of male and female beauty and the politics of the gaze. However, in other quarters it is in revival: a Drawing Professorship has been introduced at the Royal College of Art, and artists such as Paula Rego and

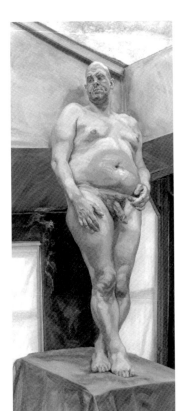

Leigh Under the
Skylight
1994
Oil on canvas
297 × 121 cm
Photo: Scott Bowron

Jenny Saville have turned working from the live model to their own ends.

None of this bothers Lucian Freud. For over half a century he has been painting the human form with an obsessive and unwavering intensity, and his pictures of bodies old and young, male and female, in all their flabby, fleshy, blue-veined rawness have earned him the title of greatest living realist painter – as well as the Establishment accolade of Companion of Honour (1983). Yet he remains a maverick, outside the styles and movements of the art world, with admirers and detractors in all its camps. In many ways, Freud is the epitome of the old-fashioned artist: he admires Frans Hals and John Constable, not Marcel Duchamp and Bruce Nauman; his sittings go on for hours and continue over years; he has loved and painted a multitude of women, and he is rarely available for interview.

Then there's the paint. For some, the thickly rendered, painterly physicality of Freud's naked individuals – who loll against mattresses, lean among rags, and sprawl on the floorboards of his grimy studio – borders on the repulsive. He has been condemned for subjecting the bared bodies of his sitters to such clinical scrutiny that both they and the viewer are compromised. In the current climate, when artists are more apt to analyse the expressive power of paint than to make claims for it, such Freudianisms as 'The paint is the person. I want it to work for me as flesh does', or 'I would wish my portraits to be of the people not like them', seem somewhat out of kilter with the knowingness of the times. Yet however tangled his paint surfaces, explicit his poses, or focused his painterly explorations, in this ability to allow many readings – all, none, or some of which may be true – his is a very contemporary art.

Almost perversely, Freud can be both grungily modern and agelessly grand. *Leigh Under the Skylight* (1994), Freud's full-length painting of Leigh Bowery, the designer, performer and constantly mutating symbol of London's clubland, never looked better than when it resided for a brief spell in London's Dulwich Picture Gallery, hung next to Rubens' *Venus, Mars and Cupid*; while his paintings of the vast bulk of Big Sue (the claimants officer who has become an increasingly regular presence in Freud's work since Bowery's death in 1996) would look at home alongside the most voluptuous odalisques of art history.

THE MAKERS: PRESIDING FORCES

Like his friend Francis Bacon, Freud claims simply to be presenting the facts of life. Unlike Bacon, however, he does not conjure up psycho-dramas – or not intentionally, anyway. Underpinning all his work, from the hard-edged miniaturist paintings of the 1940s and early 1950s, to his current painterly swoops and dabs, is an obsessive and highly complex objectivity. Freud doesn't paint nudes, he paints bodies. They are not idealised, they are not arranged (his sitters choose their own poses), they are simply there.

When he describes the head as 'just another limb', by this he means that every bit of the human anatomy – whether the inside of a splayed female thigh, the connection between an eyebrow and a cheekbone, or a belly jutting above a limp penis – is of equal importance. He declares that he wants his paintings to be factual, not literal – 'with the nude, not of the nude' – and he gains these visual 'facts' over exhaustive periods of time and in close collaboration with sitters to whom he is either instinctively drawn, or knows well. (He repeatedly paints his many children.) Freud's realism is not a photographic verisimilitude, nor is it purely a process of psychological scrutiny.

Essentially, Freud paints skin; he doesn't want to get inside it. And it is this battle to remain detached from, while at the same time being intensely involved with, his subjects that makes him – reclining naked figures, antique gold frames notwithstanding – an artist of our times. His sombre, slathered paint surfaces in muted shades of epidermis, mattress and floorboard may seem worlds away from the shiny, visual candy of Gary Hume, but both in their different ways are painters of surfaces who refuse to dig deeper. By restricting themselves only to what is externally evident, they leave any story-telling up to us. For Freud, as for so many younger artists, there are no barriers between art and life, just uneasy relationships. But then, as he has said, 'the task of the artist is to make the human being uncomfortable'.

GILBERT AND GEORGE

Gilbert Proesch: b. 1943 Dolomites, Italy
1967-70 St Martins School of Art
George Pasmore: b. 1942 Devon
1967-70 St Martins School of Art
White Cube
Live and work in London

They may have won the Turner Prize in 1986, their shows may attract record

audiences from Moscow to Beijing, and they may – along with Damien Hirst and David Hockney – be Britain's best-known living artists, but in this country feelings are still mixed about Gilbert and George.

Is their fused artistic persona an ongoing continuation of their 1960s decision to become 'Living Sculpture', or an attention-seeking joke at the world's expense? Are their massive photopieces a celebration, or a critique, of all things English? In a career spanning some thirty years, the living logo that is G & G has followed in the footsteps of Andy Warhol in achieving the three-way formula for contemporary artistic success: ubiquity, inscrutability and – above all – controversy. Like increasingly ageing Lords of Misrule, or a silent Greek chorus of two for our inner cities, they impassively preside over their lurid panoramas of high-rises and bad behaviour. Delivering no judgements and providing no answers, they have presented a potent role model for many of today's younger artists.

From the beginning of their joint career, Gilbert and George have deliberately embraced extremes of tastelessness. But they've always made a point of combining outrage with ambiguity. Often, the more crudely shocking the content, the more complex the reading. From the early *Magazine Sculpture* of collaged photographs showing the laughing, youthful artists labelled as *GEORGE THE CUNT AND GILBERT THE SHIT* (1970); to photopieces such as *PAKI* (1978), where the artists stand on either side of a young Asian man; through a multitude of works with titles like *SPERM EATERS*, *FRIENDSHIP PISSING* and *HOLY COCK*; to the monumental cruciform turds of the NAKED SHIT PICTURES (1994), their work tempts, mocks, and threatens – often simultaneously.

The constant appearance of the artists in their own works only adds to the uncertainty. Whether they are bronze-painted and singing the now infamous 'Underneath the Arches' for eight hours at a stretch in the 'Singing Sculpture' marathons that they began when students at St Martins; divulging the minutiae of their daily lives in the postal sculptures of the 1970s; or appearing as a ubiquitous element in the hundreds of photopieces they have been making since 1974, their role hovers between participator and observer, author and actor, motif and presence.

Gilbert and George may pride themselves on an 'unarty', emblematic style, but the throat-grabbing immediacy and lasting impact of their work relies as much on a complex web of visual strategies as it does on the garish shockingness of their photographic images. One of their greatest – some say their only – talents is a sense of design. Their technicolour grids skew the sensibilities of viewers of all inclinations by playing off the scale, grandeur

Money
1998
Photopiece
226 × 508 cm

and vividness of Victorian ecclesiastical stained glass and the figure composi-tions of religious paintings in order to present a problematic form of visual propaganda that is at the same time disquietingly totalitarian and twentieth-century in appearance. With source imagery ranging from Christian, Eastern, heraldic and Islamic, to that of their own east London surroundings, the work can, perversely, be said to live up to its claim to be an 'Art for All', while also depending on the artists' virtuoso technical skills and 'arty' for-malism. Recently they've followed artists such as Helen Chadwick and Mona Hatoum into their bodily interiors with series such as their *RUDIMENTARY PICTURES* of 1998, in which they present greatly magnified and therefore sanitised images of their blood, urine, sweat and semen.

So what then, lies behind these deadpan and increasingly formulaic

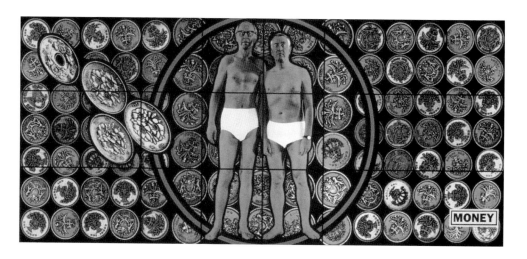

depictions of the unacceptable? Gilbert and George make lofty claims for their work as 'de-shocking' the spurious taboos of fine art and polite society. They state that they are striking a universal chord by addressing 'the subjects that are inside every single person wherever they are: death, hope, life, fear'. While this could be a little megalomaniac, there's no doubt that, through compositional skill, high production values and sheer chutzpah, Gilbert and George can neutralise some of the least appealing aspects of our existence. Who else could line an entire room with wraparound photographs of their own excrement and get away with it?

Their aim is surely to subvert rather than convert. In this respect, they have much in common with the Surrealist René Magritte, whose bank-clerk appearance both concealed and complemented his transgressive spirit, and

who felt that he could communicate more directly by painting in the style of a lumpen commercial illustrator. Yet whereas Magritte wanted to act on the viewer's subconscious, the art of Gilbert and George forces a face-to-face – or cheek-to-cheek – engagement with, and consideration of, the complexities of the grittily immediate.

It is now almost expected of art that it should dismantle traditional distinctions between painting, sculpture and performance, and a whole range of artists from Damien Hirst and Sarah Lucas to Tracey Emin and Mark Wallinger, are embracing urban contemporary life, frequently appearing in their own art while simultaneously remaining aloof from a specific personal and political stance. At their head are Gilbert and George, those masters of the mixed message who seem hellbent on scouring the least appealing surfaces of their city and themselves for base matter to elevate into art.

RICHARD HAMILTON

b. 1922 London
1938-40 Royal Academy Schools; 1948-51 Slade School of Fine Art
Anthony d'Offay Gallery
Lives and works in Oxfordshire

Just what is it that makes today's homes so different, so appealing? enquired Richard Hamilton in a revolutionary 1956 collage of Mr and Mrs Perfect preening their flawless bodies in a modernist home stuffed with the latest in consumer durables. Some forty years later, the work has become a Pop icon, the art world groans with a glut of appliances and pop references, and Hamilton is still bedazzled by the high-tech paraphernalia that dominates our lives.

It is now common convention for art, advertising and the mass media to indulge in mutual cross-dressing, and for artists to use their work as a process of enquiry into the meretricious world we occupy. But while his ideas can sometimes seem to be several steps ahead of the images that emerge from them, and his recent experimentations with computer generation lack the edge of earlier work, Hamilton continues to feed off double standards by simultaneously celebrating and criticising the art-as-mass-media bandwagon that he himself rolled into the 1960s as a pioneer of British Pop art.

Hamilton's numerous splicings of art and popular culture have included

The state
1992-3
Oil, Humbrol
enamel and
mixed media on
Cibachrome on
canvas
2 parts, each
200 × 100 cm

a TV commercial advertising his Marcel Duchamp-meets-Jasper-Johns
'assisted readymade' of dentures and electric toothbrush (*The critic laughs*
1971-2); a painting based on advertisements for Andrex toilet paper (*Soft pink
landscape* 1971-2); and a specially designed, fully functioning stereo amplifier
that mutates into an abstract painting (*Study for 'Lux 50' IV* 1976). With a
mixture of wonder and knowingness that has been adopted by today's
younger artists, Hamilton also employs state-of-the-art image-manipulation
technology to investigate the three-way traffic between politics, mass media
and the making of myths. His paintings of an ascetic, Christ-like figure (*The
citizen* 1982-3), a sashed and bowlered Orangeman (*The subject* 1988-90), and
a camouflaged solider (*The state* 1992-3), each originated from the television

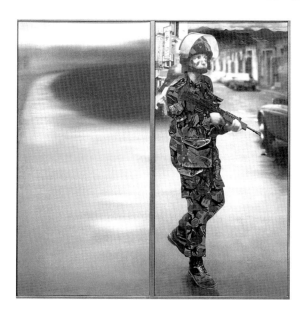

screen. With the help of a Quantel
Paintbox, Hamilton turned a film
of the IRA hunger striker Raymond
McCartney, a televised Orangeman
march, and footage of a British
soldier on patrol into three painted,
quasi-religious diptychs that
encompass and transcend their
politically specific subject matter.

Like his friend and hero Marcel
Duchamp, Hamilton has remained
devoted to undermining traditional
categories of 'fine art', and this is
often combined with an updated
spin on Dada's ambiguous view of
the machine. Whereas Duchamp's
dysfunctional mechanisms doubled
up as a metaphor for human foibles, Hamilton's ambivalent mechanical
marriages have ranged from an exquisite painted collage of the voluptuous
curves of a classic Chrysler car (*Hommage à Chrysler Corp.* 1957); a series of
self portraits made by scanning Polaroids into a Quantel Paintbox; and a spe-
cially designed Diab DS-101 mini computer (1985-9). In this context it is hard
not to think of Hamilton as the granddaddy of a multitude of subsequent
artistic forays into the world of product design, whether Steven Pippin's
Heath Robinson contraptions, or Damien Hirst's balloon-blowing machines.

He may have been speaking in 1957, but Hamilton could have been
echoing the aspirations of many of today's artists when he called for an art
that was 'Popular ... Low Cost, Mass-Produced, Young ... Witty, Sexy ...

Glamorous, Big Business'. In his desire to present a true art of the twentieth century, not only did Hamilton collaborate with Marcel Duchamp (he reconstructed his *Large Glass* in 1965-6) but he has taken up from where Duchamp left off and forged the way for many of today's young artists to find rich possibilities in the worlds of art, design, technology, movies and TV, and to move easily between whatever media they deem the most appropriate.

SUSAN HILLER

b. 1940 Carson City, Nevada, USA
1961-5 Smith College, Massachusetts, USA;
1965 Tulane University, New Orleans, USA
Lives and works in London

It is significant that Susan Hiller practised as an anthropologist in South and Central America before she started making art. She has described her work as 'retrieving and reassembling a collection of fragments', and an anthropological curiosity underpins the way in which she seeks out overlooked and undervalued aspects of our familiar environment – photobooth portraits, seaside postcards, tacky wallpaper or cow-shaped milk jugs. Yet Hiller abandoned the world of anthropology in the late 1960s, feeling disillusioned with its finite methods and assumptions; and when she employs scientific processes of assembling, labelling and categorising, it is to challenge, not to add to, fixed 'scientific' notions of truth, history, identity and meaning.

For Hiller, divisions between rational and irrational, present and past, fact and memory are ones that are manmade (and the gender distinction is deliberate). As far as she is concerned, reality is just as likely to lie outside official parameters, and she uses whatever means she can to connect her audience into areas of collective personal experience. The result can be spectacular: *An Entertainment* (1990) is a video installation in which scenes taken from over thirty Punch and Judy shows are projected onto immense screens that engulf and dwarf the viewer. On this scale, the relentless violence of that classic children's entertainment of wife beating and infanticide is both hard to take and perversely intoxicating – there's no moral message here (there never is in her work) but Hiller succeeds in representing seemingly familiar territory as dark, unfathomable and full of paradox.

Long before a younger generation of artists had begun to use the rigours of science and Minimalism as a foil for an unruly subjectivity, Hiller was

employing orderly geometric forms and systematic processes in order to express what was the very antithesis of objective and finite. Her series of anti-monumental monuments go beyond their specific subjects and neat, carefully assembled appearance to deal with wider, more untidy complexities of death and commemoration. The geometric grid of *Sentimental Representations in Memory of my Grandmothers (Part II for Rose Hiller)* (1980-1) consists of eighty small squares, lovingly built up from single preserved rose petals; while *Dedicated to the Unknown Artists* (1972-6) sent out powerful contradictory messages of remembrance, association and nostalgia in the unlikely form of hundreds of common 'rough sea' postcards sent and collected from resorts around Britain and organised in sober blocks with accompanying analytical charts and a map locating their origins.

Hiller's obsession with the marginal and overlooked has led to her 'exca-

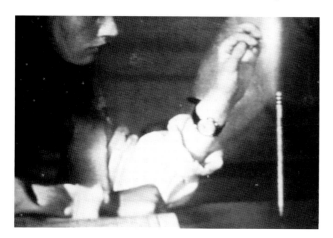

vation' and reinstatement of processes that are commonly dismissed as irrational, unreliable and without credibility. She has investigated dream imagery and worked extensively with automatic writing, messages through spiritualists and other unexplained transmissions. While she is loath to bang a feminist drum, Hiller is aware that such activities are given a respectable

artistic and scientific provenance when practised by men, but are traditionally linked with madness and mediumship in women. Her 1999 video installation *PSI Girls* picks up on this theme, presenting excerpts from five mainstream Hollywood movies in which young girls telepathically move objects around. Drenched in vivid colour, the clips jump from screen to screen, accompanied by the rhythmic hand-clapping of a gospel choir. These forays into the so-called supernatural are not intended to confirm or deny the existence of extra-terrestrial forces, and nor is Hiller a contemporary Surrealist trying to harness the subconscious to find the key to our existence. For Hiller, as for subsequent artists who have benefited from her freeing-up of such material – whether Gavin Turk's experiments with levitation, Jane and Louise Wilson's dual hypnosis, or Mat Collishaw's images of angels and fairies – the emphasis is on process as much as product. Her aim is to point

out new areas of human potential and creativity, and to look at what these phenomena mean to each of us personally.

Hiller's art strives to be open-ended but also refuses to take anything for granted. Every element is exhaustively (and sometimes exhaustingly) interrogated and shown to be in a state of flux. At times, the wealth of reference and density of these enquiries can threaten to overwhelm. Her ongoing installation *At the Freud Museum* (begun in 1992) finds Hiller rather over-doing her quasi-anthropological collecting, and it can feel as if there's little space for the audience to negotiate its own routes though her boxes full of ephemera, relics and writings.

More often, however, her work rises above its dense layers of meaning to stir the senses and capture the imagination. We see light used to dissolve the clarity of the world as well as to fix it, texts that both conceal and reveal, while language emerges as a process of restriction as well as freedom. Again and again her work stresses the now very contemporary notion that 'one person is many voices but there is no bounded unit who contains them', and there is no doubt that Hiller's insistent probing of the certainties upon which we build our lives and identities raises issues that are crucial to all of us.

DAMIEN HIRST

b. 1965 Bristol
1986-9 Goldsmiths College
White Cube
Lives and works in London

Such is Damien Hirst's current status that it wouldn't really affect his reputation if he gave up making art altogether. (Indeed, lately, restaurant ventures, record releasing and book publishing seem to have taken the place of a focused artistic output.) He's guaranteed his place in art history as the artist whose attitude and influence – for better or worse – has been at the forefront of the publicity-hungry art world that emerged during the final decade of the last century. What he will achieve in the next remains to be seen.

Hirst's swift rise to household-name celebrity was as dramatic as the ping-pong ball dancing on top of a column of air that he exhibited at the ICA in London in his annus mirabilis of 1991-2, under the title of *I want to spend the rest of my life everywhere, with everyone, one to one, always, forever, now*. On show across town was another piece that was to assure the artist his now

Rehab is for quitters
1998-9
Full plastic skeleton, glass, ping-pong balls and compressor
91 × 274 × 213 cm
Photo: Stephen White

ubiquitous star status: *The Physical Impossibility of Death in the Mind of Someone Living* – a 4-metre tiger shark suspended in a greenish tank of formaldehyde, commissioned by Charles Saatchi for a reputed £25,000.

Since then, Hirst's now-familiar motifs of cows, flies, butterflies, cigarettes, hovering balls and sliced tanks have either been elevated to near iconic status or – depending on how you regard such things – repetitively recycled to the point of meaninglessness. The trouble with being a famous master of spectacle is that however much you up the ante, everyone just wants more. It was therefore not altogether surprising that Hirst's first solo show in America, *No Sense of Absolute Corruption*, at the Gagosian Gallery in 1996, attracted more celebrities than the Oscars and was then slammed for being a mini retrospective of his greatest hits: the giant ashtray full of butt

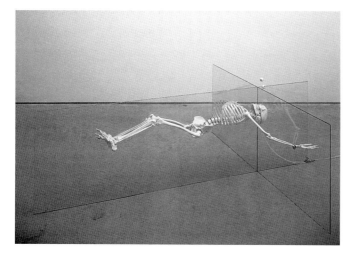

ends and bar-room detritus (*Party Time* 1995); the two cows sliced into twelve tanked-up, walk-around vertical sections (*Some Comfort Gained From the Acceptance of the Inherent Lies in Everything* 1996); the wall of whirling 'spin' paintings; and the floating beach ball, *Loving in a World of Desire* (1996).

But being a dab-hand at spectacle and having an engaging way with the popular has also concealed Hirst's ability to be a serious – and in many ways, traditional – artist who knows his art history well enough to employ a keen formalism and sense of scale, and who still believes that art should grapple with the hefty issues of what it is to be human, to live and to face death. From the shark to the ping-pong ball, Hirst's work covers the extremes and anomalies of our existence – 'the unbearable lightness and the ineffable heaviness of being' – as one critic has put it. Sometimes, as in the case of his mechanical spin paintings, Hirst's work can indeed seem unbearably light, but his installation *In and Out of Love* (1991) – where live tropical butterflies flew around a gallery and settled on the audience – or the bisected cow and calf of *Mother and Child, Divided* (1993), confirm that he can also make something poetic and profound that lodges itself in the psyche. When Hirst declares 'Art

is about life, and it can't really be anything else. There isn't anything else', he isn't being glib, he means it.

Like his hero Francis Bacon, Hirst also intends his images to act directly on the nervous system. But as a child of his times, he spent his formative years watching television and listening to Pop music. Therefore, whether he is using a preserved animal, a cabinet of pharmaceutical drugs, or shooting a feature film, he doesn't balk at employing carefully orchestrated spectacle and slick production values to grab the audience's attention and force an engagement. His first mini-feature film, *Hanging Around* (1996) was shot in the style of a soap opera, and he repeatedly uses cinematic devices to frame and present his images: the giant glass cases containing empty chairs and brimming ashtrays present these mysterious scenarios with the haunting intensity of film stills.

Although there's nothing new in Hirst's promiscuous plundering of the naffest of sources, his work can still reduce some traditional elements within the art world to a state of near apoplexy. What particularly seems to rankle is the non-hierarchical audacity with which he mixes up disparate elements from TV series, children's toys and mainstream movies with such art-historical influences as the outsized Pop sculptures of Claes Oldenburg, the pristine Minimalism of Donald Judd, the floating basketballs of Jeff Koons, or the geometrically framed fleshiness of Bacon. Hirst doesn't make great claims for his art: like a true child of Warhol he professes to be happy with any response. He once summed up the shark as 'a thing to describe a feeling'. And just as Bacon declared 'you are reporting fact not as simple fact, but on many different levels, where you unlock the areas of feeling which lead to a deeper sense of the reality of the image', so Hirst also defies any single interpretation by describing his works as 'universal triggers ... situations that make people try and find meanings ... physical objects which can be intellectualised'. He has famously declared: 'sometimes I have nothing to say. I often want to communicate this.'

The work may have an instant impact, but it is deliberately riddled with contradictions. It is as simple or as complex as you want it to be – and that's another reason why it irritates some people. His handmade 'spot' paintings look mechanical, and his mechanical 'spin' paintings tap into the whole history of angst-ridden brush strokes. His titles intentionally ask more questions than they can answer. The preserved animals in the ongoing *Natural History* series carry art history's tradition of the memento mori as well as the irony that they were killed in order to be preserved, while simultaneously gaining eternal life through a deadly poisonous liquid.

This friction between insoluble realities lies at the heart of Hirst's art. Both physically and symbolically, his work and methods revolve around relationships: how they are made and how they can be expressed. As a student, he made collages from pieces of collected flotsam and began his career by curating the legendary *Freeze* exhibition in 1988, when he was in his second year at Goldsmiths College. Subsequently he has insisted that his art practice continues to be a process of assembling, containing and framing – albeit in a highly controlled form. 'I curate my own work as if I were a group of artists', Hirst has said. He cites as a crucial early influence on his recurring themes of ordering, containment and proliferation a reclusive neighbour who, in an inadvertent rerun of Kurt Schwitters' Dadaist *Merzbau*, crammed his house from floor to ceiling with decades worth of carefully hoarded objects and then, when there was no more space left in this three-dimensional collage, vanished without trace.

At the heart of Hirst's success – or, according to some, his fatal flaw – is his impudent updating of Marcel Duchamp's conviction that anything can be art if the artist says so. According to Hirst, the only artistic parameters that exist are those you draw up for yourself. Whether he is making a video for the Britpop band Blur, producing artwork for a Dave Stewart album, decorating a fashionable restaurant, or slicing up a pig to make a sculpture, it is all art. 'I just wanted to find out where the boundaries were', he says. 'I've found out there aren't any. I wanted to be stopped, and no one will stop me.' So far, no one has.

BRUCE MCLEAN

b. 1944 Glasgow
1961-3 Glasgow School of Art; 1963-6 St Martins School of Art
Anthony d'Offay Gallery
Lives and works in London

Whether he's draping himself across a plinth, painting a giant picture, or shooting a movie, Bruce McLean believes that art should both feed off and into the world in which we live. He makes big art out of small details – the gestures, styles and mannerisms that, whether we like it or not, orchestrate our lives and obsess us all. This concern with seemingly trivial aspects of appearance and body language, and how they inform the different identities we knowingly or subconsciously assume, is one shared by many

Bruce McLean in
still from
Urban Turban
1996
Video projection
Photo: Gautier
Deblonde

younger artists – it is perhaps no coincidence that Bruce McLean was one of Douglas Gordon's tutors at the Slade – and McLean has also consistently demonstrated that art can be serious without taking itself too seriously.

Although he first made his reputation with performance, McLean has always considered himself a sculptor; but that didn't stop him sending up centuries of sculptural tradition with works such as his *Installations for Various Parts of the Body and Pieces of Clothing* (1969) or *Pose Works for Plinths* (1970), which further fuzzed interdisciplinary boundaries by evolving into photopieces in their own right. With the formation in 1971 of Nice Style, 'the World's First Pose Band', McLean went on to parody human behaviour. Wearing straight faces and immaculate evening dress, McLean and friends

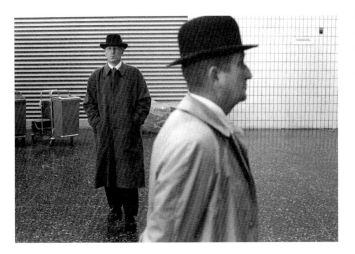

regaled audiences with farcical enactments of every permutation of Western urban pose – from the quest for the perfect Bogartian mackintosh crease, to the rhythmic banging of deep-freeze lids. Nice Style folded in 1975, but a preoccupation with live gesture and the minutiae of human behaviour has remained at the core of McLean's activities.

McLean's modus operandi is to keep – often manically – on the move. During the 1980s he was swept up in the painting revival that gripped the decade, while, with characteristic perversity, denying that he was a painter at all. But however much McLean is playing the court jester, even his detractors acknowledge his exceptional ability to orchestrate form and colour, and his bravura paintings demonstrate a genuine love of the medium that goes beyond pose. Posing, both personal and professional, is often a disguise for something more serious. Despite (or maybe because of) the jokiness, the easy-viewing canvases, the stylish ceramics and the designs for chic fire-places and trendy bars, which seem to embrace the very world they originally set out to parody, McLean's intensity of feeling can sometimes catch you – and maybe him – unawares. The 1980s were his glory years, but while

McLean's copious outpourings on canvas, ceramic, even carpet, had made him one of Britain's most successful and visible artists, his attitude to the decade of plenty was ambivalent to say the least. Works such as *Going for Gucci* (1984), which depicted a crucifixion attended by figures wearing hand-bags on their heads; or the black-grounded *Red Wine Sea* (1985), complete with scratched-in battleship, belied their titles to show, with McLeanean obliqueness, that there was a dark underbelly beneath all the frivolity and conspicuous consumption.

Never one for restraint, in 1996 McLean caused more art-world conster-nation by combining all his obsessions and concerns in a feature-length video. *Urban Turban* ran for nearly two hours, with McLean, his paintings, members of the art world, poses galore, hats in abundance, friends in attendance, slabs of colour and scattered fragments of storyline all projected simultaneously onto three screens and accompanied by a deafeningly rhythmic soundtrack composed by Dave Stewart. Some found it unwatch-able, some found it trivial, some applauded its exhilarating freedom from convention – it was certainly unforgettable. McLean's definitions ranged from 'A comedy, a tragedy, a prediction, an artfilm, a sexual film, probably the first architectural movie' to 'perhaps the first real hat movie'.

Long before Hirst's multifarious engagements with the world of style, fashion and pop culture, McLean had paved the way, and the extraordinary outpourings of *Urban Turban* continue to confirm that younger members of the current art scene do not have the monopoly on cheek and effrontery.

PAULA REGO

b. 1935 Lisbon, Portugal
1952-6 Slade School of Fine Art
Marlborough Fine Art
Lives and works in London

In today's post-postmodern climate, 'narrative' is no longer a dirty word in contemporary art. Subjective stories have become the artistic norm – the more offbeat and open-ended the better – from the bizarre, vox-pop rantings recorded by Gillian Wearing, to the autobiographical extravaganzas of Georgina Starr, and the fractured fictions of Sam Taylor-Wood. But the doyenne of skewed narration is Paula Rego, who, for over forty years, has trawled her own myths and memories to conjure up ever more

psychologically complex scenarios where it is up to the viewer to decide what is taking place – if they can bear it.

Starting points for Rego's paintings, prints and pastels can be whatever captures, or has lodged itself in, her imagination. Traditional stories remembered from her Portuguese childhood, a newspaper item, a movie, or any amount of seemingly mundane personal occurrences all act to trigger and fuel the storylines that run through her work. Yet she is no illustrator. In a series of large pastels from 1995, *Snow White* becomes a Freudian psychodrama that hones in on the sexual tension between Snow White, her absent father and her vampish stepmother, with not a dwarf nor animal in sight. The action unfolding in *The Family* (1988) may not be from any recognisably familiar tale, but the viewer is still sucked into an uncomfortable complicity with the intricate and highly ambiguous relationships between the woman, the two stocky girls and the man whom they are pinning to the bed.

For Rego, stories both familiar and imagined, whether expressed in full-blown set-pieces or merely hinted at through individual characters or details, are sites of shared experience that we can all, in our particular ways, recognise and understand. It may be maddening that what looks so explicit can also be so obscure, but that is the point: how you read these goings-on is up to you. Rego cuts through the contemporary sentimentality of fairy stories and nursery rhymes to tap into their dark, transgressive origins where symbols of authority are toppled, the 'natural' order of things is reversed, and mayhem and violence can erupt. Her *Three Blind Mice* (1989) scrabble in wall-eyed terror as a sinister farmer's wife brandishes a savage blade, while versions of other children's classics such as *Baa Baa Black Sheep* and *Little Miss Muffet* (both 1989) are fraught with the darkest of sexual innuendo.

There's nothing nostalgic about Rego's child's-eye view, which plunges unblinkingly into the darker side of childhood on which no one likes to dwell, yet it is often affectionate. Her children may be monsters, but she doesn't demonise them, and she makes it hard to distinguish between the brutality of playfulness and the playfulness of savagery.

Childhood associations permeate the style as well as the content of Rego's work. At times she has plundered infantile doodlings, cartoons, and – most famously – children's storybook illustration. There is also an abundance of old-masterly 'high art' sources including Giotto, Goya and Tintoretto, and the volume and scale of her colossal tumbling figures can lend some of Rego's works the unexpected appearance of High Renaissance altarpieces. Her desire to give form to the most atavistic of feelings has resulted in a disregard for artistic trends and the art world's enduring hunger for a

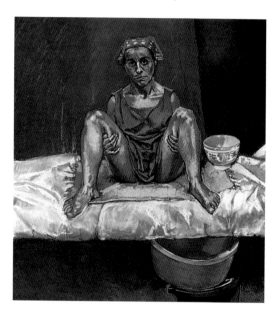

Untitled No. 1
1998
Pastel on paper
mounted on
aluminium
110 × 100 cm

signature style. Rego throws herself into the physical processes of painting, etching and drawing as a means to unleash her imagination, not to comment on the state of contemporary art. Collaged cut-outs of the 1960s and lurid cartoon romps of the early 1980s show the influence of untrained 'Outsider' art, as well the free-association techniques of Surrealism, while the ungainly volumetric figures and stagy settings of works from the 1980s and early 1990s show direct and deliberate borrowings from the illustrations of John Tenniel, Arthur Rackham and Beatrix Potter.

But just as Rego was establishing an impressive reputation for presenting complicated goings-on in a pointedly illustrative style, in 1994 her work made another stylistic shift. She committed what was to the avant-garde the ultimate crime of making large, academic life drawings in coloured pastel, and then compounded the offence by extolling the voluptuous pleasures of the act of drawing. Yet, typically, things were not quite as they seemed. In an idiosyncratic twist on the interchange between animals and humans that runs throughout her work, these highly finished, anatomically correct images of squatting, sitting and sleeping women communicate the intensity of human existence by assuming the uncannily accurate gestures of dogs. Her *Dog Women* (1994) hunch, grovel and snarl in poses that are submissive and defensive, appealing and ungainly. In 1995, Rego continued to use the life model for anthropomorphic crossover in a series of gallumphing ballet dancers inspired by the ostriches in Walt Disney's *Fantasia*. More recently, in her *Abortion Series* (1998-9) the source becomes uncomfortably human: young women are presented in the bleak aftermath of terminated pregnancy. Even here, many assume the convoluted poses of old-master paintings.

Women may predominate in Rego's work – and men often get their come-uppance – but this has nothing to do with feminist polemic. Rego doesn't take sides or express opinions, and her sympathy for her protagonists is always highly ambivalent. From the earlier paintings through to *Snow White*, women and girls are often unspeakably cruel to each other. The *Dog*

Women are a welter of conflicting emotions, the *Ostriches* series both celebrates and pokes fun at notions of femininity, and the young girls in the *Abortion* pastels may suffer, but are never portrayed as victims.

In common with many younger artists working at the moment, Rego views identity not as a clear-cut entity but as something to be constantly struggled towards and reassessed. In this context, stories can mean different things to different people, and act as a springboard for the discussion of human nature, power and relationships – however scary they may be. Rego walks a fine line between whimsicality and melodrama, but she's prepared to carry on taking risks. She may relish games, but she knows that play is also deadly serious – as she once said: 'I paint to give fear a face.'

BRIDGET RILEY

b. 1931 London
1949-52 Goldsmiths College
1952-5 Royal College of Art
Karsten Schubert
Lives and works in London

There's nothing new about art stardom – Andy Warhol and Salvador Dalí used it as a medium in its own right – and today's artists have learned to incorporate the impact of celebrity into their work. However, as Gillian Wearing recently discovered when Volkswagen used her *Signs* photographs as the starting point for a series of commercials, popular culture's increasingly omnivorous need for novelty is no respecter of artistic sensibilities and can ultimately be detrimental to the reading of an artwork. An early casualty of this double-edged relationship between art, design and advertising media was Bridget Riley, who in spite of a career spanning over three decades, and a body of work that, since 1967, has involved an increasingly complex use of colour, is still best known for the pulsating black and white Op art paintings that catapulted her to instant media stardom, and became a ubiquitous and lasting symbol of the 1960s.

It is particularly ironic, therefore, that these same works are now attracting a following amongst many of today's young artists, and yet again for reasons that often have little to do with her original intentions. For Riley was – and still is – carrying out a serious and rigorous investigation into the nuts and bolts of how we sense and see. In the short but significant period

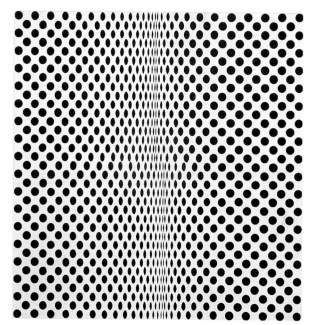

Fission
1963
Tempera on
board
88.8 × 86.2 cm

between 1961 and 1965, this involved taking the most simple of shapes, in basic black and white, and exploring what they could be pushed into doing. Riley herself preferred the term 'Perceptual Abstraction' to Op Art, insisting that she worked intuitively without recourse either to optics or mathematics. Her aim, she said, was 'to bring about some fresh way of seeing again what had ... been experienced ... that thrill of pleasure that sight itself reveals'.

But her hard-edged configurations of curves, diamonds, rectangles and dots were crudely reproduced and smothered over every conceivable surface, admired for their instant impact and trippy visual buzz. Riley was mortified: these were paintings 'about states of being, states of composure and disturbance', not swirly lampshades and fashion accessories. Her work wasn't even safe in the museum: the 1965 exhibition *The Responsive Eye* at New York's Museum of Modern Art, in which she showed alongside Josef Albers, Ellsworth Kelly, Agnes Martin and Victor Vasarely, should have been a high point of her early career. At the opening, however, many of those present were wearing dresses made of fabric copied from her paintings. Riley attempted (unsuccessfully) to sue the designers. This was in direct and significant contrast to Damien Hirst who, some three decades later, chose to take it as a compliment when designer Rifat Ozbek based part of his Spring 1996 collection on his 'spot' painting *Asialoglycophorin*, even requesting a dotted outfit for his girlfriend to wear at the Turner Prize ceremony. (However, he was less sanguine when he accused British Airways of appropriating his spots in the logo for their economy airline.) Hirst claims that his endlessly variable grids of multicoloured spots, painted in coloured household paint have nothing to do with paintings by Riley such as *Black to White Discs* (1962), *Fission* (1963) or *Static 2* (1966). But the paradoxical way in which Riley's flatly mechanical, assistant-executed canvases can induce an almost overwhelming emotional and visceral impact

on the viewer undoubtedly made an impression. Just as Riley's use of simple black and white geometric shapes became the logo of the 1960s, Hirst's multicoloured spots were an equally omnipresent, happy-clappy sign of the 1990s.

Riley's rigorous, lifelong quest to provide artistic analogues for the intense physical and psychological sensations that accompany the act of looking have been blithely appropriated by a wide range of younger British artists. Though she is deeply influenced by the art of the past, as far as these artists are concerned, her importance is in the here and now. 'Bridget Riley, so complicated but such eloquent funky results', declares Peter Davies in his text painting *The Hot One Hundred* (1997), in which he places Bridget Riley eighth in his league table of artists. In other works such as *Small Touching Squares in a Pattern Painting* (1998-9) and *Small Circles Painting* (1996) he uses obsessive tessellations of pattern that shimmy and dance off the canvas with the quick-hit dazzle beloved of Riley's 1960s fans, but with a painstaking handmade wonkiness which, in direct contrast to Riley's cool suppression of self, flags up the painstaking presence of the artist. Another admirer is Paul Morrison, in whose paintings cartoonish plants and trees are mixed up with naturalistic and often out-of-scale silhouettes of instantly recognisable flowers, ferns and trees. Here, the impact is primarily optical – the crisp shapes begin to shimmer, conjuring up associative colours and paying homage to Riley's ability to be at once emphatically lucid and physically disorientating.

Riley may consider the optical sensations induced by her paintings to be just one element in a raft of wider concerns, but there's no doubt that it is the way in which her canvases take on a physical life of their own that strikes a particular chord with artists today. In an era in which personal, physical and psychological space is under constant assault from virtual reality, IMAX cinema and increasingly sophisticated computer graphics, Riley's early explorations of the untrustworthiness of our eyes carries a particular relevance.

RICHARD WENTWORTH

b. 1947 Samoa
1965-6 Hornsey School of Art; 1966-70 Royal College of Art
Lisson Gallery
Lives and works in London

Twenty Seven
Minutes, Twenty
Two Nouns,
Seven Adjectives
1999
Dictionary,
mirror and
assorted
materials
Dimensions
variable

Photo: Dave Morgan

Richard Wentworth first emerged in the late 1970s as part of a group of sculptors who were breathing life into British abstract sculpture via an irreverent use of materials more commonly associated with the skip or the DIY shop than the world of high art. Never mind that the main factor uniting these disparate practitioners of the so-called 'New British Sculpture' was their international outlook, there's still no doubt that their focus on everyday objects and their belief in humour and playfulness has been crucial in opening up the option for the current generation of British artists, many of whom now endeavour to make serious points while using tacky, up-to-the-minute source material.

However, unlike Tony Cragg, Richard Deacon and Bill Woodrow, whose earlier transformations of urban detritus seem to have metamorphosed into

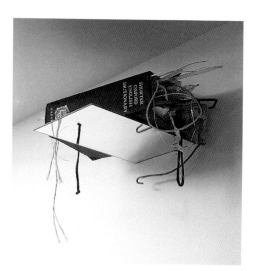

sculpture that risks becoming as monumental, formalist and self-referential as the Henry Moores and Anthony Caros against which they were originally reacting, Richard Wentworth's investigations of the everyday world continue to reflect the irreverent, questioning spirit of our times. It is significant that for sixteen years, he was a tutor at Goldsmiths College, up until 1987 – the year before second-year student Damien Hirst curated the famous *Freeze* exhibition. Evidence of Wentworth's influence can be spotted throughout today's art world, whether in the works of Julian Opie and Grenville Davey, who explore the shapes and messages of functional objects, or in the dead-pan humour of Simon Patterson's free-association word games.

Wentworth generally works with ordinary objects whose forms are dictated by their function. Ladders, chairs, pillows, galvanised and corrugated steel, and a variety of containers such as buckets, ladles, dishes, cups and cans all feature prominently and it is this very familiarity that provides a starting point for sculpture that makes the most mundane of objects acquire new identities and uses. Sometimes, this is achieved with the minimum of artistic intervention: *Pair of Paper Bags with Large & Small Buckets* (1982) is just that: two metal buckets wrapped in brown paper and exhibited as purchased. Other pieces can be more complex, such as the epic *Drift* (1993), which fills an entire room with a higgledy-piggledy maze of twenty-seven

steel-mesh cages containing various characteristic Wentworth items such as mirrors, lightbulbs, bricks and tyres. In 1998, his love of objects and the fluidity of their function spilled into curating *Thinking Aloud*, an exhibition of over 200 eclectic and unexpected objects, ranging from Joseph Paxton's first sketches for the Great Exhibition building of 1851, to the prototype for a Dyson vacuum cleaner, and a range of artworks in every media by artists of all ages – excluding himself.

Whether he's making a sculpture or selecting a show, Wentworth relishes the abstract qualities of his materials: concrete against mesh, metal against fabric, the timeless, universal shapes of beaker, box and bowl. He also enjoys a Dadaist joke. Yet what distinguishes Wentworth from his artistic antecedents is the human, handmade, handheld element that permeates his work. Inextricably intertwined with the appearance of the objects he favours are the associations they conjure up in all of us. Technical skill is a crucial component: for his sculpture to succeed it has to appear easy and inevitable, but at the same time remain up-front about how it has been constructed. 'I try very hard to make my work appear matter of fact', he says. Associations, oblique and overt, are tweaked, teased and confounded in works such as *Surd* (1991), where a bollard-shaped blob of granite rises out of the floor, joined by a tin ladle whose bowl is sealed by a soldered disc of brass and penetrated by corks; or *World Soup* (1991), in which the upper rims of nine opened food tins, their labels still intact, are immaculately fitted into a sheet of galvanised metal, which they both pierce and support.

A crucial subtext to all Wentworth's activities is an ongoing series of photographs, which he has been taking since the 1970s, entitled *Making Do and Getting By*. Described by the artist as records of 'situations that attracted me', these thousands of images celebrate the ingenious and often almost unthinking ways in which people adjust their surroundings and possessions to suit the necessities of the moment: a ladder becomes a barrier, a doormat wedges open a door, a folded cigarette packet stabilises a table leg. Improvised solutions to urban life, they form what Wentworth calls 'an international language of signs' that operates in cities across the world, while at the same time being particular to a specific place, moment and need. He doesn't copy them directly, but they provide the conceptual underpinning to his work. It is the lightness, rightness and the incongruity of this series that permeates the best of Wentworth's sculpture, and constitutes a crucial shift in emphasis away from Duchamp's 'assisted readymades', or from a quasi-Surrealist search for weirdness in the streets.

Similarly, while there seems to be a strong element of Surrealist provoca-

tion in Wentworth's playful – and often complicative – choice of titles, which can carry a multitude of different readings, they also show an interest in everyday linguistic solutions. Titles such as *Mould* (1991) – for an inverted empty metal house shape, its inner and outer surfaces blurred by a layer of steel mesh – or *Buttress* (1990) – for a flimsy section of wooden ladder straddling a pair of bricks – have as much to do with the puns, gags and narratives that sit at the core of British culture and humour as with any desire to assign true meaning.

With his love of games, wordplay and the serendipitous recording of spontaneous examples of human ingenuity – not to mention a penchant for manufactured objects that hark back to an era of welded, riveted manu-facture – Wentworth inevitably lays himself open to accusations of folksiness and whimsicalilty. But he keeps on his guard. He salutes the unknown makers-do and getters-by without mythologising them or classifying his dis-coveries, and this open-ended pragmatism feeds into the sharp-edged clarity of his sculpture. In spite of some quaint raw material, Wentworth's pristine finishes and formal rigour usually succeed in keeping nostalgia at bay, while at the nimble humanity and humour of these leaning ladles, balancing din-ner plates and dangling ballcocks flies in the face of arid objectification.

Wentworth describes his combinations of materials as 'emulsion' where, like oil and vinegar in salad dressing, the elements bind but do not lose their distinct character. Occasionally, when this process fails to take place, his art can seem obdurately cryptic. Yet there are also times when Wentworth mischievously makes the relationship between object and title appear so screamingly obvious that you refuse to take it at face value and are led to conjure up an alternative range of elaborate interpretations. If Wentworth gives one message to his audience, it is this: keep looking, keep wondering, and consider all options.

RACHEL WHITEREAD

b. 1963 London
1982-5 Brighton Polytechnic; 1985-7 Slade School of Fine Art
Anthony d'Offay Gallery
Lives and works in London

These days, the notion of monumental public sculpture is a problematic one. There's already a nationwide excess of 'turds in plazas' and a time-honoured

tradition of art being used as 'lipstick on the gorilla' of innumerable unsuit-able property developments. Lately, the UK's sculptural surplus has been topped-up by a slew of Lottery-funded eye candy that dares not challenge a spurious idea of public consensus. It is therefore perhaps appropriate as well as ironic that three of the sculptures (*House* 1993, *Water Tower* 1998 and *Plinth* 2000) that have helped to win Rachel Whiteread international renown as Britain's leading maker of monuments have been intentionally imperma-nent; the fourth, the *Holocaust Memorial* in Vienna (2000), was only achieved after over three years of political wrangling.

It is also ironic that Whiteread, whose reputation as a major international artist is shrouded in a gravitas that is the polar opposite of the lurid celebrity of her contemporary Damien Hirst, should have first risen to fame on a wave of controversy. *House*, her concrete mould of the space inside a Victorian ter-raced house in east London, may have had a life-span of only two and a half months (it was demolished by a hostile local council in January 1994, who had refused to extend the temporary permission for the public work), but it attracted tens of thousands of visitors, heated debate, questions in Parliament, and helped Whiteread win the 1993 Turner Prize. As the last survivor of a street of such houses, and as an intimate container of ordinary lives, the three-storey sculpture expressed both individual memory and col-lective public consciousness, and became in turn the focus of a surprising range of grievances against the Government's housing policy, the aesthetics of public sculpture, the British class system and contemporary art in general. Like all Whiteread's sculptures, *House* sent out disconcertingly mixed mes-sages. At once modest and grand, this three-tier pile of room-sized blocks, with its surfaces delicately moulded by reversed indentations of windows, skirting boards and even light switches, evoked everything a house should be – a shelter, a sanctuary and a space for human drama. But it also denied any sense of homeliness by presenting a cool, strange cenotaph of impregnable, outward-facing cubes and strangely bulging fireplace cavities.

This tension between the mundane and the monumental is central to Whiteread's work, and *House* was just one element in a continuing explo-ration of the intimate, overlooked spaces that encompass daily life. There's much more to Whiteread's sculpture than a filling-in of blanks. Not only does she take casts from objects that are part of our everyday world – beds, chairs, tables, hot-water bottles, entire rooms, as well as morgue slabs and benches – but her casting also goes beyond the objects themselves to objec-tify the spaces in, on, around, and below them. Not so much 'inside out' as 'outside the inside', these slabs, chunks, and blocks in plaster, concrete, resin

Untitled (Stack)
1999
Plaster,
polystyrene and
steel
236.5 × 176.5 ×
240.5 cm

and rubber owe their form to a space that previously had no form, but was instead the emptiness between objects, walls, or the sides of containers.

This consistent concern with solidifying space extends back to early pieces such as *Closet* (1988), in which Whiteread created a sinister, sectioned chunk of darkness by covering a plaster cast of the inside of a child's wardrobe with black felt; through to the gleaming, jelly-like blocks of *Untitled (One Hundred Spaces)* (1995), which result from casting the gaps underneath stools and chairs in translucent resins the colour of antique glass. It also governs the form of Whiteread's two most ambitious public works to date: the concrete cast of a library that stands in Vienna's Judenplatz as a permanent monument and memorial to the 65,000 Austrian Jews who died

at the hands of the Nazis; and the water tower cast in semi-transparent resin for lower SoHo in New York City.

The activity of making moulds and taking casts, the starting point for all Whiteread's sculpture, may be within a time-honoured artistic tradition, but Whiteread is no tradition-alist. Nor, despite what her detractors may believe, is she mechanically trotting out a tried-and-true device. In the same way that a painter like Fiona Rae will explore and express precedents, processes and possibilities thrown up by her chosen medium, so Whiteread is highly attuned to the aesthetic, conceptual and art-historical implications of her capture of space.

She herself has compared her process to the making of a death mask, the conjuring-up of an absence. Another part of her working practice involves photographing the numerous gaps, chasms and chinks that she encounters around the world: structures, grids and objects that can range from the rows of crosses in a war cemetery to the space between two tropical huts, or the cage of girders around a council block in east London's Commercial Road. She's also well aware of American artist Bruce Nauman's 1965 snub to the matter-obsessed Minimalists in the form of a concrete cast of the space under his chair – thirty years later she was to make her own multiple version. And it's hard not to view Whiteread's glitter-ing, dark-green resin cast of the underside of floorboards as a wryly poetic antidote to arch-Minimalist Carl Andre's floorbound wooden sleepers.

While it's certainly no accident that Whiteread's choice of material and presentation transforms a cast-iron bath tub into an ancient alabaster sarcophagus (*Ether* 1990); or that a humble Victorian room (*Ghost* 1992) cast in blocks of plaster can resemble an Etruscan burial chamber, her choice of objects that have been designed for, and used by, ordinary people also gives her sculpture a physical, human presence. Propped up against a wall, the sagging underside of a bed moulded in amber rubber seems to echo the bodies it once supported, a cast hot-water bottle becomes a poignant torso, the plaster underside of a sink bulges suggestively, a concrete library invites you to thumb its pages. These are sculptures that we all can, and do, inhabit.

CURRENT CONTENDERS

CHRISTINE BORLAND

b. 1965 Ayrshire
1983-7 Glasgow School of Art; 1987-8 University of Ulster, Belfast
Lisson Gallery
Lives and works in Glasgow

Scottish artist Christine Borland's projects with experts from the world of ballistics, forensic science archaeology and human genetics have sometimes seemed so close to these disciplines as to be indistinguishable as art; but, unlike her collaborators, she is not in search of conclusions or certainties. Instead, she employs their systematic processes of classification, reconstruction and presentation to show that all systems are intrinsically arbitrary and unreliable, and to point to more enduring questions and doubts.

For *A Place Where Nothing Has Happened* (1993), Borland took local police officers to a piece of wasteland in central Newcastle, where they carried out all the procedures of a routine investigation – combing the area for potential clues, and displaying their finds in a Portakabin placed within the area under scrutiny. However, what was being investigated here was not a crime, but the investigation itself. In this seemingly forensic laying out of pieces of evidence – shards of glass, tyre-tread casts, empty cans – as the traces of a non-crime, Borland forces an examination of the fragile and mundane substances upon which decisions of guilt or innocence are so often based. She also throws up some surprising similarities between the random and intuitive systems relied upon by both art and policing, which, albeit for different reasons, are designed to make us look and look again.

Reconstruction continues to be a dominant theme. In the name of art she has shot at porcelain, bed sheets, apples and melons, and coolly presented the aftermath. In works such as *Shot Glass* 1993, an apparently factual presentation of the aftermath of a violent act only increases our desire to

From Life, Berlin
(detail)
1996
21 glass shelves,
dust traces of the
bones of a
human skeleton,
21 lamps
Dimensions
variable
Photo: Uwe Waller

conjure up our own stories around such suggestive symbols as a small hole in a bed sheet or a splintered shard of timber. As with Willie Doherty's enlarged photographs of bullet holes taken in Northern Ireland, the absence of any perpetrator actually serves to heighten the menace and suggestiveness. Yet Borland's work not only explores the processes of reconstruction, it also attempts to make reparation. In *Blanket Used on Police Firing Range, Berlin, Repaired* (1993) the bullet holes have been neatly darned; in subsequent series of works, she reminds us of the way in which medical and anatomical research results in an often brutal loss of identity for its subjects.

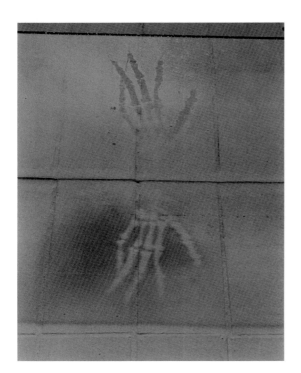

From Life (1994-6) involved working with experts in osteology, facial reconstruction and computer technology to recover the identity of a human skeleton purchased from a medical supplier. The ultimate result of these elaborate processes was twofold: a 'traditional' cast-bronze portrait bust modelled by medical artists, and a text describing the scientifically reconstructed identity of the skeleton: 'Female/ Asian/23-25 years old/5ft 2in tall/At least one advanced pregnancy.' With these two 'likenesses' of the same person, each in their own way equally suggestive – and inadequate – our expectations of art and science, subjectivity and objectivity, are irrevocably destabilised. No amount of number-crunching can replace the human intuition that ensures the most accurate modelling of a missing nose or a cheek, yet human history cannot be charted without these kinds of facts and figures.

In *Phantom Twins* (1997), Borland lovingly hand-stitched contemporary replicas of a pair of eighteenth-century leather childbirth demonstration models, shaping their heads with replica foetal skulls, rather than the real thing of the original. Again, she was attempting to reinvest some humanity into scientific images and procedures. In the body of work that resulted from her 1999 residency in the Biochemistry department of Dundee University,

she continued to reintroduce the personal into the clinical. Here, her personal, multifaceted response to the field of human genetics ranges from projected depictions of the luminous jellyfish whose chemical structure enables the visualisation of DNA (*The Aether Sea* 1999), to the image of a small boy, taken from a nineteenth-century engraving illustrating physical deformity, who is made to walk again by contemporary animation (*Infantile Paralysis: Endless Walk: Engraved by Duchenne 1858* 1999).

Marcel Duchamp's readymades may have given contemporary artists the freedom to nominate any object as an artwork, but by extending art into the most surprising areas of life, Borland shows that it has often been there all along. Parallels can be drawn with the way in which Helen Chadwick's *Stilled Lives* pointed to the central role of aesthetic judgement in the science of embryology, and thus to a more interconnected, unstable way of looking at seeming certainties. Like Chadwick, Borland is at pains to show that the subjective is as valid and 'accurate' a system of appraisal as any other, and in doing so she reveals the limitations of closed systems, artistic and otherwise.

BRIAN CATLING

b. 1948 London
1968-71 North East London Polytechnic; 1971-4 Royal College of Art
Matt's Gallery
Lives and works in Oxford

Poet, performer, sculptor, installation artist – Brian Catling is as difficult to categorise as his work is to describe in print or capture on film. What he does depends on the location in which he is working, and he draws on past and present aspects of his surroundings as a major inspiration for his unpredictable combinations of written texts, live performances and collections of objects. The outcome can be spectacular and dramatic, or so low key as to be barely noticeable, but a crucial component is always the live presence of the artist himself, sometimes performing, sometimes just occupying the space, while projecting a range of personae that can ricochet between Mr Normal, Idiot Savant, Mad Professor or Malevolent Mobster.

Catling rejects 'a fossilised studio practice' for a more spontaneous (and risky) engagement with the essence of a specific place. The results are as various as the locations themselves. During a nine-day marathon at London's Serpentine Gallery (*The Blindings* 1994), the artist used his own words,

Lunar Prayer
1989
Performance at
Museum of
Modern Art,
Oxford
Photo: Paddy
Summerfield

objects and actions to commune with the space and memories of the gallery and its environs – from the manholes in the floors to the blue whale in the Natural History Museum. His eight-hour video projection *Cyclops*, at the South London Gallery in 1996, came into its own at dusk when the eerie whispering presence, invisible in the natural daylight, seemed to suck in the last glimmer of light to reveal a monstrous image of the artist, with mirror pressed against one eye – an alienated Cyclops for our times.

Catling may possess a rich command of language and the ability to conjure up the presence of Caliban crossed with a Kray brother, but it is not literature or theatre that lies at the core of his work. Although the objects that populate and punctuate his pieces rarely survive a single showing, and despite the fact that he is well known for his published books, sculpture is the metaphor linking Catling's many modes. He is currently Head of

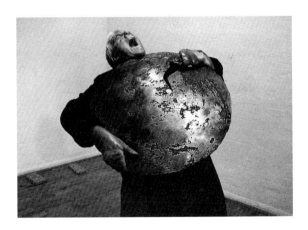

Sculpture at the Ruskin School in Oxford, and throughout the 1980s, taught sculpture at a number of art schools including Camberwell and the Royal College of Art. His graphite-coated publication *The Stumbling Block* (1990) was 'a direct attempt to write sculpture', and the forms he casts, carves, assembles and arranges – whether the hide of a deer, a dish of Perspex, or a smoked fish coated in clay – act as lightening rods for the emotional charge of his environments and performances; or, as Catling puts it, 'poultices to draw out meaning'.

Though Catling was a student during the heyday of 1970s Live Art and draws on cultures both beyond and before our own, his is not a hippie sensibility. And while his work can be placed within a metaphysical artistic tradition that extends from Joseph Beuys' view of the artist as shaman through to Duchamp's notion of the artist as a form of medium or spiritualist, it also has a directness, subjectivity and pragmatism that is very much of the here and now. For *Vanished! A Video Seance* (1999), produced in collaboration with screenwriter Tony Grisoni, Catling employed professional actors to relive the true story of a famous case of spiritual possession on the Isle of Man, but in its style and installation the work went beyond drama documentary into an exploration of the uncanny.

Catling's idiosyncratic approach, his open-ended, metaphoric view of making art, has influenced and continues to respond to wider artistic concerns. He reflects a very contemporary desire to push at the boundaries of what art can and should do, yet he also maintains his outsider status by rejecting the art market. 'I'm interested in the phenomena the work creates rather than the work itself. I think that once you remove it as an object, once you remove it as a commodity, and you actually say "you can't have this but it's yours anyway", a different thing occurs in the work.'

Catling's projects are governed by creating dialogues rather than fashioning individual objects, and the actual activity of making art and the materials he uses are part and parcel of the outcome: 'substance – stuff, the manipulation process, making things – is a very important part of my understanding of the world.' When asked about his occasional use of video projection for example, Catling could have been speaking for an entire generation of hands-on young artists when he declared: 'I don't want to be a video artist. It's just an appropriate thing at this time.'

JAKE AND DINOS CHAPMAN

Dinos Chapman: b. 1962 London
1979-81 Ravensbourne College of Art; 1988-90 Royal College of Art
Jake Chapman: b. 1966 Cheltenham
1985-8 North East London Polytechnic; 1988-90 Royal College of Art
White Cube
Live and work in London

'We are sore-eyed scopophiliac oxymorons. Or at least, we are disenfranchised aristocrats, under siege from our feudal heritage ... our bread is buttered on both sides ... ' With this, and more of the same, cleanly stencilled onto a mess of brown paint smeared faecally over a white gallery wall (*We Are Artists*), Jake and Dinos Chapman launched themselves into the British art world in November 1992. And, for the rest of that decade, sticking to the letter of their initial, ironically inflammatory manifesto, Chapman & Chapman assiduously cultivated their status as art-world bad boys.

Like contemporary art's other famous double act, Gilbert and George (for whom they once worked as assistants), the Chapmans have benefited from

Hell
1999-2000
(detail)
Glass fibre,
plastic, enamel
paint and mixed
media
9 parts, each
approx 122 × 122
× 122 cm
Photo: Gautier
Deblonde

the PR advantages of presenting a twinned front. They have also embraced scandal and outrage by creating images that many people find offensive – childish mannequins with misplaced adult genitals, a facsimile of Steven Hawkin marooned on a rocky outcrop (*übermensch* 1995) – while declaring that they are only dealing with what is already floating in the cultural ether. More significantly, however, the Chapmans have followed the example of Gilbert and George by presenting often outrageously transgressive subject matter in a way that appears mechanical and pristine – thus further distancing themselves from the work.

But unlike Gilbert and George, whose slogan is an overtly low-brow 'Art for All', the Chapmans use art history and theory to support what they have dubbed their 'scatological aesthetics for the tired of seeing'. They began in 1993 by reworking Goya's classic *Disasters of War* etchings into the form of

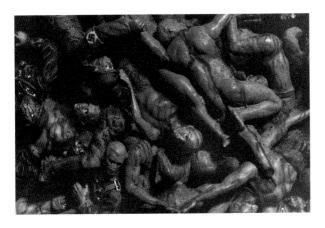

miniature figures, meticulously altering and painting toy soldiers to produce eighty-three tiny tableaux of atrocity, each mounted on an individual island-plinth of artificial grass. In this scaled-down state, more reminiscent of a model railway than an artwork, Goya's indictment of war became a chilling comment on today's aestheticised amorality. This was compounded when the Chapmans focused on one notorious image from Goya's portfolio – the three mutilated resistance fighters of *Great Deeds Against the Dead* – which they reworked first as miniature toytown multiples, then upscaled as naffly coifed, life-sized male mannequins (*Great Deeds Against the Dead 1* and *2* 1994) and then as freckled androgynous children, gambolling on a Disney-esque tree stump (*Year Zero* 1996). In 1999, the Chapmans returned to *Disasters of War*, this time as the starting point for a portfolio of eighty-three of their own etchings, which, in format, techniques and often in content, make direct reference to Goya's original while also drawing on other artistic precedents such as Jacques Callot's sixteenth-century *La Grande Misères de la Guerre*, Otto Dix's *Der Krieg* (1924) and Andy Warhol's *Disaster Series* from the 1960s, as well as a raft of imagery invented by the Chapmans themselves.

However, while their various reworkings of Goya's images remain

among their best pieces, what won Jake and Dinos Chapman their notoriety was their ever more audacious manipulation of commercial mannequins to present a perverted, post-Freudian playground where anything seems possible. Sometimes disturbing, often plain daft, *Chapmanworld* (as they called their first major public exhibition at the ICA, 1996), is an amoral bio-mayhem in which genetic engineering has gone horribly wrong. Fully formed adult genitals crop up in strange places on smooth prepubescent bodies, and good taste is further jettisoned in the deliberate vulgarity of such bluntly self-explanatory titles as *Fuckface* (1994) and *Two Faced Cunt* (1996), or in works such as the inverted, silver cyber-victim gushing stage blood (*Cyber-Iconic Man* 1996), and the mannequin bodies of *Mummy Chapman and Daddy Chapman* (1994), in which Mummy Chapman sprouts vaginas and penises and Daddy has developed a nasty rash of sphincters.

But amidst the pranks and the posturing, one mannequin work came closest to fulfilling its taboo-busting brief. *Zygotic acceleration, biogenetic desublimated libidinal model (enlarged × 1,000)* (1995) shows the Chapmans synthesising their freely plundered influences – from Picasso's scrambled anatomies, to Cindy Sherman's prosthetic sexual parts, and the erotically charged mannequins of Charles Ray – in order to produce an image worthy of their much-cited heroes Antonin Artaud and Georges Bataille. This fused circle of sixteen bland, genderless, child mannequins, wearing nothing but immaculate trainers, their faces obscenely disfigured by misplaced adult genitals, presents a chillingly contemporary consumerist spin on the monsters spawned by Surrealism's sexual fantasies: Salvador Dalí's *The Great Masturbator* (1929), René Magritte's *The Rape* (1934) or Hans Bellmer's fetishistic dolls.

Recently, the Chapmans have returned to miniature model making, but on an unprecedentedly epic scale. *Hell* (1999-2000) presents a vision of Armageddon in nine walkaround parts, upon each of which unfold scenes of appalling atrocity between anatomically deformed mutants and Nazi-uniformed hordes. Enclosed in glass cases of varying height, these table-top views of mass graves, burnt buildings, death and dismemberment are arranged in the shape of a Hindu swastika, with a figure-spewing volcano at their midst. Peering down into this tiny, self-contained world of horror is both fascinating and repellent, arousing a sense both of God-like omnipotence and futile impotence as these gruesomely customised toy figures go about their grisly business. Like the *Last Judgement* by Hieronymous Bosch (another artist admired by the Chapmans), the parallel universe of *Hell* is both ridiculously grotesque and deeply affecting. In this

extraordinarily ambitious sculpture, the Chapmans demonstrate that they are capable of harnessing their liberal-baiting shock tactics to produce a work that stands as a rich and horribly pertinent image for the twenty-first century.

MAT COLLISHAW

b. 1966 Nottingham
1986-9 Goldsmiths College
Lisson Gallery
Lives and works in London

In his self portrait *Narcissus* (1991), Mat Collishaw, stripped to the waist, reclines in a bleak urban setting, contemplating his reflection not in a limpid pool, but in a muddy puddle. This closed circuit of all-absorbing artistic self regard is broken by the camera-shutter release button, which Collishaw grips in his left hand in an almost masturbatory fashion. The message about the dishonesty of the photographic image and the erroneous objectivity of art comes over loud and clear; and it stands as a visual manifesto for an artist whose work revolves around questions regarding the essence of our surrounding reality, and the ambivalent position of the artist within it.

Collishaw was yet another Goldsmiths student who achieved an early notoriety with his contribution to the 1988 *Freeze* exhibition curated by Damien Hirst. He exhibited *Bullet Hole*, a photograph of what appeared to be a bloody head wound, displayed in the form of a 366×244 centimetre grid of fifteen separate light-boxes. In this highly aestheticised format, there was a deliberate disjunction between the subject and its presentation that both accentuated and neutralised the nastiness of the image: on the one hand it was a huge, raw vortex surrounded by hair; on the other, an abstract arrangement of warm browns and reds.

Collishaw continued to explore the problematics of the image by using composition and design to contradict – and therefore complicate – responses to deliberately loaded subject matter: whether sado-masochistic pin-ups, colour pictures of women using sanitary towels, photographed from the waist down, or images rephotographed from police files of suicides. Lately, however, he has side-stepped accusations of sensationalism by becoming more light-footed – although in many ways more provocative – in his quest to see things as they really are. 'Our emotions are being manipulated so

Who Killed Cock
Robin?
1997
(detail)
Iris print, glass,
wood
Edition of 10
107.5 × 81 cm

much that problems begin to occur', he has commented. 'What is true feeling? What makes a genuine response? And these same problems occur with the vast deluge of imagery churned out every day. Representations of degradation and suffering no longer have an effect on us.'

To drive home the point that we are increasingly more affected by the quality of the image than by its content, he began to produce works that represent but pass no judgement on these double standards. *Snowstorm* (1994) and the related *Small Comfort* (1995), present projected images of the contemporary homeless trapped inside a kitsch, Victorian-style glass dome in which snowflakes swirl to the twinkling backdrop of Yuletide music. Less about making a precise political point, and more an expression of the almost surreal visual paradoxes that are encountered by us all on a daily basis, it aims to 'instigate dilemma in the viewer'. These works acknowledge our – and the artist's – complicity in a situation where emotions can swing towards

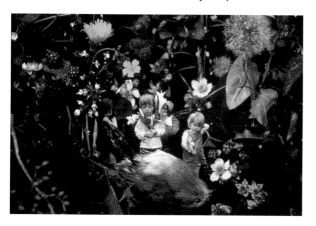

a vagrant in a doorway one minute, and be diverted by a toyshop window the next.

In *Snowstorm* and *Small Comfort*, Collishaw researches and updates the nineteenth-century praxinoscope – and Victorian references and optical toys frequently crop up in his work. He does not use these merely as appealingly unfashionable attention-

seeking devices, but employs them for their ability to evoke a lost time when the mechanics of illusion were more obvious and – we might like to think – more innocent. *Enchanted Wardrobe* (1994) explores key Collishaw themes of illusion and desire (with specific reference to C.S. Lewis' classic story) by taking an old-fashioned wardrobe, replacing the mirror on the front with a two-way reflective surface, and projecting a photograph of a forest glade inside. However, the viewer's curiosity can never be satisfied: if you get too close, a sensor shuts off the light. There's more tantalising artifice in the hand-tinted series of self-portrait photos, *Catching Fairies* (1994), which, in presenting the artist as a stalker of the supernatural, also pays homage to a famous hoax in 1917 whereby a pair of children convinced an adult population that their pictures of fairies were genuine. Yet the evocative nostalgia of these storybook images is also tinged with malevolence: why is

he stalking these fluttery figures? What does he intend to do with them? As with so much of Collishaw's work, the image is freighted with scary sexual possibilities.

This preoccupation with our ever-increasing detachment from the real world has taken Collishaw from images of the past to the latest in computer technology. Digitally manipulated photographs of flowers with petals of animal fur or lividly diseased human flesh present perfect images that are decadent, disgusting and delicious all at once. The unnatural beauty of, for example *Infectious Flowers (Intra-Epidermal Carcinoma)* 1996, like Helen Chadwick's *Bad Blooms* or *Wreaths to Pleasure*, stands as a fitting symbol of our biologically blighted times, as well as reminding us that the word 'art' has its origins in 'artifice'.

In another series of digitally manipulated colour photographs (*The Awakening of Conscience*, 1997) Collishaw continues to speculate on sinister possibilities simmering beneath a seemingly innocuous surface as uniformed schoolgirls recline in idyllic woodland glades, which on closer scrutiny we find clogged with the debris of drugs and alcohol; while in *Who Killed Cock Robin?*, two angelic children are digitally transported to a flowery bower, which contains the feathery corpse of the title. To Collishaw, it seems, there's no such thing as innocence.

MELANIE COUNSELL

b. 1964 Cardiff
1983-6 South Glamorgan Institute; 1986-8 Slade School of Fine Art
Matt's Gallery
Lives and works in London

Installation art often tends to be associated more with spectacle than subtlety, but Melanie Counsell has built a reputation on work that can either be so austere as to be virtually indistinguishable from its surroundings, or which can combine the most mundane of elements with an informality that appears to border on the casual. Described in terms of basic components, Counsell's art doesn't seem much, and the titles only tell you the date and venue of the work: a curtain of chintz hitched up above a roll of sodden carpet sitting in a shallow trough of stagnant water (*Matt's Gallery, London, 1989*); an empty room with a glazed-over doorway (*Sydney Biennale, 1993*); a flooded gallery divided by a bobbled glass wall (*Galerie Jennifer Flay, Paris,*

Coronet Cinema,
London, 1993
Commissioned
by Artangel
Film projection
Photo: Melanie
Counsell

1991); a film made from hurling a camera from the top of a sixteen-storey tower block (*110 Euston Road, London, 1996*).

Yet while Counsell's low-key vision has provoked inevitable hostility from those who see most of today's contemporary art in terms of the Emperor's new clothes, with this artist, appearances – or lack of them – are deceptive. Often Counsell's interventions are large-scale and drastic – even if it takes a while to realise it; and they are meticulously planned with painstaking attention to form and detail. At Matt's Gallery in 1995 she exhibited what looked like an empty space – until you realised that she had sandblasted the columns and installed a low, false ceiling of absorbent, toffee-coloured insulation board that stopped just short of the windows and was edged along this open end with sheets of reflective black Perspex. It may not have been immediately apparent what had taken place, but as the light changed, the transformations in the proportions, textures and volumes of the gallery

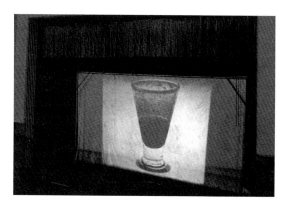

inspired corresponding shifts in mood, atmosphere and association – with the added, paradoxical effect of making you all the more aware of what the space had looked like before.

The term 'site specific' has become overused, but Melanie Counsell is one of the few artists to whom it can legitimately be applied. The appearance and content of her work is always meticulously determined by the physical, social and often historical details and connotations of its surroundings. In her most successful pieces the resulting experience can be a rich one, where a profound sense of a particular place extends out into more general concerns of human mood, emotion and the passing of time. In Derry in 1990, Counsell both incorporated and transcended the specifics of the immediate political situation with a traditional tin-whistle tune, repeatedly played on a record player placed in a marquee on the site of the factory where it had originally been manufactured (*TSWA Four Cities Project, Derry, 1990*); while in a derelict 1930s cinema in London's East End she reactivated notions of audience participation by showing a half-hour film of an evaporating glass of liquid to a group of visitors huddled in the one place where the view was not obscured by a screen of textured bathroom glass (*Coronet Cinema, London, 1993*).

Probably the only other British artist whose work is so dependant on its location is Richard Wilson, and although Wilson's flamboyant architectural interjections may seem the polar opposite of Counsell's quiet interventions, the two also have a surprising amount in common. Both – at their best – extract rich readings from the most mundane materials, each needs to work directly on site, and in each case surroundings are altered in order to reveal what had always been there. Most importantly, both, in distinct but complementary ways, make work that avoids nostalgia, and where poetry emerges from a no-nonsense pragmatism.

At times, however, Counsell's minimal approach can leave viewers wanting rather more than she has given them. Her work is uncompromising, demanding and requires a commitment that is at odds with the instantaneous impact of so much current art. It may seem surprising that Counsell has described her work as 'humanistic', and her installations as 'symbolic containers for unacknowledged emotion', but her suggestive interactions of sites and substances, fluids, smells and sounds, can form a meeting ground for feelings as well as thoughts, and can be interpreted and experienced in a way that is physical and psychological, aesthetic and intellectual. In response to the trend for art that provides a brash, quick fix, increasing numbers of artists are following Counsell in the belief that sometimes a quieter voice can be more enduring.

WILLIE DOHERTY

b. 1959 Derry
1977-81 Ulster Polytechnic
Matt's Gallery
Lives and works in Derry

'I've tried to give a voice to what has been unspeakable', said Willie Doherty in 1994, just after the government lifted its media ban on Sinn Fein in Northern Ireland. 'My work is trying to undermine various notions about what opposites might be, and to show how the media's perceptions of Ireland are completely unreliable.' Today, the peace process is still fragile, and press coverage of Northern Ireland continues to favour easy demonisation and the quick soundbite. As a lifelong resident of (London)Derry – a city whose very name is a bone of sectarian contention – Willie Doherty immerses his art in the complexities and contradictions of the Northern Irish

Same Difference
1990
Slide projection
with text
installed at Matt's
Gallery, London

situation; but the issues he raises extend beyond a specific time and place to remind us that several truths can exist at the same time.

Doherty first attracted art-world attention in the late 1980s with a series of black and white photographs showing bleak panoramas of Derry and its surroundings, devoid of any human presence but charged with the suggestive words and phrases printed across their surfaces. 'My starting point was the way political and physical landscapes were fused', he declared. In such works as *Undercover/Unseen Derry* (1985), where innocuous images of a footpath through tangled undergrowth and an empty road are paired with the accompanying inscriptions UNDERCOVER/BY THE RIVER and

UNSEEN/ TO THE BORDER; or *The Other Side* (1988), which emblazons a dour panorama of the Foyle valley taken from the east bank with a trio of captions WEST IS SOUTH/EAST IS NORTH/THE OTHER SIDE, texts and images play off each other to show how easily emphasis can be shifted and certainty overturned.

Rather than attempting to explain what is taking place in Northern Ireland, Doherty goes beyond sectarian specifics to destabilise the role of photography within a situation that is both saturated by photographic images and dominated by scrutiny of all kinds. A public billboard project of 1992, displayed on hoardings in Great Britain and the North of Ireland, showed a blown-up newsprint detail of a man's eyes overlaid with the statements 'I am ruthless and cruel. It's written all over my face. I am proud and dedicated'. In 1990, the slide installation *Same Difference* juxtaposed two identical television images of IRA suspect Donna MacGuire, one identifying her as 'MURDERER ... PITILESS ... MURDERER ... MISGUIDED ... MURDERER ... EVIL', the other as 'VOLUNTEER ... SENTIMENTAL ... NOSTALGIC ... VOLUNTEER ... WILD ...'

More recent Cibachrome prints, Doherty's own pictures of blockades, bullet holes and burnt-out cars, comment on the standard line-up of images that is now automatically associated with Northern Ireland: 'A lot of stuff I

present already exists in the wider consciousness', he says, 'even Sinn Fein and the Northern Ireland Office often end up using the same images'. But Doherty's ambitions go beyond bandying about interchangeable emblems of warfare. His series *No Smoke Without Fire* (1994) scrutinises the environs of Derry with such forensic intensity that even an empty road, a tyre-tread or a parked car become rife with potential danger, while the rich tones and luxurious quality of these large-scale photographs and other later works, such as the lush grass verge in *No Visible Signs* (1997), emphasises their status as artworks and fires them with a problematic beauty.

In their openness to opposing interpretations, Doherty's works do more than throw up the divided certainties that identify one person's terrorist as another's freedom-fighter: they destabilise the language, both visual and verbal, that allows such rigid distinctions to be made. Nowhere is this more evident than in his video installation *The Only Good One is a Dead One* (1993), which engulfs the viewer in two video projections: one shot from a moving car at night, driving along a winding country road, and the other taken from a parked car in a city street, also at night. The ambiguity between target and terrorist, surveillant and stalker is further compounded by a soundtrack of a male Irish voice vacillating between the fear of being a victim and the fantasy of being an assassin. 'It's possible for the perpetrator to be the victim and the victim to be the perpetrator', Doherty comments. 'The aggressor and the victim are after all mutually dependent on each other.' Such subtleties were lost on the English press who, when this piece was exhibited at the Tate Gallery in 1994, branded Doherty an 'IRA artist'.

Paradoxically, it is precisely because Willie Doherty has decided to work within the context of Northern Ireland that his art is able to transcend its specific geographical and political location. By drawing on artistic antecedents ranging from the language-art of Americans Jenny Holzer and Barbara Kruger to the photographic re-presentations of Europeans Christian Boltanski and Gerhard Richter, as well as the photo-text combinations of British Conceptual artists such as Richard Long and Hamish Fulton, and by applying these strategies to the precise and loaded context of a war zone, Doherty produces images that have a universal, rather than a local reading. After all, it's not just on the subject of Northern Ireland that the media determines our preconceptions and tells us what to think.

PETER DOIG

b. 1959 Edinburgh
1980-3 St Martins College of Art; 1989-90 Chelsea College of Art
Victoria Miro
Lives and works in London

Oil paintings of figures in landscapes, houses in woods and cities at night hardly seem the stuff of radical art. Yet the work of Peter Doig has been crucial in demonstrating that, in our multi-media, anything-goes era, making highly personal figurative paintings can still be relevant and progressive. Rather than being burdened by the cultural baggage that accompanies the act of putting paint on canvas, Doig takes an evident pleasure in the history of painting, and his work is a rich brew of assimilated techniques and pictorial conventions. He is, however, neither nostalgic, nor interested in slick sampling or easy quotation. His paintings are just as likely to take inspiration from the pages of a sports catalogue, a family snapshot, or a film still as they are to draw on the limpid layers of Pierre Bonnard, the emotive contours of Edvard Munch, the jewelled surfaces of Gustav Klimt, or Caspar David Friedrich's explorations of man, nature and the sublime. Out of this complex set of considerations emerge works that are suffused with an uneasy – and very contemporary – ambiguity and which, by the sheer power of paint, suck the viewer into strange but uncannily recognisable places.

Doig was born in Edinburgh, but his family moved to Canada when he was a child, and there's no doubt that the Canadian landscape and the intense physical experience of the snowy slopes have made their presence felt in his work. But, like every artist of his generation, he grew up watching TV, movies and videos, and his work is also steeped in photography and film. He takes and collects photographs in the same way other artists use sketchbooks, but he doesn't make paintings directly from them in the manner of, say, Gerhard Richter. Instead, his magazine clippings, personal photos and newspaper pictures act as compositional starting points, common areas of recognition that ground his painting in a shared reality, sparking unconscious associations in the viewer. The result is a rich brew of individual memory, collective experience and the depiction of what Doig calls 'nowhere places'. These are never intended to represent a specific location or event – even when based on a particular source, such as *Cabin Essence* of 1993-4, which derives from a photograph of Le Corbusier's Unité d'Habitation in

Figure in Trees
1997-8
Oil on canvas
233 × 170 cm
Photo: J Littkemann

France; or *Canoe-Lake* (1997-8), based on a still from Sean Cunningham's horror film *Friday the 13th* (1980).

Doig's paintings employ many of film's narrative triggers, its ability to play with our emotional expectations: houses hidden in the woods, canoes seen from across the water, the solitary car on the road, figures in desolate settings viewed from a distance or from behind. Their compositions are often subject to cinematic framings, croppings, long shots and panoramas, all of which can have a direct and often unsettling impact on a cinema-literate audience. Figures seem lost in a world of their own, unaware that

they are being scrutinised as they gaze at their reflection, look up at the sky, crowd into stadia, or hurtle down ski slopes; they have no history – it is up to the audience to supply any narratives – in Doig's words, 'the viewer becomes the director of the movie'.

Perhaps this is why one feel oddly complicit in the creeping sense that something unpleasant could happen. In *Bird House* (1995), even a seemingly harmless nesting box dangling from a tree covered in snow and fairylights, whose electrical flex wraps itself around the trunk like a serpent, becomes redolent with possibility. But, as in all the best movies, intensity is spliced with a sense of humour. Hunkering down in his pointy pixie hood and lurid anorak, Doig's *Figure in a Mountain Landscape* (1997-8) presents a comical as well as sinister blot on the sublimely snowy landscape – *Fargo* meets Friedrich. Hovering at the edge of the watery expanse of *Reflection (What does your soul look like)* (1996) is a pair of legs, sliced off at the knees by the top of the canvas.

Doig's paintings may draw on the images and atmosphere of the movies, but they owe their presence and magnetism to his involvement with the quality of paint itself. No smooth, brushless photorealism here: the stuff of paint asserts itself in the thin washes and rich layers, the looping skeins and impasto blobs that punctuate, animate and orchestrate the surfaces of his canvases. Not only is Doig unintimidated by art history, he positively revels

in it. He is particularly interested in the way in which artists from Bonnard to Bacon have relished the materiality of paint. Add to this the use of highly artificial colour combinations, and the effect can be close to hallucinogenic: a floodlit inner-city basketball court explodes with the febrile jewelled atmosphere of a symbolist painting in *Night Playground* (1997-8); while *Green Tree* (1998) sets Day-Glo green conifers and their dancing shadows against a searing orange backdrop to burn on the retina like the after-flash of a catastrophic explosion.

Back in 1994, when Doig was nominated for the Turner Prize, it still seemed incongruous to be looking at paintings of ski slopes and woodland scenes in the context of the cutting edge. But now, greatly due to Doig's example – he has been a tutor at the RCA from 1994 – an increasing number of young artists are following his lead in reclaiming subjects from the traditionalist camp. Whether George Shaw's meticulous rendering of scenes from his childhood in Humbrol enamel paint; David Rayson's paintings of the Wolverhampton estate on which he grew up; Kaye Donachie's suggestive nocturnal scenes; or Gillian Carnegie's exquisitely painted landscapes, still lifes and self portraits, it is now no longer taboo for artists to make paintings of the world around them. Or, in the case of Michael Raedecker, to combine paint with thread, wool and other media to produce strangely blighted land-scapes that hover in the margins between dream and reality. The approach and intention of each of these artists may be very different, but Doig has helped subsequent generations explore the physical and psychological qualities of paint, the way in which it can carry personal associations, and its very particular ability to conjure up a compelling sense of atmosphere and place.

TRACEY EMIN

b. 1963 London
1986-8 Maidstone College of Art; 1987-9 Royal College of Art
White Cube
Lives and works in London

It has been said by both her supporters and her detractors that Tracey Emin is the epitome of contemporary Britain's obsession with true-life drama and gut-spilling confession. Certainly, Emin's fame owes much to the way in which her intimately autobiographical art chimes with the current public

Pysco Slut
1999
Appliqué blanket
244 × 193 cm

hunger for docudramas, breast-beating studio debates and journalistic columns exposing private lives for public consumption. But what also strikes a chord with a wide audience, both within as well as outside the art world, is the way in which this direct chronicling of her own personal experiences can be intensely – often uncomfortably – visceral and immediate while at the same time eliciting complex, contradictory interpretations and reactions. She may be 'Mad Tracey from Margate', hell-bent on a cathartic egomaniacal quest to bear all – but whether in thread, appliqué, video, or print, Emin can also be a powerful storyteller, a compelling performer and a sophisticated creator and arranger of unforgettable images.

At her best, Emin has the ability to hoover up and personalise classic art of the past. Take, for instance, her infamous sculpture *My Bed* (1998). Installed in the centre of the gallery at the Tate's 1999 Turner Prize exhibition, Emin's squalid double bed with its grubby sheets, slashed pillow and surrounding piles of accumulated rubbish was simultaneously a strangely quiet and poetic refuge, an emblem of despair, and a site of possible violence. It conjured up memories of the creepy griminess of a Ed Kienholz installation, constituted a new, female spin on Robert Rauschenberg's famous 'Combine', *Bed* (1955), while at the same time being emphatically Emin's own. In other works, Minimalist neon is twisted into heartfelt slogans in Emin's own handwriting (*Kiss me, Kiss me, Cover my Body in Love* 1996; *It's Not Me That's Screaming, It's My Soul* 1997), while in pieces such as *Garden of Horror* (1998) or *No Chance* (1999) the unfashionable feminist quilt stages a dramatic and defiant comeback.

After receiving a first-class Honours degree from Maidstone College of Art, Emin graduated with an MA in painting from the Royal College of Art, but her current artistic direction emerged out of a period of crisis when, having destroyed all her canvases and abandoned her studio, she wrote to friends and acquaintances inviting them to 'invest in her creative potential'

for £10. Fifty did, and received in return personal letters from the artist. In 1993, Emin joined forces with fellow artist Sarah Lucas to run The Shop in the East End of London which, for six months, sold objects made by them and acted as the most lively artistic meeting place in London. The following year, Emin held her first solo show, entitled *My Major Retrospective*, which consisted of a mass of personal memorabilia – a shrine to a barely begun life, ranging from toy trolls and teenage diaries to the Benson & Hedges packet her uncle was clutching when he was decapitated in a car crash. The opening of the Tracey Emin Museum in 1995 on London's Waterloo Road was a logical step for an artist who had chosen to use her life as the source and subject matter for her art. Part studio, part showcase, part performance space, part social centre, this idiosyncratic establishment had a brief but significant life until Emin's escalating celebrity forced her to shut up shop.

In many ways, Emin is primarily a performance artist and in the absence of her emphatic physical presence and powerfully direct use of language her work can struggle to rise above the role of memorabilia or stage props for her unfolding narratives. But in pieces such as *My Bed* or the igloo-shaped tent lined with the appliquéd names of *Everyone I Have Ever Slept With – 1963- 1995* (1995), which includes an in-utero twin brother, school friends, lovers and two aborted foetuses, Emin shows that she doesn't always have to be face to face with her audience in order to achieve her emotionally charged quest to 'start with myself but end up with the universe'.

The title of Emin's solo show at the South London Gallery in April 1997 was *I Need Art Like I Need God*, echoing her acknowledgement that her art-as-life is a form of personal therapy. But she also takes knowing sideswipes at the world of art and its abundance of self-mythologised heroes. *The Exorcism of the Last Painting I Ever Made* (1996) found her naked in a Stockholm gallery, where visitors could view her at work through a peephole containing a fish-eye lens. This is an artist who in every respect does what she damn well chooses, often to her potential detriment, and it is this chutzpah as much as the gory details of her troubled life that has made her such an important and influential figure, especially for women. Whether she is writing, performing or making videos, these highly specific accounts of a life that is both ordinary and extraordinary, can, like the poetry of Patti Smith, the paintings of Frida Kahlo, or Nan Goldin's photographs, go beyond an individual context and refer to a wider consciousness. As Emin says, 'at heart, I'm a raving, hard-core Expressionist'.

ANYA GALLACCIO

b. 1963 Glasgow
1985-8 Goldsmiths College
Lives and works in London

Most artists expect their art to outlive them, but Anya Gallaccio isn't inter-
ested in immortalising herself for posterity. Her work rots, melts, putrefies
or ends up in the bin. A ton of fresh oranges strewn on a warehouse floor
pungently decomposes to the point of soggy unrecognisability in front of a
wall papered with perfect silk-screened specimens (*tense* 1990); sunflower
heads pressed between sheets of glass ooze a sinister black goo before they
dry out (*preserve 'sunflower'* 1991); threaded chains of vivid gerberas droop
and darken (*head over heals* 1995); and walls painted with liquid chocolate
either whiten (*stroke* 1994), or sprout technicolour mould (*couverture* 1994).

Gallaccio sees this exposure to the physical processes of decay less as a
reminder of our own deterioration and inevitable demise than as a reflection
of what it means to be alive. Her art is a multi-sensory adventure that can
only be experienced at first hand, in the here-and-now. In her work, as in real
life, time cannot be made to stand still, and whatever precautions are taken, it
is never absolutely certain how things will turn out. Light and moisture can
speed up decay as well as create unexpected new life forms; a piece of glass
can simultaneously preserve and destroy.

Gallaccio has stated that 'For me, a lot of the history of art is about men
imposing their will on material. I'm more interested in a collaboration
between me and the material ... it's like a relationship'. Yet although she
eschews traditional art practices by deliberately putting herself at the mercy
of her materials, her pieces are always underpinned by meticulous preparation
and a keen formal eye. In both content and appearance, Gallaccio's work has
a rich and knowing relationship with its art-historical antecedents. The
poetic use of non-traditional sculptural materials pioneered by the Italian
Arte Povera movement of the 1960s is an important and acknowledged
influence; as is American Minimalist sculpture. But while Gallaccio's work
often assumes the configurations of Donald Judd, Carl Andre et al, in
common with other artists of her generation such as Rachel Whiteread and
Damien Hirst – and with a hard look at Helen Chadwick – Gallaccio adapts
the procedures of Minimalism to her own more emotionally charged ends.

Whereas the heavy-metal heroes of Minimalism were concerned with
expressing the objective qualities of their materials to the exclusion of any

intensities and surfaces
1996
35 tons of ice,
half ton rock salt
300 × 400 × 400 cm
Installation at Wapping Pumping Station, London
Photo: Anya Gallaccio

subjective storyline, Gallaccio takes the opposite view. Works such as the 35-ton, 3-metre-high block of ice in *intensities and surfaces* (1996); or the dense carpet of severed red rose heads resting on their leaves and stalks, *red on green* (1992), present physical stuff arranged in simple geometric forms, but because Gallaccio chooses material that perishes – often spectacularly – over the passage of time, the correspondence between an initial order and ensuing decomposition elicits a complex and highly individual response. On the rare occasions when her work doesn't vanish of its own accord, it is nonetheless ephemeral, as much event as object, as in the magical *chasing rainbows* (1998), a sandy white carpet of glass grains, in which, viewed from the correct angle, real rainbows floated and shimmered.

For a contemporary female artist to indulge in such stereotypical activi-

ties as working with flowers, dealing in emotion and pronouncing herself to be 'romantic' and 'poetic' is to flirt with prejudice and misinterpretation. However, Gallaccio relishes juggling the ambiguities of what is and is not deemed suitable artistic subject matter. While her flower works deliberately play with clichéd 'female' activities of flower pressing and arranging, and the choice of chocolate is also rich in luxurious, indulgent connotations that have been traditionally associated with feminine sensuality and excess, there is nothing charming or decorative in the processes of decay they present. By her rejection of both traditional and contemporary notions of beauty and propriety in art, Gallaccio presents a view where categories of seduction and repulsion, subjective and objective blend, bond and ultimately become irrelevant in the face of the work itself.

DOUGLAS GORDON

b. 1966 Glasgow
1984-8 Glasgow School of Art; 1988-90 Slade School of Fine Art
Lisson Gallery
Lives and works in Glasgow

Confessions of a
Justified Sinner
(detail)
1996
Video projection,
strobe light
2 screens, each
122 × 92 cm

Douglas Gordon was a prominent early member of Glasgow's Scotia Nostra arts scene, which is acknowledged worldwide and continues to burgeon with a new generation of artists, including Simon Starling, Richard Wright, Jim Lambie, David Shrigley and Craig McKenzie. He is best known for winning the 1996 Turner Prize by making art out of other people's films. His *24 Hour Psycho* (1993) was a projection of Alfred Hitchcock's famous movie slowed down to last an entire day; while *Confessions of a Justified Sinner* (1996) showed footage from Rouben Mamoulian's 1939 version of *Dr Jekyll and Mr Hyde* on two freestanding screens, slowed down, enlarged and alternating between positive and negative prints.

For Gordon, movies are just like any other artistic material: there to be altered, cut into, changed and displayed in a new context. Their original authorship is not concealed; it is crucial to the piece. Like so many of his con-

temporaries, he sees film as part of the shared landscape of the modern imagination, and an effective means to probe the troubled territory of the human psyche: how do we give meaning to what we experience? What do we remember and why?

Silently back-projected at two frames per second onto a screen that can be walked around and viewed from

either side, Hitchcock's *Psycho* (1960) takes on a new life. Each sequence becomes a mini-movie – the shower scene lasts for over half an hour – and what emerges is the 'unconscious content' of this celebrated study of voyeurism, desire and suspense – unexpected tensions, narratives and details that have little or no relation to the film everyone thinks they know so well. Yet what makes *24 Hour Psycho* more than just a clever dissection, is the way in which its presentation forces us to interrogate and challenge how we think we recall and understand those familiar images.

In *Feature Film* (1999) Gordon returns to Hitchcock, but this time to make his own film, which focuses not on the images, but on the soundtrack of another of the director's classic movies, *Vertigo* (1958). Gordon's own directorial debut features James Conlon, Byronic *chef d'orchestre* of the Paris Opera, conducting Bernard Herrman's score. But this work is less successful

because in spite of Herrman's intense, soaring composition and Gordon's dramatic close-up footage of Conlon in action, *Feature Film* requires a film buff's knowledge of *Vertigo* for pictures to form in the mind and for memory to play its tricks.

A fascination with the functions (and dysfunctions) of memory runs through Gordon's work in all media. In 1990 he exhibited *List of Names*, a wall text compiling 1,440 names of everyone he had ever met and could remember; while the installation *Something Between My Mouth and Your Ear* (1994) harnessed the power of music as a psychological trigger by placing the viewer in a dreamy, blue-painted room that resounded to what could be the soundtrack to the artist's earliest memories: thirty pop songs that were on the airwaves between January and September 1966.

Gordon's desire to unearth what is subliminal and unconsciously thought has sometimes brought him dangerously close to Beadle territory. *Speaker Project* (1992), involved anonymously telephoning targeted strangers in an Italian bar with messages such as 'you can't hide your love for ever' and 'I won't breathe a word (to anyone)'. And a series of signed letters sent to members of the art world between 1991 and 1994 bearing such statements as 'I forgive you', or 'I am aware of what you have done', was variously regarded as innocuous, threatening or plain irritating.

Overall, Gordon's work is most effective when it uses the seductive power of the moving image to force us to question what we think we know. Just as he used Hitchcock's movie to draw us in and force us to reassess our precon-ceptions, so his *Predictable Situation in Unfamiliar Surroundings* (1993) selected extracts of *Star Trek*, which, when slowed down, dwelt on a darker side of Captain Kirk as the purveyor of a most unchivalrous sexual violence. In works such as *Trigger Finger* and *10ms^{-1}* (both 1994), and *Hysterical* (1995), fragments of vintage medical films documenting various kinds of psycholog-ical malfunction become fraught with mixed messages surrounding power, voyeurism and potential victimisation.

Our shifting, unreliable readings of all that we see, and the co-existence of such apparent opposites as good and evil, truth and fiction, hero and villain, all come under scrutiny in Gordon's re-rendering of *Dr Jekyll and Mr Hyde*, starring Fredric March as the doomed doctor. *Confessions of a Justified Sinner* showed three scenes where good Jekyll merges into fiendish Hyde, but the torturous speed and silent grimacings, projected simultaneously in positive and negative, muddle the boundaries between man and monster. Here, the forces of light and darkness literally and metaphorically slug it out.

This binary theme is picked up by Gordon in *The Divided Self* (1996), a deceptively simple video installation where a pair of TV monitors show two writhing, gripping hands. On one screen, the hairy arm seems to be dominant, on the other the smooth one appears to be winning; nothing is resolved. Out of these simple components, elaborate relationships and power structures emerge. But beware any easy interpretation: both arms are the artist's own.

ANTONY GORMLEY

b. 1950 London
1968-71 Trinity College, Cambridge University; 1975-7 Goldsmiths College; 1977-9 Slade School of Fine Art
White Cube
Lives and works in London

At the beginning of the 1980s, when his contemporaries were busy putting Britain on the international art map by playing with the form and content of abstract sculpture, Antony Gormley did the unfashionable thing and started making three-dimensional work about the human body. Now, nearly two decades later, when most of the 'New British Sculptors' are fast becoming Grand Old Men, contemporary art is awash with bodily concerns and Gormley's corporeal works have won him innumerable international shows, some high profile public commissions, and also the 1994 Turner Prize.

While the human figure – usually his own – forms the starting point of Gormley's sculpture, it is absence rather than presence that animates his work. *Bed* (1981) consisted of a mattress of stacked 'Mother's Pride' sliced white bread with two Gormley-shaped hollows literally eaten by the artist out of its surface; and the human form has remained both conspicuous and absent ever since. The blank-faced humanoids upon which his reputation was launched may have a powerful – even unnerving – physical presence, but they are hollow cases, described by the artist as 'vessels that both contain and occupy space'.

These smooth-edged, robotic figures, which strike their enigmatic poses on the floors, walls and ceilings of galleries across the world, have emerged out of a laborious, ritualistic casting process in which Gormley is wrapped first in clingfilm and then in scrim (an open-weave cloth) and plaster. When this has set, he is cut out of the mould, which is then encased in an outer

Close I
1992
Lead, fibreglass,
plaster and air
25 × 192
× 186 cm
Photo: Antony
Gormley

skin of lead (or more recently, cast-iron) sheets, beaten over the contours and soldered together in a grid of seam-linked sections. The artist endures this voluntary mummification not because he wants to produce a perfect self portrait – in fact all identifiable details are deliberately smoothed out – but because he is as concerned with the human interior as he is with its outside.

'I am trying to make a sculpture from the inside by using my body as the instrument and the material', he states. 'I concentrate very hard on maintaining my position and the form comes from this concentration'. A Catholic upbringing, a degree in Anthropology and History of Art (his thesis was on that very English mystic Stanley Spencer), and time spent in India studying with the Buddhist meditation teacher Goenka have all played their part in shaping an art that attempts to marry the physical with the spiritual and the specific with the universal, or as Gormley puts it, 'whatever it is that connects space and the imagination'.

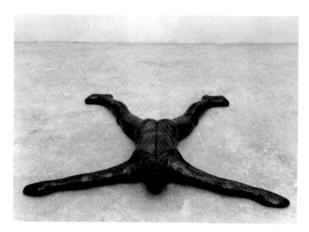

This subjective desire to evoke human experience via the body's 'intimate architecture' sits somewhat uncomfortably with the sculpture's appearance of rigorous – even ruthless – objectivity. Gormley has declared that he is tired of 'art about art', but he also states that 'I look at the body with the same fascination that I look at a cube of polished copper', and it has been suggested that his sculptural concerns are not that far removed from uber-Minimalist Richard Serra's arrangements of mighty slabs of steel. Even though they perform the familiar human actions: standing, squatting, crouching, lying spread-eagled – one even gazes down at its own erect penis – Gormley's faceless, fingerless, metal men are more form than figure, more emblem than image, their subjective origins belied by their apparent lack of consciousness. By becoming everyman they risk ending up in a no-man's land.

Gormley intends all his work – especially that in public places – to act as a kind of 'poultice' or 'catalyst for healing', but the impassive uniformity of his sculpture can appear more confrontational than comforting. In 1987 he attracted considerable hostility with *Sculpture for Derry Walls* – three identical, cruciform, cast-iron figures, each composed of two body-casts

joined back to back, and sealed except for eye holes – which were placed at symbolic and politically sensitive points on the fortified walls of the Northern Irish town. However, while his 20-metre-high, steel *Angel of the North*, erected by the A1 in December 1997, undoubtedly dominates the approach to Tyneside, it also seems unexpectedly vulnerable, a rusting and obsolete reminder of the area's once heroic shipbuilding and steel industries, which, like this earthbound colossus, will never again get off the ground. In contrast, for *Quantum Cloud* (1999), Gormley's largest work to date, he has employed the latest in digital imaging and modelling to realise this airy, egg-shaped swarm of some 3,500 sticks of galvanised steel, which rises above the Thames adjacent to the Millennium Dome. Unfortunately, the central figure, which is supposed to coalesce in the midst of all this chaos, appears more effectively in computer-generated image than in 30-metre-high reality, where it stands as a disappointingly mute testament to the fact that technology doesn't always deliver the goods.

There's a more effective, as well as literally hands-on, fusion of individual and collective, subject and object, instinct and intellect in the floor-level sea of up to 40,000 densely packed figurines that make up the various versions of Gormley's installation *Field* (the first was produced in 1989). Working on site with communities in Mexico, the Amazonian rain forest, Sweden and, most recently, St Helen's in Lancashire, the artist has directed groups of up to 100 local people to make hand-sized figures from the local clay.

Some find Gormley's role in this project problematic (he has always taken pains to acknowledge everyone involved, but the piece is repeatedly exhibited under his name). However, whether it is community art or a truly public sculpture, of all Gormley's work *Field* still comes closest to his aim of communicating the general and the specific experiences that link us all. It is impossible not to feel both immense and insignificant in the face of this miniature multitude, an essentially human landscape that is both of and from the land and which manages to be simultaneously timely and timeless.

SIOBHÁN HAPASKA

b. 1963 Belfast
1985-8 Middlesex Polytechnic; 1990-2 Goldsmiths College
Kerlin Gallery, Dublin, Tanya Bonakdar, New York
Lives and works in London

Delirious
1996
Fibreglass,
opalescent paint,
two-pack acrylic
lacquer, wood,
metal fixings,
audio
components
68 × 159 × 103 cm

Siobhán Hapaska's sculpture is difficult to place. On the one hand, her shimmering, curvaceous fibreglass forms seem to be the product of the most advanced – even futuristic – technology. On the other, they have the ageless universal shapes of bleached bones, or eroded rock. They also behave in strange ways. The opalescent surfaces of three wall-mounted pieces of moulded fibreglass, *Want*, *How* and *Hanker* (all 1997), are reanimated by a single blue LED dot; the pristine undulating *Land* (1998) – a kind of cyborg Henry Moore – sprouts plants from its pristine indentations and collects pools of water in its scooped-out hollows; while the dark, gleaming *Home* (1996) confounds its malevolent Darth Vaderish appearance by mysteriously exuding the smell of baking bread.

Other works are even more aberrant. What should we make of a hyper-real waxwork of a Jesuit priest (*The Inquisitor* 1997) whose left hand

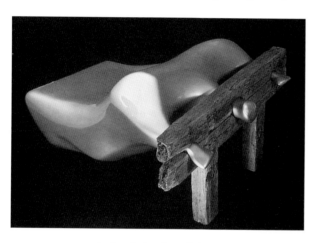

holds an egg-shaped object that emits an apologetic Latin monologue while his right has spookily grown extra fingertips? Especially when he is accompanied by a molten, pearly white presence that oozes incongruously into weathered wooden stocks while 'singing' a digital version of Elvis' 'Love Me Tender' (*Delirious* 1996). Then there's the motorised ball of tumbleweed that shuttles pointlessly back and forth on a metal track (*Stray* 1997) or, in the case of *Ecstatic* (1999), whizzes manically round the edge of a shiny steel cube.

But this sculpture's near-surrealism is a deliberate strategy emphasising that there are no simple readings on offer. As far as Hapaska is concerned, the more mixed its messages the better. Just as she can move between hyper-reality and fine-honed abstraction, combine found and fabricated objects and – most recently – photography, so there are no definite answers or fixed positions in her work. She has described her sculptures as 'lost', without origins or destination, but they are also autonomous entities that function independently in their own meticulously orchestrated, self-contained worlds.

'Uncertainty in my work is very important to me. I'm really not interested in definitive explanations of things – I find certainty so claustrophobic', says Hapaska, who feels that 'people have become lazy at trying to extract

meaning for themselves from works of art'. She deliberately avoids the autobiographical – there's no evidence of the artist's touch in these highly finished works, which look as if they're machine-produced or have grown (and sometimes are still growing) on their own. Instead she uses unexpected strategies – touch, sound, smell – to hi-jack the senses and tug at the emotions. However fine-tuned its appearance, she sees her sculpture as expressing restlessness and a state of flux, in a world where nothing is static and finite. Specific references to the real world act to complicate rather than to simplify, and to expand rather than pin down possible meanings.

Many of Hapaska's sculptures play with notions of travel and speed. Often, movement and velocity are simultaneously suggested and denied, and it is no coincidence that the first of her two waxwork sculptures was of St Christopher, the de-canonised but much invoked patron saint of travel, who is presented pathetically propped against a wall, his legs worn away to rounded stumps (*St Christopher* 1995). Hapaska has said that she likes the 'push and pull' of contradictory qualities and this troubled tension between dynamism and entropy charges much of her work. Her sleek, aerodynamic forms are grounded, pinned down and left to pulsate with possibility; the titles of *Want, How* and *Hanker* imply that their flawless, flexing, stretching forms are still somehow striving and unresolved, while the tumbleweed in *Stray* and *Delirious* has forgone its spontaneous natural life for infinite, structured movement that is both reliant on and constrained by technology.

Hapaska's ambivalence towards modernism and its consequences finds a literal vehicle in *Mule* (1997), where a fibreglass cast of a Ferrari P4 projects fierce beams from its headlights and hugs the ground with seductive, streamlined promise. However, this high performance vehicle is going nowhere, since its back end has been sliced off to reveal an ominously cosy hollow interior, lined with fake donkey skin, a hairy excrescence that also seeps out of the front radiator, spills from the petrol cap and replaces the wheels. An ominous rumbling soundtrack of thunderclaps, falling shells and panic-stricken braying, signals approaching catastrophe and adds to the disorientation. Mule is both aggressive and pathetic, a paradigm and a relic of technological aspiration. Repulsive and gorgeous, its white heat is stifled yet also strangely ignited by its fusion with organic furriness. Like so much of Hapaska's work, it takes you to many different places at once.

MONA HATOUM

b. 1952 Beirut, Lebanon
1975-9 Byam Shaw School of Art; 1979-81 Slade School of Fine Art
White Cube
Lives and works in London

Just looking at Mona Hatoum's work is not enough. Her sculptures and installations have a powerful, theatrical presence that deliberately invites participation and puts the senses into overdrive. A major concern is with power and the forms it takes, and her various interpretations of this broad subject extend through surveillance, oppression and voyeurism to pleasure, seduction and playfulness. Whether she is playing off the effects of heat, light, movement or magnetic fields, this is an art of total immersion that revolves around the human body – both ours and hers – in order to engage with broader issues of identity and experience.

Just because she often uses her body as raw material, it doesn't follow that the work is specifically about Hatoum herself. *Recollection* (1995) presents thousands of her own hairs – hanging singly from the ceiling, stuck in soap and drifting in balls across the floor – in order to spin and tangle sensations of pleasure and disgust. And in what has become her best-known piece, *Corps étranger* (*Foreign Body* 1994), Hatoum submitted the most intimate parts of her body to intense endoscopic and coloscopic scrutiny, not to present a personal point of view, but to provoke powerful and conflicting responses to how we view our own physicality. The impact of *Corps étranger*'s fleshy Cresta Run through Hatoum's body, which took the form of a video piece projected onto the floor of a cylindrical viewing chamber and accompanied by a soundtrack of heartbeat and breathing, was especially intense and problematic. By turns intimate and alienating, enthralling and repulsive, objective and voyeuristic, *Corps étranger* seemed less a view of the female anatomy and more a high-speed 'fantastic voyage' through an unfamiliar, distorted bodyscape where the term 'foreign body' could equally be applied to artist, viewer and lens.

Hatoum's earliest works were performances, and although she has now shifted from these live events to video, installation and sculpture, there continues to be much cross-referencing between pieces and over time. The best of her more recent work communicates the intensity of earlier self-imposed ordeals, while extending its psychological possibilities by substituting actual for potential danger. *Corps étranger*, for example, can be partially

Mouli-Julienne
(×21)
2000
Mild steel
Main sculpture:
425×325×
560 cm
Discs each:
210 cm diameter
Photo: Edward
Woodman

traced back to a performance work of 1980 during which Hatoum filmed both herself and her audience; while the seductively hazardous clear glass *Marbles Carpet* (1995) could be read as an elegant distillation of the excruciating *Under Siege* (1982), where Hatoum enclosed herself for seven hours in an upright Perspex box, her naked body so slippery with wet clay that whenever she tried to stand up she fell over.

Hatoum was born in Beirut, a British subject of Palestinian parents, and when war broke out in the Lebanon in 1975 she settled in London. While early pieces were overtly political (*Under Siege*, for example, was accompa-

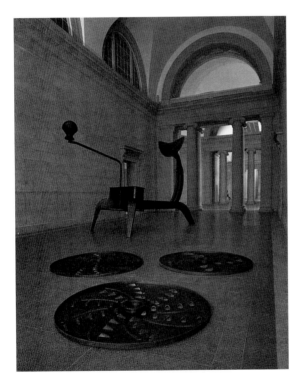

nied by revolutionary songs, news reports and statements in Arabic, English and French), it's too easy to read her work simply as a continuing response to war and exile. Hatoum's art may confine, unsettle, and flirt with dread and danger, but her strength as an artist is in the way in which she fuses aesthetic with political issues so that nothing is too obviously stated. The grids and linear structures that appear in so many pieces (notably *Light Sentence* 1992, in which two rows of wire lockers are lit by a single bulb whose almost imperceptible rise and fall enhances the mesh of shadows it casts) undoubtedly conjure up connotations of containment and repression. But they also have their origins in the honed-down language of Minimalism – and Hatoum is eager to stress the importance of artistic as well as personal influences in her work.

In common with many of her peers, Hatoum uses the rigour of minimal forms but charges their sober neutrality with near-traumatic psychological significance. Whether it is a barred gate of electrical elements glowing red hot at the end of a darkened room (*The Light at the End* 1989); a 2-metre cube covered in a ridged magnetic fur of iron filings (*Socle du Monde* 1992-3); or the perfect Corbusian cylinder whose floor pulsates with the moist mayhem of human innards (*Corps étranger*), it is the tension between these mixed

messages of order and coercion that frames and animates Hatoum's work.

In recent works, the most utilitarian of everyday items is rendered threatening and even potentially lethal, as in the giant vegetable shredder *Mouli-Julienne*, or the electrically charged table of utensils *Sous Tension* (both 1999). There is no refuge from this fraught and perilous world, not even within your own skin.

GARY HUME

b. 1962 Kent
1985-8 Goldsmiths College
White Cube
Lives and works in London

Gary Hume's career reads like a blueprint for contemporary art stardom. In his last year at Goldsmiths College, he took part in the seminal 1988 *Freeze* exhibition, curated by fellow-student Damien Hirst, and was accordingly catapulted into the international art world. Sell-out shows in London and New York followed, he was selected for the survey *British Art Shows* of 1990 and 1995, was voraciously collected by Charles Saatchi, and was nominated for the Turner Prize in 1996.

But this cursory skip through Hume's CV ignores two key factors: first, a change of artistic direction that threatened to scupper his career, and most importantly, the problematic nature of his paintings. He first attracted the full glare of art-world attention with a seemingly perpetual series of works based on the institutional double swing doors that punctuate our hospitals, schools, offices and prisons, their windows, press panels and kick-plates lovingly reproduced in gleaming layers of institutional-coloured household gloss. What looked like large, abstract works were in fact life-sized depictions of these overlooked symbols of everyday existence through which every rite of human passage takes place.

Critics and collectors loved them. Were they paintings of doors, or paintings as doors? Here was the modern aesthetic debate about art and reality neatly encapsulated, as well as a refreshing alternative to the hot and heavy Neo-Expressionist painting that had clogged up the 1980s. These works were smart and knowing, with blank unyielding surfaces that – literally and metaphorically – shut themselves in your face but also dematerialised into mirrored surfaces. Hume made multicoloured versions, freestanding

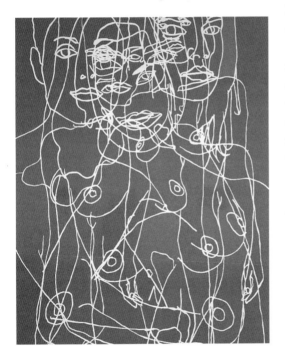

Water Painting
1999
Enamel paint on
aluminium
300.5 × 244 cm
Photo: Stephen White

versions, highly reflective, unphotographable versions. He got other people to decide on colours. The results could flip between glamorously tacky (the sticky, highly reflective *Dolphin Painting 1* 1990-1); threatening (*Stop* 1991, a three-panel symbol of faceless authority in shades of grey); or ironically humorous (the institutional pinky magnolia of *Four Subtle Doors* 1989-90). But just as Hume's doors moved ominously close to becoming the purely abstract paintings they were never intended to be, he stopped doing them.

What followed was a hiatus in which he took stock, created sculpture from assembled objects, and, perhaps cathartically, made a provocative video of himself sitting fully clothed in an overflowing tin bath, mumbling the legend of King Canute and wearing a cardboard Burger King crown (*Me as King Cnut* 1994). 'I couldn't think what it was that I wanted to describe. So during that process I was making things I actually didn't want to describe.' While staring that endgame in the face, Hume had returned to painting and opened up the mute surfaces of his doors to let in the world outside – but through the filter of his very particular vision.

The brightly coloured, fluid shapes of the post-Pop paintings that he first exhibited at the ICA and White Cube gallery in 1995 may be easy on the eye, but their maker refuses to offer any explanation. Hume once remarked 'all you ever get from me is the surface' and he is adamant that once he has completed a painting he is just a viewer and the audience's interpretation of the work is as valid as his own. Whether this is an act of democracy or a cop-out is open to debate; it is perhaps telling that the first image to come off these smooth, gleaming pools of household paint is the viewer's own reflection.

It is hard to tell where the paintings end and the world begins: everything is deliberately slippery; there is no perspective, no shading, just slinky generic forms that are deceptively simple and knowingly evasive. Usually Hume traces the outlines of what he has described as 'flora, fauna and portraiture' from photographs onto sheets of acetate, which are then

projected onto the aluminium panels, where they are retraced and painted in. Although Hume has described his subjects as 'embarrassingly personal' it is hard to discern whether the artist is keeping a straight face when he declares that these Poppy, bittersweet images are chosen 'for their ability to describe beauty and pathos'. What is in no doubt is that the starting point can be anything that grabs Hume's fancy – pictures taken from magazines, the shape of a child's toy, or the head in a painting by Holbein or Vermeer.

These silkily inscrutable works may be given specific titles and may form instantly recognisable generic shapes, but they tickle the subconscious in their ability to look and feel like something completely different at the same time: Tony Blackburn, tragi-comic with the face of a shamrock; two sets of bare feet making a Rorschach blot-like silhouette; a puppy-dog mask sprouting a goatee beard. Hume's titles can provide clues for alternative interpretation or act as booby traps for the unwary. With its decadent shades of green, sinuous shapes and velvety smoothness *Whistler* (1996), for example, conjures up the opiated aura of Aesthete dandy artist James McNeill Whistler (and the famous *fin-de-siècle* feud between Whistler and the critic John Ruskin, which according to many, inaugurated the polarity that has plagued the British art world ever since). However, effete art-historical footnoting is confounded by the painting's depiction of a very literal 'whistler', the woozy, liquid shapes making up the image of a heavy-lidded, beauty-spotted female with her fingers in her mouth and – for that extra touch of blatancy – the word 'blow' spelt backwards. More recently, Hume has been simultaneously unravelling and knitting together his images in ever more intricate and abstract webs of outlines. The works in the 1999 series Water Painting overlay the multiple outlines of female nudes to pro-duce limpid, barely recognisable shapes that configure into breasts, faces and the curve of a hip or buttock, then melt back into loopy skeins reminiscent of the swirls of Art Nouveau or the enamelled forms of Gustav Klimt. Less effectively associative are the masses of tangled lines that make up Hume's paintings of *Angels* (1999), out of which emerge the barely discernible forms of the concrete angels of Oscar Niemeyer's cathedral in Brasilia, but which teeter dangerously on the edge of formulaic pattern making.

Like so many of his contemporaries, Hume revels in seductive colours, forms and textures, which, in more traditional fine-art circles, would be dismissed as 'decorative'. He relishes the instant appeal of the unashamedly aesthetic, describing himself as 'a beauty terrorist', and these paintings can hold the senses hostage by showing how the most innocuous shapes and substances can be simultaneously vacuous and brimming with semi-

conscious meaning. However, as he distils his images to the sparest of elegantly interconnecting outlines, it is to be hoped that Hume does not void them of all but an empty prettiness.

SARAH LUCAS

b. 1962 London
1984-7 Goldsmiths College
Sadie Coles HQ
Lives and works in London

Sarah Lucas' attitude can be summed up by one work: the life-sized, pink plaster cast of her middle finger, sitting on a high white pedestal and raised in that time-honoured gesture of 'up yours!' Its title, *Receptacle of Lurid Things* (1991) could also stand as a description of this artist's imagination. Lucas is known as the rudest artist on the British block – her work is calculatedly casual, tasteless, in-your-face, and full of vulgar visual/verbal puns.

At its best, Lucas' knockabout bawdiness masks more serious concerns. In *Two Fried Eggs and a Kebab* (1992) she both paraphrases and parodies the female body – not to mention the unsavoury term for a woman, 'two fried eggs and a kipper' – by placing a pair of fried eggs and a doner kebab (nestling in its labial folds of pitta bread) on the top of a cheap wooden table, and propping a photograph of this greasy still life in place of a face. In *Bitch* (1994), she makes the same point by dressing another second-hand table in a tight white t-shirt containing two pendulous melons, and hanging a vacuum-packed kipper round the back. Men's most blatant desires and women's deepest fears thus find an audacious and unholy union in these two slangy contemporary spins on René Magritte's famous 1934 painting *The Rape*, which puts a naked body in place of a woman's face.

In front of a Magritte it is often difficult to know whether to smile or scream, but Lucas' work is more affable. She doesn't pass judgements, but plays off the pleasure and predicament of being a woman in the 1990s by seizing the basest of prejudice and throwing it back in her audience's face. She prefers to provoke you to think by making you laugh – albeit uneasily. *Figleaf in the Ointment* (1991) consists of white plaster casts of Lucas' armpits, complete with hair: mini monuments to what she has described as 'that tension between disgust and desire'. She is equally merciless to machismo in pieces such as *Get Off Your Horse and Drink Your Milk* (1994), a series of

Bunny
1997
Tights, plywood
chair, clamp,
kapok
102 × 90 × 64 cm

photos depicting a faceless naked male covering his crotch with a pint bottle of milk and a pair of digestive biscuits.

As far as Lucas is concerned, what you see is what you get – it just depends on how you want to look at it. But her cheap and cheerful aim to 'make images that are instantly accessible' can work against her. Pieces such as *One Armed Bandits (Mae West)* (1995) – where a plumbed-in toilet, a cigarette end floating in its dingy bowl, is paired with a man's singlet and underpants draped over a chair with an erect wax candle penis rising from its seat – wobble on a fine line between engaging humour and gratuitous

gross-out. Other works like the grotty brown Ford Capri with a rear end that bumps up and down (*Solid Gold Easy Action* 1997) or the A5 photocopies of pages lifted directly from the *Sunday Sport* newspaper, *Fat, Forty and Flabulous* and *Sod You Gits* (both 1990) have an engaging chutzpah but lack the lightness of touch that enables Lucas' straightforwardness to act as a conduit for greater complexity.

More deceptive in its simplicity is the series of photographic images that Lucas has been making since 1990, when she took a picture of herself eating a banana. Since then, she has exhibited self portraits in which she is lounging, drinking or standing in front of a washing line full of women's underwear. In all, she is clad in her trademark wardrobe of mannish workman's clothes – baggy jeans, Dr Martens, a beaten-up leather jacket, no makeup. Her hair is straight and stringy, her gaze steady and unsmiling. Sometimes she looks like a pretty boy, at others like a butch girl, sometimes aggressive, sometimes bored – always in control. Unlike Emin's work, in these seemingly candid images the boundaries between truth and fiction blur and crumble as Lucas explores myth-making by playing herself.

Lucas' throwaway, flung-together materials and methods belie serious formal concerns. She is just one of many young artists who have absorbed the crucial influence of the 'New British Sculptors' – most notably Bill Woodrow, Tony Cragg, Richard Deacon and Richard Wentworth – whose

work of the 1980s played with notions of 'high' and 'low' art. Her often quite drastic alterations of seamy everyday items – the burnt out armchair with its legs supported on cigarette packs, and the motorbike helmet made of cigarettes of *Is Suicide Genetic* (1996) for example – are reminiscent both of Woodrow's early carvings-up of skip-salvaged household appliances and Wentworth's ongoing investigations into mundane of functional items. But Lucas' emphasis on our most basic habits and desires is very much her own.

At their most effective, these seemingly unaesthetic arrangements of objects carry an instant, epigrammatic punch by looking exactly like themselves while at the same time suggesting something subversively different. Works such as *Is Suicide Genetic* or the disquietingly fleshy pair of stuffed tights that droop with oddly touching vulnerability from the seat of a plywood chair (*Bunny* 1997) manage to transcend the visual pun to convey intense and often profound qualities of terror, tenderness and poignancy. In her 1998 series of toilets cast in urine-coloured resin, *Human Toilet Revisited* (1998), Lucas not only scores a double whammy in parodying art's fixation with body fluids as well as Rachel Whiteread's sanctification of domestic spaces, but also achieves sculptures that, almost in spite of themselves, rise above gag status to become powerful and poetic objects in their own right.

This strategy looks back to the legacy of the 'assisted readymades' that emerged out of Dada and Surrealism. Many of Lucas' sculptures could perhaps be seen as salutes to pieces such as Man Ray's *Gift* (1921/73), an iron whose smooth surface is violated by a single row of tin tacks. By producing art that insolently refuses to look like art, that flicks its finger at craft, class and connoisseurship, Lucas plays with the national prejudice against contemporary art, while also making work that is about living in the here and now. When she gets it right, this prejudice is both confronted and confounded.

STEVE MCQUEEN

b. 1969 London
1989-90 Chelsea School of Art; 1990-3 Goldsmiths College;
1993-4 Tisch School of the Arts, New York University, USA
Anthony Reynolds Gallery
Lives and works in London

On leaving art school, Steve McQueen wanted to make feature films. However, a year at NYU film school among Scorcese and Spielberg wannabes

Deadpan
1997
16mm black and
white film, video
transfer
(Video still)

brought him back to London and fine art. Yet the very nature of film remains at the core of his work. It is not just that the camera is his means of expression: of all the artists currently working with the moving image, McQueen is unsurpassed in his profound engagement with film as a particular visual medium, as well as with the many messages it carries.

The ten-minute *Bear* (1995), was the first of a trilogy of short films. Two naked black men engage in a highly ambiguous encounter, resembling a cross between a mating dance and a wrestling bout, where nothing is resolved. Shot from low down, with a suffocatingly close camera tracing the shifting patterns of emotion as revealed by facial expression and body language, this almost excruciatingly physical scenario provides a more complex take on familiar race and gender debates – especially since the artist himself is one of the protagonists.

Like many of his contemporaries, McQueen steers clear of offering directives. Instead, his films both conjure up

and confound stereotypes about representations of black, male sexuality, and ask us to look more closely at our own preconceptions and prejudices. The ante is further upped in *Stage* (1996), the third in the series, where a black man (again, McQueen) and a white woman seem to be stalking each other but never actually meet. Although each remains within their own portion of the vertically split screen, a format that runs the risk of being read literally in terms of black and white, any such interpretation is instantly complicated by the way in which both, and neither, of the protagonists is victim or predator. The man crawls on all fours, baring his anus, the woman tiptoes down stairs; their glances could be read as full of foreboding – or simply inquisitive. As in *Bear*, one is free to interpret these ambiguous, human, emotional contradictions.

Equally important to McQueen are the very specific ways in which film can present and manipulate images. In *Bear*, content, form, framing and lighting combine in an intense study of erotic power, and this transcendent sexuality extends the film's ambiguity while McQueen's meticulous pacing and editing further complicate the viewer's reading. A shameless relishing of the language and magic of cinema is especially evident in the middle film of the series, *Five Easy Pieces* (1995), where distinct sequences break up the

frame like the rhythms and patterns of abstract painting. But this is no abstract study of forms in motion. In true McQueen style, visual rigour oozes with psychological tensions and mood shifts: a shoe sole bites into a tight-rope and a female tightrope walker picks her way above our heads; five male hula-hoopers bump and grind in a Russian Constructivist-style formation, before one of them falters and the scene switches to a single figure who whips out his penis and urinates directly down onto the camera lens in glittering circular ripples – pissing, if you like, on any attempt to read the work in terms of either theory or aesthetics.

Even when he uses a specific cinematic source, McQueen's take is emphatically his own. *Deadpan* (1997) is based on a famous Buster Keaton stunt from *Steamboat Bill Jnr* (1921), in which the comic is saved from the falling side of a wooden house because an open window in the facade exactly matches up with the piece of ground on which he stands. In McQueen's version, what was originally a one-off humorous event becomes anything but, as, from a variety of angles and viewpoints the wall crashes down again and again, leaving McQueen's unflinching and impassive figure unscathed. A split-second moment is unravelled and made monu-mental.

McQueen's vision is both rich and restrained. He revels in the form of cinema with a voluptuous austerity, presenting simple events in an uncluttered style, which reclaim the magical, physically overwhelming power of the moving image. In *Stage*, virtually nothing happens, but the viewer is still swept up in its non-narrative; and McQueen becomes even more minimal in his 1996 *Just above my Head*, which is simply that: a film of the artist walking along, shot from above. This projection, which fills an entire wall of a darkened room with an expanse of white sky and a single bobbing black head disappearing and reappearing at floor level, shows McQueen using the most straightforward of means to convey complex and often con-tradictory ideas and emotions. This is an image that appears both fragile and invincible, poignant and defiant, barely there and utterly captivating.

Recently, McQueen's involvement in the physical mechanics of film has become even more direct. In *Catch* (1997) McQueen and his sister tossed the camera back and forth between them, while for *Drumroll* (1998) – his first use of both colour and sound – McQueen installed three video cameras in an oil drum and rolled it through the streets of midtown Manhattan. The result was a three-screen triptych that presents synchronised tapes of a revolving, oil-drum's-eye view of shops, cars, pavements, sky and McQueen himself, accompanied by a recording of the ambient sounds of the journey. At once

sculpture, performance and film, this whirling study in movement makes you feel seasick while acting as a reminder that elaborate and grandiose statements are not necessary in order to explore the rich, expressive potential of the moving image.

CATHY DE MONCHAUX

b. 1960 London
1980-3 Camberwell College of Arts; 1985-7 Goldsmiths College
Sean Kelly Gallery, New York
Lives and works in London

With so many of today's artists making spins on the geometric austerity of Minimalism and skimming their subject matter off the surface of our daily existence, Cathy de Monchaux's intricately detailed, painstakingly fashioned sculpture seems out of kilter, if not perverse. Even when she uses mechanical assistance, the message of these labyrinthine lattices of metal, traceries of fine patterning, threading of ribbon, and tucking and pleating of leather and velvet is one of obsessive – almost insane – industry. And that's before you've even registered the suggestive shapes thrown up by these unholy alliances of unexpected materials: the teeth of metal biting into dusty, fleshy calfskin; the slices of velvet licking riveted brass; the ceremonial sheets of glass carrying a series of shadowy paper cut-outs across a wall.

Yet although these elaborate confections bristle with association and innuendo, the very ornateness that pulls you into the work also acts to deflect any single reading. The sculpture seethes with sexual reference, but despite the fact that the forms are often outrageously genital, there's too much going on to interpret them in simple sexual terms. What, for example, are we to make of *Evidently not* (1995), where rolled folds of pink leather are both restrained by, and grow around, the row of gleaming, riveted brass brackets that clamp them to the wall? Like many of the artists currently working in the gap between Freud and feminism, de Monchaux is more elliptical than her feminist forebears. The erotic charge that ignites her sculpture draws its power from highlighting the contrary desires that simultaneously divide, unite and define us all.

In early pieces such as *Ferment* (1988), where she lined riveted lead pipes with ruched crimson velvet, de Monchaux subverted the no-nonsense associations of everyday, utilitarian hardware with sly slivers of fabric; and with

Sovereign
1999
(detail)
Brass, copper,
leather, fur, oil on
canvas, graphite
and chalk
90 × 400 × 20 cm

ever-increasing audacity, she continues to tweak the tension between opposites. Whether in extravagantly ornamental pieces such as the wall-mounted brass rosettes of *Holding back from nothing* and *Scarring the wound* (both 1993), which sprout baroque spikes and curls, flutter with threaded ribbons, and seep velvet from between their metal plates; or the mutant leather coils of *I thought you said you loved me* (1996), which split open to reveal fleshy interiors and spill down from claw-like metal clamps into a heap on the floor, de Monchaux conjures up multifarious, contradictory readings.

Yet all this juggling of beauty and cruelty, attraction and revulsion, pleasure and pain carries considerable artistic risks. Too much exquisiteness can lead to an empty decorative beauty, and an excess of fleshy innards can look like a piece of early feminist womb art or a sci-fi special effect. De Monchaux has become increasingly aware of the nimbleness required to negotiate this

hazardous territory, and while in many ways her sculpture has become more audacious in appearance, she has also refined her strategies to keep its meanings on the move and to damp down excess with what she calls a 'minimalist fundamentalism'. Scale and materials are manipulated to ensure that the larger the work, often the more fragile and elusive its appearance, whereas smaller pieces carry a physical presence that is almost overwhelmingly intense. Strips, lumps and bumps of even the most ornately embellished calfskin settle into harmonious arrangements of horizontal and vertical; expanses of pattern are rhythmically repeated almost to the point of invisibility; and although some pieces have expanded to an architectural scale, they are the most evanescent. The eight-sided, walk-in *Confessional* (1997), for example, conceals fleshy upholstery and filigree grille within an envelope of milky white-painted glass; while in *Never Forget the Power of Tears* (1997) an intricately wrought central spine is offset by twelve minimal lead slabs.

Beauty continues to be both a bait and a defence, but de Monchaux often blights and confuses it by tarnishing once-gleaming metals with corrosive chemicals and dusting sharp edges and intricate folds with a film of white powder. Pieces such as *Cruising disaster* (1996) – which consists of 111 small, spiky, metal parts, jutting from the wall like sprung traps, each baring a

bulging leather centre – become even more ambiguous when treated with a powdery substance that has connotations both of spore-like fecundity and ashy old age and decay.

De Monchaux's work is therefore more to do with evoking atmosphere and suggesting feeling than with telling stories and setting agendas. It is highly formal, but doesn't lend itself to formal analysis; it is fabricated with intense precision, but at the same time has the perplexing appearance of an autonomous organism that has continued to evolve according to its own rules; and its titles are as likely to pre-empt responses as to offer up meaning. When, for example, she defiantly christens a wallpiece where nine fleshy confections of pink leather and fur sprout brass spikes and whiplash tails *Don't Touch My Waist* (1998), de Monchaux demonstrates that she is all too wearily aware of the gamut of psycho-sexual interpretations that have been applied to her works.

Recently, she has also introduced photographic images, which, far from rooting the work in any easily identifiable reality, act alongside the titles to throw up yet more narrative possibilities. Whether the fifty small photos of fruit, flowers and meat trapped between the metal claws in *Assuaging Doubt Through Other's Eyes* 1997; the four large lightboxes depicting a dreamily romantic rural scene, rudely interrupted by a fleshy pink leather fissure in their midst (*Fretting Around on the Brink of Indolence* 1998), or the single framed photograph of a girl dragging a toy across a park (*The Day You Looked Through Me* 1999), these images – all of which have been taken by the artist – provide rich pauses for reflection within the welter of obsessive detail.

CHRIS OFILI

b. 1968 Manchester
1988-91 Chelsea School of Art; 1991-3 Royal College of Art
Victoria Miro Gallery
Lives and works in London

There's a time-honoured tradition of ordure in art: Piero Manzoni, the fore-runner of the Italian Arte Povera movement, canned and sold his excrement; American Mike Kelley has made drawings of huge beribboned turds; while in the autumn of 1995, Gilbert and George devoted an entire exhibition to giant photopieces featuring some of their finest specimens. Now, thanks to Chris Ofili, elephant dung has entered British art practice. Protruding from

He
1999
Mixed media on
canvas with 2
dung supports
183 × 244 cm

the vivid, densely patterned surfaces of his paintings are great boulders of resin-coated elephant dung, often studded with bead-like map pins. Down on the floor, more can be found, supporting the canvases like the reassuring ball-feet of a Victorian sofa.

It was on a British Council Travelling Scholarship to Zimbabwe in 1992, while studying for his MA at the Royal College of Art, that this Manchester-born son of Nigerian parents discovered what has now become his trademark medium. In an exasperated attempt to make his anecdotal acrylic paintings of black, English, urban life reflect the intensity of this new experience, Ofili stuck a lump of dried dung onto an abstract canvas. He liked what

he saw: a piece of real Africa fused to a Western surface, the ultimate in ugliness in collision with conventional beauty, the gesture complicating notions of both. Shit, he realised, is a great signifier.

For a while, Ofili made exclusive use of his unorthodox new medium, displaying it in street markets in Berlin and London (in Berlin they thought he was a witch doctor, in London a drug dealer), making a dung self portrait crowned with his severed dreadlocks (*Shithead* 1993), and even rolling enormous spliffs of the stuff. It soon became established as a crucial element in his paintings, where it has remained ever since, along with an intricate dotted painting style adopted after a visit to the ancient cave paintings in Zimbabwe's Matopos Hills.

But there's nothing folksy about these psychedelic canvases, where beauty meets kitsch in scatterings of glitter, flamboyant patterning and magazine cut-outs, and where issues of identity, ethnicity and exoticism all dip and dive between translucent layers of clear resin. Ofili began by splashing patches of shiny varnish onto conventional acrylic paint surfaces, but in 1996 he opened up a new seam of possibility by trapping richly painted details in surfaces of transparent resin, and he has continued to explore visual and interpretative possibilities with the jewel-like colours and enamelled textures of paintings that can be milky or translucent, tarry or opaque. For Ofili – as with Gary Hume and a number of other contemporary artists –

there's no stigma in being decorative. Instead, he revels in piling on the patterning in intricate layers to produce audaciously flamboyant paintings that have as much to do with problems of abstraction as with issues of identity.

Whether he's presenting an African-style goddess baring a beaded elephant-turd breast amidst a shower of female genitals snipped from porno mags (*The Holy Virgin Mary* 1996), or a collaged pantheon of black heroes – each with their own 1970s Afro hairstyle – emerging from a welter of pattern (*Afrodizzia* 1996), Ofili stands apart from previous generations of black British artists in his savagely humorous refusal to be pinned down by polemic. Instead, he knowingly plays with prejudice and preconception as part of a polyglot, late twentieth-century existence, where being black is just part of his story, even if other people don't see it that way.

These are works of the inner city: pneumatic women such as *Foxy Roxy* and *Blossom* (both 1997) were initially inspired by the prostitutes working the streets around Ofili's studio; the weeping woman in *No Woman, No Cry* (1998) is a homage to Stephen Lawrence, in which tiny photographs of the murdered south London teenager are trapped inside each of her tear drops.

Men are depicted as powerfully and as ambivalently as women, melting into and out of the surface design. In *He* (1999) a shadowy deity with a Haile Selassie beard swirls out from a vortex of pattern, surrounded by a constellation of collaged faces of black musicians, sportsmen, etc. A whole series is devoted to Captain Shit, a black Captain Fantastic, proud and wary, awesome and ridiculous, with his bared chest, bulging crotch and padded shoulders. Sometimes this superstar is clawed by eager pink hands (*The Adoration of Captain Shit and the Legend of the Black Stars*), sometimes, in an echo of Andy Warhol's 1963 *Double Elvis*, he appears in duplicate (*Double Captain Shit and the Legend of the Black All Stars* 1997); often he glows in the dark. In his various guises, Captain Shit hovers like a translucent spectre, emerging out of a background spattered with inky black stars, each with a watchful pair of eyes that knowingly returns your gaze.

JULIAN OPIE

b. 1958 London
1979-82 Goldsmiths College
Lisson Gallery
Lives and works in London

Blinking portraits
1999
Continuous
computer film or
projected video
(stills)

Subsequent waves of Hirst-hype have tended to obscure the fact that
Goldsmiths College was already attracting attention several years before the
class of '88 put together a show called *Freeze*. Opie was still a student there
when he was selected to exhibit his painted sheet-metal sculptures alongside
works by Keith Haring, Jenny Holzer, and Anish Kapoor at the Lisson
Gallery in 1982; and his one-man Lisson show in 1983 launched him into the
art world as the youngest practitioner of the 'New British Sculpture' that
caused such a stir during the early 1980s. This seamless transition from
studenthood to international art-world status was keenly noted by later
generations of Goldsmiths students, and Opie compounded his influence by
returning to teach on the Goldsmiths degree course between 1990 and 1993.

Opie's work doesn't conform to a single style or lend itself to easy
classification. By the late 1980s, he had surprised the art world by moving
from his distinctive, folded-steel sculptures with their sloshily painted *trompe
l'oeil* surfaces depicting toppling domestic objects and appliances, to produce

hard-edged, coolly minimal pieces that looked more like the appliances
themselves. Since then, he has become increasingly multifarious – and slick
– in his cross-referencing of art, architecture, industry, technology and
children's toys. He has tapped into all of these categories to produce walk-
through arrangements of sculptures and wall-mounted vistas that distil our
everyday surroundings – roads, cars, buildings and the landscape – into the
smoothed-out, Legoland reality of the driving simulator, or computer game.

But whether he is making a boxy, life-sized replica of a Volvo 440, a
miniature model castle, or a Minimalist light box, Opie has remained pretty
consistent in his concerns. Everything he produces is underpinned by a
preoccupation with how we negotiate and experience the modern world: its
forms, its spaces, its places and its non-places. And this has in turn led to a
whole gamut of visual and conceptual spins on the affinities shared by, as
well as the distinctions between, the world of art and the world at large.

Opie's work may sometimes look as if it comes from the Early Learning

Centre, but getting its message can be far from child's play. Bright colours and simple shapes are no guarantee that Opie believes the world can – or should – be tidied up; he's too cool and ambivalent to be either utopian or judgmental. He likes the mind to boggle. *There are 1800 electrical storms in the earth's atmosphere at any one time* (1991) is a 2-metre column made from fused, brightly painted strips of the wooden decorative moulding that can be bought at any builders' merchants. But take a closer look at this giant, 3-D, vertical barcode, and its clarity breaks down into a bumpy, curvy, tubular surface that cannot be seen all at once and where form and colour conspire to confuse the eye. The world according to Opie is one of infinitely changeable systems, and he shows this again in the series of paintings and sculptures *Imagine you can order these* (1992), where he exploits the limitless visual potential offered by a group of coloured blocks.

In many ways, Opie's entire output can be read as simulations of simulations, always at one, or sometimes several, removes: whether paintings of paintings, sculptures of sculptures, models of models, or places that are reproductions of places. His more recent computer-generated works are infinitely reproducible and adaptable, playing with the relationship between the generic and the specific, and how the human imagination fills in the gaps. Sometimes, this can backfire into blandness, as in the 1996 installation *You are in a car*, in which Legoland cars and buildings and wraparound wall paintings of roads and countryside fail to express a high-speed view, and instead resemble static imagery taken from a computer screen. However, more recent computer-generated portraits reduce the photographed faces of *Clara, schoolgirl*; *Rosie, businesswoman*; or *Younghoe, factory owner* (all 1999) to the most cartoonish of bare essentials, while at the same time highlighting their individual characteristics so that these facial logos seem miraculously humanly recognisable. Whether shown on the gallery wall, a billboard or as a computer animation with their dot eyes blinking with an unnervingly realistic randomness, Opie's portraits are a rare example of the effective employment of digital technology.

CORNELIA PARKER

b. 1956 Cheshire
1975-8 Wolverhampton Polytechnic; 1980-2 Reading University
Frith Street Gallery
Lives and works in London

In the summer of 1995, 21,000 visitors poured into the Serpentine Gallery during a single week to see actress Tilda Swinton sleeping in a glass box. She was one of the bizarre exhibits on show in the installation: *The Maybe*, her collaboration with Cornelia Parker. The other items were identified by their captions as having belonged to a range of historical figures: the rug and cushion from Freud's couch, Arthur Askey's suit, the half-smoked cigar dropped by Winston Churchill when he heard that the Germans were suing for peace, Queen Victoria's stockings, and the headgear worn by Stanley and Livingstone at their historic meeting in the Congo. In this complex, poetic meditation on memory, mortality, posterity and value, these evocative curios – both worthless and priceless – conjured up their dead owners with an uncanny immediacy (Wallis Simpson's shiny black ice-skates provided a more accurate portrait than any Cecil Beaton photograph), and paradoxically communicated more physical presence than the one living, but inanimate exhibit.

Whether she is blowing up a garden shed, sending a meteorite back into space, or gathering the whorls of vinyl after a record has been cut, Parker is devoted to throwing up the levels of meaning that lie beneath the surface of things. By interfering in the material world she also prods at our mental structures: mounted on a plinth in the Serpentine Gallery and labelled as part of the aircraft in which Lindbergh crossed the Atlantic in 1927, a tatty piece of canvas is transformed into something magical. A loopy tangle of glinting thread also carries a very different set of associations when you learn that it consists of two wedding rings stretched to echo the contours of a living room (*Wedding Ring Drawing* 1996).

This ever-inventive ability to make the ordinary extraordinary often results in the lucid depiction of the seemingly unfathomable – in her words 'using something visible that everyone recognises to describe the indescribable'. Though highly idiosyncratic, these interpretations of life's imponderables possess a peculiar logic of their own. Drawing on procedures that owe as much to the whizz-bang world of children's cartoons as to the alchemist's search for truth from base ingredients, Parker combines both method and mayhem to make the physical world that surrounds us yield up its secrets.

The term 'Cold Dark Matter' is the name for the stuff that makes up a large part of the universe and keeps it in balance, and which science has so far failed to define; but this did not deter Parker from using this mind-boggling intangible as the starting point for one of her most famous pieces. In *Cold Dark Matter: An Exploded View* (1991) she conjured up an entire

Cold Dark Matter: An Exploded View
1991
Exploded shed and contents
Dimensions variable

parallel universe by first blowing up a wooden garden shed stuffed with everyday odds and ends, and then painstakingly suspending its contents in a constellation-cum-swarm, in orbit around a single domestic lightbulb.

Just as 'exploded view' diagrams in technical manuals and encyclopaedias deconstruct engines, mountains and organisms in order to explain their structure, so Parker works to make sense of the world by wreaking havoc with familiar objects and then rearranging them on her own terms. Yet this deliberate use of the banal items with which we structure our lives also destabilises any expectations we might entertain about them – or by implication, ourselves. When a multitude of chalk strokes swarm over the

walls of an entire school building (*Exhaled School* 1990), sea-smoothed remnants of bricks and mortar rear up into the shape of a house (*Neither from nor towards* 1992), or eroded miniature lead models of historical landmarks are drawn into a point like a termite's nest (*Fleeting Monument* 1985), nothing, it seems, can be taken for granted.

For Parker, everything is open to investigation and disruption, and the most prosaic manufacturing processes can be hijacked and plundered for the poetic and the phenomenal. Removed from the production line of the Colt Firearms Factory at the earliest stage, a pair of *Embryo Firearms* (1995) are simply two pistol-shaped blocks of gunmetal; yet in this harmless, arrested state they are still redolent with the menace of their potential future, and our imaginations can easily turn them into the finished product. Conversely, a series of *Pornographic Drawings* (1996), made from image-sensitive ferric oxide removed from pornographic video tapes, suspended in solvent and pressed between sheets of high-quality art paper, forms an unexpectedly exquisite by-product of a debased industry. There is no easy explanation for the unerring way in which these images, reminiscent of Rorschach ink-blots, repeatedly form the delicate, shadowy shapes of breasts and genitals. In Parker's open-ended – exploded – view of the universe, laws of reason, science and art are set free and woven into a network of contingent properties where anything and everything is possible.

FIONA RAE

b. 1963 Hong Kong
1984-7 Goldsmiths College
Luhring Augustine, New York
Lives and works in London

Fiona Rae makes paintings about painting. But there is nothing dry or analytical about the jumbled shapes, wandering brushstrokes and patches of vivid – sometimes livid – colour that inhabit her canvases. Looking at one of Rae's paintings – especially one made around 1990 – is like being taken on a ram-raid through art history, grabbing handfuls of popular culture on the way. Whether in canvases like *Untitled, triptych (purple and orange)* (1994), where a flat fragment of a Matisse cut-out can mutate into a biomorphic blob courtesy of Joan Miró only to be zapped by a juicy smear of late De Kooning and a fragment of Krazy Kat; or in the more syncopated discs, smears and scribbles of *Untitled (yellow with circles)* (1996), there are no hierarchies – anything can come along for the ride, provided it keeps on the move.

Like her Goldsmiths College contemporary Gary Hume, Fiona Rae plays with our expectations of painting and the cultural baggage it carries. In the same way that Hume's puddles of candy-coloured household gloss sail riskily close to sickly kitsch, so Rae deliberately dices with danger with her disrupted compositional devices and a synthetically shaded palette that she has described as 'seventies airport lounge'. Occasionally, this can result in a technicolour yawn – but Rae is generally too nimble to let her canvases become the arena for art-historical trainspotting, and nothing in her sampling of images and styles is quite what it seems. 'If anything starts to look too recognisable then I scupper it', says the artist, whose paintings – in both form and content – rely for their impact on a risky, edgy, teetering uncertainty whereby smears, patches, doodles and dribbles are not allowed to reveal too much of themselves, become blandly generalised, or to unravel into mayhem.

In her quest for what she has called 'the right kind of chaos', Rae devises formal (though never formalist) ground rules for her paintings, but only in order to test and depart from them. Increasingly, she has shifted from works that display a cartoonish collision course to compositions governed by a syncopated, uneasy rhythm. A series shown at Waddington Galleries in 1995, for instance, had the narrow, horizontal proportions of Cinemascope screens or viewing slits, and was orchestrated and underpinned by a repeated

Untitled (parliament)
1996
Oil on canvas
275 × 244 cm

geometric structure of large and small compass-drawn circles, slicing into, or contained by, the picture plane. This potentially restrictive composition became a springboard for more flights of fancy, with smeared, hooped and solid circular shapes suggesting a multitude of possible readings – whether as holes, planets, windows or targets; eclipsed, veiled, shimmying or exploding; as static as a full stop or as dynamic as a circular saw.

Circles again dominate in works such as *Untitled (emergency room)*; *Untitled (parliament)* and *Untitled (phaser)* (all 1996), where anxiety prevails and nothing is resolved. Solid discs that could be planets, saucers, or even Liquorice Allsorts, punctuate and emerge out of a densely stippled black and white surface in a way that is both precise and highly ambiguous. Like cogs

in a pinball machine, they send the eye shooting across this marbled, smeared ground, which itself boils with possibility and looks as if it is about to mutate into something else. It is no coincidence that one of the works in this series is called *Untitled (T1000)* after the liquid metal android in the movie *Terminator 2*, which can assume the exact shape and appearance of anything with which it comes into contact.

With her continuing use of contrasting marks and methods, Rae stands in sharp contrast to many of today's artists such as Ian Davenport, Jason Martin or Callum Innes, who restrict themselves to a single specific painterly process – whether pouring, layering, scraping or stripping away – in order to explore its nuances and possibilities. Such purity of practice would be anathema to Rae. She relishes everything that paint can do; and it is by this combination of intellectual enquiry and sheer gusto that her canvases bear out the continuing validity of Le Corbusier's maxim that a painting 'is a machine for creating emotion'.

GEORGINA STARR

b. 1968 Leeds
1987-9 Middlesex Polytechnic; 1990-2 Slade School of Fine Art;
1993-4 Rijksakademie Van Beeldende Kunst, Amsterdam, Holland
Anthony Reynolds Gallery
Lives and works in London

Georgina Starr plunders her past and her present in a way that deliberately conflates fact, fiction and fantasy. She does not search for – or provide – answers and conclusions, but instead transports us into a complicated parallel universe – which we then have to negotiate for ourselves. Starr is a born storyteller; her starting point may be a chance event or a half-remembered personal detail, but what saves her work from being an exclusive, self-regarding exercise is the way in which it takes on a dramatic, unexpected and frequently excessive life of its own.

Often, her art appears to have come out of almost nothing: a sudden flood of tears, puffs of wind blowing up rubbish, a boring stay in a hotel room. But these random beginnings are the starting point for an intricate, quasi-scientific process that evolves according to its own bizarre logic. For *Eddy 1/Whistle* (1992), made while still at the Slade, Starr threw about a hundred paper darts into eddies produced by currents of wind on the public concourse of Euston station, and photographed them in mid-air. She then laid a musical score over the photograph, marking the position of the darts on the staves. This produced a piece of music that she could whistle. Having made it into a 45 rpm record, she played it in the Slade building. As passers-by started spontaneously to hum it, they revealed how easily the unconscious can be tricked into an erroneous sense of familiarity.

Specific incidents, often involving the artist herself, may appear to be the subject of the work, but it is never that simple. Increasingly, Starr chooses to leave it unclear whether she is being 'herself' or merging with the identity of others. Even when precise parts of her life are explored, they usually turn into something else. One of her best-known pieces, *Visit to a Small Planet* (1994-5), revolved around an old Jerry Lewis movie of the same name, which had captured Starr's childhood imagination. The resulting extravaganza of video pieces, installations, drawn story boards and elaborate published film script turned out to have little to do with the original film: the true subject of the piece was not a specific movie but Starr's completely inaccurate memory of it.

Tuberama
1998
Mixed media
Dimensions
variable
Installation at Ikon
Gallery, Brimingham

In these lavish and often loony scenarios Starr uses every means at her disposal to hook and captivate her audience; as far as she is concerned, more – not less – is more. Film and fantasy, magic and madness all featured in her epic installation *Hypnodreamdruff* (1996) where props, TV monitors and video projections enabled the visitor to sit down at the dinky, detritus-strewn tables of The Hungry Brain nightclub and observe its dysfunctional clientele; to squat in a re-creation of Starr's teenage bedroom and observe her acting out the main female parts in the movie *Grease*; to eavesdrop in the eat-in kitchen of three ill-suited flatmates; and (most disturbingly) to enter the claustrophobic trailer home and the intimate life of its occupant Dave, aspirant magician and Lionel Ritchie fan. For *Tuberama: A Musical on the Northern Line* (1997-8), what began as a comic strip became a musical

animation with a 13-song soundtrack, a life-sized painted set and electric tube train, in which the characters on London Underground are transported to Dopplestadt, a town filled with their emotional replicas.

Like many of her contemporaries, Starr is not squeamish about jettisoning good taste and decorum in these elaborate mind games in order to destabilise carefully guarded certainties and securities. Yet it is not her aim merely to immerse the viewer in kitsch recall. There's a frenzied fragility in her intricate, overloaded vision; and this sense of insecurity is compounded by the ambiguous proximity of filmed events and vacated sets, real props and fictional narratives. In her art, the trivial and mundane are not relegated but highlighted as the key to our memories and emotions: after all, it is the pop song rather than the political event that lodges itself in our collective memory. And as she becomes more and more involved in the world of music (she is in two bands, Pony, and Dick Donkey's Dawn), it is Starr who is both singing and writing those songs.

SAM TAYLOR-WOOD

b. 1967 London
1988-90 Goldsmiths College
White Cube
Lives and works in London

In the scenarios conjured up by Sam Taylor-Wood's photographs, videos and films, the display of intense emotion is no guarantee of reality or truthfulness. It is unclear when the acting stops and reality begins, and as with the art of so many of her contemporaries, nothing is exactly what it seems, or is ever resolved. But that is the point – we have to complete the story.

Taylor-Wood deliberately plays off discrepancies between form and content, appearance and intention, sound and vision. Provocatively – and often maddeningly – she avoids traceable narrative, interchanges actors with friends, and selects her film-stock and soundtracks for a very precise, if uneasy relationship with the action. Whether she's using home video to present a solitary, naked man dancing in a domestic interior, his manic gyrations set in slo-mo and overlaid with the orchestral sweep of Samuel Barber's *Adagio For Strings* (*Brontosaurus* 1995); or dividing two walls of a gallery between a couple immersed in a protracted domestic battle, set to a backdrop of channel-hopping musak (*Travesty of a Mockery* 1995), Taylor-Wood's work deliberately encourages a sense of dislocation and anomaly.

This is epitomised by the savagely ironic photographic images of the artist herself. These range from *Slut* (1994), where she is professionally shot in full glamour makeup, her confident smile and closed eyes further complicated by a neck-full of livid love bites; to an image where she strikes a spoof Venus de Milo pose, wearing her trousers around her ankles and a t-shirt bearing the words *Fuck Suck Spank Wank* (1993). Self consciousness and exhibitionism add to the ambiguity and establish themselves as major and recurring themes. In the video *Hysterical* (1997) a young woman soundlessly laughs/cries, leaving her emotional state – and therefore the viewer's response – unclear; while in *Wrecked* (1996) Taylor-Wood uses a line-up of her friends to produce a photographic recreation of Leonardo's *Last Supper* (with more than a nod to Derek Jarman) into a contemporary dinner party, in which the central figure of Christ rears up incongruously as a woman bare to the waist, her arms outstretched in a gesture that is both spiritual and insane.

Direct and oblique art-historical references run through much of Taylor-

Soliloquy 1
1998
C-type colour
print (framed)
211 × 257 cm
Photo: Attilio
Maranzano

Wood's work. The *Soliloquy* series (1998) is a complex, modern adaptation of the traditional altarpiece format. Lower predella panels depicting episodes relating to the main image are replaced by a photographic frieze in which disquieting events often unfold. These dioramas provide a subtext and parallel exploration for the psychological state of the single figure above. This often adopts an overtly familiar 'arty' pose, whether that of Velásquez's *Rokeby Venus* (*Soliloquy III*), David's Marat (*Soliloquy V*) or Henry Wallis' Chatterton (*Soliloquy I*), in grungy contemporary surroundings.

A more ambitious, if less successful, work was Taylor-Wood's installation *Pent Up* (1996), which filled an entire wall of Chisenhale Gallery with a row of film projections, each showing a huge individual immersed in an intense personal monologue. Shot in different styles and separate environments –

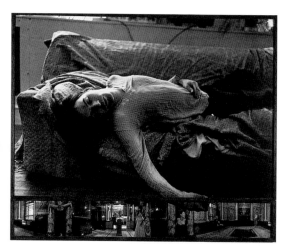

one actor seated in Rodin-like contemplation, one striding down a street, another gloomily sozzled in a bar – these angst-ridden giants would suddenly jump out of their isolation by appearing to have inter-screen conversations before lapsing back into their separate ruminations. While Taylor-Wood, for the time being at least, seems more comfortable with image and soundtrack than with dialogue, the possibility that these divided beings may, in fact, have been talking to each other as much as to themselves inevitably raised new narrative possibilities and coloured the way in which the viewer related and responded to what each was saying; as usual, nothing was confirmed or denied.

Increasingly, Taylor-Wood's work reflects a febrile and often decadent world of glamour and celebrity; a world that sucks in and spits out. This seductive sterility is reflected in the series *Five Revolutionary Seconds* (1995-8), in which photographic dioramas present a seamless space, punctuated by groups of people whose activities run the gamut of, in Taylor-Wood's words 'absolute normality to excess'. Shot with a camera that takes five seconds to pan 360 degrees, these elongated images take in stylish loft or salon surroundings with a single panoramic sweep, in which the protagonists argue, play the piano, stand in doorways, look out of windows, fight, or have sex, each trapped in their own world, and completely oblivious to everything

else going on around them. A soundtrack of background noise and snippets of conversation taped during the photoshoot, adds to both the work's voyeuristic appeal as well as to the futility of trying to make these individuals fit into an unfolding sequence of events. There's more eavesdropping in the three-screen projection *Atlantic* (1997), in which a couple argue in a crowded restaurant. One screen zeroes in on the woman's anguished face, the central screen is a panorama of the grand restaurant surroundings, and the third is restricted to the man's anxiously fidgeting hands. Only an occasional fragment of the intense on-screen exchange emerges out of the soundtrack of background restaurant babble; again, the viewer is tantalised but excluded.

There's no doubt that Taylor-Wood has looked hard – perhaps on occasions too hard – at the ambiguous, emotionally intense video work of American artists Bruce Nauman and Bill Viola, but her heroes are as much from the movies as art history. The high-octane, psyche-obsessed films of John Cassavetes, Francis Coppola, Michael Cimino and Martin Scorcese, as well as the voyeuristic lens of Andy Warhol and the kinky narratives of Alfred Hitchcock all fuel Taylor-Wood's art of altered states, while a spell working backstage at London's Royal Opera House has also made its mark in providing a crucial insight into how even the most stylised and 'inauthentic' form of expression can be a lie that turns out to tell the truth. However, as her work becomes increasingly adept at employing the glossy language of magazine and advertising media, it runs the risk of becoming indistinguishable from the very genres it explores.

WOLFGANG TILLMANS

b. 1968 Remscheid, Germany
1990-2, Bournemouth & Poole College of Art & Design
Maureen Paley / Interim Art
Lives and works in London

Wolfgang Tillmans' photographs have appeared in *i-D* magazine, *Vogue* and *The Face*, as well as in solo shows at Kunsthalle Zürich, Frankfurt Portikus, the Museo Reina Sofía in Madrid and Chisenhale Gallery in London. As far as he is concerned, there is no distinction between a gallery installation, a magazine assignment, a poster, a postcard or a clothing catalogue. He regards all as vehicles with which to communicate his view of the world.

Man Pissing on
Chair
1997
C-type print

In an age of eclectic boundary blurring in which rigid distinctions between 'fine art' and 'commercial' photography have become increasingly obsolete, this open-ended approach has won Tillmans many admirers, especially since his lack of inhibition extends to the multifarious worlds he depicts. His photographs present a web-surfing, channel-hopping, serendipitous study of our times, in which a sun-drenched colour portrait of Kate Moss can be grouped with a black and white shot of stoned, sweaty ravers, and a meticulous table-top still life composed from the debris of a breakfast. The crop-haired couple who prod and pry into each other's bodies in a 1992 *i-D* fashion story crop up again in a Chisenhale exhibition of 1997, this time next to a giant print of a skinhead urinating into an office chair, who is flanked on the other side by an almost unbearably cuddly shot of a puppy and a sheep touching noses.

Yet these eclectic images, which Tillmans pins, unframed, onto gallery walls, are more than a superficial and occasionally sensational-ist swish over the surface of modern life. This is an artist who digs deep, and on many levels. Despite their informal presentation and often spontaneous appearance, everything about these photographs is meticulously considered. Whether they're small-scale black and white snapshots, colour C-prints or giant bubble-jet prints, Tillmans processes them all himself in order to ensure just the right pitch of colour and tone for the particular context in which they will be shown. His trademark style of exhibiting has involved a highly intuitive mix of old and new work in varying formats and configurations, all of which point to different narratives and conversations.

Although he frequently presents his own milieu, Tillmans' is not an autobiographical diary project *à la* Nan Goldin, nor is it a process of gritty, intimate documentation in the style of Richard Billingham. He produces series such as the 1997 *Concorde* works showing the supersonic jet climbing in the sky above the suburbs of London. But in spite of being shot in sequence and presented as such in books, they can also appear singly, mixed up in other groupings. While these images often seem close in appearance to Paul Graham's photographic scrutinising of contemporary life from Belfast

and Tokyo, Tillmans isn't seeking to chronicle, distil or define. He simply presents what is there in a particular and captivating way. With no overt agenda or message – they've been described as a 'stream of consciousness' – they simply capture a moment. Size or their exposure may vary, but there's never a sense of ironic distancing or glib manipulation as Tillmans objectively records the view out of an aeroplane window, the twisted trunk of a tree in a landscape, or rats running in and out of street gratings at night. Tillmans is an artist enthralled by the world around him, who can find something special – even sublime – in the most banal of everyday reality. Caught in his camera flash, sewer rats appear as perky urban survivors, while the down-beat, snapshot style of his C-print *Concorde L449-6* (1997) nonetheless captures the heart-stopping moment of euphoria as the vehicle's absurdly exotic shape is spotted, soaring above a muddily mundane parking lot. Similarly, his photographs from the *Total Solar Eclipse* series (1998) record a natural phenomenon in the most down-to-earth style – concentrating as much on the people watching and their surrounding as the event itself, imbuing it with infinitely more strangeness than a more obviously aestheticised or systematic view.

Despite the full-on contemporaneity of much of his subject matter, however, Tillmans is no documenter of grunge. His photographs only look like snapshots when he wants them to. In other works, such as the carefully composed still life of fruit, roses and purple plastic, *Stilleben, Marktstrasse* (1997) or a whole series devoted to detailed studies of fabric – the crumpled white t-shirt in *Sportflecken* (1996); the legs of jeans curled round a radiator *Falten-wurf (Oliv)* (1996); the rich textures of a patched denim crotch (*Adam's Crotch*, 1991), Tillmans splices highly formal traditional concerns with a strongly physical sense of the here and now. The white t-shirt is slightly stained, there's a bedsit connotation to jeans drying on a radiator, and out of the symphony of denim blues pokes a chunk of underpant and a slice of leg.

In his 1999 solo show at Interim Art, Tillmans aestheticised his works to the extent of showing them large scale and conventionally framed behind glass. But with a characteristic aversion to potential pigeonholing, he devoted the other half of his exhibition to two rooms lined, pinboard style, with *Soldiers – The Nineties*. These photographs of young men in uniform were not taken by Tillmans himself, but selected from newspaper clippings that spanned a decade. The work presents not so much soldiers per se, as young men being soldiers. Unlabelled and unidentified, they dress up, play, sometimes fight but more often fraternise with those around them. As in all his work, this is a human's eye view that thwarts our preconceptions.

GAVIN TURK

b.1967 Surrey
1986-9 Chelsea School of Art; 1989-91 Royal College of Art
White Cube
Lives and works in London

Gavin Turk's career began with what appeared to be its end. For his degree show at the Royal College of Art in 1991, he presented *Cave*, a cleaned-out sculpture studio, empty except for a blue ceramic English Heritage plaque fixed high on the back wall that read 'Borough of Kensington/Gavin Turk Sculptor/Worked Here 1989-1991'. This simple comment on the myth of the artist, the exclusivity of creativity, reputation, and the death of art in general was lost on the authorities of the Royal College who decided that Turk had displayed insufficient work to pass his MA degree. His response was to re-christen the plaque *Relic* (1991-3) and to mount it in a reverential glass case to denote its 'significance' as an artwork and its symbolic role as a salute to all the artists – Joseph Beuys in particular – who have mythologised their own lives and created their own legacies.

Just as his career was born with a memorial, Turk's reverse progress continued when his first solo exhibition was staged as a full-blown retrospective. *Gavin Turk Collected Works 1989-93* occupied an entire building with pieces in all media, including various versions of the artist's own signature. By creating the ironic fictitious persona of Gavin Turk the artist, and staging re-runs of iconic artworks of the past, Turk continues to play with and parody the way in which reputation is gained and status conferred, as well as our desire for artists to be heroes. To this end, he has mounted balls of his chewing gum in a museum-style glass case (*Floater* 1993), exhibited the silk-screened *Gavin Turk Right Hand and Forearm* (1992), and – most famously – presented himself in life-sized, waxwork form as Sid Vicious, shooting from the hip in the same pose as that in which Andy Warhol depicted Elvis Presley in 1963 (*Pop* 1993).

By portraying himself as a Sid/Elvis hybrid out of Andy Warhol and the Great Rock 'n' Roll Swindle (via Madame Tussauds and the Rock Circus), Turk was not only presenting a multi-referential statement about how our culture both reveres and neutralises any authentic expression of rebellion, he also chose Vicious 'because he's an icon of modern Britain, but at the same time such an incredible loser'. In a seemingly cynical world, compassion can be conjured up in the most unexpected of places. Turk is especially fond of

Che
1999
Waxwork in
virtine
Plinth:
280 x 114 cm

making his own cover versions of the art of Italian artist Piero Manzoni, whose entire life's work was devoted to interrogating the authorship of artworks and the transformative powers of the artist; but his representational recycling can also take him back to points where politics converge with popular culture – as in *The Death of Marat* (1998), a waxwork of Turk as the expiring hero of the French Revolution as depicted by Jacques Louis David, or *Che* (1999), in which he becomes the Cuban Revolutionary leader and patron saint of bedsit rebels the world over.

While there's nothing new in making art about the idea of art – or art about art about art for that matter – Turk's multilayered spins on key works of the past display a directness and a poetry that goes beyond postmodern reference spotting. They are charged with a self-effacing humour that is uniquely British in character. He clouds the pristine clarity of American Minimalist Robert Morris' mirrored cubes by picturesquely distressing them with mildew (*Robert Morris Untitled 1965-1972*, 1990); while his liquorice pipe cast in bronze (*pipe* 1991) may be a multiple homage to René Magritte, Jasper Johns, Le Corbusier, van Gogh et al, but marooned on its huge plinth, it belies these art-historical antecedents with its poignant

sweetie-shop status. With his black-painted, steel replica builder's skip, *Pimp* (1996), Turk unleashes yet another volley of deliberately mixed references. Whether he's tipping his hat to the readymades of Duchamp (whose urinal was after all, just another everyday container for waste) or to the no-nonsense utilitarian aesthetic of the Minimalists, as the viewer's reflection shimmers off the various facets of *Pimp*'s perfectly reflective bulk, it is not clear to whom its title is meant to refer: artist, object or viewer.

MARK WALLINGER

b. 1959 Essex
1978-81 Chelsea School of Art; 1983-5 Goldsmiths College
Anthony Reynolds Gallery
Lives and works in London

The theme of identity is a common one among contemporary artists; but Mark Wallinger's extensive exploration of how we define ourselves has established him as one of Britain's most inventive and conceptually nimble artists. He's also not one to blanch at big subjects. Not many artists attempt to address the meaning and purpose of religion in today's society, let alone take it upon themselves to produce a public sculpture of Christ. Yet when Wallinger's *Ecce Homo* was installed on an empty plinth in Trafalgar Square for six months between 1999-2000, this life-sized figure in sanded resin found almost universal favour, being praised by both the devout and the unbelieving as well as both traditionalists and champions of the artistically adventurous. In its androgynously modern appearance, human scale and positioning at the edge of a plinth four times its size, *Ecce Homo* appeared fragile and vulnerable, blending modestly into its grand surroundings but at the same time attracting attention through the incongruity of its Everyman appearance and relationship to its enormous plinth. Here was an image of Christ brought before the crowd not by Pontius Pilate but by Mark Wallinger, to question belief systems as well as assumptions about authority and the positioning of artworks.

Ecce Homo emerged from a whole body of work addressing religion and faith in characteristically unpredictable ways, such as an eye-chart lightbox whose letters spell out the Gospel of St John (*Seeing is Believing* 1997) or a loose trilogy of videos entitled *Angel* (1997), *Hymn* (1998) and *Prometheus* (1999), in which Wallinger presents himself variously as blind deity condemned to spout the gospel at the foot of an underground escalator; soapbox prophet squeaking out a cheesy hymn; and a convulsive blinded figure strapped into an electric chair.

This continuing interrogation of our cultural territory has also extended into an area closely related to religion: the world of sport. Undoubtedly Wallinger's most unorthodox artwork was the thoroughbred racehorse who ran in the 1994 flat season, registered under the name of *A Real Work of Art*. No matter that this equine artwork failed to perform as well as expected (the horse now belongs to a German collector), she still formed the culmination

of a multifaceted examination into the intertwined worlds of horse racing and the thoroughbred, which began in 1992 with *Race, Class, Sex* – four life-sized paintings of thoroughbred stallions directly descended from Eclipse, a horse painted in the eighteenth century by George Stubbs. Other explorations of the richly symbolic – and symbiotic – territory of breeders, punters and blood stock have included four composite paintings that joined the back half of one thoroughbred stallion to the front section of another (*Half-Brother* 1994-5); and a wall-sized video projection of the chillingly controlled, ritualised 'covering' of a mare by a stallion (*National Stud* 1995).

For Wallinger, the metamorphosis of living horseflesh into 'real' artwork was an easy, almost inevitable one. He described *A Real Work of Art* as 'a history of aesthetics in microcosm' – no species in the world being more closely documented, artificially bred and subject to cold financial considerations than the racing thoroughbred.

He extended the artistic analogy via some playful linkage with racing 'colours' and art traditions, producing *Brown's* (1993), a series of paintings based on the registered colours of all the owners called Brown (the shade that would result from mixing all the pigments on the palette). Then, with supreme audacity, Wallinger not only subverted the male bastion of the Jockey Club by registering his own animal in the violet, green and white colours of the Suffragette Movement, but compounded this act by putting on the colours and posing in drag at the exact spot where suffragette Emily Davison threw herself in front of King George V's horse at the Epsom Derby in 1913 (*Self Portrait as Emily Davison* 1993).

Another personal passion that Wallinger has integrated into his work is the world of football. In the name of art he has been photographed among the crowds leaving Wembley, brandishing a Union Jack banner emblazoned with his own name; constructed a fake marble memorial to the 1966 World Cup (*They think it's all over ... it is now*, 1988), and in 1996, exhibited a giant scarf for his team Manchester United, arranged in a double helix to give a biological twist to the notion of *Man United* (1996). By taking the position

both of critic and fan, Wallinger is particularly effective in splicing the cerebral with the accessible while showing that England and its inhabitants are complicated, contradictory and not as Merrie as we may have thought.

Though Wallinger does not deal in heavy polemic, he still takes a sharp and trenchant look at the flaws, contradictions and preconceptions thrown up by the culture that surrounds us. His variety of media and subject matter can range from a reversed video of Tommy Cooper performing his hat trick (with the aptly palindromic title *Regard a Mere Mad Rager* 1993); to a single hose trickling water in leaky homage to Duchamp's urinal through a gallery window into the street outside (*Fountain* 1992), and a series of intricate one-point perspectives of his Chigwell secondary-modern school, drawn in chalk on blackboard and illuminated by a single lightbulb. In Wallinger's work a seeming one-liner can speak volumes, such as his *Oxymoron* (1996), a re-colouring of the Union Jack in the green, white and orange of the Irish Tricolour, confirming that the biggest and most complex ideas can be conveyed in the most instant and accessible forms.

GILLIAN WEARING

b. 1963 Birmingham
1987-90 Goldsmiths College
Maureen Paley / Interim Art
Lives and works in London

Gillian Wearing engages directly with the reality (and fantasy) of every-day English life. Drawing on the social anthropology of the 1930s Mass Observation Movement as well as more recent practices of market research and 1970s fly-on-the-wall TV documentaries, her videos, films and photographs present members of the public in guises ranging from the banal to the bizarre. Yet, whether she is photographing passers-by holding placards inscribed with their thoughts and feelings – *Signs that say what you want them to say not signs that say what someone else wants you to say* (1992-3) – filming strangers in bizarre masks baring their souls to camera – *Confess all on video. Don't worry you will be in disguise. Intrigued? Call Gillian ...* (1994) – or presenting seemingly staid citizens painstakingly blowing tunes from the necks of bottles – *I'd Like to Teach the World to Sing* (1995) – the view presented generally comes over as an affectionate one, the subjects inviting empathy rather than ridicule.

While there's no doubt that this documentary format plays off an innate curiosity about people's lives, Wearing's work usually manages to go beyond the straightforward vox pop or the pruriently voyeuristic to become a more complex study of individual, collective and artistic identity. By entering into an open and collaborative partnership with those she depicts, she may make people's private experiences public, but she does so on their terms as much as her own. She chooses how to frame these slivers of 1990s Britain, but offers no judgement – it is up to the viewer to decide what is being shown. This work presents no programme, no political agenda, beyond a commitment – in the artist's words – 'to gauge what makes us live, breathe and tick using my own methods'.

The fact that she cannot control what these strangers choose to reveal,

and offers no explanation as to why they agreed to participate, presents an uncomfortable reality fraught with mixed messages, ambiguity and an overwhelming sense of isolation. A man replies to a magazine advertisement, dons a grinning rubber Neil Kinnock mask and, on camera, confesses his theft of some computer equipment to a stranger; a besuited young man wears a smug smile but holds a placard declaring I'M DESPERATE; heavy metal fans are filmed frantically strumming their air guitars in the safe havens of their bedrooms. One series of work made in 1996 displays photographs of a range of participants alongside reproductions of their handwritten replies to her request to look back over their lives and forward to the millennium. In these immaculately presented combinations of text and image, our immediate first impressions are both undermined and enriched by their individual thoughts, hopes and fears.

There's more friction between appearance, expectation and apparent actuality in Wearing's 10–16 (1997) where, in seven short films, back-projected onto a 5 1/2-metre screen, adult actors lip-synch to a soundtrack taken from Wearing's interviews with children aged between ten and sixteen. The sight and sound of childish voices relaying their hopes, fears and

preoccupations through the mouths of sometimes unlikely looking adults can be arresting, disquieting and often very funny. At best, the disjunction between what is being said and who is saying it encourages the audience to look and listen in new ways, and to reassess the baggage we bring to notions of youth and age. However, Wearing has to be on her guard against charges of exploiting her subjects, and in the sequence where a naked adult dwarf talks in the voice of a thirteen-year-old child of his hatred for his lesbian mother and her girlfriend, there's a risk of veering into voyeuristic territory.

Often, Wearing further complicates the distinction between subject and object by physically putting herself into the work. For *Take your top off* (1993), she photographed herself in bed with three transsexuals, subjecting her own sexuality to the same analysis as those depicted with her; while in her video projection *Homage to the Woman with the Bandaged Face I saw Yesterday Down Walworth Road* (1995), she took the eponymous role herself, bandaging her own face and filming the reactions of the people she walked past. In *Dancing in Peckham* (1994), Wearing danced for twenty-five minutes, non-stop, in the middle of a shopping precinct. In spite of her energetic display of 1970s disco steps, there was no music. Watching the filmed reactions (or non-reactions) of passers-by to this odd spectacle was an uncomfortable experience – did we feel sorry for Wearing putting herself through this ordeal, angry with a society that has cut itself off from so much surrounding it, or sympathetic to the desire of many Peckham shoppers just to keep their eyes down and walk by as quickly as possible?

Wearing's more elaborate scenarios may require careful orchestration, but they carry the same uncertain tension between real life and artifice, truth and fiction as the rest of her work. In the video *I love You* (1999) she uses professional actors and a documentary style to reshoot the same sequence of events eight times. As four people get out of a car in a nocturnal suburban street and make their way into a house, one woman is always more agitated than the rest, shouting the words 'I love you' before they go inside. But, in a device that has been employed in movies from Akira Kurosawa's *Rashomon* (1951) to Harold Ramis' *Groundhog Day* (1993), each version of the same event has been shot from a different point of view. On one occasion, the woman seems hysterical, on another just tipsy and, as the different versions pile up, any search for a single interpretation becomes increasingly futile. Like Sam Taylor-Wood, Wearing is playing with the slippage between extreme emotional states, using increasingly cinematic devices in order to explore where fantasy stops and reality begins. The trouble is, movies often do it better.

JANE AND LOUISE WILSON

b 1967 Newcastle-upon-Tyne
Jane Wilson: 1986-9 Newcastle Polytechnic; 1990-2 Goldsmiths
College
Louise Wilson: 1986-9 Duncan of Jordanstone College of Art, Dundee;
1990-2 Goldsmiths College
Lisson Gallery
Live and work in London

The fact that Jane and Louise Wilson are identical twins has provided them with a very particular insight into strangeness and difference; and it is therefore not altogether surprising that much of their jointly produced art has been an exploration of altered states. In the past, this has involved films of the duo tripping on LSD (*LSD* 1994) or under the influence of hypnosis, *Hypnotic Suggestion* (1993); as well as using the power of the camera to transform what can be the most mundane and innocuous of surroundings – a room in a King's Cross Bed & Breakfast (*B & B, Kings X* 1993), a series of dingy New Jersey motels (*Routes 1 & 9 North* 1994) – into fraught and spooky scenarios in which strange events unfold.

The Wilsons have been working together since 1989, when, in spite of being at different art schools, they put on identical degree shows. However, they claim that this was due less to sisterly telepathy and more to pragmatism: 'We were getting to the point where we were using each other and bouncing ideas off each other, and so it would have been absurd to try and decide who had done what.' Nonetheless – especially in their earlier works – they frequently make reference to the psychic and the supernatural, while their trademark use of split-screen projections and intricate intercutting also gives a sense of multiple views and realities.

Abandoned interiors often provide the setting for the twins' bizarre acts. The double-wall projection *Normapaths* (1995) finds them in what looks like a derelict factory, where, in Emma Peel-style cat-suits, they become dysfunctional action heroines, bouncing euphorically on a trampoline, breaking into fights, hurling themselves through walls and uncannily bursting into flames or caressing each other's faces with feet where their hands should be. The paranormal ante is upped to a *grand guignol* level in the sinister abandoned

Mirrored Figure:
Gamma
1999
C-print on
aluminium with
aluminium
edging
122 × 122 cm

house of *Crawl Space* (1995), which piles on the horror-movie quotes as walls bulge, ectoplasmic bubbles hover and telekinetic twins cause doors to slam and bloody missiles to hurtle through the air.

More recently, they have let their locations do the talking. While on a DAAD scholarship in Germany, they made *Stasi City* (1996), a double video projection that penetrates the deserted headquarters of the notorious East Berlin intelligence service and a former Stasi prison to pan through deserted corridors, offices and interrogation rooms, all of which have remained untouched since the wall came down. In 1999, they uncovered another notorious and hitherto secret site in *Gamma*, which was shot in the now-decommissioned US military base at Greenham Common, and presented in the same double split-screen format. In the same year, they completed the

triptych with *Parliament*, a work devoted to exposing and exploring the Palace of Westminster, yet another highly sensitive location steeped in association, history and authoritarian connotations.

The Wilsons say of these works that they 'wanted to examine what was already there' and see 'how power was manifested in the architecture'. As their camera pans through these notorious sites of Cold War paranoia and the ornate chambers and corridors of British government, they don't have to look very hard for shots in which the banal meets the bizarre, and the atmosphere escalates from faint disquiet to downright dread. The most effective of this series is *Stasi City*, in which tacky 1970s interiors and clunkily low-tech equipment do nothing to alleviate the foreboding, heightened by a clicky, sinister soundtrack and the appearance of a mysteriously levitating track-suited figure. The cavernous silos and chambers of Greenham also offer up fascinating traces of what went on there: the arrows painted onto the floor to guide contaminated personnel through the warhead silos, the Russian Embassy numbers by the control-room telephone, or the tufts of hair left behind by the women protesters, poignant traces that sit strangely with the defiantly gung-ho graffiti painted by the American servicemen. However, Greenham Common has enough of its own ghosts to render the physical presence of the Wilsons

extraneous, even though they appear more as human props than identifiable presences. More effective is their kaleidoscopic split-screen examination of the weird details and over-ornate, ritualistic environment of Parliament and the House of Lords, from which they prudently absent themselves. Yet, how much the impact of these works relies on the locations themselves, rather than on any artistic presentation of them is open to debate.

As Jane and Louise Wilson's use of film becomes more abstract, so their manipulation of specific locations has become more nimble and complex. In their photographs of the corridors of the *Hoover Dam* and the video projection *Las Vegas, Graveyard Time* (both 1999), the Wilsons no longer need to rely on their own theatrical interventions or the viewer's curiosity about a location in order to evoke an atmosphere and place. Instead, they manage to convey a sense of dislocation, manipulation and oddness via the way their films are shot, spliced and framed. In *Home/ Office* (1998) where they present, on a single screen, devastated interiors taken by the London Fire Brigade's Film and Video Department, they are also aware when to keep their intervention to a minimum.

RICHARD WILSON

b. 1953 London
1971-4 Hornsey College of Art; 1974-6 Reading University
Matt's Gallery
Lives and works in London

No one can disrupt a gallery like Richard Wilson. He's still best known for the glassy, pungent expanse of sump oil that, since 1987, has filled galleries from Edinburgh to Los Angeles (its permanent home is in London's Saatchi Collection) with a surface so disorientatingly reflective that it is almost impossible to judge where the reflection stops and the surface begins. The initial impact of *20:50* (the title refers to the viscosity of standard engine oil) derives from the way in which it deceives the senses. Even when you reach the very end of the rising, narrowing platform that leads into its centre, it's still not clear whether you are buoyantly suspended in space, or claustrophobically hemmed-in by a filthy, potentially lethal mass of darkness.

At once devastatingly simple and poetically rife with contradictory readings and associations, *20:50* has entered the annals of art history along with Walter de Maria's *Earth Room* (1977) in New York, or James Turrell's

Slice of Reality
1999
Bisected dredger
Installation on Thames
shoreline at
Millennium Dome,
London

sky-gazing *Air Mass* (1993) as a classic piece of installation art. Yet *20:50* is just one high-profile element within Wilson's continuing process of questioning the spaces and structures that contain art, and by wider implication, society.

This has often involved the use of the buildings themselves as sculpture, and in Wilson's hands, these manipulations can be radical. He has pulled in heating systems from the margins of a room, reinstating them as the subject of the piece (*Return to Sender* 1992; *I've Started so I'll Finish* 1992-3); he has cut out window frames and thrust them inside to be looked at rather than through (*She Came in through the Bathroom Window* 1989); and his adjustments to floors include tilting wooden floorboards sharply upwards and outwards to form an impromptu balcony (*All Mod Cons* 1990). In *watertable* (1994) he dug down to the actual watertable beneath Matt's Gallery and then meticulously filled the trench with a green baize billiard table, its surface flush with the floor and a cement pipe fitted into one corner. However, all these have been temporary interventions whereas *Over Easy* (1999), Wilson's slowly rotating 8-metre disc, which he cut into the facade of the ARC Arts Centre, Stockton, makes his disruption to its fabric a permanent part of the building itself.

During the 1980s, Wilson was a member of the Bow Gamelan Ensemble, a group that staged extravagant live events involving industrial debris as musical instruments, pyrotechnics, steam and even remote-controlled miniature helicopters. Although he no longer gives live performances, Wilson's work continues to invite a very physical participation; a theatrical use of spectacle designed to put one's instincts on alert and to illuminate or destabilise many of the things we take for granted, remains at the core of everything he makes. The use of mundane raw material has also remained a constant theme. When 'tampering' with architecture, Wilson often introduces other commonplace structures into the gallery space, making them perform in highly irregular ways. A domestic greenhouse penetrates seemingly solid partition walls (*High Rise* 1989); a garden chalet is tipped upside

down and tilted on its pitched roof like a discarded toy (*Lodger* 1991); or a kidney-shaped swimming pool is upended, seemingly balanced on its tubular stair rails, its drainage pipe puncturing the roof into the air outside (*Deep End* 1994).

However, Wilson is no demolition man. His works may be constructed in situ rather than in the studio, they may even draw on the imagery of the building site – *Jamming Gears* at the Serpentine Gallery in 1996 comprised forklift trucks, tilted site sheds and core-drilling – but they are meticulously conceived and choreographed with an obsessive eye for detail and finish. As a result, his displacements go beyond the directly physical into more subtle disruptions of inside/outside, public/private, permanent/temporary, secure/precarious, familiar/unfamiliar. Social and historical aspects also play an important part. *Deep End* struck a particular chord in earthquake-prone, pool-obsessed Los Angeles, while the vertically sliced 600 ton commercial dredger that Wilson moored on the shoreline by the Dome (*Slice of Reality*, 1999) provided an elegiac reminder of the shipping that once crammed this stretch of water. In a way that is uniquely his own, Wilson harnesses the epic scope of American 1970s Land art, and, in particular, the architectural sculpture of US artist Gordon Matta-Clark, to produce an art that is intrinsically British but has no limits to its horizons.

NEW VOICES

DARREN ALMOND

b. 1971, Wigan
1991-3 Winchester School of Art
White Cube
Lives and works in London

All art is concerned with time, but Darren Almond is especially preoccupied with its passing. Temporality, whether measured in seconds, minutes, a day, a lifetime, or expressed as a collective memory, underpins his films, objects and installations. In various ways, Almond makes us look at the progress of our existence, how we view the things that take place and how we process what we see and feel. Time becomes a plastic medium in its own right, unfolding in anticipation of an event, assuming the form of a journey from one place to another, or simply passing. Yet, although Almond grapples with the physical and psychological dimensions of time and space, his work manages to express these vast concepts in ways that are surprisingly immediate and straightforward, charged with unexpected emotion.

A Bigger Clock (1997) is just that: a giant 2-metre-long digital clock, the kind you see on station platforms, with numbers that flip over every minute. Installed in a gallery, this scaled-up timepiece becomes an almost overwhelming presence, an intrusive, ominous reminder of the relentless passage of time, with every sixty-second number change punctuating its surrounding space with a resounding clunk. In A Real Time Piece (1995), Almond transmitted a wall-sized projection of the inside of his empty studio via twenty-four-hour live satellite link to a space on the other side of London. Nothing much happened: daylight gradually changed, the digits clicked by on the wall clock. The lack of incident made time appear to slow down, each change of the clock becoming a major, eagerly anticipated event, as well as the only immediate indication of 'real time' passing. HMP Pentonville (1997) at the ICA also broadcast an empty room live to another place – this time an unoccupied cell, accompanied by the cacophonous noise of prison life. Again, nothing happened, but the combination of uneventful, incarcerated

A Real time Piece
1996
Live video
broadcast with
sound
Dimensions
variable

stillness surrounded by continuous deafening sound conveyed a fraught sense of unfolding drama. Beaming a prison cell into an art gallery could be seen as an exploitative act, but Almond avoided this by keeping the emphasis on the space itself, offering, without recourse to a specific inmate, an unforgettable glimpse of what it might mean to be literally 'doing time'.

For Almond, these real-time pieces function more as performance works than videos or installations. They are unique, physically immediate events that exist only for the length of their own duration. While satellite links may be complicated to set up, the emphasis is not on conjuring altered states by technological trickery, which anyone with a television can see on a daily basis. What is important is Almond's framing of time itself, and the way in which

he allows his audience to occupy these very particular scenarios. His live works have much in common with the camera obscura – a device used by artists from Leonardo to Canaletto and Vermeer to project images from the external world into their studios. However, Almond not only uncannily evokes two very distinct places at once, but he also transforms the camera obscura into an artwork in its own right, which he invites the audience to occupy.

Travel is also a recurring theme. As a child, Almond was a keen trainspotter and not only did these hours spent on station platforms instil an early awareness of clocks and timetables, they also provided him with an opportunity to escape – to jump onto a train and be carried away. *Schwebebahn* (1995) is a short, 8mm film that goes on a dreamy journey inside Wupperthal's monorail 'Skytrain', which is suspended beneath the track. Almond inverts the footage so that the train appears to be running 'normally' with the track underneath, until you notice that the lakes and trees are hanging in the sky, and the sky is where the ground should be. This reversal plays on what happens every time any image hits the retina, before the brain turns things the right way up, but Almond adds to the disorientation by reversing the film so that the train goes backwards, accompanying it

with trippy dance music. The second of Almond's train films is *Geisterbahn* (1999), shot in a ghost train in an Austrian fun fair, but slowed down and edited to become something more uneasy than a cheap thrill – a shadowy place where anything can happen. A third 'underworld' train film will be shot in a Russian coal mine.

Another of Almond's films, *Oswiecim March 1997*, consists of a pair of 8mm black and white films, projected side by side, showing two bus stops in Oswiecim, Poland, also known as Auschwitz. One is for visitors travelling from the concentration camp museum, the other is for those who wish to journey further into Poland. No buses come, traffic goes by, time passes, rain falls. The place could be anywhere – but it isn't. Accompanying these two minimal films, and providing a form of emotional outlet amidst their austerity, is a swelling piece of music by Arvo Part, based on the rhythm of breathing. The installation *Bus Stop* consists of the actual bus stops, which Almond first exhibited in a gallery in Berlin in 1999 (he persuaded the authorities to let him have the real bus stops by promising to replace them with his own replicas). In both pieces, with delicacy and economy, Almond reminds us of the actuality of Auschwitz: it is a real place situated in the middle of a functioning town, as well as being one of the darkest words in history. By using something as prosaic as a bus stop, Almond finds a way to engage with an impossible subject that continues to consume us all. Everyone has stood at a bus stop, but here, it is a reminder of the transportations to Auschwitz, the events in Kosovo, and the chilling way in which normality can tip into horror.

That Almond doesn't shy away from emotional risks is especially evident in the three-screen video projection *Traction* (1999), his most explicitly autobiographical work to date. On one screen he interviews his father about all the physical injuries he sustained as a manual worker in England's industrial north. This often excrutiating account of mishap takes us up his father's body from his feet to the top of his head, while the camera remains trained on his face. On another screen his mother responds, sometimes tearfully, to an audio tape of the interview, while on the middle screen, separating them both, the arm of a digger relentlessly gouges into the ground. What emerges is not only a catalogue of often shocking physical damage, but also a complex web of relationships and histories – father-son, husband-wife, worker-boss – a life mapped out by what has been inflicted on a body under the conditions of manual labour in the late twentieth century. All the time, the central piece of heavy machinery digs away, peeling back the layers, acting as a respite from this highly personal narrative as well as a violent reminder of the circumstances in which so many of his father's injuries occurred.

FIONA BANNER

b 1966 Merseyside
1986-9 Kingston Polytechnic; 1991-3 Goldsmiths College
Frith Street Gallery
Lives and works in London

Like many artists of her generation, Fiona Banner makes work that interrogates the nature and impact of the moving image. She is best known for her 'wordscapes' – blow-by-blow accounts of action-adventure movies that take the form of solid, single blocks of text, written on large surfaces recalling the shape and often the size of the cinema screen. Sometimes, as in *Apocalypse Now* (1996) or *Top Gun* (1994), the plot of an entire movie is exhaustively handwritten in pencil, typed, or printed onto a single sheet of paper. *The Desert* (1994) recounts *Lawrence of Arabia* in a vast printed poster over 17 feet long (1994); *The Nam* (1997) is a 1,000 page book, sold as a multiple edition, in which detailed descriptions of six Vietnam movies – all running into each other and typed in capitals – come together in one doorstop volume. At other times she focuses on individual episodes – such as the car chases from *Bullitt* or *The French Connection*.

Banner calls these textual chunks 'still movies' and they recapture in a single static image – one frame – an experience that goes beyond words. She zeroes-in on films or scenarios that rely for their impact on the power of images, and which are therefore the most difficult to convey in words. Her choice of gung-ho movies has less to do with their macho boy's-own qualities than with the way in which they pull out all the cinematic stops to convey a sense of territory along with a high-speed deluge of political and emotional agendas. And although they are written in straightforward language, Banner's text pieces are almost impossible to read. The eye swims over these massive blocks of words, struggling to follow the lines – letters becoming patterns, words fragmentary clumps. 'The Nam: It has been described as unreadable', proclaimed the publicity blurb for the fat paperback.

But these texts evoke the movies they spell out in unexpectedly abstract ways. The wide-angled, illegible expanse of *The Desert* echoes the seemingly infinite, epic spaces of David Lean's movie. *Break Point* (1998), an account of a single chase sequence in Kathryn Bigelow's *Point Break*, is stencilled onto canvas in punchy letters that mirror the unfolding action they describe by becoming progressively smaller and more bunched together until they finally crash into unreadability at the bottom.

Underlying all Banner's work is a fascination with language as a form of communication, the possibilities of words as well as the way in which they so often fail us. 'I've always been interested in the limitation – and the power – of descriptions', she says. *Un********believable* (1995) consists of no words at all, just punctuation marks written in pen across sheets of Formica.

Another abiding interest is the power of the pause. In 1997, Banner exhibited a tiny blue neon *Full Stop*, and more recently she has made a series of sculptures of vast full stops in different fonts. Carved and sanded from white polystyrene – one of the lightest solids in existence and itself a space filler – and named after the fonts they represent, the abstract, freestanding, highly individual forms of *Bell Gothic, Confidential,* or *Korina Kursiv* literally

punctuate the space. In Banner's 1999 solo show at Frith Street Gallery, these were shown with giant pencil drawings of full stops in different fonts – *Avant Garde, Dot Matrix NY* etc. Making a great deal out of nothing, their laboriously filled-in graphite surfaces were part mirror, part black hole. Like Banner's movie remakes, these images occupy a no-man's land, a linguistic limbo that says nothing while speaking volumes.

SIMON BILL

b. 1958, Kingston upon Thames
1977-80 Central St Martins College of Art and Design;
1982-5 Royal College of Art
Modern Art
Lives and works in London

Simon Bill launched his career with large, luminously nasty paintings of cuddly icons gone to the bad. Often painted directly onto brown pegboard

Swarm Form
(Duck/rabbit)
1999
Stonefleck and
blackboard paint
on MDF
127 × 97 × 5 cm

in a combination of oil, tufts of hair and translucent wax, these works represented mutant creatures derived from children's toys or TV programmes as faded ectoplasmic presences, drained of innocence as well as colour, but nevertheless ominously eager to please. In such paintings as *Abbadon the Destroyer* (1994), in which Mr Blobby mutates into a septic spectre with an ejaculating forefinger, or the obscene hovering vagina that is *Mork's Mother* (1996), the contrast between exquisite painterly execution and grotesque unpleasantness goes beyond mere sensationalism to become something highly manipulative and disturbing. The fact that these creatures, trawled from the most banal corners of contemporary culture, nonetheless have a poignant and melancholy delicacy as well as a sense of humour makes them all the more unsettling.

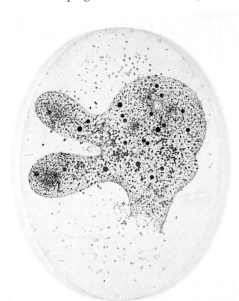

More recently, Bill's deformed Children's Hour characters have been replaced by what appear to be organically abstract forms. Pegboard has been replaced by plywood or MDF, and rather than making scary monsters out of translucent wax encaustic or delicate painterly impasto, Bill now creates blobby biomorphs that flow and undulate like microscopic organisms and emergent universes, using techniques better suited to the DIY enthusiast – or the nursery school. *King Corn* (1999) consists of a knobbly pool of maize seeds clogged in snot-textured PVA; *Ghost of Chance* (1999) is a fragile solar system conjured up out of a few drilled holes and strokes of a marker pen; *Chewy Spongy (Duck/Rabbit)* (1999) is a glutinous concoction of foam-rubber chips, PVA, flexible filler, silicone and woodstain on a base of MDF.

These molten amoeboid shapes recall the wobbly, well-intentioned biomorphism that was so popular with many English painters and sculptors from the 1930s onwards. In their use of improvisational, amateurish techniques, 'natural' muddy colours and suggestive shapes, they wistfull conjure up an idealistic era that believed in the beneficial social effects of abstract art. Yet, while they have much to say on the subject, these are not abstract paintings per se. As with all Bill's paintings, there are often many contradictory

things going on at once. His titles send up easy readings and, unlike his abstractionist predecessors, this artist gives his 'universal forms' conspicuously individual identities. His biomorphs still tug at the collective consciousness, but in ways that can be both lofty and debased. *King Corn* sprouts an impressive pair of globular antlers that could suggest either a primeval deity or a cartoon moose; *Cosmic Dolphin Embryo* (1999) is a suggestively evolving form, despite its daft name and distinctly Flipper-esque beak; the clunkily punning title of *S-Tar Child* (1999) may seem to be a crude reference to the work's debris-encrusted bitumen surface, but this pocked, pitchy expanse bears an unexpectedly poetic resemblance to the night sky.

Bill's blatantly perverse use of clichéd imagery and flagrantly low-rent materials tease at the boundaries of artistic probity and good taste while at the same time demonstrating his skill and relish in dealing with 'abstract' properties of form, tone and texture. In the *Duck/Rabbit* series a bulbous Miróesque form in the grandest of abstract traditions is also a childish visual palindrome that flips backwards and forwards to depict two creatures at once; yet Bill's repeated reworking of the image in often bizarre combinations of substances gives each version a distinct and varied range of readings and references.

These days, the idea of 'pure' abstract form may seem anachronistic and irrelevant, and the pursuit of technique and 'truth to materials' as ends in themselves similarly quaint, but artists are still venturing into this territory and nimbly negotiating its cultural baggage. The dense, tangled web of marker pen wanderings that makes up *A Single Thought* (1999) is at once a giant obsessive doodle pad, a pulsing mass of particles, and a homage to Jackson Pollock's all-over paintings. But it is orchestrated in such a way that it goes beyond being an obsessively abject spin on a time-honoured gestural tradition, to work as a queasily beautiful and richly associative image in its own right. It's no accident that Bill's panels are often oval shaped, and always over a metre high – they are meant to stand in as personages. In Bill's words, 'I'm trying to produce something that is highly idiosyncratic at the same time as being utterly, utterly recognisable. They are still portraits of things, but they're things that are in my head'.

MARTIN CREED

b. 1968, Wakefield
1986-90 Slade School of Fine Art
Cabinet Gallery
Lives and works in London / New York

Martin Creed's art can be so low key it almost vanishes. His limitless multiple *Work No. 88: a sheet of A4 paper crumpled into a ball* (1994) is precisely that, and even though it is crushed into a near-perfect sphere and accompanied by a certificate of authenticity, it is easy to throw away by mistake. It may be similarly easy to overlook *Work No. 79: some Blu-tak kneaded, rolled into a ball and depressed against a wall* (1993) or *Work No. 115: a doorstop fixed to a floor to let a door open only 45 degrees* (1995).

Declaring that he has 'nothing in particular' to say, Creed rigorously strives to find the most limited means with which to say it. There's nothing random or slipshod about his very human brand of minimalism. His self-effacing view of his art can be summed up by *Work No. 143*, a text piece of 1996 stating that 'the whole world + the work = the whole world'. But despite their acute modesty, Creed's low-key spins on our quotidian existence are strangely expressive, asserting themselves in unexpected ways. Seen from the street, a floor of flashing lights (*Work No. 160: the lights going on and off* 1999) becomes something perplexing, even uncanny; there's anger and frustration captured in a screwed-up ball of paper, slapstick humour in a door jammed half open, while words cannot describe the intensely physical experience of being swamped in the ocean of bouncing, popping, squeaking balloons of *Work No.202: half the air in a given space*. This epic sculpture/installation/happening (1999) is an encapsulation of half the cubic air volume of a chosen venue, contained within several thousand party balloons – an insubstantial work that is also overwhelming. It is art that allows the minor to become major and which reminds us that – whether we like it or not – in real life it is the inconsequential that dominates.

For Creed, sound is as important as vision – it's all part of the stuff that surrounds us. Early sound pieces include *Work No.92: a doorbell amplified* (1994); *Work No.97: a metronome working at a moderate speed* (1994); or *Work No.117*, an audio cassette of *all the sounds on a drum machine* (1995). Sometimes, Creed even presents musical scores in their own right, made to be played, such as the deliciously restrained *Work No. 101: for pianoforte* (1994), which consists of middle C, played just once. The musical compositions that

Work No. 88:
A sheet of A5
paper crumpled
into a ball
1994
Paper
Approx 5 cm
diameter

Creed performs both on his own and as part of the rock trio owada, employ the same systematic reduction to the barest essentials. It's not difficult to guess the lyrics of owada songs '1-100', 'start middle end', or '1234', which, with a wry wit, play with standard rock riffs and formulae. But just as his ultra-pragmatic art carries a surprising emotional charge, so Creed's precisely rhythmic music is anything but austere – owada are one of the few art bands you can dance to.

Music is more than just an element within Creed's art: its influence lies at the core of every work he makes. The descriptive certificates accompanying each one function like a piece of sheet music: just as anyone can make music if they read the score, so anyone can make a Martin Creed if they follow the instructions. As with music, there is both leeway for individual

interpretation and a rigid set of rules to be adhered to. Any piece of furniture the right size and placed the correct way, for example, could become *Work No. 142: a large piece of furniture partially obstructing a door* (1996).

Not only does Creed encourage his work to make itself, he also likes it to cancel itself out. This seemingly perverse desire to make both something and nothing can manifest itself formally – as in his 1994 *Work No 99: an intrusion and a protrusion from a wall* – while it also allows his bursting balloons, his binned balls of paper, his buzzing door bells and flashing lights to dip in and out of the world at large. For Creed's art is both about and made from the reality of the environment we all inhabit, where options are open, decisions are difficult and the commonest things can have the most profound impact. When, in his most permanent and conspicuous work to date, he writes in white neon *EVERYTHING IS GOING TO BE ALRIGHT* (*Work No. 203*, 1999) across a ruined building in one of London's lowest income areas, he means just that – but exactly what it signifies is up to you.

ANGELA DE LA CRUZ

b. 1965 La Coruña, Spain
1985-9 University of Santiago de Compostela, Spain; 1991-4
Goldsmiths College; 1994-6 Slade School of Fine Art
Anthony Wilkinson
Lives and works in London

Angela de La Cruz gives her works a hard time. Since 1994 she has been making what she calls 'everyday paintings', which start off life conventionally enough, as monochrome abstracts, built up in layers of oil on canvas and then stretched on wooden supports. Then all hell breaks loose. She smashes their stretchers, rips their surfaces, frays their edges and crumples them into strange shapes. The coolly meditative, inscrutable spirituality of Minimalism is irrevocably shattered, and the results of this collision with rude reality are crammed into corners, propped saggily against walls, squeezed into unsuitable spaces, or even pinned down by chair legs. In another life they may have belonged on a wall, but they rarely make it back there.

De La Cruz is fully conscious of the Modernist – not to mention macho – baggage that any monochromatic canvas drags behind it. Yet her works do more than cock an irreverently destructive snook at artistic traditions and this is not simply a feminist trashing of monastic painterly purity. Although they could be seen as performance pieces, they also go beyond beating the action-painting boys at their own game. By destroying her paintings, de La Cruz embues them with new life, transforming them into 'painting-objects' with their own powerfully human identities. 'All my work is activated by human experience', she has said. 'My paintings are figurative objects.'

These painterly personages occupy three-dimensional space, fold fleshily in on themselves and engage in personal relationships both with the viewer and each other. Psychologically, as well as physically, they are damaged goods. Theirs is an apologetic existence. *Homeless* (1995) crumples uncertainly into a corner, its canvas partially pulled off a snapped stretcher and its pristine white surface tainted by a covering of urine-yellow varnish. *Self* (1997) reclines uncomfortably in a grungy chair, its snapped sides resting on the arms while it faces its unscathed double hanging on the wall. In *Bully* (1997), a massive, dark brute of a canvas squashes a smaller one into oblivion. All this anthropomorphism could become insufferably whimsical were it not for de La Cruz's skill in manipulating her canvases into abject, emotionally charged presences. They always remain recognisable and

Falling on your
own butt
1997
Oil on canvas
4 parts, each
60 × 60 × 8 cm

convincing as paintings, while colour, texture, scale, form and positioning combine to ensure that each piece exudes its own distinct personality.

Larger than Life (1998) was made specifically for the Ballroom of London's Royal Festival Hall. As well as being one of the largest oil paintings ever made, this 14 × 10 metre behemoth is also one of the most pathetic. What should have been monumental and awesome turns out to be quite the opposite. Wedged uncomfortably between the pillars in an open-plan space, most of its middle lying flat on the floor, it was a vanquished Samson, without even a wall to lean against, let alone to hang on. Adding to its embarrassment was its nasty shade of fecal brown – not helped by exhaustively applied coats of varnish, which made the oil paint look even more sticky and unsavoury. The Herculean effort required simply to bring this thing into existence only contributed to its air of inadequacy. At the time, de La Cruz described the painting as 'too big for its boots', and it was the very fact that it had come such a cropper that made this monster painting such a spectacular success.

De La Cruz is one of several young artists currently reworking the objective techniques and conventions of abstract painting in ways that are unashamedly emotional. Alexis Harding describes the puckered membranes of oil paint that slip and slide off the surfaces of his works as being as much about human relationships and portraiture as the result of his mechanical device. This involves pouring gloss paint through a perforated trough onto another paint-covered surface and letting the different kinds of pigment dry. Jason Martin rakes his thick oil surfaces with a variety of homemade combs until he hits the right striated gesture to create what he describes as a 'physical and psychological map'. The works of both owe much of their impact to the seductive materiality of paint itself. By facing up to the futility of the search for a completely new painterly language, de La Cruz shows that the possibilities of paint are by no means exhausted.

JEREMY DELLER

b. 1966, London
1985-8 Courtauld Institute of Art; 1991-2 Sussex University
Cabinet Gallery
Lives and works in London

Throughout the twentieth century – and into the twenty-first – artists have used sound and music to extend their work, engage with modern life and tap into new audiences. Italian Futurist Luigi Russolo deafened audiences with his cacophonous 'orchestra of noises' in 1914; the Dadaists made a fearful din at the Cabaret Voltaire, and Warhol engaged in multimedia collaborations with the Velvet Underground in the 1960s. These days, an increasing number of British artists play in a band of some kind – whether Angus Fairhurst's Lowest Expectations, Martin Creed's owada, Georgina Starr's Pony and Dick Donkey's Dawn, or Big Bottom, the all-bass line-up of Cerith Wyn Evans, Tom Gidley and Angela Bulloch. But none have so far achieved such total immersion in the world of pop music as Jeremy Deller. And he doesn't even play in a band.

He has, however, involved himself in the music of others to make art that, both in its production and its presentation, manages to be genuinely democratic. For *Acid Brass* (1997), Deller contacted Stockport's Williams Fairey Band, persuading them to abandon their usual brass band repertoire for a selection of classic Acid House anthems. The unforgettable, euphoric experience of hearing one of Britain's top brass bands playing the likes of 'Voodoo Ray' and 'What Time is Love' quickly won a large following in performances all over Europe and the UK – most notably when Deller joined up with KLF for their 'Fuck the Millennium' comeback in London's 3,000 seater Barbican Hall. To date, Deller and the Williams Fairey Band have released two CDs, been reviewed in the *NME*, and appeared on breakfast television, and Acid Brass scores can now be bought at any music shop.

For all its crossover success, Acid Brass was always more than a novel idea. It was a way of bringing together what Deller considers to be 'the two most important social phenomena of the last fifteen years': the Miners' Strike of 1984-5 and the advent of Acid House. He also wanted to show that these two seemingly incompatible areas of British culture actually have a great deal in common. 'At its most extreme, Acid Brass is as much about the kick of a policeman's boot as the kick of an 808 bass drum', Deller has declared, and to prove his point, he made *The History of the World* (1997), a

I Love
Joyriding
1996
Bumper
sticker and
police car

diagram that maps out, in doodled flowchart style, the cultural Spaghetti
Junction linking House to brass bands, via such routes as 'Pit Bands–
Deindustrialisation–Warehouse Parties–Sound Systems', or, going the
other way, 'E-media hysteria–The Miners' Strike–Return to work'.

Similarly, Deller's various projects around the Manic Street Preachers
use their music to throw up more insights into the often unexpected connec-
tions between fine art, folk art and popular culture in today's Britain. *The
Uses of Literacy* (1997) was an exhibition of artworks and memorabilia made
by Manics fans, sent to Deller in response to an advertisement he had
placed in the band's fanzine, *Spectators of Suicide*. These paintings, drawings,
poems and writings, along with one fan's shelf-full of suitably intense
Manics-recommended books – Sartre, Plath, Levi, Camus – were exhibited
in Norwich and London and then travelled throughout the UK as part of a
Hayward Gallery touring show. This not only gave rare gallery exposure to a

rich vein of hitherto disregarded British
creativity, but also attracted enthusiastic
young audiences of Manics fans to step
inside an art show, often for the first
time.

Deller's most ambitious shake-up of
cultural categories and norms was
Unconvention (1999), an exhibition at
Cardiff's Centre for Visual Arts of
paintings, photographs and artefacts,
selected on the basis that they had
influenced and/or been referred to by The Manic Street Preachers. Major
works by artists as diverse as Francis Bacon, Pablo Picasso, Jackson Pollock,
Andy Warhol, Lawrence Weiner, Don McCullin, Jenny Saville, the
Situationists and Willem De Kooning, many of which have never been seen
in Wales before, came together in unexpected relationships completely
beyond typical curatorial considerations. At the opening weekend, the show
lived up to its name when the gallery was transformed into a bizarre conven-
tion-cum-fresher's fair containing stalls set up by a multitude of organisa-
tions reflecting both the band's concerns and Wales' local and international
perspective. These ranged from Manics fanzines to Campaign Against the
Arms Trade, with special appearances from, among others, Emyr Lewis,
Bard of Eisteddfod, and Arthur Scargill, President of the National Union of
Mineworkers, who delivered an impassioned indictment of capitalism in
front of a case of relics from the Spanish Civil War.

Both in the art gallery and out on the street, Deller intervenes directly and often subversively in real life, working with others to make his mark. He has achieved this through such strategies as his *My Booze Hell* t-shirts (1995), as worn by Robbie Williams on MTV, or his *I Love Joyriding* stickers (1996), which he stuck on the bumpers of flashy motors – and even a police car – in Middlesbrough, the capital of that activity. But, unlike many other artists who attempt to intervene in the wide and murky waters of so-called 'popular culture', Deller manages to do so without being either exploitative or patronising. In 1996, he printed snatches of lyrics by The Smiths, The Happy Mondays, The Stone Roses, to resemble the cheaply made religious posters quoting extracts from the Gospels that one sees outside churches in cities throughout the UK, doing so because he believed in what they said. 'The quotes are moral, about redemption, loss, love, the whole gamut of human emotion. Religion doesn't have a monopoly on these values', he said. Neither an objective observer nor an ironic appropriator, Deller is an eager enthusiast and participator – in short, he's a fan.

RACHEL LOWE

b. 1968, Newcastle-upon-Tyne
1987-90 Camberwell College of Art; 1992-3 Chelsea College of Art
Lives and works in London

For over a hundred years, the camera has been used as a miracle machine, to manipulate time, to record or capture a particular moment. Whether she is using her own films, working with pieces of found footage, or borrowing other people's snapshots, Rachel Lowe gears her work around the plethora of still and moving images that document and define our history, memory and experience. Often combining high- and low-tech media – digital video, slide projections, painting, drawing, photocopying or Super-8 – Lowe manipulates and explores the seductive pull of these images and the way in which they operate in the increasingly confused territory that lies between experience and its representation.

The slide projection *Carousel* (1999) presents two chronological series of photographic archive images selected from each year from 1918 to 1998. However, it is almost impossible to pin down what is being shown, since these pictures come from a wide range of sources – historical events, film stills, book plates, personal photographs – with any attempt at identification

further thwarted by the way in which all the figures have become blacked-out silhouettes. What originally had a highly specific reading is now a generalised pictorial type, recognisable but not identifiable, with each turn of the carousel a reminder of the repetitive relentlessness of history and how partial our understanding of it is. Because one of the two projectors is set at a faster speed, the combinations of images on the adjacent walls are always different, open to unexpected, speculative and interconnecting narrative readings. To add to the ambiguity, the shadows of the audience join the life-sized silhouettes on each wall to become part of the action. In *Untitled Ohio* (1999), there is yet more confusing of preconceptions: the silhouettes of a group of figures that gather round a single, prone form recalling the dead Christ (in fact a student shot by a state trooper in the Kent State University riots during the Vietnam war) are actually painted in flat black onto the wall, their surroundings beamed in by a super-8 projector – a piece of equipment normally associated with a moving image, not a static one. Again, the shadow if the viewer is inserted into this mysterious frozen event, part history, part art history.

Much of Lowe's work expresses our futile striving for certainty and resolution. In the video *65 × 65* (1996), it is both mesmerising and excruciating to watch a hand trying again and again to pin down with black marker on a TV screen the image of two racing cars repeatedly turning the corner of a track. Similarly, in *A Letter to An Unknown Person* (1995-8), a life-sized hand frantically attempts to draw on a car window the outline of what is whizzing by outside, only to create a meaningless tangle of lines that blots out the very landscape it was trying to duplicate. In *A Rough Outline of the Plot* (1996), it is only when, for a split second, a hand holding a gun marries up with its drawn outline on the TV screen that the meaning of the strange squiggles there become evident. But immediately the action on the screen fits the drawing, it cuts out, and you're back at the beginning of the loop, surveying an elderly Chinese man wallowing in a swimming pool. With each repeat, the feeling of powerlessness and impending doom increases. Although you never see the gun fire, it is obvious that the outcome does not bode well. It is not necessary to recognise the sequence from John

Cassavetes' *The Killing of a Chinese Bookie* (1976), just as knowing the origin of *Untitled: Ohio* or any of the scenes in *Carousel* are not integral to understanding these works. A large untitled projection of 1998 shows a filmic fragment of a woman viewed from above, who jerks and twists in agitation and fear. The fact that this is a two-second sequence from Hitchcock's *The Birds* (1963) is neither here nor there – what matters is that Lowe has manipulated this short clip forwards and backwards at full speed and half speed, with multiple edits in between, to create one and a half minutes of what appears to be real time, which is then looped onto a one-hour tape. In doing so, she has created a new piece of time, an image stuck forever in its eternal present. In the same way, *South of the Thirty First Parallel* (1999) presents a piece of grainy black and white film in which a woman in turn-of-the-century clothes perpetually walks up and down a domestic staircase. Again, images are not what they seem: this apparent vintage found footage has in fact been shot by Lowe herself and made to look old through digital manipulation.

Lowe's work reminds us that we are so hungry for what images can tell us, we need little information to construct elaborate stories around what we see. *Elizabeth* (2000) is another series of projected images, this time using black and white family snaps of ordinary people from the 1940s and 1950s, found in car boot sales. Each of these has been divided vertically into three, the middle section removed and the two side sections moved together and rephotographed. Deprived of their identifying characteristics, these strangely filleted images take on a mysterious new life of their own, especially since Lowe has organised them chronologically to suggest the passage of an individual life – the 'Elizabeth' of the title – beginning with baby pictures and progressing to old age. The fact that each of these denuded images once meant something to someone poignantly underlines our reliance on photo-graphs as a means of remembering, of hanging on to the past – a past that we eventually recall as photographs rather than the actual events they record.

PAUL NOBLE

b 1963 Northumberland
1983-6 Humberside College of Higher Education; Sunderland
Polytechnic
Maureen Paley / Interim Art
Lives and works in London

Nobspital
1997-8
Pencil on paper
250 × 150 cm

At some point in their careers, most artists find themselves becoming rather too well acquainted with the social security system, but few turn the experience into art. Paul Noble's board game *Doley* (1995-6), 'a game for three or more players over the age of sixteen', does just that, by immersing its players in the pitfalls and problems of life on income support. What initially appears to be a wryly humorous version of Monopoly, unfolds into biting satire in which Noble not only takes a swipe at the realities of Britain's welfare state – *Doley* is a nihilistic game for losers, where skill is pointless and players struggle fruitlessly for survival – but also exposes some of the less appealing elements of the male psyche. In order to take part, players must don daft costumes and props and assume the identity of one of five characters – Aimless, Formless, Ineffectual, Oblivious and Burnt Out.

These abject, amoeboid characters, whose names and amorphous blob-like appearance reflect the overall mood of hopelessness, are further explored in a series of laboriously meticulous pencil drawings that use a comic-strip format to present their slacker activities and often depraved masturbatory fantasies. At once funny and grotesque, savagely satirical and amiably cackhanded, drawings such as *Meet Ineffectual (2)* or *Last Orders* (both 1995-6) use a deliberately nerdy amateur style that gives the world of *Doley* a good-humoured pathos, camouflaging some of its more repellent qualities.

There are no inhabitants in Noble's ongoing creation *Nobson*, a fantasy town, which he has been creating in obsessive detail since 1996. In fact, it would be truer to say that the town inhabits the artist, since it is the world inside his head. Made up of buildings owing their forms to a special typographic font that also spells out their names, it is described by Noble as 'town planning as self portraiture', yet it is no idealistic piece of megalomania. In true Noble style, it is a melancholy, dystopian place with a swampy 'uncentre' whose twin mottoes are 'No style, only technique. No accidents, only mistakes'. Various aspects of this desolate metropolis continue to generate a rich range of artworks in a wide variety of media. There are giant pencil-drawn panoramas of particular places such as *Nobslum* (1996) or *Nobjobclub* (1998) and a guide book called

Introduction to Nobson Newtown (1998). One installation, *Welcome to Nobpark* (1998), has even recreated part of Nobcamp, with a computer-generated woodland wallpaper backdrop, sinister, smiling wildlife, and a folded geometric tent looking ominously like a body bag.

Even when he's using new technology, Noble is at pains to make his work look dysfunctionally handmade. The bunnies, squirrels and owls may inhabit a panoramic laser print of Nobcamp's gloomy sylvan glades, but their faces have been altered with marker pen, and Noble's drawings continue to be nerdily over-detailed, like those of an obsessive adolescent. As far as he's concerned, the less his work looks like 'art', the more it communicates. 'Both *Nobson* and *Doley* are self-consciously anti-avant garde', he claims. 'It's almost like I've spent the last five years being retarded in a way – I didn't want to make work that looks new or challenging.' Like many artists currently working in Britain – Grayson Perry and Martin Maloney for example – Noble is well aware that seeming naiveté provides an effective smokescreen for qualities that are quite the opposite.

TIM NOBLE AND SUE WEBSTER

Tim Noble: b. 1966, Gloucester
1986-9 Nottingham Polytechnic; 1992-4 Royal College of Art
Sue Webster: b. 1967, Leicester
1986-9 Nottingham Polytechnic
Modern Art
Live and work in London

In 1994, with a series of flyposters that appeared on streets throughout London, Berlin and New York, Tim Noble and Sue Webster announced the arrival of a new double act in town. Entitled *Hijack*, the posters bore images of their own faces, crudely superimposed over those of the world's best-known artistic duo, Gilbert and George, along with the slogan 'Tim Noble Sue Webster: The Simple Solution'. Since then, Noble and Webster, who met at art college in Nottingham and have lived and worked together ever since, have continued to make their dual presence felt in attention-grabbing artworks that both work with and send up the high media profile and cultish

The New
Barbarians
1997-99
Glass-reinforced
plastic,
translucent resin
plyboard,
fibreglass
114 × 84 × 71 cm

mythologising of so much of today's contemporary art and artists.

As far as Noble and Webster are concerned, impact is all, and permanence is not a major concern. Their pieces can be as much event as artwork: in 1997 they literally made their mark by covering many of the major players of the London art world in tacky felt-tip tattoos (*Tim and Sue's Handmade Tattoos, Livestock Market*), and hosted a memorable one-nighter at the Chisenhale Gallery, which turned the likes of Sarah Kent, Tracey Emin, Gillian Wearing and Sarah Lucas into DJs, as well as providing some extremely rude food (*Turning the Tables*). When Liam Gallagher and Patsy Kensit appeared under their Union Jack duvet on the cover of the 'Cool

Britannia' issue of *Vanity Fair*, it provided an irresistible opportunity for Noble and Webster to seize their slice of the celebrity couple action by putting their own less famous faces over rock's first couple in another deliberately cackhanded photomontage *London Swings*, 1997.

Sometimes, however, Noble and Webster prefer a more stealthy approach. *Dirty White Trash (with Gulls)* (1998) is a giant pile of their accumulated household rubbish, which, when lit by a slide projector on the gallery floor, appears to cast a perfect, strikingly recognisable shadow portrait of the pair onto the white wall. As any dustbin-scouring fan will affirm, the right celebrity provenance can transform the most repellent detritus into priceless relics, and here the shadowy presence of the artists is literally conjured up by their leftovers. Sitting back to back, they relax contentedly, he smoking, she drinking champagne. What looks random is in fact meticulously orchestrated, what seems rancid is a romantic labour of love.

Notions of permanence, immortality and pair-bonding are given a very different form in *The New Barbarians* (1997), a fibreglass reconstruction of two Australopithecines (early relatives of Homo Sapiens), which have been meticulously copied from a pair of models in New York's Natural History Museum and then overlaid with the facial features of the artists. These uncannily recognisable prehistoric dopplegangers are both alien and

familiar, aggressive and loving, skinheads who are rendered more vulnerable by their lack of hair. Here, the artist is billed not just as alien, but as the precursor of the human race. After all, civilisations are assessed by the artworks they leave behind. There is romance in this piece too. Based on evidence taken from 3.5 million year old footprints, both the New York figures and Noble and Webster's version walk side by side, the male arm touchingly encircling the female shoulder.

'We've always been interested in making work that is constantly restless, never static and could transcend itself to become something else', says Noble. 'That's why we like working with light, because it spreads itself everywhere but you can't put your finger on it.' Not only have they used light to animate their 'rubbish' portraits, but they also employ the quick-hit impact of coloured light in sequenced text pieces such as the giant punning *Vague Us* (1998) in which the words light up, letter by letter, in white bulbs backed by a flush of red neon; or *Walk on Water* (1998), which flashes out the letters 'WOW' in various colour combinations. Embracing brashness and bad taste, they pile on the illuminated excess in works such as the orgiastic flashing fountain, over a metre in height, entitled *Excessive Sensual Indulgence* (1996). However, just when it looked as if they were simply introducing a skewed tourist's-eye view of Blackpool's Golden Mile or Vegas' Caesar's Palace into the art gallery, Noble and Webster downscaled to a minimal white Robert Rymanesque panel (1998), which spells out in a twinkling strand of fibre optics, *We only Wanted to Be Loved*.

GRAYSON PERRY

b. 1960 Chelmsford
1979-82 Fine Art Portsmouth Polytechnic
Laurent Delaye
Lives and works in London

Some artists may use it as a playful sideline, but pottery is not a medium usually associated with contemporary or even fine art; that is precisely why it is so appealing to Grayson Perry. He describes himself as 'a self-confessed hater of contemporary ceramics who only keeps on using clay because pottery is held in such low esteem in the art world'. His pots and vases both subvert and play off conventions of art and craft in order to launch a more general assault on British culture, class, sexuality and taste.

Boring Cool People
1999
Earthenware
63 × 27 cm

In both form and content, Perry's pieces are designed to provoke, perplex and offend. From a distance they appear to be handsome, classically shaped vessels, richly patterned, interestingly textured, and glittering with coloured and metallic glazes. But close up, these impressive funerary urns, luxurious Oriental-style jars and giant vases teem with obscene scenes of perversion, mutilation and depravity – where no one, not even Perry himself, is spared. *Me Wanking Off* (1996) measures in at nearly a metre and would look at home on a country house mantelpiece – until you notice that the gold motif on its lid is a howling naked gremlin and its richly glazed and lustrous surface is etched with scenes of the most appalling sado-masochism, elegantly spliced with the cheesiest commercial transfers of roses, country cottages and willow-pattern chinoiserie.

Perry learnt his ceramic skills at evening school and cherishes his amateur status as one of his most effective weapons. Although he has been making ceramics for well over a decade, he rejects the reverential rituals surrounding the potter's wheel and persists in the beginner's technique of building up his pieces coil by coil, or slab by slab. His pots may have become increasingly showy, but their combination of elaborate decoration and clumsy wonkiness flouts the potter's traditional quest for perfection, as do their overcrowded surfaces, which combine childish incised graffiti and tacky transfers with time-honoured techniques of *raku*, painted slipware and sprig moulding. Modestly sized, shakily executed early pieces such as the ornamental plate *Our Power is in Fun* (1987), both parody and undermine domestic folksiness and craft-shop gentility in their fusion of olde English techniques and motifs, cryptic slogans and crude cartoonish drawings that embrace every taboo in a parade of gun-toting babies, satanic rites, multiple dismemberments and knife-wielding hermaphrodite housewives from hell. Conflicting visions of Albion continue to collide in large pots such as the squat bulk of *Sunset Through Net Curtain* (1996), whose surfaces heave with a multicoloured welter of petrol stations, wild flowers, deviant sex and kitsch transfers of hunting scenes, watermills and Gainsborough ladies.

Perry spreads his invective far and wide, but a constant theme is his Essex

background, which provides a stream of outrageous and often hilarious vilification of all things British and 'normal', and regularly features Perry's transvestite alter ego Claire, whom he describes as 'a forty-something in a Barratt Home'. Another longstanding target has been the art world, and here Perry persistently bites the hand that feeds him, only to watch it inevitably come back for more. In the 1980s he mocked his audience with plates emblazoned with sales pitches, and titles such as *Exportware* (1985) and *Boring Cool People* (1999), and his attacks on the current art scene have increased in proportion to his success within it. *Oiks, Tarts, Weirdos and Contemporary Art*, and the Japanese-style lidded vessel *Who Am I?* (both 1996), for example, zone in on the confessional theme of so much recent contemporary art. Yet, on display in a fashionable London gallery, Perry's satirical pots veer ominously close to becoming the very thing they seek to undermine, and he has to be on his guard that his art attacks don't become indistinguishable from their targets.

It is perhaps for this reason that Perry is also embarking on another undervalued craft activity: embroidery and appliqué. *Costume for the Mother of All Battles* (1997) looks like an Eastern European peasant outfit with its brightly decorated skirt, shirt and bolero waistcoat, but a closer look at the schematic decorative details reveals what nationalism is capable of unleashing as a bus explodes inside a Star of David, a soldier with an erect penis shoots a baby, a pregnant cruciform figure is contained within a flaming fighter plane. *Tree of Death* (1999) is a quilt devoted not to commemoration but to causes of death, with images of guns and atom bombs, intravenous drug use and anal sex all buried in its cheery chintz. Another twist is that, in spite of their folk-art appearance, the designs on all Perry's quilts and garments are computer generated, and mechanically stitched. Whether using fabric, or his vexed vessels, Perry's scatological satire walks in the footsteps of Hogarth and Gilray and, by piling on the parody and horror overload, forces us to accept some uncomfortable truths.

MICHAEL RAEDECKER

b. Amsterdam 1963
1985-90 Gerrit Rietveld Academie, Amsterdam;
1993-4 Rijksakademie Amsterdam; 1996-7 Goldsmiths College
The Approach
Lives and works in London

Out Take
1999
132.5 × 188 cm
Acrylic and
thread on linen

It is a time-honoured art-historical tradition that real men don't sew. But an increasing number of young male artists are bringing their own agendas to the activities of stitching, snipping and knotting, whether Grayson Perry's perverse forays into embroidery and appliqué, Simon Periton's subversive doilies, Steven Gontarski's hand-sewn PVC figures, Enrico David's giant androgynous forms embroidered on canvas, or Yinka Shonibare's works made from batik-style printed cotton, produced in Europe for the African market. Michael Raedecker goes one step further: he commits the ultimate artistic taboo of combining thread and paint to produce sombre-coloured, uncannily atmospheric landscapes, interiors and portraits in which sewn fabric is made to function in as many diverse ways as painted surfaces.

Raedecker declares that he 'is always trying to find different means for using the thread' and a single canvas may accommodate knotting, tufting

and embroidering in an intricate combination of yarns, a single piece of cotton, used to 'draw' a line, or pieces of wool stuck directly onto the surface to produce an impasto-like appearance. *Mirage* (1999), the work that won Raedecker the John Moores 21 painting prize, uses sequins, Lurex and yarns of different shades and thicknesses to present a desolate landscape in which bobbly, regularly stitched tree trunks are given fluid, painted shadows, while the reflective liquidity of water pools are described in even lines of cotton. Grey boulders scattered around this empty, chilly scene look almost like stuck-on collage, painted as flat marbled surfaces with no volume whatsoever. A clotted, knotted, tangled mass of greenish brown thread in the bottom left-hand corner is reminiscent both of ominous undergrowth and nasty 1970s furnishing fabric. On other occasions, Raedecker's paint can be translucent (sometimes with wisps of fun fur trapped beneath its surface), crackled, or pushed through holes in the canvas in a fringe of worm-like strands resembling the pile of a rug. Sometimes, as in the bird's-eye landscape *up* (1999), he persuades stems of paint to stick out at 90 degrees.

Yet while he can achieve an ambiguous cross-dressing of paint and fabric, Raedecker's mastery of his hybrid medium goes beyond trompe l'oeil. His concerns are as much atmospheric as optical and he's increasingly adept at drawing on the tension between distancing objectivity and the obsessively

hand crafted. Skill is a means to an end, never an end in itself, and the strange chemistry between Raedecker's paint and thread staves off any cosy connotations of home handicrafts. In any case, if there's the threat of too much needle-wielding accomplishment, Raedecker tends to throw a spanner in the works. The bulky stitching of the window frames in *Out Take* (1999) is at jarring odds with the stunning sewn depictions of the glass panes; while what looks like a loopily rendered tree branch could just as easily be an aberrant artery or a river seen from the sky.

Raedecker first trained as a fashion designer, serving an apprenticeship with ultra-radical designer Martin Margiela. However, although it gave him a useful insight into the properties of thread, it was not the rag trade that encouraged Raedecker to take up the needle. For this development, he bizarrely credits the work of Winston Churchill. Raedecker had already jettisoned the world of fashion for a more contemplative career in fine art when he came across Winston Churchill's essay, 'Painting as Pastime'. 'I thought it was honest and sincere – and I liked the idea of art being a pastime. That's how I decided to use embroidery. To begin with I photographed Churchill's paintings and then embroidered all the details about each painting – the date, the title and so on – on top, in threads that exactly matched the colours of the work.'

These days, Raedecker's images are his own, and his colours are drab for maximum interpretive potential. 'If I used bright colours it would be more about the paint, and less about feeling.' His paintings have much in common with the cinematic scenarios of Peter Doig, in which the hokey is often charged with an intense sense of unease. Though both artists eschew a specific storyline or message, their work pulsates with narrative possibilities. In Raedecker's hands, the most innocuous modernist interior or hotel room is blighted by oddly ambiguous textures and invasions of thread that seem to grow out of the surface. *Guarantee* (1998) presents an anodyne hotel room whose dank pink bed covers and curtains are the stuff of nightmares, while the knotted beige expanse that spreads across the floor of *The Practice* (1998) is organically and almost obscenely at odds with the crisp abstract squares of picture window, wall and block of curtain – but then again it could just be an enthusiastically rendered shag-pile rug.

Since 1998, Raedecker has also been producing intricately stitched heads of sombre old men who stare directly out at the viewer – part portrait, part mug shot. Raedecker calls these small-scale works *Tronies*, a seventeenth-century Dutch term for a type of picture somewhere between a portrait and a history piece in which the sitter is portrayed in a particular role, often

complete with appropriate clothing and attributes, but whose identity is irrelevant. On occasion, as in some of Rembrandt's *tronies*, the model can be the artist, but the choice of sitter is arbitrary – they are types rather than individuals. Like Raedecker's rooms and views, these pensioners present a mass of meticulously stitched detail: neckties, cardigans, wattle chins, flecks of dandruff, but they tell us nothing specific. Instead, they offer themselves up for viewers to occupy.

TOMOKO TAKAHASHI

b. Tokyo, Japan 1966
1985-9 Tama Art University, Tokyo; 1990-4 Goldsmiths College;
1994-6 Slade School of Fine Art
Hales Gallery
Lives and works in London

There's nothing new about creating art out of everyday junk. Whether Duchamp's readymades, Schwitters' *Merz* works, Warhol's cans and wrappers, Robert Rauschenberg's 'Combines', or the fragile flotsam of Arte Povera, artists have been scavenging for materials for a century. These days, the garbage-collecting tendency seems to have gone into overdrive, as artists find increasingly inventive ways to demonstrate the transformative powers of art by utilising what society slings out. Tim Noble and Sue Webster create silhouetted self portraits out of accumulated trash; Ian Dawson blow-torches plastic goods into molten abstract sculptures-cum-action paintings; Mike Nelson makes richly metaphorical environments out of found junk; not to mention the clutteramas of US artists Jason Rhoades and Cady Noland, or the simulated studios and store rooms of Swiss partnership Fischli-Weiss, where the junk shows up as lovingly refabricated, carved and painted polyurethane. However, in Tomoko Takahashi's installations, the rubbish remains emphatically rubbish. Huge tides of the stuff engulf walls, floors and often ceilings, threatening to take over completely.

Line Out (1999) transformed the Saatchi Gallery into an extensive land-scape of defunct technology, its floor-bound islands of flickering junk fed by power cables looping from the ceiling in a spectacular act of sabotage against the imposingly minimal, massive white space. In an earlier version (*Untitled* 1997), in London's Beaconsfield Gallery, the existence of thirty-five power points set into the floor inspired a whirring, humming appliance-fest in

Studio Work
1999
(detail)
Mixed media
Installation at
Entwistle, London
Photo: Stephen White

which working radios, TVs, videos and projectors borrowed from Takahashi's friends were corralled into squared-off zones and steeped in tangled masses of snaking cable. For *Info Only* (1998) at London's Tablet Gallery, Takahashi spent months retrieving the materials discarded by construction workers, which she then reintroduced into the brand new gallery space.

Takahashi's work is what it is; but initial appearances are deceptive. What may seem random and chaotic, as if created by a force of nature, is in fact meticulously considered and arranged. Amidst epic masses of garbage, she zeroes-in on certain objects, which are delicately manipulated to assume new guises, and which can yield up unexpected or bizarre narratives. Turned on its side and accompanied by a cartoonish 'sound blast' of wall-mounted black plastic ties, an orange traffic cone in *Info Only* became a megaphone barking out orders; the zoned clusters of glowing, blinking electronic gadgets of *Line*

Out underwent a weird macro/micro-scale flip to resemble either an aerial view of a nocturnal metropolis, or a giant circuit board gone berserk.

While it could be tempting to read this obsession with manufactured objects as a symptom of Takahashi's upbringing in Japan's consumer boom, her practice has as much to do with process as product. She describes her installations as 'visual music' in which 'many simple elements have to be mastered to make up an incredibly complex figure', and where improvisation is underpinned by rigorous discipline. It is this sense of orchestration that allows these inanimate objects to express oddly individual personalities, while keeping any whimsical anthropomorphism in check. There's a strong performative element to all this ritualised sorting and the work owes much of its impact to Takahashi's intense, even emotional, relationship with her subject matter, its context and its origins. 'For me, each place has its own natural music, which is pre-composed by its inhabitants', she says.

While Takahashi's pieces tend to be governed by her relationship with a location, they are allowed to evolve into self-contained environments, with their own idiosyncratic rules and logic. When she was commissioned to make an artwork for the offices of a marketing company (*Company Deal*, 1997), Takahashi engulfed their pristine offices in rubbish accumulated over

six weeks, but with every image and piece of text meticulously obliterated. In *Authorised for Removal* (1997), she redeployed the obsolete contents of a disused police station with both virtuoso flamboyance and forensic delicacy to splice the violated essence of a crime scene with the precision of a laboratory.

Whenever possible, Takahashi lives on site whilst making her works, and the evidence of this remains. For *Info Only*, the fold-up bed and sleeping bag she used for two weeks was incorporated into the elaborate arrangement of plans and builder's debris that she smothered over floor, walls and ceiling. At Beaconsfield, her wall-mounted alarm clock, with its painted halo of 'ringing-bell' zigzags, was testament to three weeks of sleeping on location. At the Saatchi Gallery, Takahashi deliberately left reminder lists and notes to herself and others written on the white walls. Executed with no preconceived plans, this high-risk, often frenetically intense improvisation gives her work its edge. 'I don't make any drawings beforehand', she says, 'they come at the end, to record what I have done. There is always a kind of story – I set up a basic kind of background and then start imagining things – it's incredibly personal'.

While her installations continue to be essentially site specific, lately Takahashi has been finding new ways to work with her surroundings. At Lift Gallery (*Untitled* 1999), she not only arranged heaps of debris from the space's former life as a design agency, but also inserted annotated photographs, which she had taken of the piles of junk before she started sorting it. *Project Space* at Entwistle (1999) saw Takahashi cutting, pasting and manipulating her photographs of other works into sculptural objects and even pieces of furniture to became a personal form of two- and three-dimensional collage. With *word perhect* (2000), Takahashi entered yet another dimension by producing an online parody of a word processor, which, with a characteristically ambivalent attitude to technology, replaced the ordering structures of existing computer programmes with her own quirky version.

KEITH TYSON

b. 1969 Ulverston, Cumbria
1989-90 Carlisle College of Art
1990-3 University of Brighton
Anthony Reynolds
Lives and works in London

These days, a signature style is an option rather than a requirement for artistic success. Artists are no longer expected to develop steadily in one direction, and variety has become the greatest asset – until the ideas dry up. But artist's block is never a problem for Keith Tyson. Whether he's painting 366 breadboards and mounting them in a gallery (*AMCHII • Give us this Day in the Life* 1996-7); casting the entire contents of the Kentucky Fried Chicken menu in lead (*AMCHII • The KFC Notebooks and the UCT* 1995), using a laser torch to bounce a Morse-code message to the moon (*AMCHII • Orbital of Molecular Compound 2* 1997), or dropping a thimbleful of paint from the top of a New York building (*AMCHII • New York Action Painting* 1998), his is an art of infinite variety. This is because much of it is not his at all. It is the work of the Artmachine. 'I try to fulfil, as objectively as possible, exactly what it tells me to do', says Tyson, who defines the Art-machine as 'a complex recursive system assembled to generate detailed proposals for artworks'. The AMCH of the titles stands for 'Artmachine Iteration', and each work is the result of Tyson's slavish adherence to the precise specifications of form, content, positioning and production time it issues using flow charts and computer programmes to reference unlimited global sources. Some mind-boggling activities can ensue. *Artmachine Repeater Series: Dual Workstations (30 seconds late and early)* (1998-9), for example, consists of two seemingly identical workstations, one of which was in fact assembled exactly sixty seconds before the other. Even the plants were grown from seeds planted a minute earlier, and the two sets of photographs on the pinboards (including figures on a station platform and microscopic particles colliding in a Cern particle accelerator) were taken at sixty-second intervals.

This subjection of the artist to systems in which the idea takes precedence over the end product belongs to an established tradition. But Tyson stresses that he is no 1960s systems artist, condemned to a rigid regime. Influenced, however, by computer programming and science as much he is by art, he admits that 'there's no point in looking for an autobiographical origin or a psychological reading. The work just stands there – there's no history for it to belong to'. He sees his Artmachine as the repository of all human knowledge, able to reference unlimited possibilities for its proposals. What makes it so compelling is that it exists precisely to explore time-honoured notions of artistic inspiration, originality and creativity, including fallibility and unpredictability. It may require a boffin's expertise to decipher its coded specifications (and to understand some of the resulting artworks), but it is crucial that Tyson himself follows the Artmachine's bidding – and this accounts for the wonkily handmade appearance of so much of its oeuvre.

AMRSI•1(12) 137
Stage: Repeater
(aka Parallel
Purple Ping Pong
Pan Painting with
Piracy Pendulum)
1997
Acrylic, silicon,
plastic, emulsion
on canvas, plastic
pipe, cast-plastic
warships
3 units each
220 × 60 × 50 cm

'I'm experimenting on myself, my own thinking, my own hand, like a scientist would dissect a frog', says Tyson. 'The idea of failure and the impossibility of achieving are part of the process.'

Having scrupulously obeyed the Artmachine's conceptual system, Tyson can then use it as a point of departure in other works. In the *Repeater Series*, Tyson decides to fabricate from a given instruction more than once, producing end results that can range from almost identical – the *Dual Workstations*, for example – to unrecognisably different, depending on the type of commands generated. Similarly, *Expanded Artmachine* pieces occur when the machine stumbles upon something that Tyson feels is worth exploring, even if it can't be fully implemented. *Molecular Compound No 4* (1999) is a case in

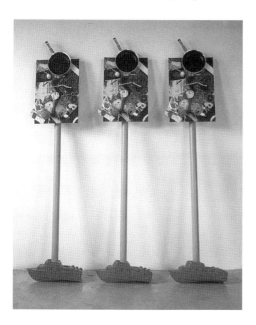

point – a single artwork proposing a central nucleus surrounded by fifty-two elements that orbit through space and time, ranging from a drawing on plastic stuffed into the brickwork of the Louvre in Paris, to a star in the constellation of Ursa Major, many thousands of light-years away. At the other end of the scale, failure is enshrined in the series of *Bastardised Iterations*, the outcome of the Artmachine's impossible demands, such as an infinitely high totem pole of random portraits ranging from Clement Atlee to German youth – which Tyson adapted into a number of vertical sections stacked from floor to ceiling: *Bastardised Artmachine Iteration Pringle Portrait Pack for A Replenishable Totem Stack* (1997).

Tyson may be one of the UK's most creative utilisers of new technology, but he is first and foremost an artist, and an unashamedly idealistic one at that. 'I want to make something that is philosophically charged – that says something about the nature of existence and origin', he says. His ongoing *Tabletop Tales* series (1998-) charts the realms of the human imagination by presenting intricate maps generated by free-associating around the random stains on the surfaces of tables. For the *British Art Show* 2000, he confounded his reputation for the prodigious output of objects by casting invisible magic spells, often unknowingly activated by the audience, with potentially damaging effects. In the scope of his art, Tyson underlines both the limits and the potential of the human imagination.

THE PLAYERS

THE GUARDIANS OF THE FLAME

THROUGHOUT THE UK, CURATORS, GALLERY DIRECTORS AND TEACHERS ARE FOSTERING THE NEW SPIRIT IN CONTEMPORARY ART. BELOW ARE SOME OF THE MOST SIGNIFICANT FIGURES OF RECENT YEARS WHOSE INFLUENCE EXTENDS BEYOND THE ORGANISATIONS THEY CURRENTLY REPRESENT.

IWONA BLAZWICK

Head of Exhibitions and Display, Tate Modern, London

As Director of Exhibitions at the Institute of Contemporary Arts from 1987 to 1993, Iwona Blazwick forged an important link between the British and the international art worlds. Now, she is bringing her considerable experience to bear at Tate Modern, where she heads the team responsible for presenting the collection, curating exhibitions and commissioning new work.

Blazwick has consistently promoted innovation in art. At the beginning of her career in the early 1980s, she was Director of the former artists' space, AIR gallery, where she curated shows ranging from Steven Pippin's first installation, to the multimedia Gamma City show by the radical architects NATØ. During her years at the ICA, it was Blazwick who gave Damien Hirst his first major public show in 1992, within a programme that combined risk-taking solo exhibitions of young British artists with significant historical re-evaluations such as *Meret Oppenheim 'Retrospective'* and *The International Situationists* (both 1989), and exhibitions that afforded early exposure in the UK to key international figures including Nancy Spero, Jenny Holzer, Fischli and Weiss, Gerhard Richter, Katharina Fritsch and Chéri Samba.

Between leaving the ICA and taking up her current post at Tate Modern, Blazwick went freelance as a curator and became Commissioning Editor of Contemporary Art at Phaidon Press. This only increased her cool, scholarly presence within the art world. Her love of the unorthodox and interest in cross-fertilisation between different forms could be seen both in her series of artist's monographs for Phaidon, and in the ambitious exhibitions that she curated in Britain and elsewhere. The international survey show *Now Here: Work in Progress* at the Louisiana Museum, Denmark, curated by Blazwick in 1996, for example, shook up artistic and cultural distinctions by juxtaposing the works of established figures such as Susan Hiller and Mary Kelly with paintings by a younger generation of artists including Chris Ofili, Stephanie Smith and Edward Stewart, and a plethora of low-cost pieces by the multifarious artists who work under the umbrella of Imprint 93.

Back home in Britain, Blazwick's wide-angled view has given rise to such distinctive exhibitions as *Ha-Ha* in 1993, which colonised an eighteenth-century National Trust park with up-to-the-minute pieces. As one of the advisors for *artranspennine98*, the major, if uneven, exhibition of international visual art stretching throughout Britain's transpennine region and organised by Tate Liverpool and the Henry Moore Sculpture Trust, she was responsible for site-specific pieces by Mark Dion, Regina Möller and Joseph Grigely.

At Tate Modern, her unstuffy adventurousness and intellectual acuity should help to prevent Britain's new museum of modern art from the curse of creeping institutional caution. With Senior Curator, Frances Morris, Blazwick has been instrumental in freeing-up Tate Modern's displays and jettisoning traditional linear, canonical or chronological formats in favour of four main themes or genres: nude-action-body; still life-object-real life; landscape-matter-environment; and history-memory-society. This dynamic approach, which presents neither a definitive nor a proscribed view, but uses

traditional artistic genres as a springboard for a multiplicity of options (with some artists, such as Joseph Beuys and Bruce Nauman, simultaneously occupying several categories) chimes with Blazwick's enthusiasm for looking at things in new ways. It is therefore appropriate that she is also at the centre of Tate Modern's remit to commission new works of art, which was dramatically inaugurated with Louise Bourgeois' *I do, I undo* and *I redo* (all 2000), made specifically for Tate Modern's Turbine Hall.

MICHAEL CRAIG-MARTIN

Artist, Millard Professor of Fine Art, Goldsmiths College, London

Michael Craig-
Martin
Photo: Gautier
Deblonde

In any account of the current British art scene, the name Michael Craig-Martin receives prominent billing. A tutor at Goldsmiths College between 1974 and 1988, and Millard Professor since 1994 (a senior position named after early Principal Pat Millard), Craig-Martin is most commonly cited as the *éminence grise* behind the band of Goldsmiths students who emerged in the late 1980s to take the art world by storm. He continues to be credited – as well as condemned – for the cool confidence, conceptual sophistication and entrepreneurial chutzpah that continues to permeate young British art.

The truth, though, is inevitably more complicated. Quite apart from the fact that the current creative boom cannot be tagged neatly to a single source, style or generation, Craig-Martin is also the first to acknowledge that he is just one among many radical influences that have made Goldsmiths an important source of artistic talent. For it was Jon Thompson, as Head of Fine Art at Goldsmiths in the early 1970s, who made the decision to abolish divisions between departments so that, since then, Goldsmiths students have been free to work in any medium they choose. It was also Thompson who was instrumental in creating Goldsmiths' famous climate of intellectual activity and interrogation, where, via an intensive programme of individual tutorials, seminars and group meetings, every student's work is comprehensively discussed in relation to that of their colleagues as well as with regard to recent art and current issues. Add to all this a rich roster of visiting artist-tutors including Richard Wentworth, Basil Beattie, Tim Head, Avis Newman, Simon Linke and Lisa Milroy, and it can be seen that the

college's tradition of experiment and enquiry extends way beyond the input of any one individual.

Nonetheless, when Craig-Martin was invited by Thompson to teach at Goldsmiths back in 1974, he was an appropriate addition to its mould-breaking environment. Born in Dublin and raised in Washington DC, Craig-Martin had completed a BA and an MA at Yale, and had come to England in 1966, where, while teaching at art schools in Bath and Canterbury, he was also building up an international reputation as a Conceptual artist in his own right. He not only reinforced Goldsmiths' links with developments in art across the Atlantic, but also brought to the south London college his experi-ence of the progressive art programme devised by Bauhaus artist and teacher Josef Albers. Much of the confidence emanating from Goldsmiths today is the direct result of a continuing policy to treat the BA students as artists from the word go, the function of the teaching staff being to offer critical advice and support, both practical and theoretical.

The impact of Craig-Martin's early Yale experience, with its emphasis on attitude rather than style, cannot be underestimated. 'I learned that art could be talked about in straightforward terms; that it needed to be rooted in the very experience of ordinary life I had thought it sought to escape; that con-temporary art existed in a context as complex as that of any earlier historical period; that, for an artist, art needed to be approached as work.'

As an artist, Craig-Martin has always been labelled as Conceptual, but his work is still rooted in the visual and the intuitive: for over thirty years he has taken perceived truths and systematically interrogated them with a forensic thoroughness that Albers would have been proud of. Probably his most noto-rious piece is *An oak tree*, made in 1973, when he took up where Duchamp had left off to present the ultimate Conceptual endgame. Placing on a glass shelf an ordinary tumbler, two-thirds full of water, he claimed via an accom-panying text in the form of an auto-interview, to have 'changed' it into an oak tree without altering its appearance.

Taking to heart Albers' emphasis on 'maximum effect from minimal means', Craig-Martin attempts to give the plainest, most lucid expression to subtle and complex observations of how and why we look at things, and what art can say to us. Behind a deliberately deadpan, mechanistic appearance lies a rigorous process of enquiry based on empirical observation. He has patrolled the boundaries between painting, sculpture and installation with assembled objects, prints, books, painted walls, and sculptures that look like wall drawings. For the last two decades, however, Craig-Martin has used as the vehicle for his ideas the uniform images of some 200 carefully selected

but utterly ordinary functional objects. Reproduced as perspectival drawings made directly on the wall in black and red tape, Craig-Martin's various combinations of chairs, tables, filing cabinets, shoes, electric fans or ladders explore the possibilities of sculptural presence without mass. But when they are flatly painted onto vivid, plain-coloured grounds, each with their own distinct perspective and coloured in with no attention to their 'real' appearance, the same sets of objects bring to our attention all the elements that we take for granted in painting – and seeing.

In his person as well as in his art, Craig-Martin uses modest delivery and straightforward syntax in order to communicate the most elusive and complex of subject matter. He is a down-to-earth idealist, a passionate prag-matist, whose influence extends from the heart of the art establishment (as a Tate artist-Trustee he was closely involved in the development of Tate Modern), to leading seminars with undergraduates. He may not have single-handedly launched an artistic generation, but his ideas and his example have certainly helped to inspire the attitude that encouraged it to succeed.

ALEX FARQUHARSON
Exhibitions Director, Centre for Visual Arts, Cardiff

The West Country is hardly a Mecca for contemporary art, but thanks to Alex Farquharson, the city of Exeter has been treated to important exhibitions of both established and emerging international artists. During Farquharson's five-year stint at Exeter's Spacex Gallery in the 1990s, he initiated Britain's first exposure to the work of Los Angeles artist Lari Pittman, curated and wrote the catalogue for the recent paintings and gouaches of veteran British abstractionist Bridget Riley, and organised leading Italian Stefan Arienti's first UK show. In addition, Spacex also inaugurated exhibitions by young artists, such as the first comprehensive showing of the paintings, videos and bronzes of Keith Coventry; new work by Tim Noble and Sue Webster; and *Finish*, a mixed show flagging up the new wave of British process/Minimalist painters such as Ian Davenport, Jason Martin and Alexis Harding. All this was done on what Farquharson describes as a 'zero budget', and such was the burgeoning status of Spacex that it soon attracted important touring shows like Gary Hume's ICA exhibition, or Gustav Metzger's solo show orig-inating at MOMA, Oxford.

Now, Farquharson is Exhibitions Director at Wales' largest venue for

visual arts, the CVA, Cardiff, and this has enabled him to shift from showing mainly British art in a small space to working on several museum-sized international projects a year. It was a bold move to open the venue in 1999 with a major new installation by US artist Jessica Stockholder, one of her most ambitious yet; and it was bolder still to follow this with Jeremy Deller's *Unconvention* (1999), a show based on references in the songs of the Welsh band The Manic Street Preachers. The opening weekend found CVA playing host to the Pendyrus Male Choir (who performed in front of a Warhol self portrait), as well as to numerous organisations, from fanzines to Amnesty International, with a rousing speech from National Union of Mineworkers' President Arthur Scargill – a groundbreaking moment for any art gallery.

'London chauvinism is breaking down a little, and acknowledging the vitality of different art scenes. My own art city of choice is Los Angeles', says Farquharson, who put on a show devoted to Las Vegas in 2000. In addition to becoming one of the UK's leading curators, Farquharson is also amongst its most lucid and intelligent writers on contemporary art. His reviews and features for *Art Monthly* and *frieze*, as well as catalogue essays for the likes of Gavin Turk (South London Gallery, 1998), also confirm that being at the centre of things is a matter of imagination rather than geography.

ANN GALLAGHER

Exhibition Officer, Visual Arts Department, The British Council, London

Although attitudes are slowly changing, it remains a depressing fact that many of Britain's most adventurous young artists have traditionally been more appreciated abroad than at home. And this is not only because foreign curators, critics and collectors seem to have a stronger shock threshold for contemporary art, but is also due to the fact that the British establishment has seemed to be more at ease promoting our talent away from home. Although it was set up over half a century ago, and continues to be funded by the Foreign and Commonwealth Office, The British Council has probably done more than any other organ of the UK cultural establishment (except the Tate) to promote and collect the most progressive work being made in this country. As well as selecting artists to represent the UK in various Biennials – including Venice, Istanbul, São Paulo, Johannesburg – The British Council has also provided a crucial showcase for the latest developments in British art

in the form of shows such as the landmark *General Release* at the 1995 Venice Biennale; *Dimensions Variable* (1997-9), which toured the British Council's acquisitions by emerging artists of the 1990s across Europe; or *Artifice* (2000), with work by Adam Chodzko, Tacita Dean, Graham Gussin, Sióbahn Hapaska, Stephen Murphy, Simon Starling and Jane and Louise Wilson at the Deste Foundation, Athens.

All of the above were curated by Ann Gallagher, who, since she joined the British Council's Visual Arts Department as Exhibition Officer in 1994, has not only been responsible for organising major exhibitions, including David Sylvester's Francis Bacon survey, which opened at the Centre Pompidou in 1996, or Rachel Whiteread's pavilion at the 1997 Venice Biennale, but has also ensured that the British Council has maintained its position at the contemporary forefront. Gallagher is especially well qualified for this role, having cut her teeth in the more radical quarters of the commercial art world, first throughout the 1980s as a Director of Nigel Greenwood Gallery's bookshop and artists' book gallery, and then from 1989-94 as a Director of Anthony Reynolds Gallery, where she selected/organised exhibitions by Paul Graham, Cady Noland, Georgina Starr, Amikam Toren and Keith Tyson, amongst others. Regardless of how British art prospers at home, it will always need such informed, adventurous and well-liked ambassadors.

MATTHEW HIGGS

Artist; Director, Imprint 93; Associate Director of Exhibitions, Institute of Contemporary Arts, London

Matthew Higgs' low-profile, collaborative approach hasn't prevented him from becoming an increasingly influential presence with a web of activities and affiliations that extend throughout the British art world, from public galleries and major publications to the most alternative of projects and artists' spaces. While still a teenager in the Lancashire town of Chorley, Higgs wrote and modestly distributed an indie-music fanzine. On receiving a surprisingly widespread response, he realised that he was onto something: 'I had inadvertently found a position for myself that was somewhere between the audience and the stage', he later recalled. It could be said that in many of his subsequent activities, Higgs has occupied

this ambiguous territory, questioning assumptions about the presentation, production and promotion of today's art.

Nowhere is this more evident than in Imprint 93, the ongoing independent postal-gallery-cum-publisher established by Higgs in September 1993, which continues to mail out artist's projects unsolicited to a list of curators, artists and writers throughout the UK and abroad. Although links can be made to earlier Mail Art precedents and to the activities of the Situationist International, Higgs sees Imprint's role as being more like a sort of exhibition space, an alternative to the gallery model, in which artists can make new work in ways that they may not otherwise have considered. To date, over fifty artists, including Fiona Banner, Martin Creed, Peter Doig, Paul Noble, Chris Ofili, Elizabeth Peyton, Jessica Voorsanger and Stephen Willats, have produced low-cost (but now eagerly sought-after) editions and related projects suitable for second-class postage and an A5 envelope.

Although he studied Fine Art at Newcastle (where a friend and contemporary was Gavin Brown, now one of New York's leading art dealers), from early on, Higgs professed himself dissatisfied with his own solitary art practice. 'It seems to me that the only pleasures beyond the economic in the art world are to be gained in working with other people', he states, 'trying to make sense for myself of what they are doing'. To this end, he only occasionally exhibits his own work, and then usually interspersed with that of others. The communicative power of text and books is a recurring theme, whether in Higgs' own artworks – which often detach and frame selected pages of books – or in his curated shows such as *A-Z* at The Approach in 1998, exploring the possibilities and permutations of the alphabet; or in projects such as Higgs' 1999 guest curatorship at Bookworks, which resulted in publications by Jeremy Deller, Frances Stark, the artists' collective Inventory, and various art-world views of the Seven Wonders of the World.

Although Higgs is making increasing forays into the mainstream – as a selector for the *British Art Show 5* and one of the ICA's team of four Associate Exhibition Directors, for example – it seems doubtful that he will ever be fully assimilated into the establishment. He's too critical of conventional approaches. Instead of writing an essay for his friend Peter Doig's Whitechapel Gallery exhibition catalogue, for example, Higgs, who can also add DJ-ing to his accomplishments, gave a more immediate insight into Doig's mind by listing his entire record collection. Similarly, his projects for the Tate's *Abracadabra* catalogue involved listing 100 records and films and reproducing in full the index of *Adhocism* (1973), a book by Charles Jencks and Nathan Silver. When he opened 'Space 1999', his own exhibition space

in the East End of London, its two decidedly non-material projects consisted of a Martin Creed light piece that could only be viewed from the street below, and Georgio Sadotti's 24-hour sound work – yet more confirmation of an enduring view that a great deal can be made out of nothing much.

ROBIN KLASSNIK

Director, Matt's Gallery, London

Robin Klassnik trained as a painter, then exhibited a selection of Mail Art objects at the ICA and a group of photographic/text pieces at the Whitechapel Art Gallery ('I couldn't paint'), before turning his east London studio into an exhibition space in 1979. Since then, Matt's Gallery (named after his Old English sheep dog, Matt E. Mulsion) has become recognised as a crucial venue for artists to make and show work that many mainstream galleries couldn't – or wouldn't – accommodate. For Klassnik is an idiosyncratic figure within the British art world: he's not a dealer (what he does isn't commercial, despite the fact that some of the works do sell); he's not a public-sector curator (although he does get public funding) and he's not a dilettante (for many years he supported the enterprise with his teaching income, along with whatever grants he could muster). Instead, he's the founder and Director of a gallery run solely from artistic motives.

'I was dissatisfied with the facilities available for artists to show work. I took it upon myself to open my space – not to show my own work but other people's. I made the conscious decision that I would work with each artist – it was to be more than a space in which art was shown. The work would involve the artist and myself.' It still does. Klassnik chooses the artists he wants to show – including Richard Wilson, Mike Nelson, Willie Doherty, Brian Catling, Jimmie Durham and Melanie Counsell – raises the necessary funds, allows them as much time as they want to realise their work, and directly collaborates with them on the gestation, conception and often the physical construction of projects that have ranged from paintings and wall drawings to video projections and installations.

Once he has committed himself to an idea, Klassnik will move heaven and earth (and if necessary walls, ceilings, floors and windows) to make it happen. His commitment is legendary – if somewhat autocratic at times. Richard Wilson, whose 20:50 oil piece made its debut at Matt's Gallery, has described this involvement as 'verging on the fanatical', and even though the

venue now has proper funding and administration, and often sells work to the Tate and the Saatchi Collection, Klassnik continues to view the whole enterprise primarily as a highly personal artistic collaboration.

Klassnik's close working relationship with artists, his determination to show new work by side-stepping the mainstream (the first Matt's Gallery was buried within a labyrinthine complex of artists' studios in Hackney, and it is now in an old warehouse by the side of a canal in Bow), and the in-house publications that accompany most exhibitions have directly influenced the current plethora of artist-led project spaces. Few, however, have a director with a vision as distinct, dedicated and downright dogged.

JAMES LINGWOOD
Co-Director, Artangel, London, and Independent Curator

Facilitator, writer and freelance curator, James Lingwood has been a crucial influence both in opening up some of the most experimental forms of contemporary art to a wider British audience, and in providing unusual venues for artists to make and show work. As Co-Director and the visual arts specialist of the Artangel Trust, the organisation that commissions, fund-raises and facilitates works by artists outside the confines of the gallery, Lingwood was instrumental in bringing about Rachel Whiteread's *House* (1993), as well as overseeing other Artangel projects including American artist Matthew Barney's *Cremaster* films; *H.G.*, Robert Wilson and Hans Peter Kuhn's eerie time-travel installation in south London's Clink Street Vaults (1995); the occupation of a disused gentleman's club in Piccadilly by the Mexican artist Gabriel Orozco in 1996; and Douglas Gordon's video installation *Feature Film* at the Atlantis Gallery, east London (1999).

After graduating from Oxford, Lingwood worked first at the Plymouth Arts Centre and then as Curator of Exhibitions at the ICA. It was during this time that he paved the way for his subsequent Artangel activities by liaising with a network of artists, sponsors and city authorities to organise two ambitious exhibitions that helped redefine the nature of public art by presenting an extraordinary range of temporary pieces in unexpected places. *TSWA-3D* (1986-7) took the work of fourteen artists to nine British cities and included Richard Wilson's suspended machine parts in the south tower of the Tyne Bridge; Edward Allington's cheeky baroque scroll peeping out of the portico of St Martin-in-the-Fields near Trafalgar Square; and Antony Gormley's dou-

ble-faced cruciform figures on the walls of Derry. The twenty-eight pieces in the *TSWA Four Cities Project* (1989-90) included Nancy Spero's paintings on an end-of-terrace wall in the Bogside in Derry, Mona Hatoum's chair made from heating elements placed in an underground tunnel in Byker, Newcastle, and Richard Deacon's huge, girder-like sculpture on a pair of disused railway piers in Plymouth.

At the same time, Lingwood was also inside the gallery, working on exhibitions at the ICA, a venue with which he had an ongoing relationship for ten years. Significant shows include Gerhard Richter's *Baader Meinhof* series (1988), *Possible Worlds: New Sculpture from Europe* (1990), and *The Independent Group: Postwar Britain and the Aesthetics of Plenty* (1990-1). Since then, he has gone on to make his mark both at home and internationally with exhibitions of Juan Muñoz in Dublin and Madrid (1994-6); Thomas Schütte in London and Tilburg; Robert Smithson in Valencia, Brussels and Marseilles (1993-4), and at the Hayward Gallery, London, a major show of contemporary photography *The Epic and the Everyday* (1994). Sometimes, he admits, he has the urge to go back in time and curate an old master exhibition, but for the time being at least, Lingwood provides a crucial resource for today's artists and audiences to immerse themselves in the land of the living.

JENNI LOMAX

Director, Camden Arts Centre, London

Jenni Lomax

It may seem obvious for a gallery to put the artists themselves at the centre of its activities, but it is still surprising how often they can be sidelined or used as a token embellishment to an exhibitions or education programme. Not so with Camden Arts Centre, whose Director Jenni Lomax is widely known as one of the most artist-friendly (and indeed, just friendly) gallery directors currently in the art world. 'Because I went to art school and trained as an artist, I've always looked at things from that point of view', she says. 'I'm excited about ideas around at the moment and it's much more interesting to put artists at the centre because they're the ones creating history and putting things together.'

In the course of more than a decade (1979-90) as Community Education Organiser at Whitechapel Art Gallery, Lomax initiated the now widespread

practice of artists' residencies, exhibitions and workshops in schools and public places throughout the local community as well as within the gallery itself. These activities fed into and emanated from the Whitechapel's exhibition programme and the welcoming atmosphere of the gallery is in great part her legacy. When she took over as Director of Camden Arts Centre in 1990, Lomax rescued it from spiralling decline and transformed it into one of London's most adventurous and engaging venues for contemporary art.

It is also one of its most unpredictable. For as well as organising shows of influential international figures including Michelangelo Pistoletto (1991), Ad Reinhardt, Joseph Kosuth and Felix Gonzalez-Torres (*Systems of Interference, Conditions of Possibility*, 1994), Barnet Newmann (1996) and Dan Graham (1997), Lomax has also taken pleasure in re-introducing figures who are not in the current height of fashion. 'I like the undercurrents rather than the overtures', she says. Reflecting this desire to consider those outside the mainstream, in 1993 CAC organised a major survey of veteran surrealist Dorothea Tanning; Patrick Heron made an impressive site-specific series of *Big Paintings* in 1994, and Avis Newman, Prunella Clough, Rita Donagh and Kim Lim are other artists outside the immediate mainstream who have benefited from solo shows at Camden. 'There still have to be places where work that has obvious strength and perhaps a quieter influence can be looked at', says Lomax. 'Just presenting this work provides a new arena for debate – these artists might get dismissed, but they are also given a chance to be part of the picture.'

Camden – which is run on a shoestring – not only reassesses older talent, but showcases the new with an impressive record for commissioning/organising ambitious solo shows from the most innovative contemporary artists. These have included Ireland's Kathy Prendergast (1991), French artist Sophie Calle (1999), or the UK's Mat Collishaw (1995) and Simon Periton (1998). Some of the above had already been participants in Camden's ongoing artist-in-residence scheme, which complements the main exhibitions programme by selecting young artists to work either in Camden's studio space or Gallery III for the duration of a particular show. In this scheme (which does not demand any specific product from participants beyond occasionally opening up their studios), young artists from Martin Creed to Enrico David, Adam Chodzko and Rachel Lowe have been given vital working/ thinking/breathing space. This has often elicited dramatic results, such as Mike Nelson's epic room full of structures made from discarded timber, which complemented the post-industrial photographs of Bernd and Hilla Becher. Not only is it invigorating and enriching for a gallery to contain a

working artistic presence, this policy also dovetails Lomax's two enduring concerns. 'In a sense, Camden has always had the air of an educational institution, and it's got to be more than just a showcase for art. Having artists working here who, in different ways, fit conceptually with the shows, and seeing the thought processes behind how their art is made and how they piece together different elements, fills in the gap.'

GREGOR MUIR

Curator, Lux Gallery

In 1991, Gregor Muir wrote to *frieze* magazine with a list of criticisms of its pilot issue. The result was that he became one of their major contributors, writing numerous articles and reviews – including an early 1993 interview with Sarah Lucas and Tracey Emin at their shop in Bethnal Green Road, the result of many days – and evenings – spent in their company. For Muir, who had graduated from a painting course at Camberwell in 1987, was already well-immersed in London's evolving art scene, having been attracted by the grit and energy of the 1990 exhibitions curated by Damien Hirst, Carl Freedman and Bilee Sellman in the cavernous Building One. 'They kept pulling me back; they were fantastically seamy, in this ruined space where everyone was getting together and talking.' Pieces for other magazines followed, from *Parkett* to *Dazed & Confused*, alongside Muir's evolving and complementary role as friend, confidant and chronicler to the close-knit group of artists that were at the core of the London art world in the first half of the 1990s. These included Gary Hume – whose transition from door paintings to his more fluid, figuratively based work was simultaneously recorded by Muir. They also included Sam Taylor-Wood, who, in the collaborative spirit of the time, kick-started Muir's career as a curator when in 1993, she asked him to help her co-ordinate *Lucky Kunst*, a show featuring her own work along with that of Hume, Don Brown, James White, and the Wilson twins. They found an old florist's shop in Soho and it was here that Hume first exhibited his now iconic image of a shamrock-faced Tony Blackburn.

Another early piece of curating was the 1994 *Liar* in Hoxton Square, which showed work by Jake and Dinos Chapman, Cerith Wyn Evans, Ann Eggbert and Sadie Bening. A year later, it was a measure of Muir's involvement in the burgeoning art scene that The British Council invited him (and James Roberts) to work with them on the 1995 *General Release*, which

brought together his generation of young British artists for the Venice Biennale. Along with work on show by Fiona Banner, the Chapmans, Adam Chodzko, Dalziel and Scullion, Ceal Floyer, Tom Gidley, Douglas Gordon, Gary Hume, Jaki Irvine, the Wilson twins, Elizabeth Wright and Cerith Wyn Evans, Muir was instrumental in making sure that the catalogue provided a valuable chronology of the developments in the British art scene over the previous five years. 'I realised that a history was happening that was so ephemeral it was in danger of being forgotten.'

Many of the artists involved in *General Release* were working with film and video, and in the same year, Muir made the crucial step of putting together *Speaking of Sofas*, one of the first-ever programmes of film and video by UK artists. 'I realised that my writing had been mostly about women and mostly about women working in video. I'd seen a lot of video and I wanted to present it with titling and clarity, to show that it was such an important part of an evolving scene.' Now, Muir is the curator of the Lux Gallery, which specialises in both commissioning and presenting film and video work by emerging and established artists from the UK and internationally. He no longer has time to write, but, as curator of Lux's varied and adventurous programme of exhibitions and events by artists working with all aspects of new media, his influence continues to make itself felt.

JUDITH NESBITT

Head of Programming, Whitechapel Art Gallery, London

'The Whitechapel is an artist's gallery – and we must continue to be responsive and light on our feet in our response to artists', says Judith Nesbitt. Since she moved across the East End from Chisenhale Gallery to take up the newly created post of Head of Programming at the Whitechapel, Nesbitt has acted as a tonic to one of London's best-loved galleries. Her first exhibition, the controversial *Examining Pictures* (1999), immediately signalled a new spirit at work – deliberately stirring up debate around contemporary uses of the medium and presenting none of the School of London artists whose work had hitherto been a Whitechapel staple. Nesbitt took an MA in Renaissance art at the Courtauld Institute, and one of her earlier incarnations was as Exhibitions Curator at Tate Liverpool, where shows from Stanley Spencer and Roy Lichtenstein to Sigmar Polke and Robert Gober confirmed her ability to work in many modes.

At Chisenhale, where Nesbitt was Director from 1995 to 1999, the emphasis was strictly contemporary and she consolidated the status of this Mile End gallery as a must-see showcase for the best new art, whether from rising UK artists such as Gillian Wearing, Wolfgang Tillmans, Paul Noble and Sam Taylor-Wood, or emerging artists from abroad like Thomas Hirshhorn and Pipilotti Rist. 'The versatility of Chisenhale meant that we were able to go the whole hog – to show strong new work like the floor-ceiling-light experience of Michael Landy's *Scrapheap Services* (1996); large-scale video projections by Gillian Wearing (*10–16*, 1997) and Sam Taylor-Wood (*Pent Up* 1996) or Paul Noble's (1997) *Nobson* drawings, a body of work that he himself had never had the chance to see all together before.' This versatility even extended to commissioning young artists Tim Noble and Sue Webster to turn Chisenhale into a giant disco, with artists, critics and curators taking turns as DJ (*Turning the Tables* 1999).

At the Whitechapel, Nesbitt continues to exercise her ability to 'go the whole hog'. In 1999, a three-week, day and night programme of British Asian culture, *ooo zerozerozero*, fulfilled the Whitechapel's remit to acknowledge its multicultural location by turning the gallery into a dancefloor/fashion show; while Nesbitt's adventurous choice of historical shows such as the maverick Arte Povera artist Alighiero e Boetti; or *Live in Your Head*, which revisited British Conceptual and experimental art of the 1960s and 1970s, show a similar boldness and desire to reinvigorate. Contemporary artists young and older, whether Gary Hume (1999), or the late Martin Kippenberger (2001), continue to play a central part in the revitalisation of the Whitechapel. As Nesbitt points out, '2001 is the Whitechapel's Centenary – what better time for us to get frisky and kick up our heels?'

JULIA PEYTON-JONES

Director, Serpentine Gallery, London

Julia Peyton-Jones' powers of persuasion are legendary. When she took over as Director of the Serpentine in 1991, it was a somewhat dilapidated former tea pavilion in the middle of Kensington Gardens, which the Department of Heritage wanted to shut down (one Minister threatened to turn it into an indoor riding school). Now it's one of London's key exhibition spaces, synonymous with a string of must-see shows, celebrity-studded annual gala dinners, and the recipient of a £3 million lottery makeover. Having Princess

Diana as patron from 1993-6 certainly made the sponsors sit up. So did the worldwide press when, with Julia Peyton-Jones (who had quietly arranged it all) at her side, the Princess became the first royal ever to visit the Venice Biennale, contemporary art's most important international showcase.

Yet Peyton-Jones' elegant PR skills should not obscure her intense commitment to the art itself. She has endeared herself to many of the artists who have shown at the Serpentine by being as happy to paint walls and stick on labels as to glad-hand the great and the good. But then Peyton-Jones' own background was in art practice, not promotion. She studied painting at the Royal College of Art in the 1970s, and then collaborated on various film and dance projects before teaching briefly at Edinburgh Art College. From there, she had a spell running a gallery attached to an artists' materials supplier in London's East End. However, funding her own art-production career gradually gave way to organising and raising money for the annual Space open studios and then a move to the South Bank Centre, where she showed her range by organising shows of Raoul Dufy, Andy Warhol and Leonardo da Vinci at the Hayward Gallery.

Peyton-Jones therefore came to the Serpentine with more experience as a fund-raiser and organiser than as a director and she herself – with characteristic self-deprecation – has admitted that she was surprised when she got the job. ('I didn't think I was a front runner.') This modesty is not well founded. What is probably her greatest achievement is that she has managed to retain the Serpentine's identity as a venue for radical art while also making it attractive to the establishment – an enviable coup.

NICHOLAS SEROTA

Director, Tate

When the Civil Service Commission advertised late in 1987 for a new Director of the Tate Gallery, it asked for someone with 'a deep and scholarly knowledge' of contemporary art as well as the flair to embark on 'an important building project and major fund-raising activities'. Nicholas Serota was the obvious man for the job. The son of an engineer and a prominent London Councillor who became a Labour life peer, at twenty-seven Serota was appointed Director of the Museum of Modern Art in Oxford, where he gave important exhibitions to Howard Hodgkin, Carl Andre and Joseph Beuys. This was followed by twelve years as Director of the Whitechapel Art

Nicholas Serota

Gallery between 1976 and 1988. Here, his exhibition pro-
gramme combined the historical – Max Beckmann,
Fernand Léger and twentieth-century British sculpture –
with up-to-the-minute contemporary shows of Anselm
Kiefer, Georg Baselitz, Jannis Kounellis, Gerhard Richter,
Richard Long and Julian Schnabel. Such a line-up, along
with a much-praised £1.7 million extension to the gallery,
amply confirmed Serota's status as an internationalist and
champion of the most modern of art – and a nifty fund-
raiser into the bargain. Combine this with the solid British
art credentials of a Cambridge BA thesis on the soberly real-
istic Euston Road School, and a Courtauld MA dissertation
on J.M.W. Turner, the anchor-man of the Tate's historic
British collection, and it begins to look as though Serota had spent his entire
adult life in preparation for the post.

Now, with the £134 million Tate Modern open on time and on budget, as
well as the expansion, reorganisation and refurbishment of Tate Britain,
there's no doubt that Sir Nicholas Serota, as he was dubbed in early 1999,
has lived up to the promise of his early track record. His personal status
within the international art world has helped to make the Tate a stopping-off
point for major international touring exhibitions, while Channel 4's ongoing
sponsorship of the Turner Prize has meant that the profile of Serota and the
Tate, not to mention contemporary art in general, has become consistently –
if often controversially – high.

Whether he likes it or not – and he professes not to – for the time being at
least, Serota is the personification of the Tate Gallery, and as such he is often
the focus for everyone's particular art gripe. Some see him as an austere and
elitist advocate of the most inaccessible of contemporary art, others take the
view that prior to Tate Modern, he remained in a 1980s time-warp and that
he lagged behind other institutions in America and Europe in responding to
the 1990s boom in young British art. And there are still more – in both radi-
cal and conservative circles – who feel that Serota has been responsible for
turning art appreciation into art as spectacle: a trendy public relations exer-
cise where labels, explanatory films and celebrity-studded TV coverage have
become a substitute for private contemplation.

In order to deal with these compound criticisms, Serota has had to hone
his political skills. However much friends and colleagues may insist on his
teamwork abilities and on his behind-the-scenes humour and affability,
there's no doubt that the move from modest east London gallery to national

institution has resulted in a more aloof leadership style. Exposure to the public eye has given Serota a reputation for reticence and reserve: he has become particularly adept at dodging questions about his personal taste in art – or in anything else for that matter.

But what is often overlooked is that Serota's ascetic image masks a vision that is exacting, rather than austere and – like the man himself – can be unexpectedly audacious. His personal preferences weren't in much doubt when, in 1991, he recommended that the Trustees authorise the Tate's £700,000 acquisition of thirty-one giant basalt blocks by Joseph Beuys; or when, after stripping back the Tate's central Duveen sculpture galleries to their grand, bare, original state, he then liaised with the artist Richard Long in 1990 to fill them with a huge circle of flints and snaking coils of painted river mud. The ongoing sculpture programme has included 'shouting' videos and flashing neon by Bruce Nauman, Rebecca Horn's rivers of mercury, live electrical currents and exploding grand piano, and Mona Hatoum's giant kitchen appliances.

But the colossal task of drumming up the funds for Tates Modern and Britain has taken Serota away from one of his greatest enthusiasms: dealing directly with artists and their work. Although he continues to maintain overall control of the four Tates – Liverpool, St Ives, Britain and Modern – it is more of a presidential role, without the direct engagement that he has so relished in the past. Unlike some of his predecessors at the Tate, he is not by choice an academic, and rather than writing catalogue essays or publishing books, he would prefer to visit artists in their studios or go to galleries to look at art. This hands-on approach also extends to Serota's ability to hang a show. The earliest rehangs of the Tate's collection were entirely his own work, and his famous – some say infamous – perfectionism continues to impact significantly on the appearance of Tate's temporary exhibitions – especially those of living artists. Virtually no show is installed without some input from the Director and, however packed his schedule, he always devotes time to suggesting alterations and making adjustments – whether the curators involved like it or not. This includes the new themed displays at Tate Modern.

Now that Giles Gilbert Scott's disused power station at Bankside has evolved into Britain's foremost gallery of modern art, there is speculation as to what Serota will do next. Having conceived and delivered Tate Modern, he has now handed it over to Director Lars Nitve and a team of curators headed by Iwona Blazwick and Frances Morris. But whatever he chooses to do, there's little doubt that Serota will go down in art history as one of its great museum directors – not just in Britain, but worldwide.

TOBY WEBSTER

Co-director, The Modern Institute, Glasgow; Associate Director of
Exhibitions, Institute of Contemporary Arts, London

Although Toby Webster is widely associated with Glasgow, his influence
extends way beyond. Whether sitting on the Committee of Transmission
Gallery (1995-7); working as Gallery Manager and Curator at Glasgow's CCA,
or, since 1998, operating as founder and Co-director of The Modern Institute
along with Will Bradley, Webster has helped to confirm that both artists and
shows can attract international attention without going via London. He has
also helped to mix up and dissolve boundaries between galleries, museums,
performance spaces, cinemas, music gigs and experimental environments of
all descriptions.

At Transmission, for example, he and the committee curated *New Rose
Hotel* (1995), which brought together designers of all forms – Philippe
Starck, Insane Clothing, Ron Arad, Sir Clive Sinclair – including architects –
Su Grierson and Monaghan and Morris – and artists such as Julian Opie.
Guitar Amp Action (1995), flung the gallery open to a series of live bands, and
21 Days of Darkness (1996) turned the gallery into a museum that combined
an international group of young and big name contemporary artists such as
Simon Periton, Glenn Brown, Christine Borland, Douglas Gordon, Adam
Chodzko, Gregory Greene, Vito Acconci and Mike Kelley with such vintage
figures as Lee Miller, Pierre Molinier and Wegee. Other Transmission pro-
jects have included *Manhattan Neighbourhood Network*, which in 1997 turned
the gallery into a TV studio; Jeremy Deller's Acid Brass, which played in
Glasgow's Royal Botanical Gardens; and *Lovecraft,* an evolving show of obses-
sively crafted work from artists/designers/individuals of all ages and inclina-
tions, dead and alive, which was co-curated with Martin McGeowan of
London's Cabinet Gallery and opened at CCA before touring to South
London Gallery and Spacex in Exeter.

When Webster, who studied at Glasgow School of Art, was practising as
an artist, he made what he now describes as 'production-type work' – his
1998 solo show at Belfast's Catalyst Gallery, for example, involved building a
replica of the Scala cinema in the gallery, which was open twenty-four hours
a day and contained films, bands and a club. Now that Webster no longer
makes his own work, he has channelled the impulse to make multifarious
things happen into The Modern Institute, which he describes as 'a research
organisation and production company for contemporary art'. Since its

foundation in 1998, this crucible for experiment has handled projects from making records, to artists posters, or more conventional gallery shows both within its spaces and in sites throughout Glasgow and Europe. This has included working with Copenhagen artists Superflex on a night for Berlin Club WMF; producing a section of *Self Service Magazine*; or putting on Rikrit Tiravanija's temporary four-screen cinema and barbecue café in a residential area of Glasgow, where it showed movies selected by the local community. However, just as The Modern Institute also works with individual artists including Simon Starling and Jim Lambie, and is not averse to putting on more classic contemporary art exhibitions, so Webster is prepared to work in different formats. It was a wise move for the ICA to appoint him as one of their team of four Associate Directors of Exhibitions.

THE PRESENCES

THE INFLUENTIAL PEOPLE, OFTEN FREELANCE, WHO ARE OPERATING IN DIVERSE WAYS IN A VARIETY OF SITES TO BREAK NEW GROUND IN BRITAIN'S ART WORLD.

CARL FREEDMAN
Curator and Writer

Carl Freedman
in video still
from **English
Rose** 1996

Popular mythology may have it otherwise, but it was in fact, not one, but a cluster of slickly presented shows held in industrial spaces during the late 1980s and early 1990s that fired the art world with the spirit of enterprise and helped to project several careers into the stratosphere. In March 1990, some eighteen months after putting together *Freeze* (which, being held in the middle of summer 1988, did not attract the high audience figures its subsequent reputation has implied), Damien Hirst joined forces with Billee Sellmann and Carl Freedman, his friend from back home in Leeds, to curate *Modern Medicine*. This exhibition of eight young artists was held in Building One, a disused biscuit factory in Bermondsey. Soon afterwards, Freedman used the same venue as the setting for two further ambitious and audacious exhibitions – the group show *Gambler* (July 1990) and Michael Landy's *Market* (October 1990).

Freedman didn't go to Goldsmiths. He studied Anthropology at University College London and first approached curating almost as a kind of social experiment. He remembers that it was 'the structure of art and how the different value mechanisms operated' that interested him, as much as the art itself; and he lists his aims for the early exhibitions he organised as 'scale, impact, professionalism and power'. *Modern Medicine, Gambler* and *Market* displayed all of the above in abundance. With their slick catalogues, prominent sponsors and art that resembled fully formed museum pieces –

whether Damien Hirst's *A Thousand Years* (1990), a mini-eco system of hatching, breeding and dying flies, bought by Charles Saatchi for around £5,000; or Michael Landy's Neo-Minimalist installation, which filled an entire space with arrangements of metal frames, bread crates and Astroturf – these exhibitions played a vital part in promoting a new attitude towards the making and showing of art.

Now, alternative gallery spaces in empty shops and people's flats have become a staple of the art world, and several colleges have introduced curating courses. Yet, although times have changed, Freedman continues to make his presence felt within the current scene. His earlier preoccupation with the mechanics of the art world has increasingly given way to a close association with artists and their work. *Minky Manky*, the mixed show organised by Freedman for the South London Gallery (1995), which then toured to the Arnolfini, Bristol, not only provided a chance to view the progression of many of the original artists who had shown together in those warehouse groupings, but also placed them in a wider context alongside earlier work by Gilbert and George and pieces by other British artists of the same age, such as Tracey Emin and Steven Pippin. For *Life/Live* (1996) at the Musée d'Art Moderne de la Ville de Paris, Freedman contributed *English Rose* (1996), a video work made in collaboration with Tracey Emin, Georgina Starr and Gillian Wearing. Simultaneously parodying and reinforcing the social, artistic and personal cross-dressing underpinning the British art world, each artist acted out the other's persona in a way that was by turns savage, hilarious and maddening.

LIAM GILLICK
Artist, Curator and Writer

The British seem to have been slow to fully appreciate Liam Gillick. Internationally, his uber-cerebral artworks-cum-philosophical propositions have been widely admired. He was among the handful of British artists to be selected for Documenta X in Kassel 1997, and in any major-league round-up of contemporary art emanating from America or Europe, his name is bound to be there, along with his installations of apparently utilitarian objects: lighting rigs, coloured banners, aluminium and coloured Perspex structures, metal wall cladding, or wrapped books. However, in a land where the term 'intellectual' can still be used as a form of abuse, Gillick's multifarious

'objects from a parallel future ... that operate in a centre ground and attempt to address some negotiated positions rather than clear-cut projections or predictions' have tended to perplex rather than stimulate. Apart from occasional appearances in commercial galleries or group shows, it wasn't until 2000, with a one-man show at Bristol's Arnolfini, inclusion in the *British Art Show 5* and an invitation to provide the first of the Hayward's inter-show turnaround projects for the new millennium, that he truly made his mark on home ground as an artist.

This was a decade after Gillick, who was two years ahead of Damien Hirst at Goldsmiths, had established himself as one of the main mouthpieces of that generation. With the critic Andrew Renton, he co-edited the 1991 *Technique Anglais: Current Trends in British Art,* which was one of the first publications to document an emerging art scene. At the beginning of the 1990s, he helped to contextualise and give intellectual weight to current developments in art, whether in publications accompanying international group shows of young British Art such as those at Barbara Gladstone and Gio Marconi, Milan, in 1992, or in texts for influential early shows at home such as Jeremy Millar's 1994 *Institute of Cultural Anxiety.* At the same time, Gillick was publishing his own books – a series of 'parallel histories' that hypothetically rewrote the past to reassess how we look at the present. He was also working on *Documents*, an open-ended series of photographs and text with his friend and Goldsmiths contemporary Henry Bond, in which they recorded their presence at news events – from a press conference to mark the fifth anniversary of Brian Keenan's captivity, to the record sale of a Stradivarius violin.

In tandem with his increasingly conspicuous activities as an artist, Gillick has also been making an international name for himself as a teacher. As well as working as an adjunct professor at Columbia University and a visiting tutor at Lausanne, from 1996 to 1998 he also utilised his web of art-world connections as organiser of an external visitors' programme of weekly lectures, inviting a wide range of artists and curators to visit his *alma mater*, Goldsmiths. It is appropriate to Gillick's idea of art as an activity in flux that he should make his influence felt through the presence of others.

MARTIN MALONEY
Artist, Curator and Writer

Martin Maloney
with his
**Untitled Portrait
(Orange)**
1996
oil on canvas
110 × 173 cm
Photo: Andrew
Montgomery

Martin Maloney is one of the most blatant members of an increasingly mongrel British art scene who no longer consider it bad taste to draw attention to oneself – and where artists simultaneously write, curate and create in order to do precisely that. All Maloney's activities feed into each other in a way that reflects an increasing tendency for art to merge with milieu and lifestyle. Since studying art at Central St Martins and Goldsmiths, he has boosted his own career as an artist by identifying, writing about and curating shows of what he dubbed 'Wannabe' art. These exhibitions, showcasing his own work and that of his contemporaries, were initially held in the grungy surroundings of his flat, and employed unforgettable titles such as *Multiple Orgasm, White Trash, Gothic* and *Guess Who's Coming to Dinner?*

According to Maloney, Wannabe art is 'made with a simplicity of materials and an imagination spawned in the boom-times. Everything is relaxed: it's okay to be dumb and to like things just because they look good.' There's nothing reticent or tasteful about Maloney's lapel-grabbing approach: his often enormous paintings are deliberately 'bad' ('they hover half-way between colouring-in and expressive painting' he has said), and his writing is unashamedly blunt ('I look at the work of Jake and Dinos Chapman and I feel deep embarrassment and utter boredom', he stated in *Flash Art* in January/February 1996, sparking a spat with the artists).

So far, these tactics seem to have achieved their aim. From April to December 1995, the art world trekked out to Maloney's home-gallery, Lost in Space, and now his squiffy portraits and wobbly crowds of figures are given individual exhibitions in white-walled galleries. He held his first solo show at Anthony d'Offay in January 2000, and a year before, exhibited a painting alongside works by many of his former Wannabes in a show at the ICA entitled *Die Young, Stay Pretty*. The works of artists who received his early support, such as the pin-up-meets-Manga-cartoon cut-out figures of Jun Hasagawa, the text and pattern paintings of Peter Davies, and 1998 John Moores Prize winner Dan Hays, have been snapped up by leading dealers and are housed in major collections.

Maloney's modus operandi – as well as his work – struck a particularly strong chord with Charles Saatchi at a point when the collector was moving

into a new phase of art acquisition. Not only did Maloney put on his writer's hat to pen an essay on the last decade of British art for the 1997 *Sensation* catalogue, but he was also the only one of two artists to be included in both the *Sensation* and *Neurotic Realism* exhibitions. Other evidence of his special place in the affections of Britain's major contemporary art patron can be found in the wonky, Y-fronted figures of Maloney's *Rave (After Poussin's Triumph of Pan)* (1997), cavorting across the cover of Saatchi's book *The New Neurotic Realism* (1998), as well as the high incidence of Maloney-supported artists nestling between its covers.

JEREMY MILLAR

Artist, Curator and Writer

'For me, art is important because it is art – which means that it can be many things simultaneously', says Jeremy Millar. The same could be said of his own writing and curating, in which multiplicity, complexity and 'difficulty' are emphasised and celebrated rather than simplified and tidied away. A case in point was the exhibition that first put Millar on the art-world map: the 1994 *Institute of Cultural Anxiety* at the ICA in London. This was a show based on uncertainties rather than absolutes, which deconstructed the ICA into a seemingly free-form installation (with no partition walls or dividers), while at the same time questioning the museum/gallery's role as a preserver and presenter of knowledge, with a twitchily eclectic selection ranging from the written work of J.G. Ballard and pieces by Hans Haacke, Thomas Grünfeld and Hieronymous Bosch, to Ross Sinclair's T-shirts, Mat Collishaw's projected canary in a real cage, and a Jean-Michel Jarre soundtrack in place of an acoustiguide. (In characteristic Millar style, this contemporary cabinet of curiosities had in fact been meticulously placed and selected to overlap with, and coalesce into, wider conversations about the accumulation and presentation of knowledge.)

RIGHT: Norman Rosenthal

Millar isn't squeamish about embracing a big idea, pulling out all the stops to show just how limitless its scope can be. Probably his most ambitious project to date was *Speed – Visions of an Accelerated Age* (1998), held both at the Whitechapel and at The Photographers' Gallery, which brought together objects, images and texts from a wide range of people, disciplines and eras, to complement a subject that is, by its nature, ever-changing. For,

as he says: 'A broad collection of views on a subject demonstrate its multi-plicity, its simultaneity, without neutralising it or rendering it safe.' He is especially sceptical about splits between art and science, and perhaps that is why he has spent so much time working with photography, which can be either – or both. During his time as curator at The Photographers' Gallery, from 1995 to 2000, Millar was instrumental in promoting the gallery's trans-formation into a revitalised site for presenting important contemporary prac-titioners, as well as a forum for debates surrounding the medium. He gave both Roman Signer and David Shrigley their first London solo shows in 1997 and his other group shows have included *Blue Suburban Skies* and *MayDay* (both 1999). In *MayDay*, Black Panther Posters, Situationist International graphics and images of Poll Tax riots were among the items demonstrating the use of photographic media as a means of revolt. His first show since becoming freelance was characteristically broad in scope: *Media-City 2000*, co-curated with Hans Ulrich Obrist and Barbara London, held in Seoul (September 2000).

Millar's own writings about art are characteristically multifarious. 'Each time I'm commissioned, it's to write something in parallel to the work, or through it, or from it, but rarely on it', he says. Sometimes, this has taken the form of a piece of fiction or, as with his text for Keith Tyson's 1999 Delfina show, was full of word-play and tricks whilst matching Tyson's formidable range of references. Amidst all this, Millar plans to continue working as an artist himself – something he sees as complementary to, and even emanat-ing from, his engagement with the work of others. Quite what form this art will take remains to be seen.

NORMAN ROSENTHAL

Exhibitions Secretary, Royal Academy of Arts, London

The Royal Academy, bastion of the English art establish-ment, received an unlikely blast of the new when it appointed the feisty, indomitable Norman Rosenthal in 1977. 'I like all art, old and new. I never studied art history as an undergraduate and I'm quite proud of that', he declares. 'I'm an amateur in the old-fashioned sense.'

Rosenthal had already made his mark as Exhibitions Director at the ICA (his bloodstains from some skirmish

with a colleague can still be seen on the walls of the Institute's mezzanine offices, lovingly preserved behind Perspex), when he was approached by the RA, which, at that point, had sunk to such a level of stagnation that it was considering renting itself out to Sotheby's. An exhibition of Robert Motherwell (1978) pointed the direction of things to come, and in 1978, Rosenthal relaunched his career – and the new reputation of the Academy – with the exhibition *Post Impressionism: A New Spirit in Painting*. Co-curated with Christos Joachimides and Nicholas Serota, it has gone down in history as one of the key triggers of the 1980s painting revival. Since then, as well as organising major historical exhibitions ranging from medieval treasures to Monet, he has continued to put himself in the hot seat and the Academy on the international contemporary art map with a series of big-theme survey blockbusters of twentieth-century German (1985), British (1987), Italian (1989) and American (1993) art; and, more audaciously, *Sensation* (1997), which featured some 150 works by many of the more flamboyant young British artists from the Saatchi Collection.

Rosenthal's legendary pugnaciousness and showmanship was given full throttle in the now infamous rows and resignations spawned in the wake of *Sensation*. Although the so-called British art phenomenon was by then nearly a decade old, for better or for worse, *Sensation* lived up to its title as Saatchi's holdings found a temporary showcase in the historical home of British art. Three years later, *Apocalypse* (September 2000), Rosenthal's next contemporary art extravaganza at the Royal Academy, which puts new work by young British artists such as the Chapmans, Darren Almond and Angus Fairhurst alongside big names of past decades such as Mike Kelley, Richard Prince and Jeff Koons, showed that Rosenthal had lost none of his boldness and ability to ruffle feathers. It is a rare coup for the most experimental of British art to have a friend in such conservative quarters. After all, what other *Chevalier de l'ordre des arts et des lettres de la Republique Français, Cavaliere ufficiale della Republica Italiana* and recipient of the *Bundesverdienstkreuz* would be found on a Saturday night crushed into the Scala in King's Cross to watch art bands owada and Big Bottom?

ANDREA SCHLIEKER

Curator

Andrea Schlieker began her career at the Arnolfini and the ICA in the 1980s. From 1988 to 1995, she was Assistant Director of the Serpentine Gallery, where she curated solo shows of Hamish Fulton (1991), Richard Serra, Ulrich Rückriem, Richard Wentworth (all 1993) and Helen Chadwick (1994). Now, as a freelance curator, she is therefore well-versed in dealing with large-scale projects, which often involve intricate and protracted negotiations with public bodies over site, design and funding. A case in point was Rachel Whiteread's *Holocaust Memorial* for Vienna's Judenplatz, on which Schlieker worked as Project Co-ordinator from 1996 and which, after interminable stoppings and startings due to changing political circumstances and the delicacy of subject and site, was finally inaugurated in 2000. Nearer home, Schlieker introduced American artist Rita McBride to Britain with *Arena*, a permanent, large-scale sculpture in Manchester, part of the Irwell Sculpture Trail, inaugurated in 2000. She was also curatorially involved in two of Antony Gormley's major public works, *Angel of The North*, unveiled in 1998, and *Another Place*, 100 steel figures placed in the North Sea in Germany, 1997.

All Schlieker's powers of diplomacy and negotiation were put to the test in her role as curator for the Millennium Dome's North Meadow Sculpture Project. Lengthy approval procedures and funding problems made the time margin dangerously narrow for the completion of seven British works on the scale of Richard Wilson's *Slice of Reality*, in which a dredger has been vertically sliced from bridge to hull, Anish Kapoor's 8-metre *Parabolic Waters*, or Gormley's 30-metre-high *Quantum Cloud*.

Since 1992, Schlieker has been a juror on the prestigious DAAD (German Academic Exchange Service) scholarship programme, in which artists are given a fully funded year's residency in Berlin. Among the British artists who have received an often early career boost from Schlieker's successful nomination were Rachel Whiteread (1992-3), Damien Hirst (1993-4), Douglas Gordon (1996-7), Jane and Louise Wilson (1994-5), Willie Doherty (1999-2000) and Tacita Dean (2000-01). As the curator of a major 2001 exhibition of British art at the Galerie für Zeitgenossische Kunst in Leipzig, Schlieker continues to provide a bridge between British and European art both inside and outside the conventional gallery space.

JOHNNIE SHAND KYDD

Photographer

Most art-world gatherings, whether large or small, private or public, are illuminated by the light of a flash-gun. Frequently, the photographer zeroing-in on the action is the lofty figure of Johnnie Shand Kydd, ubiquitous presence and chronicler of London's artists at work and play. After several years spent selling nineteenth- and early twentieth-century British art within the staid confines of the Fine Art Society in Bond Street, Shand Kydd brought a whole new clientele to this venerable establishment when, in 1995, he organised an exhibition of images, artworks and artifacts commemorating the late designer, performer and subcultural icon, Lee Bowery.

Shortly afterwards, Shand Kydd left the world of Bond Street art dealing. Through his friend Lorcan O'Neill, who was then a Director at Anthony d'Offay Gallery, Shand Kydd was already immersed in the burgeoning London art scene and, 'relying on autofocus, flash and an alcoholic bent', he began to photograph his friends in their homes and studios, at gallery openings and in their favourite watering holes. He has never made any claims to be either systematic or professional – quite the opposite in fact. But what his scattergun approach lacks in method and technique, it gains in images of surprising intimacy and immediacy. Their very roughness seems appropriate to the current mood, and it was a strange sensation to see the milling, drinking crowds at *True Brits,* his 1996 show at the IAS exhibition, mirroring their own images on the walls. These scenes were later brought together in book form in *Spit Fire* (1997), which provides an almost voyeuristically compelling view of a well-oiled seventeen months in the British art world.

As the worlds of art and celebrity collide, there is an increasing demand for images of artists as well as of their work. However, whereas other photographers of artists – Gautier Deblonde for example – pursue a definitive image or essence of their subject by painstaking scrutiny and repeated visits, Shand Kydd presents a kaleidoscopic total immersion in their milieu. Beyond his role as party paparazzo, it was the way in which Shand Kydd captured the energy, the friendships and the essential atmosphere of a circle of artists that prompted Norman Rosenthal to commission him to take the portrait photographs for the 1997 *Sensation* catalogue. Although they made no pretence at formal portraiture, these playful, on-the-hoof studies have also caught the attention of curators at home and abroad, from the National Portrait Gallery, London, to the Parko Gallery, Tokyo.

GAVIN WADE

Artist, Curator and Writer

Since he graduated from Central St Martins in 1994, Gavin Wade has moved comfortably between making art and curating exhibitions. Increasingly, his own work co-exists with that of others, often taking the form of DIY-like structures upon which the artworks of collaborators may be presented. Wade describes his practice as having two strains: 'finding new sites for art' and 'creating new sites for art'. In the former, more accessibly public category, exhibition venues have ranged from the pages of *Zing Magazine* (No. 8, 1999), to the retired warship HMS Plymouth in Liverpool. For the latter show, (*Kling Klang* 1998), Michelle Griffiths transformed herself into a human figurehead, while Mike Nelson augmented the memorabilia in the ship's museum with artifacts belonging to a Hell's Angel gang.

Wade's creation of new sites for art consists of what he describes as 'tough concept shows', such as *2 in 1 (4+1)* (1998), in which his curatorial intervention took the form of four open structures made from 2 × 2 inch timber in the shape of square, rectangle, trapezium and triangle. These presented a conceptual and physical basis for the participating artists: Gary Perkins, Kate Belton, Richard Reynolds and Keith Wilson, while the viewer was provided with the final element – a long bench to sit on. This use of a physically evident springboard for more complex ideas is characteristic of Wade's projects on all scales. *Low Maintenance/High Precision* (1997) shook up two trends in current art practice: the precise and highly finished, and the wonkily untidy. Pieces such as Tomoko Takahashi's orchestrated rubbish or Ian Dawson's blowtorched plastic were shown in a pristine space (Hales Gallery), while strivings for neat resolution such as Rachel Lowe's *65 × 65*, a video of her attempt to draw the moving images of racing cars as they sped across a screen, or Mark Titchner's hand-measured, fractal-graph drawings, were shown in the dilapidated surroundings of a derelict shop.

Wade's particular brand of imaginative pragmatism came into its own with his ambitious project, *In the Midst of Things* (1999), co-curated with Nigel Prince. This placed the work of twenty-eight artists of all backgrounds throughout the buildings and grounds of Bournville village, Birmingham, in order to explore the role played by a fusion of art, design and architecture in the formation of utopias. Increasingly, Wade is being invited to curate as many shows abroad as in the UK, allowing him to expand the framework in which he operates, within both alternative and art-establishment sites.

THE DEALERS

TO A GREAT EXTENT, IT HAS BEEN COMMERCIAL GALLERIES THAT HAVE TAKEN THE LEAD IN SHOWING THE RADICAL ART OF THE MOMENT. THE FOLLOWING IS A SAMPLE OF THE MOST PROMINENT DEALERS.

SADIE COLES

Director/owner, Sadie Coles HQ, London

Sadie Coles
Photo: Johnnie Shand Kydd

Sadie Coles started making waves in the art world when, during her five-year stint as a director of Anthony d'Offay Gallery, she not only worked with the likes of Gilbert and George, but also set up and ran d'Offay's young artists programme, which provided a plush West End showcase for underexposed practitioners from the US and the UK. Among the shows curated by Coles were specially commissioned projects from Americans Joseph Grigley, Andrea Zittel and Janine Antoni – who wove a 'dream' blanket and painted with her hair – while young Brits benefiting from this early and prestigious exposure included perverse potmaker Grayson Perry, and Sarah Lucas, with whom Coles continues to work. In 1996, Coles parted company with d'Offay to work with one of the gallery's key artists, Jeff Koons. During this time, she also consolidated the close transatlantic links that would be such a mainstay of HQ.

Back in the UK in under a year, Coles opened HQ, just off Piccadilly, in April 1997, with an exhibition of American artist John Currin's richly painted, massive-breasted, caricatured women. This was followed by two simultaneous exhibitions of Sarah Lucas: *Bunny Gets Snookered* in the gallery was presented in conjunction with *The Law*, which brought together larger Lucas pieces, such as her self-humping Ford Capri, in an appropriately grungy Clerkenwell warehouse. Since then, HQ has gone from strength to

strength. The gallery continues to focus on American and British artists who embrace popular culture, while often pushing the language of art into unexpected places. Simon Periton's giant Day-Glo doilies depicting barbed wire, guns and anarchist symbols; Angus Fairhurst's multifarious sounds and visions; Glasgow-based Jim Lambie's explorations of the altered states provided by music and club culture, have all been shown at the gallery. Coles' American line-up includes Elizabeth Peyton's lusciously idealised oil portraits of iconic figures from past and present; Andrea Zittel's art as life projects; the disquieting sculptures of Keith Edmier, who in another life worked in Hollywood special effects; and the painted jokes of Richard Prince, *eminence grise* to younger generations on both sides of the pond.

The straight-talking, down-to-earth Coles knows exactly what she wants and likes, and one of her smartest early moves was to bring in Pauline Daly to help her run HQ. Not only is Daly, who studied art at the Slade, involved in every aspect of HQ's day-to-day business, but she's also a key art-world presence in her own right, a friend and muse who crops up everywhere, whether as one of Gary Hume's favourite models, a conspicuously dancing figure in Sam Taylor-Wood's video *3rd Party*, or as a dancer/performer in Angus Fairhurst's art band, Lowest Expectations.

Coles is also a close friend and contemporary of the artists she shows, as well as many that she doesn't specifically represent, such as Jake and Dinos Chapman. It was to Coles that the brothers turned for advice when setting up their exhibition space Chapman Fine ARTS in Spitalfields, and she went on to organise both David Falconer's pile of resin mice and the Chapman's GCSE examination exhibition there. These days, the hippest young commercial galleries tend to collaborate rather than compete with each other, and Coles has also teamed up and/or arranged gallery swaps with sympathetic colleagues at home and abroad, such as Gavin Brown and Andrea Rosen in New York, the Modern Institute in Glasgow, and Berlin Contemporary Fine Arts. With characteristic flexibility, she's also committed to a policy of organising off-site projects that complement the gallery's programme. In addition to *The Law,* she has organised a sound and film installation by Angus Fairhurst in a nearby unused office; drawings by Nicola Tyson in an empty shop in Carnaby Street; and *Drive By: five artists from Los Angeles*, which Coles curated for the South London Gallery in April 1999.

Another good friend is restaurateur Oliver Peyton, who originally lent Coles the money to convert HQ into a gallery. Coles acts as (unpaid) advisor on his growing collection of international and emerging artists, which adorns his London and Manchester restaurants as well as his headquarters

and his home. It was Coles, for example, who was instrumental in commissioning Richard Prince to produce his largest ever (3 × 5 metre) *Cowboy* for the Peyton's Isola restaurant in Knightsbridge, and no purchase or commission by Peyton for his gastro empire takes place without Coles' say-so. Although many items in Peyton's collection come from HQ, she also selects pieces from other sources, and the fact that her recommendation can lead to considerable purchases from different dealers is another means by which Coles' influence spreads way beyond her first-floor space in Heddon Street.

PAUL HEDGE & PAUL MASLIN

Hales Gallery, London

Paul Hedge was pounding the south London streets as a postman and Paul Maslin was working in the City when, in 1990, they decided to join forces and convert a derelict building in Deptford High Street into an art gallery. 'I believed that this was as fine a place as any to set up an art gallery – if the work was of quality then people would come', says Hedge. Undeterred by lack of capital, clients and experience, in 1992 the duo opened Hales Gallery, a basement space with a café upstairs. 'We were both interested in urban regeneration and providing a cultural context for art, but the last thing we wanted was to be some awful community gallery – the café seemed a way to connect with people in a real way.'

To begin with, Hedge did most of the cooking as well as selling the art (before joining the Royal Mail he'd taken a Fine Art degree at Goldsmiths), while Maslin (who has a degree in economics from Cambridge) organised the business side. Their contrasting role models were Maureen Paley and Matt's Gallery: 'both operating at either ends of the spectrum, with her 80s wheeling and dealing and his 70s purity, but both functioning successfully in the middle of nowhere.' Now, Hedge and Maslin are full-time art dealers (although the ebullient Hedge tends to provide the gallery's more public face). Hales Gallery and Revival Café are attracting clients aplenty, whether major collectors (Frank Cohen and Charles Saatchi are keen patrons) making their way to Deptford, or locals and market traders, who continue to find Hales a handy place to eat and drink.

In its time, Hales has provided a platform for many young British artists: the Chapman brothers, Sarah Jones and John Frankland all had early shows there. However, all of the above are now represented by other galleries, and with its increasing success, Hales has had to weigh up the pros and cons of remaining in the depths of South London when many artists and collectors find central locations more convenient. 'We've thought seriously about moving into the West End', Hedge admits, 'but I think we'd lose more than we'd gain – where we are is what's made us different – and made us stand out. Its a bit like coming out to the factory shop: you can find something good value and really wonderful.' Rather than shift out of Deptford, Hedge and Maslin prefer to go along with the current spirit of inter-gallery co-operation, collaborating with a variety of other organisations both within the UK and abroad. This has resulted in a two-part *Nature/Culture* show with Gimpel Fils; an exhibition of photography at Hamilton's Gallery, and many Hales artists crop up in other spaces. The ubiquitous Tomoko Takahashi, for example, has made work in Lift Gallery, Entwistle, and Tablet as well as at the Saatchi Gallery. 'We're a cuckoo in so many nests', says Hedge.

JAY JOPLING
Director, White Cube Gallery, London

Jay Jopling
Photo: Fergus Greer

The rise of Jay Jopling can only be described as meteoric. From selling secondary-market Minimalism out of a small house in Brixton in the late 1980s, he is now established as one of the key figures on the current British, as well as the international, art scene. Although he was originally best known as the dealer of Damien Hirst, Jopling has also promoted the burgeoning careers of Marc Quinn, Tracey Emin, Gavin Turk and Sam Taylor-Wood (now his wife), as well as reaping the rewards of taking on Gary Hume when the artist made the transition to his current style. In addition, during the 1990s, Jopling cannily added some ballast to his reputation at home and abroad by taking on two older, widely respected artists, Antony Gormley and Mona Hatoum, while at the same time working both ends of the art world to his advantage by using his small but perfectly formed West End gallery, White Cube, as a project space for young newcomers such as Darren Almond (who,

in February 1997 filled it with an outsize ceiling fan), Steven Gontarski and Neal Tait, as well as the setting for specially invited shows of international heavyweights like Richard Prince, Gary Hill and Lari Pittman. Now, Jopling's expansion east into the pristinely converted lofty industrial space in Hoxton, White Cube², means that his premises can at last match the scale of his enterprise. (At the same time, and for the foreseeable future, Jopling maintains his original White Cube as a foothold in the West End.)

It was while he was studying History of Art at Edinburgh University that Jeremy Jopling first got the chance to flex his entrepreneurial muscles. In April 1986 – the same year as 'Band Aid' – he and two friends staged 'New Art, New World', a charity art auction held in London and beamed live by satellite to New York, which raised £500,000 for Save the Children. One of Jopling's jobs had been to visit New York to persuade the likes of Julian Schnabel, Keith Haring and Jean-Michel Basquiat to donate works, and the twenty-one year old student found a natural affinity with the edgy glamour of 1980s Manhattan, as well as the cut and thrust of the booming art world.

After a brief flirtation with film production, Jopling turned his attention to art dealing. Having no money to set up shop, he dabbled in the secondary market, while at the same time closely observing the new generation of young artists who were coming out of Goldsmiths College and were putting on slick shows in empty industrial buildings in and around London's docklands. Suddenly, it seemed a positive advantage not to be tied to a gallery space. 'I realised that I wanted to work with artists on a project-by-project basis.' His debut as a contemporary dealer was made in 1988 when he put on a warehouse show of bronze sculptures by Marc Quinn, the artist who was later to gain widespread notoriety by making a self-portrait head out of eight pints of his own frozen blood.

But Jopling's real turning point can be summed up in two words: Damien Hirst. They met at an art opening, discovered that they both lived in Brixton and loved Leeds United, and the lanky old-Etonian and the rude boy from Leeds became inseparable. That was back in 1991, and for the first half of that decade, Jopling lost none of his capacity to pull off ambitious projects. As well as encouraging Hirst's elaborate forays into animal preservation, in 1993, in the midst of the recession, Jopling gave unknown Goldsmiths graduate Itai Doron his first show in a vast Canary Wharf warehouse, which the young Israeli artist transformed into a spectacular sci-fi fantasy, complete with snowstorms, space ships and mutant mannequins. And when Gavin Turk created a life-size waxwork of himself as Sid Vicious in the stance of Warhol's Elvis (*Pop* 1993), it was Jopling who raised the fabrication funds

and then sold the piece to Charles Saatchi – just one of many such successful transactions between this dealer and the collector.

Although White Cube still handles much of his art, Hirst now has his own company to manage his increasingly multifarious concerns, and he and Jopling are no longer joined at the hip. Over the last few years, Jopling has increasingly channelled his energies into buying and selling and, as a result, he has evolved from boyishly enthusiastic, but nonetheless slick, impresario into his current more conventional incarnation of solidly established art dealer. Up to 2000, as Jopling carried out his wheeling and dealing and partied in ever more glamorous international celebrity circles, the figure who actually dealt with the artists themselves was White Cube's co-founder, Julia Royse. Now, Royse, who trained as an artist and worked at Chisenhale Gallery before joining forces with Jopling when he was still based in his home in Brixton, has left to follow her own path. When White Cube was based solely in the West end, it was Royse who was responsible for managing and maintaining its fast-turnover programme. With the gallery currently facing the challenge of combining a swankier space with a rougher location and presenting just the right combination of blue chip and edgy grit, her contribution will be missed.

NICHOLAS LOGSDAIL

Director, Lisson Gallery, London

Nicholas Logsdail
in the Lisson
Gallery

Photo: Andrew
Dunkley

The fact that the Lisson Gallery has survived and flourished for over thirty years is due to the single-mindedness (some may say bloody-mindedness) of its founder-director Nicholas Logsdail. The Lisson may now be a major presence in the international art market, but Logsdail continues to treat it as a personal obsession as much as a commercial venture. The forty or so artists he represents – from Sol LeWitt to Douglas Gordon – reflect his longstanding crusade to promote the most hard-line Minimal and Conceptual art and its contemporary legacy. He's the man who represents the 'New British Sculptors' who sprang to international prominence in the early 1980s – Richard Wentworth, Tony Cragg, Richard Deacon, Anish Kapoor and Julian Opie are all on his books. And while he's not complaining that many members of his stable have walked off with the

Turner Prize, Logsdail's approach is more akin to that of an evangelical museum director than an art dealer – in his book, speculative buying is a no-no: 'art is not a commodity, it is a cultural artifact'. Whether he's presenting the latest video by the Wilson Twins, paintings by Jason Martin, or the work of one of his more established artists, it tends to look more like a museum exhibition than a commercial show.

There's no doubting Logsdail's historical role in today's art world as the fervent internationalist who gave early British exposure to such Conceptual and Minimalist luminaries as Robert Ryman, Carl Andre, Donald Judd, Dan Graham and Dan Flavin, to name but a few. But just as crucial is Logsdail's obdurate Englishness, which has led to an equally forcible and influential demonstration that the modernist traffic between America and Europe can flow both ways. His house is furnished not with pieces of high-modernist Bauhaus, Corbusian chrome, or even chairs and tables by Donald Judd as one might expect, but with the progressive, Edwardian Arts and Crafts furniture that pointed the way to all of them. This is in keeping with the tendency of many of his chosen artists to combine the legacy of austere international art movements with eccentric details of British domesticity – whether the lowliest of DIY-store carpet and linoleum, pots of household paint and galvanised steel buckets, or lurid wrappers from a range of chocolate bars.

Logsdail's intensely personal connection to his gallery has deep roots. He describes its origins as 'a student adventure' that began in April 1967, when, depressed by London's dearth of contemporary art spaces, Logsdail and a group of fellow Slade school students – including Derek Jarman with whom he had shown in *New Contemporaries* that year – decided to hold some informal shows of their work in a dilapidated building at 68 Bell Street, near Marylebone Station. What has now become standard practice for young artists was less usual back in 1967: as a direct result of organising his first exhibition, Logsdail lost his place at the Slade. However, as the Bell Street building was his home, he continued to stage shows that even in the gallery's first year pointed to his future ambitions by mixing art-school friends with such internationally active figures as Yoko Ono and David Medalla.

'I had no formal business training and still don't ... the structure of this place was very much my own individual creation. It has broken many of the rules and successfully done so maybe because I didn't know what the rules were.' These quirky origins are still embedded in the Lisson's philosophy. The boss may no longer be an artist, but it's not difficult to see the direction in which these impulses have been transferred. Sometimes his obsessive devotion to the gallery can drive his staff mad. For many years he actually

lived there, and his current home is still just a few blocks further along the persistently down-at-heel Bell Street, which continues to house the gallery.

The extent to which the Lisson is a law unto itself and its Director was confirmed in November 1991 when Logsdail celebrated the gallery's twenty-fifth anniversary by opening, without any backing and in the middle of a major recession, five floors of a brand new, purpose-built space designed by Tony Fretton that looks more like a public museum than a commercial gallery. As has so often been the case with Logsdail, a seemingly kamikaze act evolved into a sound career move.

MARTIN MCGEOWN & ANDREW WHEATLEY

Cabinet Gallery, London

It's always a tricky transition for a gallery to move from the margins into the mainstream without losing its experimental edge. When Martin McGeown set up the Cabinet Gallery in 1992 in two rooms of his Brixton flat, he described it as 'like editing a magazine – I couldn't afford to put out a maga-zine and so I painted the walls white and treated them as pages instead'. Cabinet's early programme reflected McGeown's interest in the abject; he had spent several years in Paris, writing and pursuing his love of Georges Bataille. 'We wanted to provide a showcase for art that has no place in the present system', he declared at the time. 'The debased, the profane, the inde-fensible – all those things that recent art has chosen to ignore, but which obsess the rest of society.' In the first year of Cabinet's existence, McGeown joined forces with Andrew Wheatley, who was working in arts administra-tion and who responded to the Cabinet penchant for the dark and obsessive.

One of the gallery's earliest shows was called *From Hell*, and whether Cabinet was presenting the voyeuristic, hermaphrodite self-portraits of the French photographer Pierre Molinier, or John Cuss' psycho-geographical maps, the atmosphere was strictly twilight zone, striking a sympathetic chord with artists, critics and curators in the UK and abroad. McGeown's extensive, arcane library was another draw. There's no doubting the careful thought behind Cabinet's maverick activities; the gallery saw itself as operat-ing within a time-honoured tradition of intellectual enquiry and dissent.

In 1999, Cabinet shifted from a first-floor tenement off Coldharbour Lane to 1,000 square feet of specially converted garage space in Clerkenwell, evolving through McGeown and Wheatley's labour of love into a fully functioning gallery. It now puts on a programme of exhibitions, takes part in art fairs across the world and represents an international line-up of artists – Jeremy Deller (UK), Martin Creed (UK), Gillian Carnegie (UK), Lily Van der Stokker (NL) and US artist Rob Pruit. The opening show consisted of several thousand white balloons: Martin Creed's *Half the Air in a Given Space*, and the atmosphere was anything but dark. But the space still quivered with the Cabinet's spirit of unsettling ambiguity. 'I'm interested in mood swings – galleries need to respond to the mixed feelings of modern life', says McGeown, who sees no inconsistency with Cabinet's earlier incarnation: 'that position was then the dominant mood'. Cabinet may have taken a more extrovert direction, but as long as it continues to work with artists such as Martin Creed and Jeremy Deller, it can always be guaranteed radical status.

JAKE MILLER
The Approach, London

'I had an idea of what a good gallery should be and what it should look like – but I hadn't a clue about running one', says Jake Miller, who was making his own paintings and working as an assistant to Michael Craig-Martin when he was first shown the function-room above The Approach Tavern, a traditional Victorian pub in Bethnal Green. 'I just knew that I wanted to have a place to show art that was special, that people would talk about. The room was perfect – beautifully proportioned and not austere or intimidating.' With the support of the pub landlords – who recognised the benefit of thirsty art-world crowds on opening nights – The Approach opened its immaculately renovated 800 square feet in March 1997. But in spite of Miller's inexperience, and although The Approach began as a shoestring venture kept afloat by benign landlords and sponsorship from breweries such as Whitbread, this gallery has always felt very different from most rough-and-ready 'alternative' East End spaces.

Right from the start, The Approach has put on some of the best and most adventurous shows in town, both of relative unknowns and artists who are just starting to make a name for themselves. Some, like Michael Raedecker, who had his first UK solo show at The Approach, have gone on to become

internationally successful; while others, such as Enrico David, are likely to do so. Both these artists are now represented by The Approach, as are a number of others, including Dan Coombs, Gary Webb, Martin Westwood and Emma Kay. Almost without realising it, Miller, who now runs the gallery full time, has transformed it from non-profit-making art space to a successful gallery, attracting major collectors and mounting sell-out shows. However, for all its acquired prestige, The Approach is still a room above a pub, which can only be entered through the busy bar, and being commercial has never been a major priority. Paradoxically, this is one of the keys to The Approach's success. Low overheads and Miller's own commitment to put on shows that 'I want to see' have resulted in an ongoing number of exhibitions that generate considerably more interest than sales. These have included *It's a Curse, It's a Burden* (1998-9), guest-curated by painter Glenn Brown, which brought together international blue-chippers George Condo and Mike Kelley with relative newcomers such as Keith Tyson, Rebecca Warren and the art band Add N to (X); and the transformation of the gallery into a showcase for the artist/writer's collective, Inventory.

Miller's instincts about what makes a good gallery have proved correct, and by learning the business of the art world on his feet, he's evolved the particular blend of professionalism and informality that makes The Approach so unique. The same description could apply to Miller himself, who is surprisingly unassuming for the author of such a success story.

VICTORIA MIRO

Victoria Miro Gallery, London

Even as a painting student at the Slade, and later as an art teacher, Victoria Miro was always 'fascinated' by galleries. She set up her Cork Street space in 1986, originally working closely with Simon Cutts, formerly of Coracle Press. At the beginning, an important model was Konrad Fischer's ground-breaking Gallery in Düsseldorf. 'This was a gallery with a clear vision that was not affected by fashion, and which was supportive to all its artists', she remembers. Initially, Cutts and Miro focused on Conceptual art, but when they split in the early 1990s, she began to show a more diverse group. The current line-up reflects the evolution of her vision, from the idealistic monuments of veteran Ian Hamilton Finlay, to Cecily Brown's luscious paintings, Doug Aitken's overwhelming videos and the intimate works of Chantal Joffe.

Miro's instincts have served her well and her gallery has many of the art world's major names, both young and middling, on its books. Over a decade ago she picked out Andreas Gursky for a group show; since 1994 she has represented Peter Doig, and it was in this same year that Miro first showed the work of Chris Ofili, who has gone on to be one of the gallery's most prominent artists. Although they have since parted company with the gallery, the Chapman brothers were also launched at Victoria Miro. Jake Chapman originally worked for Miro as a technician when he was an art student, and for several years the gallery received considerable criticism – as well as sales – from the controversy surrounding their genitally-misplaced mannequins.

From the outset, Miro's emphasis was on representing leading artists from the UK and elsewhere. The outlook of the gallery has remained resolutely international – Miro even ran a second gallery in Florence in the early 1990s – and alongside her young Brits are Thai artist Udomsak Krisanamis, German Thomas Demand and Australian Tracey Moffatt. The overseas profile of the gallery is also helped by Miro's Co-director Glenn Scott Wright, who now does much of the travelling and forging of relationships with overseas artists, curators and collectors. Scott Wright, who originally worked with Maureen Paley before branching out as an independent art consultant, had collaborated with Miro for three years before becoming a Director in January 1997, and the partnership seems to suit both sides: 'we get on well and share the same sensibilities – it just seems comfortable.' The third Director, Miro's lawyer husband Warren, is also closely involved with the gallery. Both Miros take a keen interest in the spaces in which art is shown. Cork Street, Florence, and the Miro's house in Hampstead – which houses their private collection – were all converted by Minimalist architect, Claudio Silvestrin.

For the renovation of Miro's new premises, a three-storey Victorian factory building in Islington, Miro and the architect worked in close collaboration with the artists who show there, whom all three Directors agree are the main focus. 'The greatest pleasure of running a gallery is having proximity to the artists', says Miro. Even though she has had to pay Cork Street overheads for more than a decade, she is adamant that 'it's important for all galleries to do shows that aren't commercial – it's about a critical dialogue'. To this end, she has mounted shows of US ultra-radical Hans Haacke (1988), put on performances and videos by Marina Abramovic, and in 1999 gave filmmaker Isaac Julien his first solo gallery show. When Karsten Schubert closed his space in 1997, Miro stepped in to host a highly risky exhibition of the barely-there works of Martin Creed. 'Some galleries act like commodity dealers, waiting until an artist is worth a lot of money. That isn't our style.'

ANTHONY D'OFFAY

Director, Anthony d'Offay Gallery, London

Anthony and Anne d'Offay
Photo: Timothy Greenfield-Sanders

Anthony d'Offay launched his commercial career in 1961 when he used £260 compensation money awarded for a swimming-pool accident to buy up the books and papers of two obscure, *fin-de-siècle* poets from the circle of Oscar Wilde. The twenty-one year old son of a surgeon was then a student of modern languages at Edinburgh University and, having used his summer holidays to produce a meticulous catalogue, he subsequently sold the material on, very successfully. Now, the likes of Susan Sontag and David Sylvester write his catalogues, and he represents artists from Jasper Johns, Andy Warhol and Joseph Beuys to Ed Ruscha, Jeff Koons and Rachel Whiteread. But d'Offay has always maintained both his ability to seize the moment, and his astute awareness of the profits to be made by establishing a historical context.

Anthony d'Offay's route to his current status as Britain's foremost dealer in international contemporary art has been a circuitous one that has found him drawing on a complex web of interests and opportunities. He opened his first gallery in 1965 in a few tiny rooms in Vigo Street, Piccadilly, where his focus moved from archive collections and small shows of Symbolist art to the kind of early twentieth-century British work that he had first encountered as a child when visiting the local museum in his home town of Leicester. 'I was moved by the Epstein sculptures at the Museum, and I loved the English paintings from the Camden Town School.'

In the 1960s, British art from the late nineteenth- and early twentieth-century was largely overlooked, and therefore cheap to purchase, and d'Offay opened his new gallery at 9 Dering Street in 1969 with the exhibition *Abstract Art in England, 1913-1915* – the first major show of Vorticist art for more than fifty years. Over the next decade, he established himself by specialising in, and reviving the reputation of, the forgotten artistic figures of Bloomsbury, Camden Town and Vorticism such as Duncan Grant, William Roberts and John Nash, with his usual mixture of intense personal interest and keen financial acumen.

Although in the early 1970s he had begun to represent some younger living artists – Lucian Freud, Michael Andrews, Cecil Collins and William Coldstream – what shifted d'Offay's vision into the present, and his gallery

into international success, was his marriage in 1977 to Anne Seymour. An assistant keeper at the Tate Gallery, she had been a moving force in the Tate's acquisition of a Minimalist and Conceptual art collection in the early 1970s and had also organised the influential *The New Art* exhibition at the Hayward Gallery in 1972, whose line-up included Art & Language, Victor Burgin, Michael Craig-Martin, Barry Flanagan, Gilbert and George and Richard Long. Seymour left the Tate for Dering Street, and d'Offay moved from early twentieth-century British art to the international avant garde. 'It was extremely difficult to change my thinking about art radically', he later recalled. 'I had to ask myself if Gilbert and George, Richard Long and Joseph Beuys were as important to me as Wyndham Lewis, David Bomberg and Stanley Spencer. In the end I decided they were more important.'

Since then, the only way has been up. Anthony d'Offay's gallery has expanded into four different buildings in Dering Street, and by 2001 will occupy an extensive new building round the corner in Haunch of Venison Yard. Although Freud is no longer on the books – he left the gallery in 1982 – and Gilbert and George jumped ship to White Cube after twenty years with d'Offay in 2000 – the line-up still reads like a roll-call of major figures from the last five decades. The d'Offays live in a stucco Nash town house overlooking Regent's Park in London. They also own the house designed by Philip Johnson to accommodate Blanchette Rockefeller's collection of contemporary art, which is located near New York's Museum of Modern Art. What began as a livelihood has become a life – both buildings are as much like museum spaces as homes.

For all his major-league artists, hosting of big dinners and throwing his homes open to the art world, d'Offay remains a reserved, softly spoken, even mysterious figure. He is reputedly an accessible – if demanding – employer, and his sober, conventional appearance and reputation for steely shrewdness run counter to such factors as a 1989 Gilbert and George exhibition at the d'Offay Gallery that raised £565,000 for Cruisaid, or his occasional tendency to stand up and deliver unexpectedly passionate eulogies at the parties he throws for exhibiting artists – salutary signs that there's still a passion for art that goes beyond business.

MAUREEN PALEY

Director, Interim Art, London

Maureen Paley
Photo: Nancy Webber

It's now commonplace for the latest and most progressive art to be presented in small-scale, domestic surroundings, but when Maureen Paley opened Interim Art in her home in 1984, she was developing a practice that would provide artists with an alternative to the conventional gallery system, as well as playing an important part in putting the East End of London on the contemporary art map. Not that Paley saw it that way at the time. When she came to London as an Ivy League graduate in the late 1970s it was not to run an art gallery but to enrol at the Royal College of Art: 'I had already worked for a year in Sweden making super-8 films on a grant from Polaroid, and at the Royal College I was involved in the extended area of sculpture that spills into photography, performance, installation and film.' She also wanted to get first-hand experience of Punk rock: 'my interest at the time had more to do with the music scene and what people looked like in the streets than the art world', she remembers. Appropriately, Interim Art received its first write-up, not in the arts press, but in the *NME*.

Paley acquired the terraced artisan's cottage in Beck Road, Hackney, for living and darkroom space from the ACME housing association in 1979. The first shows were informal events put on in the years leading up to the 1980s boom and inspired by what Paley has described as 'a climate of closure'. 'I just wanted to get as many people on the map as possible.'

Although Paley has described Interim Art as 'an elaborate experiment that I've been forced to conduct in public', she and her gallery rapidly shed their ad-hoc beginnings to put on shows of often surprisingly major figures from Britain, the United States and Europe: the galleries that represent Jenny Holzer, Georg Herold, Richard Deacon and Charles Ray were all persuaded to collaborate with what was then an unknown space in an out-of-the-way part of London. Now Interim Art has become a permanent fixture – it moved from Beck Road to its current Bethnal Green industrial space in 1999 – and continues to flourish in its latest incarnation as a showcase for younger artists – many of whom Paley takes on straight from art school.

Paley no longer makes art herself – 'I made a very sharp decision that I was not going to be an artist' – but her preference for the experimental

blending of categories is often to be found in the kind of art she favours – whether metal plaques by Jenny Holzer, collaborative paintings by Tim Rollins + KOS, films of all kinds by Gillian Wearing, paintings, cartoons and a board game by Paul Noble, or David Thorpe's intricate paper cut-outs. It also continues to manifest itself in her own activities. Art dealers don't usually cross over into curating shows for public institutions (Paley's have included *Wall to Wall* 1995, a large-scale touring exhibition of wall drawings by international artists, and *Cauldron*, a show of work by young British practitioners for the Henry Moore Sculpture Trust in 1996), and it's even rarer for them to review art exhibitions on national radio.

Yet however unorthodox her activities, from the outset Paley established an unshakeable reputation for rigour and attention to detail that continues to permeate all she does – from her pristine exhibitions to an immaculately chic personal appearance – and these fastidious presentation skills provide an especially effective counterpoint to the often unruly works she presents.

ANTHONY REYNOLDS

Anthony Reynolds Gallery, London

Anthony Reynolds prefers to promote his artists rather than his gallery, which, although an admirable approach, has tended to mean that outside the art world he's less well known than newer arrivals who have worked with far fewer artists. His gallery in Dering Street is a fraction of the size of Anthony d'Offay's empire over the road, but Reynolds' role in the promotion and presentation of more recent generations of British artists has been consider-ably more significant than his neighbour's. A list of the names who have shown with Reynolds since he first set up a gallery in 1985 reads like a multi-generational, multimedia *Who's Who* of artists both British and interna-tional. Alphabetically, they span from Finnish Eija-Liisa Ahtila, who was the toast of the 1999 Venice Biennale, to Sylvia Ziranek, provocative, pink-clad performance artist. 'I don't look for anything – I just want to show people who are the best at what they do. I have no idea what art should be or do', he declares. 'I just want it to surprise me.'

This all-inclusive approach finds Reynolds' artists showing in galleries and spaces of all dimensions across the world – whether Steve McQueen in MOMA New York's project space, Mark Wallinger on the empty plinth in

Trafalgar Square, or Georgina Starr in the Dutch town of Oostellingwerf, where she created a pop extravaganza in 1999.

After reading History of Art at East Anglia in the 1970s, and following a spell at the Arts Council, Reynolds set up his first gallery in a huge basement space in now-trendy Shoreditch in 1985, opening his current West End space in 1989. Although he now represents over twenty artists – from vintage US radicals Leon Golub and Nancy Spero to comparative newcomers Keith Tyson and Richard Billingham, Reynolds still likes to take risks. He enjoys putting on mixed exhibitions, often with a mischievous twist, such as *What's In A Name?* 1998, an eclectic group show of artists who were all called Keith. Unlike many of his more commercially minded colleagues, he visits degree shows and also often signs artists straight from art school – Mark Wallinger from Goldsmiths and Georgina Starr when she was still at the Slade, for example. For Reynolds, working with an artist is much more than simply selling their art; it is a long-term commitment, and deciding with whom to work is an intuitive process.

THE PATRONS

SOME ART BUYERS PREFER TO REMAIN ANONY-
MOUS, BUT THE FOLLOWING ARE AMONG THE MOST
ADVENTUROUS PUBLICLY KNOWN COLLECTORS.

DAVID BOWIE
Musician and Art Collector

David Bowie
(left) with
Damien Hirst
Photo: Iman

From Peter Blake's *Sergeant Pepper* LP cover for the
Beatles, to Damien Hirst's video for Blur, pop musicians
and contemporary artists have often enjoyed a symbiotic
relationship. Damien Hirst and Blur guitarists Alex James
and Graham Coxon were at Goldsmiths together, and ex-
Central St Martins student Jarvis Cocker was happy to
ham it up for the cameras at the 1996 Turner Prize, and
performed at the party for Gary Hume during the 1999
Venice Biennale. However, in spite of the frequent com-
parisons that have been made between Britpop and
Britart, the connections between the latest in British art and music remain
surprisingly few. Indeed, it seems that the artists themselves are more often
concerned with crossing over into the world of music than vice-versa – these
days, rock'n'roll is the new art.

Some, such as Jeremy Deller and Jim Lambie, use the cults and culture of
pop music as a powerful artistic medium, while others actually make the
stuff. Georgina Starr, for example, has two bands, Pony, and Dick Donkey's
Dawn; Angus Fairhurst's Lowest Expectations supported Pulp in 1995;
Martin Creed has released three CDs as singer and lead guitarist in owada;
while Cerith Wyn Evans, Tom Gidley and 1998 Turner-Prize nominee
Angela Bulloch play in the all-bass guitar band, Big Bottom. These artists
consider participating in bands to be an extension of their practice – and they
also enjoy the glamour and buzz of performance. Art writer and television
presenter Matthew Collings was one of the earliest art rockers, with his band
Interspecies Love Child.

Reciprocally, as the older statesmen of rock'n'roll are especially aware, there's nothing like a brush with contemporary art to provide cutting-edge cultural credibility. In 1997, Pet Shop Boy Neil Tennant, a Patron of New Art at the Tate, commissioned Sam Taylor-Wood to produce a video projection for the concert 'Somewhere, Live at the Savoy'. Dave Stewart owns work by Damien Hirst, Sarah Lucas, Tim Head and Marc Quinn, as well as commissioning Hirst to make the artwork for his 1997 album, *Greetings from the Gutter*. (One of the tracks is – perhaps revealingly – entitled 'Damien Save Me'.) Brian Eno has been a Professor of Art at the Royal College, collaborating in 1995 with some of his students and American artist Laurie Anderson on the Artangel project *Self Storage*, while in May 1997, he made an ambient soundwork especially for Jay Jopling's White Cube. More recently, Elton John and his partner David Furness have become enthusiastic purchasers of the new generation of young British artists, including Tim Noble and Sue Webster. And we mustn't forget Malcolm McLaren, who is a persistent presence, if an intermittent buyer, at fashionable art events.

However, probably the most conspicuous pop musician to contribute regularly to the world of art has been David Bowie, who first started collecting Arts and Crafts and Jugenstil in the late 1960s, and whose New York house is home to a seriously heavyweight old master collection containing works by Rubens and Tintoretto. Since the mid-1990s, Bowie appears to have dedicated himself to creating a reputation as a collector, art writer and artist. He sits alongside the likes of Lord Gowrie on the board of *Modern Painters* magazine, to which he has also contributed interviews with artists such as Balthus, Tracey Emin and Damien Hirst, and idiosyncratic reviews of exhibitions including Jean-Michel Basquiat and the first South African Biennale. In 1997, he co-founded the art publishing house, 21 (with *Modern Painters* editor Karen Wright, Sir Timothy Sainsbury and Bernard Jacobson). Two years earlier, he hired a Cork Street gallery for *New Afro/Pagan*, a show of his own drawings, prints, paintings and sculptures that left no doubt as to the Thin White Duke's shamelessness as a voracious style-sampler, with a line-up including heavy Neo-Expressionist charcoal drawings, chrome-plated African heads, and even a computer-generated wallpaper print where mini-reproductions of a Lucian Freud self portrait glared out from inside rows of Damien Hirst-style tanks.

Either through genuine obliviousness, or with an insouciance born of decades of super-stardom, Bowie seems unconcerned both by the fogeyish reputation of *Modern Painters* and the chilly critical response to his own output. And his collecting shows the same eclecticism. Since the mid-1980s he

has systematically built up his British collection, starting with artists such as Frank Auerbach, David Bomberg and Peter Lanyon, along with less fashionable figurative artists such as Scots Ken Currie and Peter Howson, and then branching out to encompass work by Gilbert and George, Patrick Caulfield, Julian Opie and a Spin Painting by Damien Hirst. In 1999, Bowie pitched himself into the controversy surrounding the American leg of *Sensation* by advertising the exhibition on his personal website. All of which is greeted with faint interest within the art world, and has done little to improve Bowie's critical reputation outside. But then, when you generate enough income to float yourself on the stock exchange, it doesn't matter much what other people think.

FRANK COHEN
Founder and Owner, Glynwebb Home Improvement Stores

Frank Cohen

'All my life, I've been a fanatical collector', says Frank Cohen. 'When I was eleven, I had one of the biggest collections of cigarette packets in the country. Then, when I was seventeen, I sold them and collected coins for twenty years, until I had one of the UK's major collections of patterned coins. But it became boring – I had to keep them in safe-deposit boxes.'

More recently, it has been the work of emerging British artists that has captured the attention of this ebullient self-made man. The owner of twenty-six DIY stores across the north of England, he has fast become a conspicuous and refreshingly forthright presence amongst the notoriously reticent ranks of Britain's art collectors. Cohen may only have been collecting contemporary art since 1995, but during that time he has acquired over 200 works by a diverse range of artists including Alison Wilding, D.J. Simpson, David Rayson, Tania Kovatts, Simon Bill, Grayson Perry, Glenn Brown, Angela de la Cruz, Jim Lambie, Tim Noble and Sue Webster. And he doesn't want to keep them in safe-deposit boxes either. In 1999, Glasgow's Gallery of Modern Art mounted a show of his recently acquired works by Andrew Bick, Jason Brooks, David Thorpe, Kenny Hunter, Geraint Evans, Edward Harper, Claude Heath, Nicky Hoberman and Paul Morrison under the title *Fresh Paint;* and Cohen is currently negotiating an 'institutional home' for the collection in his native Manchester.

Cohen is no stranger to the art world – his first purchase was a small L.S. Lowry painting in 1978. But he found his real road to Damascus three years later when he walked into Waddington's Gallery in Cork Street, and saw *Heart Drawing* (c. 1970), a painting by Jim Dine. 'I loved it and I wanted it', he remembers; he bought it for £3,750. More purchases from Waddington's followed – sculptures by Barry Flanagan and Joan Miró, a Dubuffet oil and works by Mimmo Paladino. At the same time, he began to collect the modern British paintings and sculptures that he still considers his 'pet subject' – works by William Roberts, Edward Burra and sculptures by William Turnbull, Eduardo Paolozzi, Bernard Meadows and Kenneth Armitage. Although Cohen still owns many of the above, along with sculptures by Arman and Cesar, which he has installed in ten acres of sculpture garden at his house in Cheshire, an international collection began to strain his budget – 'I had my eye on loads of fabulous pieces, but I couldn't afford them'.

On the advice of Timothy Taylor, who had recently left Waddington's to set up his own gallery, Cohen began to buy paintings by the likes of Ian Davenport, Mark Francis and Callum Innes. He soon established a working relationship with a group of mainly young, east London dealers, and now he's branched out into works in all media. 'If the image is right, then it's like a gut feeling. I'm buying about one work a week at the moment – but sometimes I buy ten; other times I go away without buying anything'.

STUART EVANS
Partner, Simmons & Simmons

When companies decide to acquire art, they usually employ consultants or appoint a purchasing committee. But the extensive collection of international law firm Simmons & Simmons is the sole responsibility of one of its corporate finance partners. Stuart Evans has been passionate about art since his schooldays, and was already collecting 'art done in my lifetime' for himself when, over ten years ago, he started buying for his firm. These were modest works by early twentieth-century British artists as well as prints by such established contemporary British and American artists as Howard Hodgkin, Leon Kossoff, Roy Lichtenstein and Claes Oldenburg.

The construction of a new suite of conference rooms at the firm's London offices in 1994 provided the starting point for a fresh departure in what Evans has described as 'a collection that reflected some of the energy,

commitment and diversity of the emerging young British artists I had begun to see in and around London'. In under three years, he had, with help from private art dealer Thomas Dane, assembled a collection of forty-four paintings, works on paper and photographs. Although it includes the Scottish painter Callum Innes, the collection goes under the title of 'Made in London' and certainly fulfils Evans' desire to 'challenge the somewhat reactionary tradition of English corporate collecting'.

Meetings at Simmons & Simmons' London HQ are now enlivened by Mat Collishaw's computer-generated photographs of furry lilies (*Tiger*, *Leopard* and *Zebra Skin Lily*, all 1995); Angus Fairhurst's four large colour photographs of the back of Damien Hirst's neck, bristling with plastic price tags – *Man who wants to know what the back of his head looks like* (1992) – and Abigail Lane's image of a muzzled pit bull terrier, *For His Own Good* (1996). Although some partners have blanched at this unorthodox line-up, Evans is adamant that such challenging work is in keeping with the role of corporate lawyers: 'as merchants of solutions, we have to achieve objectives for people in powerful positions, and they expect us to be able to deliver. Part of that solution can be looking at things in a way that hasn't been done before.'

As Simmons & Simmons move to new premises, Evans continues to buy work. He has put together a new group of contemporary photographs by, among others, Richard Billingham, Willie Doherty, Sarah Lucas, Paul Seawright, Bridget Smith, Hannah Starkey and Wolfgang Tillmans, and is currently collecting landscape paintings by Michael Raedecker, David Rayson, George Shaw and Graeme Todd. His private collection is also expanding. Abstract paintings of the 1950s and 1960s by Eduardo Paolozzi, Alan Davie and Gillian Ayres have been joined by an increasingly impressive selection of works by younger British artists from Rachel Whiteread's plaster casts of bookshelves, to Mat Collishaw's 1991 photograph of himself as *Narcissus*, a series of monoprints by Tracey Emin from 1989 (Evans was one of the first collectors of her work), and a workbench sculpture by Tomoko Takahashi. Recent acquisitions include two videos by Mark Wallinger.

Evans' increasing involvement in the art world has also been a source of business, from providing Damien Hirst with legal advice on the venue for his memorable live butterfly installation *In and Out of Love* in 1991, or organising the lease on the now-defunct Tracey Emin Museum in 1995, to larger scale work such as advising the Tate on the structuring and financing of Tate Modern. Evans also acted as Chairman of the Tate's Patrons of New Art from 1997 until 2000.

PETER FLEISSIG

nvisible Museum

In putting together his collection, Peter Fleissig has concentrated on sculptors' drawings and early works by younger artists: 'not the biggest or the shiniest works ... the price never more than a second-hand Saab.' What these pieces have in common, he says, is their 'spirituality and concern with invisible spaces'. Ranging from drawings by Richard Long and Marc Quinn, to Simon Patterson's classic renaming of stops on the London Underground map, *The Great Bear* (1992), and Damien Hirst's drawing for his shark piece *The Physical Impossibility of Death in the Mind of Someone Living* (1992-4), they cannot, however, usually be seen in one place. They are scattered across London in the houses of friends and the studios of artists, creating what Fleissig has described as 'an invisible mental museum – inspired by André Malraux's concept of a museum without walls. It is a way of thinking of the city itself as a museum'.

This open-ended approach to art distribution is closely related to Fleissig's activities during the 1980s as a member of NATØ (Narrative Architecture Today), an anarchic group, founded by Nigel Coates, which saw the city as multi-layered and mutable. At this time, Fleissig was also buying the drawings of sculptors, many of whom – Edward Allington, Richard Deacon, Kate Blacker, for example – incorporated the detritus of the city into their work.

Several nvisible Museum acquisitions in the 1990s have provided a crucial fillip to early careers – Fleissig has a very early Mark Wallinger painting (*Battling for Britain* 1985), and he bought a unique text piece from Douglas Gordon's first solo show at the Lisson Gallery in 1994-5. Even though he has described his pieces as 'the kind of works that museums wouldn't buy', several have subsequently made very visible museum appearances, including an important early Rachel Whiteread sculpture, *Fort* (1989), made from a knee-hole desk, which was loaned in 1996 to *Shedding Light* at Tate Liverpool and the Reina Sofia, Madrid.

Recently, Fleissig has been concentrating on videos, such as Georgina Starr's *Crying* (1993), Steve McQueen's *Five Easy Pieces* (1995) – the first work sold by the artist – Mark Wallinger's *Prometheus* (1999) and paintings by Callum Innes and Paul Morrison.

Within the art world, Fleissig may prefer to remain a mysterious (though omnipresent) figure, but he's not averse to the nvisible Museum occasionally

being shown, especially outside London. The collection was brought together for the first time in 1994, under the title *Seeing the Unseen* in a Clerkenwell warehouse. It is currently on a world tour that started as *Infra-Slim Spaces* in Kiev monastery (1997) and travelled in a different guise, as *Family*, to Inverlieth House in Edinburgh (1998); *Infra-Slim Spaces (part 2)*, was at Birmingham Museum of Art, Alabama (1999) and in 2000 stops include San Francisco, Memphis, Zurich and a crossing point in the desert outside Cairo. The tour ends in 2001 at the Sir John Soane Museum with *Sphere*. With the passing of time, it seems, the nvisible museum is making its presence increasingly felt.

INGVILD GOETZ
Founder, Goetz Collection

Ingvild Goetz

While it is widely known that much of the most exciting contemporary art of the last decade has come from Britain, it is also a sad fact that there are very few people in this country prepared to buy it in any quantity. It is this deficit that gives Charles Saatchi such a powerful and prominent position. However, in the international sphere, he is by no means the only collector to establish his own gallery and build up substantial holdings in the most recent British art.

Not only is the Goetz Collection of contemporary art in Munich one of the most important in Europe, but the private museum in which much of it is housed also attracts international attention as an architectural showpiece. Built in 1993, it was one of the first galleries designed by the Swiss architects Herzog & de Meuron and there is no doubt that the immaculate simplicity of its three, stacked, precise rectangles of glass and wood played a major part in influencing the Tate to commission them to convert Bankside power station into Tate Modern.

From 1969 to 1984 Ingvild Goetz ran a contemporary art gallery, first in Zurich ('I was so avant-garde they kicked me out') and then in Munich and Düsseldorf, where she sold the work of Italian Arte Povera artists, along with other early radicals such as Bruce Nauman. When she decided to focus solely on collecting in the mid-1980s, she sold off her stock to concentrate on the best of Arte Povera. She now has probably the largest private collection of works from that group in existence – over 200 pieces. Also during the 1980s,

she concentrated on American art, while more recently she has turned her attentions to a carefully selected line-up of young British artists who have emerged during the 1990s, including Chris Ofili and Steve McQueen. 'I'm always collecting groups of artists and I go deeply into every artist instead of having something here and there', she says. Certainly, her approach is more rigorous, painstaking and personal than many other collectors, who cast around for a checklist of key names. 'I always try to talk to the artist and have close contact ... if it doesn't fit into my concept then I don't buy it.'

Goetz describes the philosophy of the Collection as 'social-political-critical'. 'In the 1960s, Arte Povera wanted to change the world and do some-thing new; and with the English artists, I focus on those who talk more about social criticism, how relationships function. In this time of AIDS, it's also about death – it's about young girls outing themselves and their pain. That's why I find Tracey Emin so interesting because her work is so emotional, so direct and provokes people to be open too.' In addition to pieces by Emin, which include the quilt *Mad Tracey from Margate, Everyone's There* (1997), a 1992 underwear box entitled *All the Loving,* and the 1995 video, *Why I Never Became a Dancer,* the Goetz Collection contains a substantial range of work by Sarah Lucas, including the installation *The Smoking Room* (1997); videos, texts and photographs by Douglas Gordon; sculpture, photographs and works on paper by Rachel Whiteread; videos and photographs by Sam Taylor-Wood, and works in all media by Abigail Lane, Mona Hatoum, Willie Doherty and Angela Bulloch. In 1997-8, all of the above went on show in *Art from the UK,* a two-part exhibition at the museum. In 1998-9 – when *Sensation* was on show in Berlin – the Goetz Collection of young British art was given an important international context by being shown alongside sympathetic pieces from the Collection's American art from the 1980s – Matthew Barney, Robert Gober, Mike Kelley, Sherrie Levine, Cady Noland, and Richard Prince, in the exhibition *Emotion* at Hamburg's Deichtorhallen.

The diversity and depth of the Goetz Collection is reflected in the exhibi-tions mounted in the museum, which change every half year, and which are always open to the public, accompanied by authoritative catalogues. When works are not on show in the museum, they are either in storage, out on loan to other exhibitions, or – in the case of many of her most recent acquisitions – in Goetz' own house, where she likes to become more acquainted with them at close quarters. It is this personal investment that endears Goetz to the artists she collects – although many of her better known names have now become extremely expensive, they will often make special projects for the Collection. 'The curating is the most important part of what I do', says Goetz.

EDWARD AND AGNES LEE

Collectors

Spread throughout every floor of the Lee's house in London's St John's Wood is a formidable collection of twentieth-century art. Important works by influential figures such as Gerhard Richter, Martin Kippenberger, Sigmar Polke, Brice Marden and Philip Guston are installed alongside those by younger artists from Britain, America and Europe. In a basement living room, for example, one of Sarah Lucas' resin toilet sculptures (*Untitled* 1998) sits in a corner next to a Cindy Sherman 'History Portrait' (1989), opposite Mona Hatoum's sheet-iron chaise longue (*Dormeuse* 1999) and a Fischli-Weiss installation of resin-sculpted debris (*Untitled* 1991). Across the room is Jeff Koons' sculpture *Woman in the Tub* (1987) and *Tilted Playpen* by Robert Gober (1996), along with an early photopiece by Gilbert and George (*King George V* 1980) and a painting (*Miss Fenwick* 1996) by John Currin. A small library becomes an emotionally charged environment, courtesy of a combination of works by Marlene Dumas, Mike Kelly and Tracey Emin; and a climb up the main staircase involves passing a mini-survey of Philip Guston's evolving late style.

The Lees are a conspicuous presence at art events – Edward, for example, represented the Tate's Patrons of the New Art on the 1996 Turner Prize jury, when Douglas Gordon won the prize. He made his first serious purchase in the mid-1980s – a drawing by Sandro Chia, which he bought from a gallery in Boston – and the travel requirements of the family's property development business mean that work can comfortably co-exist with collecting. His wife, Agnes, whom he married in 1989, was brought up in a family of art collectors and they usually decide on purchases together. 'Aesthetic pleasure and the embodiment of an idea' are what the Lees look for in an artwork. They collect for enjoyment rather than investment, but are not squeamish about selling on pieces to prune or upgrade the collection – although Edward Lee is still mourning a particular Gerhard Richter that he now regrets letting go. 'The collection has to work for itself – we don't have infinite resources', he says. 'We're trying to assemble a collection that forms a whole – but it's an evolving process. There's a hard core of classic antecedents to give the collection its backbone, but lately we've been concentrating on younger artists.'

JAMES MOORES

Collector, Patron, Artist

The Moores family have been associated with contemporary art patronage since 1957, when the Liverpool-based John Moores Painting Prize was established by the founder of the Littlewoods Organisation. Now, not only the prize, but also the contemporary art scene in Liverpool has been greatly reinvigorated thanks to the involvement of James Moores, artist, art collector, and the great nephew of Sir John. Relative youth (he was born in 1962) and a diffident demeanour have done nothing to diminish the impact of James Moores' determination to put Liverpool on the artistic map. Not only is Moores a major trustee of the city's John Moores Exhibition Trust, which in great part funds the bi-annual prize, but he has also been the prime mover in the Liverpool Biennial, launched in 1999. It was James Moores who provided the seed funding to get the Liverpool Biennial off the ground, paying for the office and financing the appointment of an international curator, and his fund for supporting art and artists, the aFoundation, also assisted many of the higher-profile fringe shows.

As a child growing up in Liverpool, Moores was a regular visitor to the John Moores exhibitions, as well as to the contemporary art shows put on by his uncle, Peter Moores, at the Walker Art Gallery. Later, partially inspired by working on these exhibitions, he went to Camberwell to study painting and spent four years in New York from 1990-4 'producing large-scale action paintings'. In addition to his involvement in the Liverpool art world, Moores continues to work as an artist – although he tries to keep these two areas of his activity separate. In 1998, his solo show at Richard Salmon Fine Art presented both hand- and computer-generated paintings, drawings and sculpture, which inquired into our contradictory and fruitful relationship with systems and machines. One series, for example, consisted of sculptures made from piles of crisply painted planks, which took as their starting point the digital distillation of Turner landscapes into horizontal bands of colour.

As well as making and showing his own art, Moores has also acquired an art collection, which ranges from the estate of 1950s photographer John Deakin and the work of veteran performance/installation maverick David Medalla, to pieces by Gavin Turk and Rikrit Tiravanija. Although not confirmed as yet, it seems likely that this range of artists, British and international, historical and contemporary, will ultimately find a permanent residence in Moores' home town.

OLIVER PEYTON
Restaurateur

Oliver Peyton

The relationship between artists, bars and restaurants is a time-honoured one. Picasso exchanged paintings for meals at the Lapin Agile; Warhol shot films and held silent court in Max's Kansas City, New York; the entire Abstract Expressionist movement propped up Manhattan's Cedar Bar; while in London, Francis Bacon, Frank Auerbach and Lucian Freud were all oyster-imbibing regulars at Wheeler's in Soho.

These days, there are no shortage of restaurants – and bars – frequented by artists. Another Francis Bacon Soho haunt, The Colony Room drinking club in Dean Street, has taken on a new lease of life with a clientele of young, hard-drinking artist-members whose work lines the walls and who occasionally join up with their partners to serve behind the bar: Damien Hirst and Maia Norman, Sarah Lucas and Angus Fairhurst, Jay Jopling and Sam Taylor-Wood; Tracey Emin and Mat Collishaw; Tim Noble and Sue Webster; and Ben Langlands and Nicki Bell have all been drink-pouring double acts at the Colony. A few doors down, a slice of the British art scene can also be found in the more luxurious surroundings of the Groucho Club, while gallery dinners are often held either at the restaurant above the French House (yet another Bacon watering hole), run by Margot Henderson or across town at St Johns bar and restaurant in Clerkenwell, run by her husband Fergus Henderson. In 1998, Damien Hirst even opened his own establishment, but artists are rarely to be seen around the tables of Pharmacy. For in terms of direct patronage, the restaurants that are having the greatest impact on today's art world are undoubtedly those owned by Oliver Peyton.

Peyton launched his restaurant business on the proceeds of being the sole UK importer of Japanese Sapporo beer and Swedish Absolut vodka. In 1994, when he took over the derelict basement at 20 Glasshouse Street, London W1, which is now his Atlantic Bar and Grill, the Irish restaurateur threw it open to the art world by hosting *Venus Eclipsed*, a one-night-only installation by Mat Collishaw. Since then, artists and their work have played a central part in his empire. Collishaw, Sarah Lucas and Angus Fairhurst are just some of those who have designed labels for Atlantic's house wine, and, along with pieces by Douglas Gordon, Tatsuo Miyajima and Mariko Mori,

their works line Atlantic's bar and restaurant walls. The Atlantic is also the eponymous setting for the arguing couple in *Atlantic*, Sam Taylor-Wood's 1997 video piece.

As well as collecting art, and serving as a member of the Tate Modern Promotions Advisory board, Peyton also commissions it. Angela Bulloch's *Luna Cosine Machine* (1995), a giant wall-mounted drawing machine, was commissioned specifically for Peyton's Coast, in Mayfair, where it is activated every time someone uses the staircase; American painter John Currin made his *Jack Ass* (1998) especially for Mash on Great Portland Street, while Peyton's Isola in Knightsbridge sports a 3 x 3.5 metre, photoprinted cowboy by American artist Richard Prince.

'I started to collect because the type of restaurants we run are forward-thinking, and I got really fed up with going to restaurants and seeing just wallpaper', says Peyton. 'Restaurants are a very good opportunity to show things that can confront an audience – we purposely try and buy things that attract their attention.' 'We' means Peyton and art dealer Sadie Coles, who has advised him from the start on all his contemporary purchases and commissions – whether or not they emanate from her gallery. 'I only buy from people I like – I don't like buying from assholes', says Peyton, whose own particular interest is photography, especially Andreas Gursky and Wolfgang Tillmans. Nothing is for sale, and Peyton's ever-expanding collection of work by British and international artists also occupies his own home and the headquarters of his company, Gruppo.

Peyton, who left a Leicester Polytechnic textiles course after two years, started his working life running nightclubs in Brighton and London in the early 1980s – most notably RAW in London's West end; and he feels that whereas in the early 1980s 'clubs were a place of change and doing wild things', the same dynamism now emanates from the partnership of restaurants and art. Now that he's given Somerset House, home to the Courtauld Institute, a full gastro-makeover with a deli, bar, café and The Admiralty restaurant, Peyton seems to be dedicated to taking his art-food ethos to the heart of the British art establishment.

MARK REED
Collector

Mark Reed

Mark Reed's two major purchases in 1999 were a 4-foot-long LED sign by Jenny Holzer and a bass viol, dating from the late-seventeenth century. Reed, who plays the viol and harpsichord, sees the seventeenth-century Baroque and the late twentieth-century electronic as completely compatible. 'It's a love of geometry and systems – and yet the artist manages to say so much within this framework.' Other pieces in the pristinely austere white interior of Reed's Victorian terraced house in West London include two LED works by Tatsuo Miyajima, Carl Andre's steel floor piece *Tentin Sum* (1995), and a 'Telepathic' white painting by Keith Tyson (1995). In the minimal kitchen, Bill Viola's self-portrait head (*Incrementation* 1996) stares and sighs out of a video monitor surmounted by an LED sign that counts off his every breath, while in the basement there's a seventeenth-century oil portrait of a periwigged Daniel Purcell, Henry's brother and fellow composer.

Reed's background may not be artistic – his family manufacture caravans in Hull – but that hasn't stopped him from becoming one of the UK's youngest and most rigorous art collectors. It was while he was studying philosophy at Southampton University that Reed's interest in art was fired by an optional contemporary art course – although, characteristically, he chose Italian seventeenth-century and English architecture from 1500 at the Courtauld Institute as the subject of his MA in 1996.

'I feel slightly uneasy with things that are obvious at first reading', he says. 'For me, living with something is about a growing relationship to it that changes on a daily basis.' A particular interest is artists who work with light. As well as his works by Holzer and Miyajima, Reed also owns neon pieces by Tracey Emin (*Fantastic to Feel Beautiful Again* 1997) and Cerith Wyn Evans (*TIX3* 1996), along with a site-specific fluorescent light piece by Martin Richman, which works with a wall of bookcases, changing colour every time a book is removed. 'If you're collecting for a domestic situation, then light is ideal because although these pieces are small, they have such a big effect.'

DON AND MERA RUBELL

Owners, Rubell Hotels

The Rubell Family Collection in downtown Miami is familiar to millions – not as a showcase for a formidable collection of contemporary art, but from its numerous appearances on the TV series *Miami Vice*, in a previous existence as a contraband warehouse for the US Drug Enforcement Agency. Since 1994, however, the two-storey building has provided 30,000 square feet of exhibition space for Don and Mera Rubell's collection of some 1,000 artworks by artists from America, Europe and recently, Africa. It puts on a changing programme of public exhibitions as well as keeping some pieces on permanent show. The Rubells, who were involved in developing New York's SoHo in the 1970s and 1980s (Don's brother was Steve Rubell, co-founder of Studio 54 and the Paramount Hotel), have now transferred their attentions to the hotel business in Miami, where they own some of the city's most fashionable hotels: the Albion, the Greenview and the Beach House.

'The contemporary moment is very compelling – these artists are dealing with issues that are in the world', says Mera Rubell. 'Not to look at what has been going on in Britain in the last ten years would be not to hear the dialogue of art in the world today.' The Rubells have been collecting art since the late 1970s, when they bought the first piece sold by Jeff Koons, and they have collected his work in depth ever since. Other highlights of their collection are over seventy pieces by Keith Haring, major works by Paul McCarthy, Robert Gober and Charles Ray – including his 'orgy' work, *Oh! Charlie, Charlie, Charlies* (1992), and extensive holdings in Francesco Clemente, Julian Schnabel, David Salle, Jean Michel Basquiat, Christian Boltanski, Sherrie Levine, Cindy Sherman, Juan Muñoz and William Kentridge. British, or British-based, artists in the collection include Jake and Dinos Chapman, Michael Landy, Thomas Demand, Gilbert & George, Cecily Brown, Chris Ofili and Damien Hirst. 'We first met Damien Hirst right after the *Freeze* show, and I remember standing there and looking into this cabinet of severed sheep's heads and it was so clear to me that this was the legacy of Bacon – the ability to investigate the physicality of death', says Don Rubell. More recently, the Rubells have continued their philosophy of acquiring works by artists at the beginning of their careers and have made studio visits and purchases from British painters Michael Raedecker, Paul Morrison and David Rayson. 'I think, ultimately, why we collect is the magic of that moment in the studio', they declare. 'It's a kind of vulnerability on both sides.'

CHARLES SAATCHI

Founder, Saatchi & Saatchi, M. & C. Saatchi

Charles Saatchi

Charles Saatchi's influence throughout the contemporary art world cannot be overestimated. His collection is one of the largest in the world (it currently stands at some 2,500 works) and is certainly one of the most conspicuous. He buys work in bulk and, at various points in a collecting career spanning over three decades, has sold in quantities – often controversially. His buyings, sellings and apparent changes in taste are scrutinised by artists, dealers and other collectors like an alternative stock exchange. For someone so famously reclusive, he's a public figure whose every action is hotly debated. When, in March 1999, Saatchi gifted 100 works by young artists to the Arts Council Collection, his detractors declared that it was because their market value was low and that they were taking up too much storage; when he used some of the £1.6 million proceeds from a 1998 sale of his collection to fund bursaries and new commissions for young artists at four of London's art schools, it was seen as a cynical way to acquire work by young artists on the cheap.

But, whatever Saatchi's transactions and motives, when, in March 1985 he opened up his showcase gallery in St John's Wood – 30,000 square feet of dazzling white space designed by Max Gordon – he provided a completely new way of looking at art in this country. It wasn't just that he gave Britain its first wholesale showing of such internationally established figures as Cy Twombly, Andy Warhol, John Chamberlain, Dan Flavin, Sol LeWitt, Bruce Nauman and Richard Serra – as well as younger figures such as Jeff Koons, Ashley Bickerton and Robert Gober – it was that he did so in an exemplary setting that showed the work off to its very best advantage. The upcoming generation of artists who were to become part of Saatchi's collection, came, admired, and took note. The gallery has been visited by well over a million people and has acquired the status of this country's unofficial museum of contemporary art (now that Tate Modern is at last providing an official one).

With no one else in this country collecting on a comparable scale, inevitably Saatchi's taste has come to dominate the popular view of the British contemporary art world. Although such work in fact only forms a relatively small proportion of his overall holdings, Saatchi's penchant for the throat-grabbingly immediate has undoubtedly been crucial in launching the careers of individual artists. His acquisitions – whether Damien Hirst's

preserved shark (which he commissioned), Marc Quinn's blood-head *Self* (1991), the mannequins of Jake and Dinos Chapman, or Richard Wilson's *20:50* oil piece (which he has kept on permanent display since 1987) – have also been instrumental in raising awareness of British contemporary art both at home and abroad. More recently, however, Saatchi's profile-raising capabilities have proved to be a mixed blessing for the artists in his collection. The various furores surrounding the aptly titled *Sensation*, the selection of works from his collection shown at London's Royal Academy in September 1997 and then toured to Berlin and Brooklyn, may have attracted reams of publicity and record attendances, but tended to eclipse any considered appreciation of the art itself. More scorn has been poured on Saatchi for his recent attempt to corral his multifarious post-*Sensation* purchases into a quasi-art movement under the perplexing title of *Neurotic Realism*.

But the branding and promotion of a product is in his blood. As the director of the advertising agency Saatchi & Saatchi, which he set up with his younger brother Maurice in 1970, Charles was personally responsible for originating the 'cut in the silk' Silk Cut cigarette campaign that doubled the market share of that brand. It is perhaps inevitable that a man who is himself so adept at visual communication should feel an affinity with artists such as Damien Hirst and Sarah Lucas, whose work relies on a similar ability to distil complex ideas into a powerful and accessible message. For his part, Hirst has acknowledged that 'I get a lot of inspiration from ads in order to communicate my ideas as an artist and of course Charles is very close to all that'.

Too close, some may say. It was Saatchi & Saatchi's 'Labour isn't working' advertisement, with its snaking dole queue, that sold Margaret Thatcher to Britain in 1979, and the company was then employed by the Conservative Party for another three victorious election campaigns. In 1997, the legendary creative skills of Charles – now as half of the new breakaway agency M. & C. Saatchi – were enlisted again in order to try and salvage the election campaign for John Major. These allegiances, however, seem to arouse little comment in the largely leftish art world. But then, as the Medicis were well aware, art investment is a great image-enhancer: the Catholic church was quick to forgive the banking dynasty the sin of usury, just as the contemporary art world – especially in Britain – tends not to be too picky about the politics of those who patronise it.

In spite of his role as the presiding patron of the contemporary British art boom, Saatchi has owned not one, but three collections. His first art purchase, made in 1970, was a Sol LeWitt drawing, bought for £100. During the next decade, as the advertising business boomed, Saatchi, along with his

wife Doris, built up major holdings in American Minimalism, collecting large-scale works by LeWitt, Carl Andre, Donald Judd, Brice Marden and Robert Ryman. During the 1980s, Charles and Doris Saatchi followed this up by assembling a world-class collection of fashionable contemporary art ranging from the Neo-Expressionism of Julian Schnabel and Anselm Kiefer, to the slickly subversive work of Ashley Bickerton and Jeff Koons. It was only at the end of the decade, after his divorce from Doris in 1988 and the stock-market crash in 1989, that Saatchi sold off most of his blue-chip works to become young British art's most enthusiastic champion.

Whatever he buys or sells, and for however much (1996 company records indicated that his Conarco partnership had made at least $42 million worth of profit by dealing in works of art), there is no doubting Saatchi's enthusiasm for the art itself. He may not socialise with the artists, but he is personally involved in the installation of every show in his gallery: visitors to the Saatchi Gallery a few days before the opening will find him moving works around, hanging pictures and altering the lighting. He also personally hung *Sensation* in each of its three venues. Saatchi rarely attends art openings, but buys from studios (often at reduced prices) or arrives at exhibitions the day before the other collectors arrive. However, although he continues to invest in artists of all ages, Saatchi no longer exercises such supreme power over the British art world. Times have changed, artists have found alternative champions and outlets, and as Tate Modern and Tate Britain expand their potential to show contemporary British art of all inclinations, the name Saatchi doesn't quite command the awe of past years.

BERNHARD STARKMANN

Owner, Starkmann Ltd

Bernhard Starkmann is a rare species – in this country at least. His company collection eschews the easily decorative or the corporate status symbol to focus on the kind of Minimalist and Conceptual work that the British traditionally find most problematic. For some twenty years, Starkmann has been educating his company and his colleagues (who distribute scientific and humanities literature to academic libraries throughout Europe), by assembling important works from the 1960s and 1970s as well as recent pieces from the latest generation of young British artists. His ever-growing collection – which spans Carl Andre, Dan Flavin and Christo to Christine

Borland, Liam Gillick, Georgina Starr and Martin Creed – is one that deals with 'current issues and ideas'.

Instead of tailoring the collection to fit its surroundings, Starkmann has had his business premises renovated to accommodate the art. In 1988, Milanese architect Claudio Silvestrin (who also designed Jay Jopling's White Cube and Victoria Miro's West End gallery) successfully met his brief to create a space within a former dairy depot just off Lisson Grove, where the art and the daily business of the company could be incorporated to interact with one another.

But this doesn't mean choosing easy pieces to hang on a beautifully designed wall: a distinctive feature of this collection is that many of its components require careful installation and maintenance while still forming part of an active working environment. Works have included a pair of pigment-covered Anish Kapoor sculptures (*1000 Names (No. 27)* 1980-1; *1000 Names* 1985) on the wall and floor of a much-used thoroughfare; a sound-activated light piece by Angela Bulloch (*What's Said is Seen* 1991) in the operations area; Craig Wood's polyurethane-covered boardroom table, *Boardroom* (1991); and Douglas Gordon's sound and light installation *Something Between my Mouth and your Ear* (1994), housed in an interview room.

In keeping with this museum-style approach, the works on show change roughly every six months, when they are replaced by a rigorously curated new exhibition that combines a work from the collection with special commissions or installations by individual artists. This all-encompassing philosophy extends to inviting artists to contribute to the company's bibliographies and brochures, sent to universities and research libraries in Europe and overseas. Starkmann's 1996-7 brochure for science, technology and medicine, for example, must have cheered up the sober ranks of academia with a cover and centre spread sporting epic watery images from Peter Newman's surfing film, *God's Speed* (1996). As Starkmann says, 'With some imagination, determination and lateral thinking, it must be possible to bring the creativity of artists to the boardrooms and offices of corporations – not as status symbols but to enrich the daily life of everyone sharing in the enterprise.'

THE OPERATORS

BEHIND EVERY EXHIBITION IS A TEAM OF UNSUNG BUT CRUCIAL ENABLERS. HERE ARE JUST SOME OF THE SPONSORSHIP AND PUBLICITY AGENTS, FRAMERS, FABRICATORS, INSTALLERS AND PHOTOGRAPHERS WITHOUT WHOM SHOWS COULD NOT BE BROUGHT TO THE PUBLIC EYE.

ERICA BOLTON AND JANE QUINN

Erica Bolton and Jane Quinn Ltd

In Britain it is notoriously difficult to obtain press exposure for exhibitions of contemporary art. And when you do, it's usually the wrong kind. Unless there's a sensation, a scandal or a silly-season absence of news, many sectors of the mainstream press just don't want to know, and even the most committed of art critics need to be steered, prodded and cajoled – as well as furnished with the facts. That's where Erica Bolton and Jane Quinn come in. Since the company's foundation in 1981, Bolton and Quinn have established themselves as the dual doyennes of arts publicity – although they prefer to call themselves a 'cultural communications consultancy'.

Certainly, what they do goes way beyond PR. While they can lay on a press trip or a launch party with the best of them, each of their enterprises involves very different treatment: artists, sponsors, local authorities and gallery staff often have to be carefully handled – and that's before the press have even entered the picture. Probably their greatest achievement is an ability to cross over from the heart of the establishment into the wilder shores of art practice: clients/projects can range from the Tate (its architectural projects at Bankside, Millbank and St Ives, in addition to its exhibitions, such as the Cézanne retrospective), to the Millennium Bridge across the Thames

from St Paul's to Bankside, and Artangel's multifarious events. Often, they are brought in to pep-up coverage of individual events such as Anthony d'Offay's 1999 Howard Hodgkin show, or *Retrace Your Steps: Remember Tomorrow* (1999), an exhibition of contemporary art and architecture put together by Swiss curator Hans Ulrich Obrist and British artist Cerith Wyn Evans in London's John Soane Museum.

While they may only cover a small fraction of art activity in this country, Bolton & Quinn have had considerable impact over the years. Ironically, they have become famous as profile raisers despite the fact that they have a strong aversion to publicity about themselves. Not only has their light-footed mode of operation enabled many individual projects to reach a successful fruition, but their ability to deliver the goods and their understanding of the intricate machinations and manifestations of the art world has had a knock-on effect for a more widespread and intelligent awareness of contemporary art in the general national consciousness.

MARK DARBYSHIRE
Darbyshire Framemakers

These days, art may come in myriad forms, but how it is framed and presented is as important as ever. For today's artists, the frame is more than a finishing touch, it is a crucial part of the work itself. This applies equally to Sarah Lucas' tough-girl self-portrait photographs encased in industrial MDF; the vast Perspex frame for Sam Taylor-Wood's 4-metre-long photograph *Wrecked* (1996); or Tracey Emin's shrine-like arrangement of tiny, blue-sprayed votive receptacles that contained her teeth, diary pages, medical reports and IUD in the South London Gallery's *Minky Manky* in 1995.

All of the above were produced by Mark Darbyshire, who custom-makes frames, cases and furniture for artists ranging from Rachel Whiteread and Antony Gormley to Damien Hirst and Gillian Wearing. What makes Darbyshire so attuned to the needs of artists is that he is one himself. After completing a BA in Fine Art at Goldsmiths in 1986, he spent five years creating his own paintings before gradually moving into more and more framing work, initially just for his friends and then for an increasing number of galleries and individuals, from Interim Art to White Cube to the Tate. Although they may be made in unusual shapes and materials, Darbyshire's frames still have to meet the conventional exacting archive standards: they

must preserve as well as contain the artworks. The inside of Sarah Lucas' MDF frames, therefore, had to be treated with a neutral, water-based sealant to protect the photograph from chemicals leeching out of the wood, just as the Formica frames for Damien Hirst's butterfly paintings contained moth-balls and desiccating silica crystals to keep all forms of disintegration at bay.

More recently, Darbyshire has been expanding his activities into all aspects of art-related design. In 1997, artist Glen Seator set the company one of its more challenging tasks by requesting a full-size reproduction of the entrance to White Cube to be built within the gallery itself; and when Maureen Paley moved to her premises in Herald Street, east London, it was Darbyshire who helped her design every aspect, from gallery space to bookshelves.

ANTHONY FAWCETT

Founder/Director, Anthony Fawcett Consultants

Anthony Fawcett
Photo: Peter Fleissig

Go to almost any contemporary art event, whether it's a performance in a Soho basement by Angus Fairhurst's art band Lowest Expectations, or the latest large-scale project by Artangel, and everyone will invariably be drinking Beck's Bier. Over the last decade, the British art world has been engulfed in a tide of this Bremen-brewed beverage, while the Beck's logo has become the ubiquitous symbol of the latest and trendiest in contemporary art. Even when the Walker Art Center in Minneapolis put on its British art blockbuster *'Brilliant!' New Art From London* in 1995, it was Beck's who were the corporate sponsor.

The man behind this fruitful marriage of British art and German beer is arts consultant Anthony Fawcett. In 1985, he was taken on by Scottish and Newcastle Breweries to find a stylish, youthful market for a little-known German pilsner that they had started to import into Britain the year before. Now Fawcett is one of the most powerful and courted figures in the art world, handling an annual budget of over £500,000; which, as far as Beck's is concerned, is a small price to pay for a marketing coup that continues to keep their brand up with the top three bottled beers in the country.

Pale of face and slight of stature, Fawcett doesn't look like a typical PR

man – and he isn't. He has carved out a very particular niche in today's hybrid culture, where art, style and popular culture can all – with the right handling – be made to mix, match and make money. Having dropped out of studying Art and Art History at Oxford's Ruskin School, Fawcett switched to writing art criticism for *Vogue* before his enthusiasm for Yoko Ono's Fluxus work resulted in two years' employment as John and Yoko's right-hand man, art advisor, and orchestrator of John Lennon's Peace Campaign of 1969-70. 'If anyone in the world wanted to get to John Lennon, whether it was Salvador Dalí or Harold Wilson, they had to come through me ... a very strange position for someone who was only twenty years old.' This was followed by a spell in Los Angeles, doing PR for rock performers such as Crosby, Stills, Nash and Young, The Eagles and Joni Mitchell, before Fawcett returned to England, where he paved the way for a seamless transition into arts sponsorship by writing art criticism for the newly launched style bible *The Face*.

In the financially booming, image-obsessed 1980s, focusing on art was a canny commercial strategy. However, art sponsors come and go – and in the contentious sphere of avant-garde art they tend to do more of the latter. But thanks to Fawcett's astute choices of project (the sponsorship programme really took off when Beck's backed Gilbert and George's hugely successful 1987 Hayward Gallery exhibition), as well as bright ideas like commissioning limited-edition bottles with artist-designed labels, Beck's Bier has proved to be not just a stayer but a heavy investor in the future. In addition to the complimentary crates that lubricate opening nights across the UK, and financial backing for selected shows at prominent public galleries, Beck's has taken the unprecedented step of instigating new work. Since 1993 it has been committed to commissioning an annual project with the Artangel Trust, of which Rachel Whiteread's *House* was the first; and in 1998 Beck's crossed the channel to collaborate with New York's Public Art Fund on the financing of Rachel Whiteread's translucent resin *Water Tower* on the corner of Grand and West Broadway. In 2000, Beck's celebrated fifteen years of art sponsorship by entering a new phase with the launch of Beck's Futures, an award that distributes a total of £45,000 to emerging artists in every media, all of which goes to confirm that Fawcett's impact on Britain's art world will continue to extend beyond the promotion of small green bottles.

JIM MOYES

Founder Momart, PLC

Momart at the Saatchi Gallery in 1992 installing **The Physical Impossibility of Death in the Mind of Someone Living** (1991, tiger shark, formaldehyde solution, glass, steel, 213 × 518 × 213 cm) by Damien Hirst (right)

Photo: Anthony Oliver

Most people never become aware of the intricate procedures that lie behind the mounting of an art show. Indeed, if the installers have done their job properly, they shouldn't. And the most invisible but ubiquitous of all art handlers is Momart. You name it – a bisected cow, a head made from frozen blood, or the V & A's Raphael cartoons – Momart will transport it, install it, take it down, put it back, or keep it in storage. From a single blue Austin van, bought for £150 in 1971 and kitted-out with some carpet off-cuts and pieces of string, to today's fleet of climate-controlled, custom-built 'Fine Art vehicles', complete with jolt-free air suspension and padded leather panels, Momart has come a long way in providing the continuous road show that is a crucial but unsung part of the art world.

Pretty much every major art exhibition, contemporary and otherwise, both within and emanating out of the UK, from the Royal Academy's Poussin and *Sensation* shows, to *'Brilliant!' New Art from London* at the Walker Art Center in Minneapolis, has involved the services of Momart. Their east London warehouses contain all the major names – racked, packed, labelled and kept at a steady 20°C. (Never mind what they hold, the crates themselves are works of art, hand-constructed in wood, painted in different colours – one for every major gallery – and lined with acid-free foam, specially carved to fit each object.)

Every piece Momart handles poses particular and sometimes substantial problems. In 1992, in order to place Richard Serra's massive steel slabs in the Saatchi Gallery, part of the space had to be demolished. When Richard Wilson's *20:50* was installed at Matt's Gallery, and later at the Saatchi Gallery, the oil had to be pumped in from a tanker. The tiger shark for Damien Hirst's notorious *The Physical Impossibility of Death in the Mind of Someone Living* arrived from Australia deep-frozen ('like a giant fishfinger' as a Momart staffer memorably described it) and could only be installed after it had been defrosted and fixed in a solution of formaldehyde in a gigantic holding tank by technicians wearing protective paraphernalia.

All this tender loving care goes far beyond good business practice. What distinguishes Momart from other art movers is a genuine love of, and

ongoing involvement in, the art with which it deals. Jim Moyes, the company's founder and guiding spirit, studied sculpture in the 1960s and took a temporary job painting gallery walls and hanging shows for the Marlborough Gallery as an ex-student with a wife and young child to support. When he was asked to make plinths for sculpture and to carry out various technical jobs for gallery artists such as R.B. Kitaj and Barbara Hepworth, Moyes spotted a gap in the market and in 1971 'Jim Moyes' Compendium of Working Possibilities' was born. True to its name, the company entered into and 'muddled round' every problem of the exhibition process, and Momart, as it was re-christened in 1980, has evolved into today's high-tech enterprise, employing more than 100 people, and becoming in 1993 Transporter of Fine Arts by Appointment to Her Majesty the Queen.

Even though he has restructured the company so that he can make and exhibit his own work, Moyes continues to be a Company Director and his legacy is felt throughout every part of the art world. As well as shifting art, he also promotes it: Momart's offices are lined with works by friends such as Gillian Ayres and Bruce McLean (Moyes made a memorable appearance in McLean's film *Urban Turban* as 'The Hatless Shipper'), and many artists supplement their income by working part-time at Momart. There has been a Momart Fellowship at Tate Gallery Liverpool for an artist every year since the opening of the building; and among the many organisations and events supported by Momart have been The Whitechapel Open, the 1995 *British Art Show* and the 1996 Lucian Freud exhibition at Abbot Hall, Kendal. He may not have a high public profile, but within the art world, Moyes continues to be the provider of a compendium of working possibilities.

MICHAEL SMITH

M.J. Smith Design and Fabrication

Mike Smith has made some of the most talked-about pieces of contemporary British art. His work is currently on display in major museums and collections worldwide. Yet, outside a small circle, he is virtually unknown. For Smith is a 'fabricator' – he's the man who actually makes the stuff. Ever since the Renaissance, artists have employed workshops of skilled craftsmen to paint parts of their canvases or to cast their sculptures. Today, it is Smith who is the man behind key pieces by artists such as Damien Hirst and Mona Hatoum – they bring him the ideas, and he turns them into finished works.

These ideas may sound simple, but the logistics can be nightmarish. For Damien Hirst's 1996 New York exhibition at Gagosian Gallery, Smith was asked to construct two mechanised glass and steel tanks that would contain two and a half tons of bisected pig and formaldehyde solution and be capable of making consistent slicing movements without disrupting the contents. He also designed and made the gizmos that enabled Hirst's two-metre spin paintings to whirl on the wall and the twelve tanks that housed the sliced-up cows in the sculpture *Some Comfort Gained from the Acceptance of the Inherent Lies in Everything* (1996).

Smith and his assistants have also made the glass-walled, stone-floored chamber, *Confessional* (1997), for Cathy de Monchaux, a giant shredder for Michael Landy's *Scrapheap Services* installation (1996), Alex Hartley's *Pavilion* (2000), commissioned by Goodwood Sculpture Park, and Rachel Whiteread's *Plinth* for Trafalgar Square, among other well-known works. 'What I'm doing is solving problems of design and problems of aesthetics within a set of parameters, a sort of specialised engineering', he says. Even as a fine art student at Camberwell, when he won a New Contemporaries sculpture award, Smith always helped other artists with fabrication difficulties. Now, more than a decade on, he and his team of fifteen work for over fifty artists worldwide and the number is increasing.

MARK STEPHENS
Founder, Stephens Innocent

When artists need legal advice – and in these censorious and hard-nosed times they frequently do – they tend to head for Stephens Innocent, the law firm that specialises in artists' needs. When, in 1987, the Bank of England prosecuted American artist J.S.G. Boggs under the 1981 Forgery and Counterfeiting Act, it was Mark Stephens who organised the case, appointed Geoffrey Robertson QC to defend him, and accepted five of Boggs' limited edition £1 notes in payment for his successful defence. Unfortunately however, when the police seized Rick Gibson's pair of freeze-dried foetus earrings from the Young Unknowns Gallery in 1988 under an ancient common law offence of 'outraging public decency', Stephens and Robertson were less successful, revealing an ominous chink in art's armour: work can be withdrawn without having recourse to expert opinion or discussions around the defence of the public good.

Mostly, the work carried out by Stephens and partner Robin Fry is on more mundane (but no less crucial) commission agreements, gallery contracts, copyright infringement and compensation for damaged works. Stephens, the son of a painter, began his law career representing musicians, first becoming involved with the legal needs of artists in 1976 when he was made Legal Director of Art Law, an organisation set up by long-term artists' supporter Henry Lydiate. When the Art's Council's core funding for what had become a national legal advice centre for artists was cut in 1984, it was incorporated into Stephens Innocent as a private law firm. As Stephens remembers, 'artists came and we gave them advice, which, instead of being free, was funded by legal aid, as all of them qualified!' Many still do, although Stephens Innocent's scope now spans the representation in this country of the estates of Picasso and Matisse, the legal underpinning for public projects like Rachel Whiteread's *House*, or the defence of Anthony Noel Kelly, accused in 1997 of stealing corpses for the purpose of taking casts from them.

BEN WEAVER

General Assembly

Nike Savvas
Glam Genie
1999
Aluminium disks,
steel wire
Selfridges atrium,
London

There's nothing novel in the relationship between art and shopping. For the last decade or so, fashionable shops have resembled white-walled galleries, and now a great many offer art as the ultimate accessory. For their part, artists have been using the language of commerce and advertising media in one form or another for the better part of a century. Yet amidst all this commercial cross-dressing, some retail establishments stand out as being more creative than most in their relationship to contemporary art.

In the early 1970s, Habitat perked up the British aesthetic consciousness by commissioning special prints from Peter Blake, Eduardo Paolozzi and David Hockney; and in the 1990s it resurrected this practice with a collection of limited edition prints that included specially commissioned works from Gary Hume, Gillian Wearing, Gavin Turk, Martin Maloney, Simon Periton and Anya Gallaccio, among others. Yet this time the household store went one step further by inaugurating an adventurous rolling programme of contemporary art exhibitions in shops across the country. Other artistic offshoots

included Habitat's good-looking, give-away quarterly *Arts Broadsheet*; an increasing number of sponsored shows and art-school scholarships nation-wide; and even, in the year of the Tate's Centenary, a special Habitat range of house paints.

The man responsible for this new context for art was Ben Weaver, who, after studying History of Design at the Royal College of Art, was appointed Habitat's Art Co-ordinator in September 1995, when the company wanted to improve its range of prints and posters. By the time Weaver had left Habitat in 1998 to set up his own company, Farm, Habitat's Art Programme was an established part of company policy, and it remains so today. There's a special emphasis on contemporary art in Habitat's Glasgow shop as well as its flag-ship London stores, yearly Habitat Awards for students are given at Glasgow School of Art and the store sponsors exhibitions and events such as the *British Art Show* 2000.

Meanwhile, Weaver has gone on to make his mark on another retail establishment in need of the invigorating effect that contemporary art can provide: this time it is Selfridges that is enjoying his particular brand of creative marketing. Farm, now re-launched as General Assembly, not only orchestrated Selfridges' sponsorship of a series of exhibitions at the Serpentine Gallery, including Richard Wilson, Piero Manzoni, Andreas Gursky and Yayoi Kusama, it also facilitates commissions from young artists to make site-specific works for the store. In 1999, Goldsmiths graduate Nike Savvas produced the installation *Glam Genie*, a sparkling screen of hundreds of mirrored disks, hanging the length of Selfridges' atrium and visible from five floors. And with the opening of the Tate's own shop in Selfridges' ground-floor stationery hall, Weaver has matchmade two of General Assembly's clients to their mutual benefit. Weaver's company was also responsible for the marketing and promotion of Tate Modern, and for the billboards advertising Channel 4's series 'This is Modern Art', by Martin Creed, Sarah Lucas and Gavin Turk. However, by far the most conspicuous Weaver-instigated project to date has been the wrapping of the entire facade of Selfridges in a 900-foot-long Sam Taylor-Wood photograph during the store's six months of renovation in 2000.

EDWARD WOODMAN

Photographer

While the whole point of an artwork is first-hand experience, if you can't manage a direct encounter, the next best thing is to look at a picture by one of the specialist art photographers such as Hugo Glendinning, Anthony Oliver, Stephen White, or the longest- established of them all, Edward Woodman.

Photographing art is an art in itself, and photographing installations is the hardest task of all. Yet the temporary nature of this multifarious area of art practice means that it relies more strongly than any other on the photographic image for its place in posterity, and Woodman has been the photographer chosen by many British artists to immortalise their pieces. Perhaps it was a childhood spent watching movies from the projection box of an east London cinema, where his father was manager, that gave Woodman an affinity with intense visual experience, leading to a job producing TV stills. It was not until 1981, when he received a commission to produce photos for the catalogue of the ICA and Bristol Arnolfini's enormously influential *Objects and Sculpture* exhibition (which provided an early launchpad for Richard Deacon, Antony Gormley, Edward Allington, Anish Kapoor and Bill Woodrow) that he started working first with sculptors and then with artists in all media, both helping them to make and record their work.

Woodman has been responsible for pinning down some of the most elusive, ephemeral and evanescent artworks made in this country over the last decade. Whether Helen Chadwick's *Blood Hyphen* (1988), where a single red laser beam in a London chapel pierced the darkness to illuminate a photographic panel of the artist's blood cells; Anya Gallaccio's twenty-one whistling metal kettles installed in the chimney of an old pumping station in east London (*in spite of it all* 1990); Ron Haselden's strings of flashing LED lights that defined their surrounding space in his *Coliseum* (1989); or the perfectly reflecting oil surface of Richard Wilson's *20:50* (1987), it was Woodman who had the necessary technical know-how and ability to work with the artists to produce the images that captured the piece.

When the precocious Damien Hirst and his Goldsmiths contemporaries wanted to put on the slickest possible exhibition of their student work, Woodman was the obvious choice for the catalogue images, and the subsequent reputation of *Freeze* relies more on Woodman's pictures than the memories of the few people who actually visited the show. The cluster of high-profile, high-production-value exhibitions of the early 1990s – *Gambler*

(1990), *Modern Medicine* (1990) and Michael Landy's *Market* – relied on Woodman's camera to live up to their reputation in years to come.

Not only does Woodman record the work and exhibitions of innumerable artists both in Britain and internationally, he also helps many of them to make their art. The artists may have the ideas, but Woodman provides the equipment and technical expertise to turn those ideas into images (he calls himself 'the camera operator'). The striking pictures of flattened objects in Cornelia Parker's artist's book *Lost Volume, a Catalogue of Disasters* (1993) rely for their almost physical presence and impact on Woodman's lens. Other crucial collaborations include producing the Cibachromes for sculptor Edward Allington's *Pictured Bronze* series in 1990; travelling to Cairo with Hannah Collins in 1987 to make desert photographs on a large-format camera for her *Heart and Soul* series; and producing all the images for Helen Chadwick's *Meat Abstract*, *Meat Lamps* and *Wreaths to Pleasure* photopieces. If these artists were film directors, Woodman would be their cinematographer – without whom the picture could not be made.

JOHN WYVER
Chairman, The Illuminations Group

With their shared desire to feed off and engage with all forms of our culture, it would seem that contemporary art and television should be a match made in heaven. Instead, the relationship is frequently either one-sided (celebrity presenter dominates proceedings and art barely gets a look-in); patronising (art is subsumed by gimmicky packaging); or just plain abusive (art is treated as elaborate joke at the public's expense). One of the few programme-makers to explore the creative potential of representing the visual arts on TV is John Wyver, who, since he co-founded the production company Illuminations in 1982, has been responsible for producing programmes on subjects ranging from Sandy Nairne's six-part series on the art and ideas of the 1980s ('State of the Art' 1987), to a profile of Sarah Lucas ('Two Melons and a Stinking Fish' 1996) and a two-hour, live broadcast from the opening of Documenta 1992 ('Round IX').

Wyver began his career as Television Editor of *Time Out* magazine, and his passionate interest in the medium is reflected by his extensive writings and lectures on television and new media technologies. Although, in person, Wyver comes over more as a benign academic than a high-tech media

whizz-kid, it's easy to be deceived by his unassuming presence. In fact, this man has his finger firmly on the various pulses of the communications future. His interest in new art and ideas extends across the various disciplines and is reflected in the programmes he has produced for BBC2 since 1994 as editor of its arts strand 'Tx' and in the ground-breaking computer series, 'The Net'. The latter has pioneered innovative linkups between television and the Internet, including an interactive, on-line, virtual world called 'The Mirror', co-created by Wyver himself.

Wyver and his team, which has included such inventive art-documentary directors as Ian Macmillan and Chris Rodley, not only break new ground with their choice of subjects, but they also use television as an artistic medium in its own right. It was Illuminations that gave international video artists their first airing on British television, with its two series of 'Ghosts in the Machine' for Channel 4 (1986 and 1988) and with 'White Noise', a selection of video and electronic work for BBC 2 (1990), exploring innovative and appropriate ways of presenting different artists and their work. The American photographer Nan Goldin was directly involved in making the film about her life and work 'I'll be Your Mirror' (1995); while the Sarah Lucas documentary was shot by director Vanessa Engle on a hand-held digital camera, which allowed an appropriately immediate, intimate and rough-edged view of Lucas and her milieu.

Before 'Tx' was axed by the BBC in 1999, Wyver was opening up new horizons by commissioning artists to work for television, often for the first time. Thanks to his vision, Richard Billingham's *Fishtank* (1998), Nick Waplington's *Nothing* (1999) and John Maybury's *Museum of Memory* (1999) were able to find a mass audience way beyond the art gallery or private screening. It is this dedication to exploring the innovative presentation of different artists and their work that, since 1993, has given Illuminations the prestigious job of making Channel 4's Turner Prize documentaries, where the quality of the films on the shortlisted artists are one of the few things about the prize upon which pretty much everyone can agree.

THE COMMENTATORS

CONTEMPORARY ART IS DEPENDENT FOR ITS DOCUMENTATION, CRITICAL AND PUBLIC PROFILE, EVEN ITS SPONSORSHIP, ON THE PEOPLE WHO WRITE ABOUT IT IN THE POPULAR AND SPECIALIST PRESS. THE FOLLOWING CRITICS ARE ITS MOST INFLUENTIAL, SUPPORTIVE AND PERCEPTIVE CHAMPIONS.

MATTHEW COLLINGS

Artist, Writer and Broadcaster

'This is Modern Art' was the title of Matthew Collings' 1999 Channel 4 series and book, and, as far as British TV watchers are concerned, the same could be said for Collings himself. Ever since the burly, bespectacled Collings first appeared in front of the cameras as an art critic and presenter for the BBC's 'Late Show' in the early 1990s, for many he has become the face of modern and contemporary art – with Collings the two categories are indistinguishable. He fronts the Channel 4 Turner Prize coverage, writes snazzily titled books (*Blimey! from Bohemia to Britpop!*; *It Hurts: New York Art From Warhol To Now*) and his 'Hello Culture!', another Channel 4 TV series airing in 2001, goes beyond art to look at the roots of all contemporary culture.

People either love or loathe Collings' distinctive, breezy, blokey style. Whether in person or print, he presents a scattergun, high-tempo, seemingly stream-of-consciousness outpouring, in which, amidst wide-eyed moments, confessional interludes and self-deprecating gags, it's often difficult to know

what he really thinks or believes. In a few seconds of airtime, or inches of column space, he can flip between sincere/cynical or art-world innocent/knowing insider, and whether this non-committal routine is stimulating and entertaining or flippant and self-referential is a matter for debate. But there's no doubt that Collings knows his contemporary art world. No arts presenter to date has been so immersed in as many of its aspects. After attending Byam Shaw School of Art between 1974-8, he worked for *Artscribe*, then the UK's leading art magazine, which he edited from 1983 until his stormy departure in 1987 (*Artscribe* folded in 1990). Whilst working for the BBC, Collings completed an MA in Fine Art at Goldsmiths and throughout the 1990s he continued to make and exhibit his own art – which often took the form of painted targets. Amidst all his media manifestations, which include articles in national papers and magazines, he also continues to front his own art rock band, which has a frequently changing line-up and goes by the name of Interspecies Love Child. All of the above are irreverently chronicled in Collings' long-running, regular diary column for *Modern Painters*.

RICHARD CORK
Chief Art Critic, *The Times*

Richard Cork is a rare species among newspaper art critics of his generation: he gives the very latest in contemporary art as much consideration as he allots to established artists who have already acquired a reputation. This may seem the obvious – indeed the only – thing for an art critic to do, but many of his colleagues in the national press still feel that art should know its place, which is firmly on a plinth, or in a frame, credible only if it displays as much perspiration as inspiration on the part of its maker. It is therefore especially important for radical art to have an ally at the heart of the establishment – in addition to being chief critic for the *Times* since 1991, Cork also had a voluntary commitment to chair the Arts Council of England's Visual Arts Panel from 1995 to 1998. This standard art-world practice, by which a few figures perform a variety of interconnected roles – Cork has also curated exhibitions – has been criticised by some, but is seen by those in question as a labour of love for which they receive unjustified flak.

Cork's training is as an art historian, and his great passion is European art of the first half of the twentieth century (he has written books on

Vorticism and David Bomberg and curated a major exhibition about art and the First World War, *A Bitter Truth: Avant-Garde Art and the Great War*, which was held in Berlin and London in 1994). However, an early encounter with Richard Long's work during the 1960s pointed him towards modern British sculpture, and an enduring support for the work of Tony Cragg, Richard Deacon, Bill Woodrow and Anish Kapoor as well as more recent arrivals such as Cornelia Parker, Anya Gallaccio and Rachel Whiteread.

Both in his column in the *Times* and in previous posts on the *Listener* and as art critic for the *London Evening Standard* (a job he held from 1969 to 1983, when, on a black day for contemporary art, he was succeeded by the fulminating Brian Sewell), Cork has consistently turned his clear eye and lucid prose towards the latest in art practice. In addition, he nailed his avant-garde colours to the mast by being one of three selectors for the *British Art Show 4*, which toured Great Britain during 1995-6, with twenty-six artists (many of whom are in this book), described by Cork as thriving on a 'bracing diet of irony and scepticism'.

MEL GOODING
Writer and Curator

'I hate the notion of interpretation, I hate the notion of explanation', declares Mel Gooding in what might sound like a surprising statement for an art critic. Just for the record, he isn't that wild about art history either and feels that art should not be looked at as evidence of something else outside it: 'art isn't about issues it is about realities, art creates realities.' It is this passionate dedication to art not just as a part of life but as a force of life itself that comes through Gooding's writing. He is as informed about the history of art as anyone, and as aware of the surrounding cultural and political terrain, but what sets Gooding apart from many visual arts writers is his adamant belief that the starting point for a critic should be looking carefully at the work itself to see how its overall effect is dictated by its specifics, independent of any historical setting.

This approach has its origins in Gooding's early career when, throughout the 1970s, he taught literature and poetry. His roots, therefore, are in the written word, and although he has been concentrating on art since the late 1970s, he continues to subscribe to the view of the literary critic F.R. Leavis that the critic must first and foremost examine the text, or in this case,

artwork, and provide no answers, only clues. This strategy is especially conducive to the examination of paintings, and despite the fact that his interests extend into all media (he was on the Turner Prize jury in 1996 when it awarded the prize to Douglas Gordon, the first artist using the moving image to win), it is painting that is Gooding's greatest love.

Whether he is discussing the wryly subversive painted texts of Simon Patterson, the lyrical images of St Ives artist Patrick Heron, or the vivid, flamboyant gestures of abstract painter John Hoyland, Gooding's ability to make his style of delivery reflect and illuminate his subject matter is particularly important in the context of today's artistic climate. Unlike so many writers who try to pin down in prose the most elusive qualities of painting, Gooding does so in a way that is devoid of nostalgia, with his enthusiasm for the medium couched in terms of possibilities, rather than the staking out of territories.

For his own part, Gooding himself is not restricted to one medium. As well as writing for art magazines (especially *Art Monthly*), contributing to exhibition catalogues, and sitting on several panels and committees, he also collaborates on a variety of projects, both within and around the art world. In 1985, he set up Knife Edge Press with Bruce McLean, where he worked on eight original artists' books and other print-related projects. He has also teamed up with the architect Will Alsop on a number of projects, including radical – and unrealised – proposals for a new Tate Gallery of Modern Art.

SARAH KENT
Visual Arts Editor, *Time Out*

Over more than twenty years of covering visual art for London's *Time Out* magazine, Sarah Kent has been an energetic chronicler of the contemporary, hoofing off to the most obscure and inaccessible venues long before it became fashionable for art to be exhibited in unusual places, and championing both young artists and writers at the beginning of their careers. Now, thanks to Kent's continuing support of the latest and the experimental, the magazine lists several categories of 'alternative' spaces, and a review in its pages carries far more weight than you'd imagine from the capital's weekly listings guide. Kent's personal influence also extends beyond this outlet: she curates exhibitions, sits on panels, and on television and radio she is often

pitched against more conservative elements as an animated advocate of the wilder shores of today's art.

Kent's roots are in the radical era of the late 1960s and 1970s, in which Feminism emerged as a fully fledged movement and polemic wasn't a dirty word. After studying painting at the Slade, she worked as an artist until 1977, when she became Exhibitions Director at the ICA, writing for *Time Out* at the same time. In her two years at the ICA, exhibitions of Andy Warhol, Allen Jones and Christo were mounted, as well as more overtly political shows, such as an exhibition of paintings by the feminist artist Alexis Hunter, and the show *Berlin a Critical View: Ugly Realism*, which compared the satirical art of Berlin in the 1920s with that of the 1970s. During this period, she gave up painting and began taking photographs, mainly of male nudes.

Kent has described her role as that of 'spokesperson, especially for women artists, in a country that is essentially hostile to contemporary art'. This stance was underlined in the book *Women's Images of Men* (1985), co-authored with the artist Jacqueline Morreau, as well as in the more recent women-only exhibitions she has curated, such as *Peripheral States* (Benjamin Rhodes Gallery, 1993) and *Whistling Women* (Royal Festival Hall, 1995), which included an installation by Anya Gallaccio, a reading by Tracey Emin, and videos by Lucy Gunning, Tacita Dean, Sarah Lucas, Gillian Wearing, Jane and Louise Wilson, and Catherine Yass.

As regards the gender issue, Kent now says that her 'partisan approach is giving way to ... a passionate neutrality'. Throughout the 1990s these passions became focused on the new wave of young British artists that had begun to emerge the decade before. Many of these were collected by Charles Saatchi, and during the first half of the 1990s, Kent was unapologetic about the fact that she wrote a number of catalogues for their shows at Saatchi's gallery whilst reiterating her enthusiasm for their work in *Time Out*. It was in the first exhibition of Saatchi's open-ended series *Young British Artists* in 1982 that Damien Hirst's infamous shark made its debut appearance, and this iconic artwork inspired the title of *Shark Infested Waters* (1994), Kent's informative account of thirty-five artists from the eclectic holdings of Britain's best-known contemporary art collector. By the late 1990s, however, Saatchi had begun to commission texts from the young painters in his collection, with Martin Maloney and Dexter Dalwood (aka Dick Witts) providing catalogue commentaries on his British purchases. At *Time Out*, meanwhile Kent and her team of reviewers continue to provide extensive coverage of unfolding developments in London's art scene.

STUART MORGAN

Critic

Stuart Morgan
(left) and Adrian
Searle (see
p.223)
Photo: Cindy
Palmano

In 'Homage to the Half Truth', a paper delivered to an art-writing conference in 1990, Stuart Morgan said that 'critics should be respected for their capacity for intuition, sympathy and imagination ... And no definition of criticism should omit this element of artistic inspiration'. Later on, however, he adds a destabilising note: 'Critics operate as double agents, at an interface between artist and audience, seeming to speak for both sides while making both equally mistrustful. But suspicion is in order. Whose side are critics on, after all? ... The critic is on the critic's side, for criticism means reserving the right to take any side at all.'

It is Morgan's rare ability to fulfil all the above criteria that has made him our pre-eminent art critic. Although he may be little known outside the art world, he has undoubtedly been one of the most original and influential writers within the contemporary art scene. He is as inventive as an artist in what and how he writes, but this doesn't get in the way of the art itself; he can be deadly serious without ever taking himself too seriously, and he combines awesome erudition with easy accessibility and a relish for the subversive. (In one short catalogue essay his references spanned physicist David Bohm, Situationist Guy Debord, postmodernist Jean-Francois Lyotard, James Gleick's book on Chaos Theory and Yogi Bear.)

Nowhere is Morgan's rigorous playfulness more evident than in his many published interviews, which are lively, informal exchanges, gripping in their own right, while at the same time drawing out important and often unexpected insights about how artists from Joseph Beuys to Louise Bourgeois, Damien Hirst and Tracey Emin think and work. His interview with Richard Wentworth for his first Lisson Gallery exhibition in 1984 still stands as the most revealing account of the thinking behind his sculpture. It is rare for a writer to be this creative in allowing others to expose their creativity.

An unpredictable and irreplaceable presence within British art, for more than fifteen years Morgan has written some eighty one-person catalogue essays for public institutions, commercial galleries and artist-run venues, and has taught in most of our leading art schools. His writings have been published by virtually every major British art magazine, as well as many in

Europe and America. During the 1980s he made his mark contributing to, and for a time editing, *Artscribe*, which, before it folded in 1990, was Britain's leading magazine of contemporary art; and he continues to be a major contributor to its 1990s successor *frieze*, which, in 1996 launched its own publishing arm with a volume of Morgan's writings under the typically droll title of *What the Butler Saw*.

Like one of his favourite artists, Louise Bourgeois, he dislikes conformity and consistency, and this is probably why he has been treated with some suspicion by the arts establishment. (He co-curated the Tate's only major exhibition of contemporary art in the 1990s, the 1995 *Rites of Passage*, yet he has twice refused to be a judge of the Turner Prize, and is one of its most vehement critics.) However, although they may not always admit it, Morgan's opinion is one of the few that today's artists respect and take notice of.

JAMES ROBERTS

Exhibition curator and writer, Editor, *frieze* magazine

The same age as many of the artists he writes about, since leaving the Courtauld Institute in 1988, James Roberts has made a point of examining the successive waves of artists emerging during the 1980s and 1990s, pointing to areas of common ground, significant shifts of emphasis and drawing distinctions with intellectual acuteness and lucidity.

There are many young writer/curators currently making their mark within the art world, but Roberts is particularly important, not just for showcasing the most recent work, but also for presenting it within a broader context. The catalogue he edited and co-authored for the British Council's *General Release* exhibition of fifteen young British artists for the 1995 Venice Biennale, for example, gives a definitive account of the social, economic and cultural climate surrounding their work, while some of Roberts' best early writings focused on older artists such as Simon Linke, Julian Opie and Richard Wentworth, whose playful and cerebral investigations of our seemingly banal surroundings continue to have a strong resonance for many younger artists working today.

Roberts based his MA thesis on post-war Japanese art, and, as well as writing extensively on the contemporary Japanese art world, he has curated a number of exhibitions of British art in Japan. His three-part *High Fidelity* at the Kohji Ogura Gallery not only introduced a range of British artists to a

Japanese audience, but also, by presenting Thomas Gidley with Douglas Gordon, Rachel Evans with Georgina Starr and Adam Chodzko with Simon Patterson, threw up new links and differences between the individual artists. In *Beyond Belief* at London's Lisson Gallery in 1994, Roberts presented more artistic interconnections, juxtaposing the work of British artists such as Jane and Louise Wilson or Thomas Gidley – whose work patrols the territory between incident and phenomenon – with kindred spirits from France and the United States.

Both as a curator and a writer, Roberts is unerringly deft in his ability to clarify without simplifying. He is the master of the unexpectedly pertinent analogy: an essay on Julian Opie, for example, begins with a celebration of Tintin the modern hero; or a discussion of Adam Chodzko's navigation of the classified columns is prefixed by an analysis of Sherlock Holmes' quest for greater and darker truths. As a result, he adds a new richness and depth to our understanding of British art.

ADRIAN SEARLE

Chief art critic, *The Guardian*

Very few writers make the crossover from the meditative pace of specialist arts press criticism to the pithier delivery of a newspaper column. Adrian Searle is an exception. Both his earlier pieces for *frieze* and his weekly articles in the *Guardian* are required reading, not just for their refreshing directness and sometimes hilarious ability (especially in the newspaper) to deliver a savage put-down, but also for his genuine creative skill as a writer.

Like many apparent cynics, Searle is a romantic at heart. Although the past few years have found him sharpening his hatchet, when he permits his sardonic guard to fall and lets his emotions off the leash he can be almost achingly poetic. In the light of his response to the late works of Willem De Kooning, the photographs of Craigie Horsfield, or the paintings of Luc Tuymans, it is not surprising to learn that he also writes fiction. Unlike so many newspaper critics, Searle is capable of evoking the impact of even the most elusive artwork, and clarifying more cerebral gestures in a way that is always personal and never pompous. His essay for Michael Craig-Martin's 1997 exhibition at Waddington Galleries for instance, is a study in how to make writing style work in tandem with artistic subject matter.

This clarity of delivery is perhaps in part due to the fact that commenting

has been combined with the direct experience of communicating: like many of our best writers on contemporary art, Searle has a long history of teaching in art schools, including Central St Martins from 1981-94; Chelsea from 1991-6, and Goldsmiths from 1994-6. As well as curating several exhibitions (most recently *Unbound: Possibilities in Painting* at the Hayward Gallery in 1994), Searle has also spent many years actually making the stuff. As an artist, his troubled, troubling paintings were widely exhibited both in the UK and in Europe and it was only when he took the *Guardian* job that he left the studio: 'I was always torn between making art and writing. Writing won.'

ANDREW WILSON
Deputy Editor, *Art Monthly*

Original thought and academic rigour characterise the writings of Andrew Wilson, who, in addition to his work for a number of contemporary art magazines (most recently *Art Monthly*), has written illuminating catalogue essays for numerous artists including Richard Wilson (*Jamming Gears*, Serpentine Gallery, 1996), Mark Wallinger (Museum Für Gegenwartskunst, Basel, 1999) and Gavin Turk (*Collected Works 1989-93*, Jay Jopling, 1993). He has also been a trustee of artist-run space Beaconsfield since 1999.

As well as studying History of Art at Sussex University, Université Libre de Bruxelles and Kent University, Wilson has completed a Courtauld Institute PhD on Patrick Heron and post-war British Abstract painting, and he describes his interests as 'split between contemporary and historical'.

Despite an outwardly sober appearance, Wilson could be described as a historian of dissent. Rather surprisingly, he declares that his work on Heron, for example, followed an initial study of the 1960s 'underground' in Britain, in all its ramifications: drug culture, protest politics, anti-institutional education, music, psychoanalysis, race, revolution etc. He has an extensive archive of items from this era, and these concerns often crop up in his writings. Wilson is also interested in the iconography of Punk, which is reflected in another collection, some parts of which went on show at the Eagle Gallery in 1996. In the same year, he curated *Made New*, the first and only historical exhibition at the now-defunct, but massively influential, artist-run City Racing gallery. This small but important exhibition took the pataphysical writings of nineteenth-century poet-philosopher Alfred Jarry as

the subtext for three infinitely re-makeable pieces by Gustav Metzger, Barry Flanagan and Tim Mapston.

Another important Wilson project was *Sluice Gates of The Mind*, the first comprehensive exhibition and catalogue of the work and collaborations of Dr Grace Pailthorpe and Reuben Mednikoff, two of British Surrealism's most influential, eccentric – and overlooked – figures. As well as working with revolutionaries of past eras, Wilson has been responsible for drawing attention to living figures, for example his long relationship with veteran radical Metzger, which has been responsible for the recent revival of interest in this pioneer of 'Auto-destructive art'.

Wilson's activities therefore present not so much a split as a join between the historical and contemporary, in which his investigations into the past give resonance and crucial context to the contemporary scene.

THE GEOGRAPHY

ART SCHOOLS

British art schools are the seedbeds for the country's art, responsible in part for its continuing vitality. Their most distinctive quality is their widespread and enduring policy of employing both part-time and visiting tutors who are not just practising, but also often prominent, artists or art-world figures in their own right. Goldsmiths College, for example, the Slade, and Glasgow School of Art – who are each particularly known for their promotion of the experimental and the innovative – make a point of exposing their students to a wide range of artists, writers, curators and thinkers within the art world and beyond. Additionally, unlike many art schools elsewhere in the world, where spaces are shared, students in the UK are invariably provided with their own personal studio areas in which to work unimpeded.

In recent years, funding cuts and administrative upheavals have led to a glossier, more entrepreneurial climate and some schools have been accused of placing presentation over innovation. But Britain's art schools, where students tend to be treated from the start as artists in their own right within an atmosphere of debate and discussion, continue to be admired and envied world wide. This reputation – and the recent hype surrounding British art – has resulted in an increasing number of overseas students, who are welcomed (some feel too warmly) as a valuable source of income for cash-strapped art schools. Yet conversely, their international make-up is another factor that contributes to the unique flavour of British art schools.

The make-up of the graduate and postgraduate Fine Art courses in Britain's fifty or so art schools is a moveable feast, but to get an idea of the variety, visit the degree shows (held in May/June) and check out the year's roster of visiting tutors. Below is just an indication of some of the most significant establishments.

Architectural Association

34-36 Bedford Square
London WC1B 3ES
t 020 7887 4000 f 020 7414 0782
email: aaschool@aaschool.ac.uk
Website: www.aaschool.ac.uk
Chairman: Mohsen Mostafavi

While the AA is not a Fine Art school, its ongoing programme of public talks, given by leaders in the contemporary art scene, and its series of adventurous exhibitions have made it a popular forum for the discussion of issues in art, as well as architecture.

Byam Shaw School of Art

2 Elthorne Road, Archway
London N19 4AG
t 020 7281 4111 f 020 7281 1632
email: info@byam-shaw.ac.uk
Website: www.byam-shaw.ac.uk
Principal: Alister Warman

Originally founded in 1910 as an independent school of drawing and painting, during the 1980s Byam Shaw shed its genteel image and opened up its facilities to cover all media. It retains independent status, has an impressive list of visiting artists/lecturers, and attracts a large number of students both foreign and British – many of whom have achieved international success.

Duncan of Jordanstone College of Art & Design, School of Fine Art

University of Dundee
Perth Road, Dundee DD1 4HT
t 01382 345203 f 01382 345363
Website: www.dundee.ac.uk
Dean of Faculty: Professor Ian Howard

This college, comprised of Schools of Design, Fine Art and Television & Imaging, has achieved status as one of the UK's leading art schools. It is in partnership with Dundee Contemporary Arts, which houses the University Visual Research Centre.

Glasgow School of Art

167 Renfrew Street, Glasgow G3 6RQ
t 0141 353 4500 f 0141 353 4746
email: d.cameron@gsa.ac.uk
Website: www.gsa.ac.uk
Director: Professor Seona Reid

Housed in Charles Rennie Mackintosh's landmark building, this is one of the few remaining independent art schools in the UK. A commitment to innovation and experiment is evidenced by the

presence of many ex-students in the international art world, and an imposing list of artist-tutors of all ages promises continued success in this field.

Goldsmiths College
University of London
New Cross, London SE14 6NW
t 020 7919 7671 f 020 7919 7673
email: visual-arts@gold.ac.uk
Website:
www.gold.ac.uk/visual-arts/menu.htm
Head of Visual Arts: Brian Falconbridge
Millard Professor of Fine Art:
Michael Craig-Martin

Goldsmiths' reputation as the alma mater of many of today's high-profile artists is the result of a longstanding commitment to encourage the international and the intellectual, to abolish divisions between departments, and to promote an atmosphere of lively debate.

The London Institute (includes Camberwell College of Arts; Central St Martins College of Art & Design; Chelsea College of Art & Design)
65 Davies Street, London W1Y 2DA
t 020 7514 6000 f 020 7514 6131
email: marcom@linst.ac.uk
Website: www.linst.ac.uk
Rector: Sir William Stubbs

Since the traumatic merger of these three venerable art schools (along with the London Colleges of Fashion and Printing) in 1986, each has worked to forge a new identity under the central umbrella of the London Institute. Chelsea maintains a reputation for vigorous painting, sculpture and combined media departments along with a strong MA; Central St Martins now avoids a modular course to allow students to range across all media, while external projects ensure that they tap into the world at large. Having lost its Fine Art Department in the merger, Camberwell now operates according to a system of 'elective' practices, but much has been done to redress the discontent regarding poor facilities and student-staff ratio that flared up into sit-ins in 1999.

Royal Academy of Arts Schools
Burlington Gardens, London W1V ODS
t 020 7300 5650 f 020 7300 5856

Website: www.royalacademy.org.uk
Head of Art: John Wilkins

A location at the heart of the historical art establishment and corridors crammed with antique plaster casts in mahogany cases hasn't prevented a spirit of artistic enquiry from pervading the RA schools.

Royal College of Art
Kensington Gore, London SW7 2EU
t 020 7590 4444 f 020 7590 4500
email: info@rca.ac.uk
Website: www.rca.ac.uk/
Rector: Professor Christopher Frayling

Entirely devoted to postgraduate studies in art and design, during the Thatcher years the RCA was criticised for slicking up its image and scaling down its courses with rather too much of a commercial spirit. There's still an air of pragmatism at the RCA, and since 1992 it has extended its activities with a special MA in Curating and Commissioning Contemporary Art, run in partnership with the Arts Council.

University College London, Slade School of Fine Art
Gower Street, London WC1E 6BT
t 020 7679 2313 f 020 7679 7801
email: slade.enquiries@ucl.ac.uk
Website: www.ucl.ac.uk/slade/
Slade Professor: Bernard Cohen

As well as a time-honoured tradition of drawing and painting from the live model, which still forms part of a now much more diverse painting department, sculpture at the Slade has produced major figures for over three decades, from John Davies, to Antony Gormley, Rachel Whiteread and Tomoko Takahashi. In 1967 the Slade developed one of the first art school media departments (devoted to film, video, photography, sound and performance) and a new Slade Centre for Electronic Media and Fine Art was opened in 1995. Now full- and part-time teaching staff include artists of all generations, working in every medium.

University of Oxford, Ruskin School of Drawing and Fine Art
74 High Street, Oxford OX1 4BG

t 01865 276940 f 01865 276949
email: stephen.farthing@ruskin-school.ox.ac.uk
Website: www.ruskin-sch.ox.ac.uk/
Master: Stephen Farthing

The Ruskin School treats the borders between its Painting, Printmaking, Electronic Image and Sculpture Departments as permeable and open for investigation. As the Fine Art Department at the University of Oxford, it also benefits from a strong academic foundation, with an emphasis on prominent visiting lecturers.

Of particular note is The Laboratory, a unit at the Ruskin that supports action research based on collaborations between artists and experts from the worlds of science, technology and the humanities. Its administrators, Paul Bonaventura and Antonia Payne, invite artists at all stages in their careers to apply for attachments. These have included Richard Wentworth, Stefan Gec, Cornelia Parker, Zarina Bhimji, Graham Gussin, Jake Tilson and Susan Hiller. It has also invited Susan Dreges and Mark Wallinger to make projects at the University's Museum of Natural History and Museum of History of Science. The Laboratory organises the Joseph Beuys and John Berger Lectures, The Arts Council of England Helen Chadwick Fellowship and the 1871 Fellowship.

ORGANISATIONS

FUNDERS AND FACILITATORS

The Arts Council of England, The Arts Council of Northern Ireland, The Scottish Arts Council, The Arts Council of Wales
Most of the organisations and venues listed in this section are on the receiving end of some form of Arts Council funding. The Arts Council of Great Britain was founded in 1946 with the aim of 'developing a greater knowledge, understanding and practice of the fine arts exclusively, and in particular to increase the accessibility of the fine arts to the public throughout our Realm'. Although its remit remains pretty much the same, in 1994 it was split into three separate

bodies: the Arts Council of England, the Scottish Arts Council and the Arts Council of Wales. (The Arts Council of Northern Ireland was already an independent organisation, receiving its funding from the Department of Education for Northern Ireland.) Each of these has close links and overlaps, and they collectively combine to form a ubiquitous cultural behemoth whose presence permeates most aspects of the contemporary art world.

The Arts Council of England (ACE)

14 Great Peter Street
London SW1P 3NQ
t 020 7333 0100 f 020 7973 6590
email: HYPERLINK mailto:info.visu-alart.ace@artsfb.org.uk
Website: www.artscouncil.org.uk
Director of Visual Arts:
Marjorie Allthorpe-Guyton

Throughout the English contemporary art world, administrators spend much of their time filling in applications to the Arts Council for grants, most of which are serviced by the Visual Arts Department. The Arts Council has restructured its departments, delegating some of its major galleries, including the Whitechapel, Serpentine, Ikon, MOMA and the Arnolfini to their respective Regional Arts Boards. The Visual Arts Department retains its national responsibility for overall development of the infrastructure of galleries, artists' spaces, agencies, distribution networks, production facilities and oversees visual arts grants in the new National Training Programme, and soon, the Publishing and Recordings Scheme. The new schemes will benefit a wide range of visual arts practice, including architecture and crafts, for which the Arts Council now has national responsibility. Visual Arts also funds national educational initiatives such as the Royal College of Art's postgraduate course on Commissioning and Curating Contemporary Art. It also leads a national action plan to enhance the professional and economic status of artists.

Although it states that its funding is 'mainly focused on leading-edge contemporary work' the ACE gives money to specific organisations and projects, no grants being directly available for artists.

Instead, artist funding – albeit on a modest scale – is one of the remits of England's ten Regional Arts Boards.

ACE's Visual Arts Department is currently headed by Marjorie Allthorpe-Guyton, previously Editor of *Artscribe* and a writer on contemporary art.

Regional Arts Boards (RABs)

While constitutionally independent from the Arts Council of England, the RABs nonetheless rely for the majority of their funding on the ACE, all ten RAB chairs being members of the Arts Council of England. Each Regional Arts Board can also dole out a modest range of funding to the different art forms within specific geographical boundaries. This includes a number of awards made directly to individual artists, which can vary regionally.

Eastern Arts Board

Cherry Hinton Hall, Cherry Hinton Road
Cambridge CB1 8DW
t 01223 215355 f 01223 248075
email: info@eastern-arts.co.uk
Website: www.arts.org.uk/rab-nf.html
(Bedfordshire, Cambridgeshire, Essex, Hertfordshire, Norfolk, Suffolk.)
Director of Visual Arts and Media:
Sue Norman

East Midlands Arts Board

Mountfields House, Epinal Way,
Loughborough, LE11 0QE
t 01509 218292 f 01509 262214
email: info@em-arts.co.uk
Website:www.arts.org.uk/directory/regions/east-mid/index.html
(Derbyshire – excluding High Peak – Leicestershire, Lincolnshire, Northamptonshire, Nottinghamshire, Rutland)
Visual Arts & Craft: Alison Lloyd
Tanya Bryan, Su Murkin

London Arts Board

Elme House, 133 Long Acre,
Covent Garden, London WC2E 9AF
t 020 7240 1313 f 020 7670 2400
email:
firstname.surname@lonab.co.uk
Website: www.arts.org.uk/lab
(The 32 London Boroughs and the City of London)
Principal Visual Arts Officer:
Holly Tebbutt

Northern Arts Board

9-10 Osborne Terrace, Jesmond
Newcastle-upon-Tyne NE2 1NZ
t 0191 281 6334 f 0191 281 3276
email: norab.demon.co.uk
Website: www.arts.org.uk
(Cumbria, Durham, Northumberland, Teesside, Tyne & Wear)
Head of Visual Arts: James Bustard

North West Arts Board

Manchester House, 22 Bridge Street
Manchester M3 3AB
t 0161 834 6644 f 0161 834 6969
email: info@nwarts.co.uk
Website: www.arts.org.uk/nwab
(Cheshire, High Peak District of Derbyshire, Lancashire, Merseyside, Greater Manchester,)
Director, Visual Arts and Media Arts:
Howard Rifkin

South East Arts Board

Union House, Eridge Road
Tunbridge Wells, Kent TN4 8HF
t 01892 507200 f 01892 549383
email: info@seab.co.uk
Website: www.arts.org.uk
(Kent, Surrey, East and West Sussex)
Director of Visual and Media Arts:
Margaret O'Brien

Southern Arts Board

13 St Clement Street
Winchester SO23 9DQ
t 01962 855099 f 01962 861186
email: info@.southernarts.co.uk
Website: arts.org.uk
(Berkshire, Buckinghamshire, Hampshire, Isle of Wight, Oxfordshire, Wiltshire, South East Dorset)
Visual Arts Officer: Phil Smith

South West Arts Board

Bradninch Place, Gandy Street
Exeter EX4 3LS
t 01392 218188 f 01392 413554
email: info@swa.co.uk
Website: www.swa.co.uk
(Cornwall, Devon, Dorset, Gloucester, Bristol, South Gloucestershire, Bath, North East and North Somerset, excluding Bournemouth, Christchurch and Poole)
Director of Visual Arts: Val Millington

West Midlands Arts Board

82 Granville Street, Birmingham B1 2LH

Catherine Yass
**Portrait: Selection
Committee for the
Arts Council
Collection**
1994
Arts Council
Collection,
Hayward Gallery
from left to right: Vong
Phaophanit, Greg Hilty,
Marjorie Althorpe-Guyton,
Isobel Johnstone, Shirazeh
Houshiary, Adrian Searle

t 0121 6313121 f 0121 6437239
email: info@west-midlands-arts.co.uk
Website:
www.west-midlands.arts.org.uk
(Hereford & Worcester, Shropshire,
Staffordshire, Stoke-on-Trent,
Warwickshire, the metropolitan districts
of Birmingham, Coventry, Dudley,
Sandwell, Solihull, Wolverhampton)
Director of Visual Arts, Crafts & Media:
Caroline Foxhall

Yorkshire Arts

21 Bond Street, Dewsbury
West Yorkshire WF13 1AX
t 01924 455555 f 01294 466522
email: info@yarts.co.uk
Website: www.arts.org.uk
(North Yorkshire; metropolitan districts
of Barnsley, Bradford, Calderdale,
Doncaster, Kirklees, Leeds, Rotherham,
Sheffield, Wakefield. Unitary authorities
of York, Hull, East Riding, North
Lincolnshire, North East Lincolnshire)
Head of Visual Arts: Adrian Friedli

ACE Collection

Curator: Isobel Johnstone

Not only does the ACE fund contempo-
rary art, it also buys it. The Arts Council
Collection was founded along with the
Council itself, in 1946, with the aim of
showing 'innovative work by British
artists through touring exhibitions and
long loans' and its function remains the
same today. The Collection forms an
integral part of National Touring
Exhibitions, administered by the
Hayward Gallery on behalf of the Arts
Council. (See Hayward Gallery.)

Now, with about thirty new works
being added each year, the collection

consists of over 3,000 paintings, sculp-
tures and drawings, 1,500 artists' prints
and 2,000 photographs. Artists, critics
and curators (as well as Arts Council
officers) are invited to act as purchasers
for the collection for eighteen months at
a time. Examples of works bought in
1999-2000 were Mona Hatoum's
Plotting Table (1998), Mark Wallinger's
The Four Corners of the Earth (1998) and
Donald Rodney's *In the House of my
Father* (1997).

Arts Council of Northern Ireland (ACNI)

Macneice House, 77 Malone Road,
Belfast BT9 6AQ
t 02890 385200 f 02890 661715
email: creative@artscouncil-ni.org
Website: www.artscouncil-ni.org
Director of Creative Arts Director:
Nóirín McKinney; Visual Arts Officer:
Paula Campbell

Following restructuring in 1995, Visual
Arts is now part of a larger Creative Arts
department that embraces painting,
sculpture and installation, architecture,
craft, and photography. Through the
department, the Council funds a net-
work of galleries across Northern
Ireland, notably the Orchard Gallery,
Derry and the Ormeau Baths Gallery,
Belfast. Other departmental aid is
allocated to artists' studios and to
organisations, as well as to an annual
fellowship in New York and a bi-annual
residency in Rome. The department also
makes modest but crucial awards
directly to individual artists in any of the
above disciplines to 'buy time' for the
completion of creative work, to pursue
specific projects, or undertake specialist

training. This artist-friendly policy
includes working closely with the Irish
Arts Council in Dublin on such perks as
the Airflight Scheme, which allows indi-
vidual artists to travel free to North
America and Europe for professional
and/or creative purposes.

The Arts Council of Northern Ireland
Collection acquires works by living
artists from Northern Ireland, which it
lends to public bodies in the region.

The Scottish Arts Council (SAC)

12 Manor Place, Edinburgh EH3 7DD
t 0131 226 6051 f 0131 225 9833
email: firstname.surname@
scottisharts.org.uk
Website: sac.org.uk
Acting Director of Visual Arts:
Amanda Catto

The Scottish arts scene goes from
strength to strength. This is enhanced
and acknowledged by the Scottish Arts
Council's Visual Arts Department,
which puts a particular emphasis on
directly assisting artists to make work,
as well as funding exhibitions and pro-
jects at galleries such as Fruitmarket
and The Collective in Edinburgh, the
Transmission in Glasgow and the Pier
Art Centre in Orkney. Visual Artists
Awards of £2,000, £7,000 or £15,000
recognise artists' achievements and
enable them to extend their own creative
development, while smaller grants help
them with the more immediate costs of
creating and presenting their work. Past
beneficiaries include Douglas Gordon
and Christine Borland. There are also
fellowships in Amsterdam, at the British
School at Rome and in Australia, as well
as a scheme to assist organisations in

Scotland to host artists in residence. The Combined Arts department also supports organisations that programme important contemporary art shows, such as the Centre for Contemporary Arts and the Tramway in Glasgow.

The Scottish Arts Council Collection, consisting of over 2,000 works built up over forty years has now been dispersed throughout Scotland.

The Arts Council of Wales (ACW)
Museum Place, Cardiff CF10 3NX
t 029 2037 6535 f 029 2022 1447
email: information@ccc-acw.org.uk
Website: ccc-acw.org.uk
Senior Visual Arts and Craft
Development Officer: John Hambley

As well as supporting key exhibition spaces such as Ffotogallery and Oriel Mostyn, ACW also offers interest-free loans of up to £1,000 to artists to buy materials and equipment and to prepare work for exhibitions. Bursaries allow recipients to take time away from their usual employment or circumstances in order to devote themselves to work, and other grants are also available.

AXIS
Leeds Metropolitan University,
8 Queen Square, Leeds LS2 8AJ
t 0113 245 7946 f 0113 245 7950
Information service: 0930 170 130
email: axis@lmu.ac.uk
Website: www.axisartists.org.uk
Chief Executive: Kate Hainsworth

Founded in 1991, Axis provides information on British contemporary artists. The Axis database features over 10,000 images by more than 3,000 artists. Printouts of their CVs, artworks and contact details are available to potential buyers, commissioners, exhibitors and collaborators. The database can be accessed on CD ROM, on their website, at Axispoint host organisations throughout the UK, and via the Axis Information Service. Axis is a non-profit organisation, funded by the Arts Councils of England, Scotland and Wales and several Regional Arts Boards. Cyber Axis is an interactive virtual gallery where works can be examined online.

The National Lottery
For the time being at least, 20 percent of the National Lottery's net proceeds is directed towards the arts. These funds, managed by the UK's four Arts Councils, are divided between all art forms, but already lottery money is making its presence dramatically felt within the British visual art world, with £20 million going on the commissioning of new works and approximately £90 million given to building projects. These include the new Ikon Gallery in Birmingham; Dundee's purpose-built visual arts centre; a customised museum and gallery for Walsall; and an international centre for contemporary art in the refurbished Baltic Flour Mills, Gateshead. Lottery money is also responsible for a crop of public sculptures emerging throughout Britain and Northern Ireland.

Recently, the original restriction of lottery grants to capital projects only has been lifted to include one-off funding for particular projects, and each Arts Council is introducing new schemes such as ACE's Arts 4 Everyone, ACW's Arts for All and SAC's New Directions, which set priorities for innovative work and fresh audiences.

The British Council, Visual Arts Department
11 Portland Place, London W1N 4EJ
t 020 7930 8466 f 020 7389 3101
email: hymie.dunn@britishcouncil.org
Website: www.britishcouncil,org/
Director of Visual Arts: Andrea Rose

Since its foundation in 1934 as part of British foreign policy 'to encourage both cultural and educational interchanges between the United Kingdom and other countries', the British Council is now represented in 109 countries and is an integral part of the UK's overall diplomatic and aid effort. It is still funded by the Foreign and Commonwealth Office primarily, but reliance on the mandarins of Whitehall hasn't prevented the British Council's Visual Arts Department from being one of the country's most significant promoters of progressive contemporary art, and has often been responsible for giving British artists a higher profile abroad than they have received at home. Also acknowledging more historical figures, the British

Council mounts some sixty major exhibitions overseas per year.

Crucially, it is the British Council (assisted by an advisory committee chaired by Richard Calvocoressi, and including curators, critics and gallery directors from across the UK) that is responsible for British participation in the regular round-up of international art events such as the Venice, São Paulo Istanbul and Johannesburg Biennales, and the Indian Triennale.

British artists who have received a firm invitation to travel abroad can apply for support in meeting their transport costs, and the Grants to Artists and Subsidies Scheme assists private and independent galleries to exhibit the work of British artists, or directly helps the artists themselves.

The **British Council Collection** was started in 1938 and now consists of some 7,000 works: 2,500 paintings, sculptures, and works on paper, as well as 4,400 limited-edition prints, photographs and multiples. These works are hung in British Council offices throughout the world and loaned to galleries in Britain and abroad, or make up touring exhibitions such as *Dimensions Variable* (Helsinki Art Museum, 1997), a show of work using new technology including a sound piece by Martin Creed, Mat Collishaw's digital flower photographs, and videos by Willie Doherty and Mark Wallinger.

Contemporary Art Society
17 Bloomsbury Square
London WC1A 2LP
t 020 7831 7311 f 020 7831 7345
email: cas@contempart.org.uk
Website: www.contempart.org.uk
Director: Gill Hedley

With the official purchasing climate for contemporary art in this country still erring on the cautious side, CAS is a welcome presence. Other organisations like the National Art Collections Fund may assist museums in buying works for their collections, but CAS uses its funds to purchase and hand over pieces outright, thus enabling many British museums to acquire riskier pieces of contemporary art. CAS also encourages all kinds of art collecting by advising member museums and companies on

collections and commissions, as well as organising a range of events – talks, trips, studio visits – to introduce its individual members directly to the most up-to-the minute British and international art.

CAS was founded in 1910 in response to a lack of official support for young artists in Great Britain. Since then, it has acquired over 4,000 works including pieces by Matisse, Gauguin, Bonnard, Vuillard, Moore, Bacon and Hockney as well as Gillian Wearing, Helen Chadwick and Douglas Gordon, all of which have been presented to member museums throughout Britain. Every year, three different individuals – private collectors, critics, independent experts – are each given a budget and sent off to buy fine and applied art on behalf of CAS. The range and scope of the purchases reflects the personal (and often idiosyncratic) tastes of each very distinct member of this constantly changing roster of purchasers.

In addition, CAS has established a Special Collection Scheme with funds of £3.5 million, aided by the Lottery, to enable fifteen museums in England to develop their collections of contemporary art and craft and for curators to travel widely in order to buy work and discuss innovative approaches to display and education. So far, the scheme has purchased works by artists including Yinka Shonibare, Gavin Turk, Richard Deacon, Steven Pippin and Ian McKeever. The museums involved are in Manchester, Birmingham, Leeds, Eastbourne, Hull, Walsall, Nottingham, Southampton, Stoke, Warwick Worcester, Middlesborough, Wolverhampton and South London.

CAS raises its funds through membership fees, events – including its monthly bus trips around London galleries (contact Kate Steel) – grants from charitable bodies, monies earned from its commissioning and advisory service CASP and from its annual Art Market, ARTfutures, where both emerging and established artists often support this organisation by making their work available at low prices.

The Elephant Trust
PO Box 5521, London W8 4WA
Director: Julie Lawson

The origins of the Elephant Trust lie in *Elephant of Celebes* (1921), a painting by Max Ernst from the collection of the Surrealist painter and poet Roland Penrose, one of the founders of the ICA and the Trust's first president. In 1976, Penrose and his wife Lee Miller sold the painting to the Tate and used the proceeds to establish a fund 'to develop and improve the knowledge, understanding and appreciation of the fine arts in the UK'. Since Penrose's death in 1984, the Trust has been augmented by other funds and now hands out one-off grants of around £2,000 'to encourage the experimental, unconventional and imaginative' both from artists and those presenting artistic projects.

The grants may not be lavish, but they can be crucial. An award of £1,500 received by Rachel Whiteread in 1989, for example, enabled her to launch her career by making *Ghost* (1990), her cast of an entire room. In 1991, the Elephant Trust supported *Show Hide Show*, an important early exhibition of Sam Taylor-Wood, Abigail Lane, Alex Hartley, and Jake and Dinos Chapman. Other young artists who received assistance to make new work were Mona Hatoum, Cathy Prendergast and Cornelia Parker.

The Henry Moore Foundation
Dane Tree House, Perry Green
Much Hadham
Hertfordshire SG10 6EE
t 01279 843333 f 01279 843647
email: info@henry-moore-fdn.co.uk
Website: www.henry-moore-fdn.co.uk
Director: Tim Llewellyn

In 1977, when Henry Moore discovered that he was paying over £1 million in tax, he established and endowed a foundation not just to handle his own work but to act as a funding body with a remit 'to advance the education of the public by the promotion of their appreciation of the fine arts and in particular the works of Henry Moore'.

Today, the Henry Moore Foundation (HMF) is one of the most important and multifaceted supporters of contemporary art in this country. It is a fitting tribute to Britain's best-known twentieth-century sculptor that his name should appear in connection with such a variety of art projects.

The HMF has four areas of activity. Firstly, it looks after a large collection of Henry Moore's work, his archive and the studios at Perry Green, and mounts shows of his work around the world. Secondly, it develops the work of the former Henry Moore Sculpture Trust through the Henry Moore Institute in Leeds (see VENUES) and Henry Moore Foundation External Programmes. Built in 1993 next to Leeds City Art Gallery, the Henry Moore Institute embraces the former Centre for the Study of Sculpture and provides archives dedicated to the subject. As well as lectures, seminars and publications, it also organises sculpture exhibitions in its galleries, which frequently include contemporary work. HMF External Programmes develops the work of the Sculpture Trust on a broader canvas, principally by creating opportunities for artists to research, make and present new work. It works chiefly in partnership with other organisations at home and abroad and also curates projects at the Henry Moore Foundation Studio at Dean Clough, Halifax (see VENUES). In 1999, for example, a collaboration with MOMA, Oxford, produced a retrospective of Michelangelo Pistoletto's work and new work made for the Dean Clough Studio. Fourthly, the HMF's Donations Programme, administered from Perry Green, provides grants and financial support for research, conservation, residencies, commissions, publications, exhibitions and acquisitions.

Virtually every institution in the UK applies to the HMF for assistance with its exhibitions. In 1999, shows receiving HMF support included Mark Wallinger at Portikus, Frankfurt, Anya Gallaccio at Tramway, Glasgow, Bethan Huws at Oriel Mostyn, Wales, Richard Deacon at Tate Liverpool, Jane and Louise Wilson at the Serpentine Gallery, and Mimmo Paladino at the South London Gallery.

Patrons of New Art
Tate, Millbank, London SW1P 4RG
t 020 7887 8743 f 020 7887 8755
email: ben.whine@tate.org.uk

With the Tate Gallery's annual budget from the government for the acquisition of artworks frozen since 1982 at around £2 million, the Patrons of New Art have

a vital ongoing role in the Tate's purchases. Founded in 1982, the Patrons now number around 250 collectors, dealers and interested individuals who are prepared to pay between £250 and £1,000 per annum 'to develop wider understanding of the contemporary visual arts', which basically translates as providing and apportioning funds for purchasing artworks for the Tate.

Every year the names of twelve current Patrons of New Art are drawn out of a hat to sit on an acquisitions committee, which works with the Tate's Modern Collection curators to select the works of art to be purchased from the Patrons' funds. These have included Bill Viola's *Nantes Triptych* (1992), Matthew Barney's *OTTOshaft* (1992), and Michael Landy's *Scrapheap Services* (1995). In addition, a Special Purchase Fund exists for members who contribute an additional £1,000, which goes towards the purchase of work by emerging artists, such as Cornelia Parker's *Cold Dark Matter: An Exploded View* (1991); Dorothy Cross' *Virgin Shroud* (1993), or a series of drawings by Tracey Emin (1998).

In 1984, the Patrons established the Turner Prize, and although it is now sponsored by Channel 4, the Executive Committee of the Patrons of New Art still works with Tate staff to select the Turner Prize jury, on which one Patron always sits.

INDEPENDENT EXHIBITION ORGANISERS

The Annual Programme
425 Lower Broughton Road
The Cliff, Salford M7 2EZ
t/f 0161 281 0122
email: info@theannualprogram.com
Website: www.theannualprogram.com
Director: Martin Vincent

An agency for contemporary art in the North West of England, The Annual Programme was founded in Manchester in 1995 with the aim of repositioning contemporary practice in the city. Taking its name from a year-long series of monthly exhibitions in which each artist made work for another artist's home, the organisation has

gone on to present over thirty shows, including collaborations with similar organisations throughout the UK such as City Racing, Bank, Transmission, Three Month Gallery and Work & Leisure International. It has commissioned new work from many artists including Helen Bendon and Jo Lansley, Virginia Nimarkoh, Jim Medway, and for the recent exhibition *Space* (1999), Sarah Dobai, Sarah Doyle, Adam Page and Eva Hertzsch, and Ian Rawlinson. All recent shows have been accompanied by specially commissioned texts. Initially working in non-gallery venues – ranging from a row of newly converted mews-style houses for *Young Parents* (1997) to three places of worship in Manchester for *Cathedral City* (1998) – the Annual Programme now runs its own exhibition space, the international 3 (see venues).

Artangel
36 St John's Lane, London EC1M 4BJ
t 020 7336 6801 f 020 7336 6802
recorded info 020 7336 6803
email: info@artangel.org.uk
Website: www.innercity.demon.co.uk
Co-Directors: James Lingwood/
Michael Morris

Artangel's quest to commission, produce and document new work beyond the white cube of the gallery or the black box of the theatre has introduced artists, art forms and – crucially – audiences to some unexpected locations throughout the UK. Since its establishment in 1985 by Roger Took, Artangel has probably done more than any other organisation to break down public preconceptions about the making and viewing of art.

It was Artangel that was responsible for commissioning and negotiating the many obstacles standing in the way of Rachel Whiteread's concrete-cast *House* (1993) in east London. It also commissioned Tatsuo Miyajima's flickering LED installation *Running Time* (1995) in a seventeenth-century house in Greenwich, while in 1997, American choreographer Bill Forsyth collaborated with writer and performer Dana Caspersen and digital music pioneer Joel Ryan to fill London's Roundhouse with a giant bouncy castle (*Tight Roaring Circle*). In 1999, Artangel commissioned Douglas Gordon's epic *Feature Film*, of James Conlon conducting Bernard Herrmann's score for Alfred Hitchcock's *Vertigo*.

Although Artangel often leans towards large-scale, spectacular projects, it has also sponsored more elliptical interventions in different media and beyond the metropolis. Matthew Barney's *Cremaster 4* (1995), for example was filmed on location on the Isle of Man, and Richard Billingham's film *Fishtank* (1998) was screened on BBC 2. In 1993, Bethan Huws worked with a Bulgarian choral group, the Bistritsa Babi, who stood on the Northumbrian coastline and sang out to sea (*A Work for the North Sea* 1993). More recently, Janet Cardiff's 1999 sound work *The Missing Voice* took the audience on an audio walk through the streets of east London; while Sigalit Landau's nomadic sculpture *The Somnambulist* – a concrete mixer converted into a music box amongst many other things – travelled throughout Britain during 2000.

Artsadmin

Toynbee Studios
28 Commercial Street, London E1 6LS
t 020 7247 5102 f 020 7247 5103
email: all@artsadmin.co.uk
Website: www.artsadmin.co.uk
Director: Judith Knight

For some twenty years, Artsadmin has been the only UK organisation to promote live art, theatre, dance and music by providing a comprehensive management service. This can range from one-off administration to longer term involvement, and its premises consist of rehearsal spaces, arts offices and a 300-seat theatre, which is used for rehearsal and performances.

New performances and installations supported by Artsadmin have included Stationhouse Opera's *Road Metal Sweetbread* (1999), Franko B's multimedia *I Miss You* (2000), *Bellring* (2000) by Ian Breakwell and Ron Geesin, works by Bobby Baker, Gary Stevens, and Moti Roti Company's two-year programme of workshops for young Asian artists.

A recent A4E award, together with funding from the National Lottery, has enabled the awarding of Artsadmin bursaries and support in kind to a range of artists/groups to assist in this most vulnerable and underfunded area of artistic activity; recipients include Franko B and Zarina Bhimji.

The Arts Catalyst

Toynbee Studios, 28 Commercial Street
London E1 6LS
t 020 7375 3690 f 020 7377 0298
email: info@artscat.demon.co.uk
Website: www.artscatalyst.org
Director: Nicola Triscott
Curator: Rob La Frenais

The Arts Catalyst was set up in 1993 to make new connections between science and the arts with the aim of improving understanding between the two. To this end, it commissions visual artists and performers to create work in collaboration with scientists and technologists. *Body Visual* (1996) toured UK hospitals and venues, combining works by Helen Chadwick, Letizia Galli and Donald Rodney in an exhibition arising from associations with specialists in assisted conception, neuropharmacology and haematology. In 1999, *Solar Wind* marked the eclipse with a collaboration between artist Anne Bean and the astronomer Marcus Chown, while the film-installation *Gravity Zero*, captured a dance work in which choreographer Kitsou Dubois experienced a state of weightlessness courtesy of the French Space Agency. Arts Catalyst was also responsible for *A Consilience* (2000), Jan Fabre's film and installation at the Natural History Museum.

Artlab

The studio, 7 Vyner Street
London E2 9DG
t 020 8983 4586
email: jc@artlab.fsnet,co.uk
Partners: Jeanine Richards,
Charlotte Cullinan

Led by two artists, Artlab mounts an adventurous annual programme of art/science projects. It often works with Imperial College of Science Technology and Medicine , sometimes showing projects there. It also collaborates with other organisations, such as Tate Britain for Graham Gussin's film, *Spill* in spring 2000. Artists in residence at Imperial College for 1999-2000 are Stephen Hughes, working with UCLA on a virtual meteor; and John Isaacs, whose installation *Matrix of Amnesia* (1998) – a dysfunctional lab with a prone melted figure – put Artlab on the map.

Artwise

2 Dalling Road, London W6 0JB
t 020 8563 9495 f 020 8563 9578
email: enquiries@artwisecurators.com
Partners: Susie Allen, Penny Roberts

Artwise are advisors and facilitators for both the public and corporate sectors. Among their clients are British Airways, for whom they curate over forty exhibitions a year, in and around airports. These include works selected from British Airways' own collection or from other sources, by artists such as Chris Ofili and Gerhard Richter, a sound piece by Janet Cardiff, as well as a line-up of unknowns. Artwise were responsible for conceiving the *Absolut Secret* exhibition for the Royal College of Art in the UK and the US, in which artists anonymously submit postcard-sized works for sale.

Commissions East

St Giles Hall, Pound Hill
Cambridge CB3 0AE
t 01223 356882 f 01223 356883
email: info@commseast.org.uk
Website: www.commseast.org.uk
Director: David Wright

Acting as a public-art resource specifically for the east of England, has led Commissions East to advise, commission and implement every possible permutation of public art from sculptures, projections and installations to bus shelters, paving and sea walls. A recent example is Tim Head's *Light Curtain* (1998) of 9,000 prismatic road reflectors for Artezium Arts and Media Centre, Luton.

As part of a commitment to the development of innovative partnerships and use of new technologies, artist Michael Brennand-Wood was commissioned as consultant for the new music venue Ocean in Hackney (2000). Other commissions include Marion Kalmus' *Restoration Drama (2000),* set in the disused Festival Theatre, Cambridge.

fig-1

Fragile House, 2-3 Fareham Street
London W1V 3AJ
t 020 7734 9269 f 020 7734 9275
email: mail@fig-1.com
Website: www.fig-1.com
Contacts: Mark Francis, Jay Jopling

This experimental exhibition space opened in January 2000 with the aim of 'exploring cultural activity in a global city' with a swift turnover of fifty multidisciplinary projects in as many weeks. Participating artists have included Richard Hamilton, Gavin Turk and Liam Gillick and there have also been seven-day projects by architects Caruso St John, milliner Philip Treacey and writer Will Self. Co-conceived and developed by Mark Francis, formerly Director of the Andy Warhol Museum in Pittsburg and Jay Jopling, Director of White Cube, fig-1 describes itself as 'an independent non-profit organisation free from commercial and institutional obligations', which relies on the Internet for the dissemination of its activities. Its website provides a live link to the space and transmits online performances. Visitors

logging on automatically receive weekly e-mail announcements of shows. Once fig-1 ends its London incarnation, there are plans for it to 'take the pulse' of ten different cities throughout the world over the next decade.

Foundation for Art & Creative Technology (FACT)

Bluecoat Chambers, School Lane,
Liverpool L1 3BX
t 0151 709 2663 f 0151 707 2150
email: fact@fact.co.uk
Website: www.fact.co.uk
Director: Eddie Berg

Established in 1989 under the name of Moviola, FACT is the UK's leading development agency for artists and exhibitors working with creative technologies. It has commissioned, supported, resourced and presented technology-based artworks such as Tony Oursler's *Tribune* at the Bluecoat Gallery in 1994, and Simon Robertshaw's *The Order of Things* (1997), a large-scale interactive installation in Liverpool's docks featuring an autopsy table. As well as staging *Video Positive,* Liverpool's international biennial of electronic arts (it re-emerged as *The Other Side of Zero* in March 2000), in 1998, FACT was a co-host of the prestigious International Symposium of Electronic Arts. In November 1999, FACT unveiled plans for a new £8.5 million FACT Centre, for the Rope Walks area of Liverpool, which opens in spring 2002 with three cinemas, two galleries, laboratories, project spaces and a café.

Institute of International Visual Arts (inIVA)

6-8 Standard Place, London EC2A 3BE
t 020 7729 9616 f 020 7729 9509
email: institute@iniva.org
Website: www.iniva.org
Director: Gilane Tawadros

Describing itself as an organisation that 'seeks to reflect a culturally diverse spectrum of artistic practices, curatorial voices and critical perspectives in contemporary art through collaborations and commissions', inIVA deliberately avoids easy definition. Since its foundation in 1994, it has operated as a production company, collaborating

with other organisations both in the UK and abroad, arranging seminars, research projects and exhibitions, producing publications and 'extending the intellectual, social and geographical boundaries of debate on contemporary visual art and art history'.

This broad, ambitious brief has resulted in some memorable exhibitions that have helped to shift some long-standing cultural assumptions in refreshing new directions. *Time Machine* (1994), for instance, allowed a range of artists from the UK and elsewhere to respond to the Egyptian Collection of the British Museum. *Mirage: Enigmas of Race, Difference and Desire* at the ICA (1995) gave Steve McQueen his first mainstream showcase; and *Offside! Contemporary Artists and Football* (1996) provided a range of artistic responses to Britain's hosting of the European Cup. Other notable shows have included *The Visible and the Invisible: Re-presenting the Body in Contemporary Art and Society* (1996), which brought new commissions by Louise Bourgeois, Bruce Nauman, Donald Rodney and Yoko Ono to public sites throughout the Euston area of London. Keith Piper's *Relocating the Remains* (1997), held at the Royal College of Art, employed touch screens, virtual corridors and other state-of-the-art technologies to explore themes of policing, surveillance and the representation of black masculinity. In 1998, Yinka Shonibare's *Diary of a Victorian Dandy* – a series of photographic self portraits shot on location at an English stately home – was exhibited as posters in London underground stations; while above ground in the summer of 1999, classic Egyptian cinema posters were displayed on billboard sites around London. Now, inIVA plan to combine their peripatetic activities with an experimental programming space in London.

Inventory

13-14 Great Sutton Street
London EC1V 0BX
t 07773 446094
email: inventory@cwcom.net
Website: www.inventory.mcmail.com

This collective enterprise was set up by a group of writers, artists and theorists

exploring 'alternatives to the limitations imposed on those disciplines' in an 'interdisciplinary space'. Since 1995, Inventory has presented exhibitions and/or interventions of visual work in venues varying from London's The Museum of Mankind, The Approach, or Glasgow's Modern Institute, as well as the Bradford Film and TV Festival and Madam Jo-Jo's piano bar in Soho. It also publishes *Inventory*, an experimental journal. All these elements operate together to form what Inventory describes as a 'viral programme', which has infected a large following both within and beyond the art world.

Locus+

Room 17, 3rd Floor, Wards Building
31-39 High Bridge
Newcastle-upon-Tyne NE1 1EW
t 0191 233 1450 f 0191 233 1451
email: locusplus@newart.demon.co.uk
Website: www.locusplus.org.uk
Directors: Jon Bewley, Simon Herbert

The name Locus+ (site, plus the input and imagination of the artist) sums up the aims of this artist-run commissioning agency that has operated out of Newcastle-upon-Tyne since 1993. Locus+ describes itself as 'a visual arts facility that places the artist at the centre of production and provides logistical and financial support to those who wish to work in different contexts and/or across formats'. Although its events often take place in the North East of England, Locus+ has also facilitated work across the globe and has provided logistical and financial support for an enormous range of activities whether in buildings, on billboards, on video, CD, or over the airwaves.

Examples include Stefan Gec's huge commemorative portraits of firemen killed after the Chernobyl disaster, *Natural History* (1995); Lloyd Gibson's figurative sculpture *Crash Subjectivity*, which combined the physical attributes of male and female, adult and infant and was shown in three sites in Newcastle, Dublin and Belfast from 1993-5; *Search* by Pat Naldi and Wendy Kirkup (1993), a series of videos captured on surveillance cameras and broadcast on Tyne Tees TV; and Cornelia Hesse-Honegger's paintings of mutated

Lloyd Gibson
Crash Subjectivity
(detail)
1993
Fibreglass, resin,
leather, silk,
wooden ladder
366 × 183 × 183 cm
Locus+ installation at All
Saints Church, Newcastle
Photo: Jon Bewley

insects collected from the perimeters of nuclear power stations: *Nach Chernobyl* (1996) and *The Future's Mirror* (1997). Locus+ also owned one twelfth of Mark Wallinger's equine art work, *A Real Work of Art*. More recently, it commissioned Anya Gallaccio's *Two Sisters* – a six-metre high tower of sand and soil rising out of the silt bed of the Hull Marina.

The Modern Institute

Suite 6, 73 Robertson Street
Glasgow G2 8QD
t 0141 248 3711 f 0141 248 3280
email:
mail@moderninstitute.demon.co.uk
Directors: Will Bradley, Toby Webster

A 'research organisation and production company for contemporary art and culture', The Modern Institute, launched in 1998 by Will Bradley, Toby Webster and Charles Esche, has quickly made a wide impact by initiating events, exhibitions and projects both within Glasgow and internationally. Although it operates out of three rooms – an office, a studio space for artists such as Simon Starling and Richard Wright to take up residencies and develop new work, and a 'laboratory-cum-exhibition space' – The Modern Institute does not

consider itself a gallery per se, attaching as much importance to projects made in collaboration with other organisations. These have included presenting artists editions and new work in the clean white space of Sadie Coles HQ in London in August 1998, when they also took over an abandoned Soho strip-club to screen Jim Lambie's film *Ultralow* (1998); or, in January 2000, taking over the project space in Kiasma Museum, Helsinki, with a series of artworks and events. The Modern Institute's contribution to Thomas Nordenstaad's *Lucia A-Go-Go* event at Stockholm's Lyndmar Hotel in 1998, was Jackie Donachie's *One-Night Advice Bar*, dispensing gin, cigarettes and conversation. The organisation's biggest production so far is *Community Cinema for a Quiet Intersection (against Oldenburg)*, Rirkrit Tiravanija's four-screen cinema in Partick, Glasgow, which showed the neighbourhood's favourite films accompanied by a Thai barbecue in 1999. Artists' editions produced by The Modern Institute are characteristically multifarious: posters (Simon Starling), a 12-inch EP (*Vodershow*), or even sculptures made from razor blades (Robert Johnston).

Peer Trust

Shoreditch Town Hall
380 Old Street, London EC1V 9LT
t 020 7739 8080 f 020 7739 2622
email: piertrust@btinternet.com
Curatorial Director: Ingrid Swenson

Founded in 1998, Peer is a charitable organisation with a wide remit that covers contemporary visual arts as well as music, film and architecture. It operates on a project-by-project basis, with no permanent space and aims to work collaboratively with other arts venues. Examples of its activities are a 1999 exhibition of films and installation by cult filmmaker Chris Marker at Beaconsfield, and Martin Creed's neon sign *EVERYTHING IS GOING TO BE ALRIGHT* (1999), installed on the portico of a nineteenth-century former orphanage in Hackney. Peer also presents projects independent of particular venues, such as *Political Homeopathy* (1998-9), which involved full-page interventions by poet Drew Milne and artists Gillian Blease and Richard Wentworth in the *New Statesman* and *The Spectator*.

Public Art Commissions and Exhibitions (PACE)

7 John Street, Edinburgh EH15 2EB
t/f 0131 620 6020
email: pace@ednet.co.uk
Director: Juliet Dean

Since its launch in 1996, projects handled by this consultancy have included Jane Fawns Watt's giant sculpture comprising 26,000 glass beads for St John's shopping centre in Perth (*Orbit*, 1996); the commissioning of Marcus Taylor to work with DCA + b engineers and the physics department of Heriot Watt University to create *Pentland Moon*, a shimmering disc-shaped work for the Midlothian Country Park, Edinburgh, and the re-landscaping of the forecourt of Ayr's Loudoun Hall with specially designed works by Gordon Young and Louise Lusby Taylor. For the new Edinburgh Dental Institute, PACE commissioned Stephen Skrynka, Jane Fawns Watt, Hermione Wiltshire and Anita Wohlen to work closely with the architects on aspects of the building, from Fawn Watt's fibre-optic ceiling constellations to Wiltshire's seats and flooring.

Sam Taylor-
Wood
Hysteria (1997)
Fourth Wall: Turner on
the Thames (1999)
PADT installation at
National Theatre,
London
Photo: Edward
Woodman

Public Art Development Trust

3rd Floor, Kirkman House
12-14 Whitfield Street, London W1P 5RD
t 020 7580 9977 f 020 7580 8540
email: padt@padt.demon.co.uk
Director: Sandra Percival

Since PADT was established in 1983 as
the first organisation for public art in
the UK, the scope of both public art and
the organisations that facilitate it has
increased beyond measure; PADT has
been niftier than most in moving with
the times. An early involvement with
BAA resulted in installations by Irish
artists within the Pier 4A walkways of
Heathrow airport's Terminal 1, and in
1997, Julian Opie's four light-boxes and
fifteen video monitors were also inst-
alled in Terminal 1's Flight Connections
Centre. PADT's projects increasingly
form part of longer-term strategies
relating to specific locations, and its
role is becoming that of curator rather
than enabler. A major diverse pro-
gramme is the three-year Thames and
Hudson Rivers Project, an international
collaboration with Minetta Brook in
New York. Working with local authori-
ties and community groups, arts and
civic organisations, PADT is enabling
artists Marie José Burki, Constance de
Jong, Stefan Gec and Roni Horn to
create public projects for the River
Thames waterfront between the South
Bank and Canary Wharf in London, and
the Hudson River waterfront between
Battery Park City and 59th Street in New
York City. Angela Bulloch's *From the
Chink to Panorama Island* (1995), for
example, involved the official renaming
of an old loading pier, and a temporary
light projection. Another ongoing

series of commissions is the *Fourth
Wall* series, which was inaugurated in
1999 by a programme of artists' films
and videos seen by an audience of thou-
sands as they were projected directly
onto the concrete cube of the National
Theatre's Lyttelton flytower on
London's South Bank.

Space Explorations

29 Camden Square, London NW1 9XA
t/f 020 7482 2443
email: louis.nixon@btinternet.com
Directors: Daniel Sancisi/Louis Nixon

Founded in 1989 by two Slade School
postgraduates in order to support
artists whose work may not be ideally
placed within conventional exhibition
venues, Space Explorations utilises the
numerous empty sites throughout
London. These have ranged from a rail-
way arch in Hackney (*The Beck Road
Project* 1990), to various sites within the
perimeter of The Old Royal Observatory
in Greenwich (*Greenwich '91*); Holborn
Town Hall (*One Million Cubic Feet*
1994); and a derelict power station in
Shoreditch (*Electric House* 1992).
However, what really put Space
Explorations on the art map was *High
Rise* (1996), where seven artists occu-
pied an empty 1970s towerblock just off
the Euston Road with works that used a
variety of strategies to play off their sur-
roundings. More recent projects
include *Tourist* (1999), where the artist-
directors, along with Matthew Tickle,
Jason Coburn and Keith Wilson, each
made a piece lasting a day in sites
across London ranging from a cherry
tree at a junction in north London to
a school gym in Southwark.

(Trans)position

10 Bourdon Street, London W1X 9HX
t 020 7493 3553 f 020 7495 3426
email: alexandrepollazzon@com-
puserve.com
Contact: Alexandre Pollazzon

Set up by five London-based collectors
to focus on the promotion of artists and
events in a non-commercial structure,
(Trans)position aims to produce works,
exhibitions and events that would have
difficulty attracting funding from the
commercial sector. Its inaugural pro-
ject in September 1999 consisted of a
one-off open-air screening of *Sleight of
Hand* by Abigail Lane and Paul Fryer,
aka the Complete Arthole, which was a
film of a magician performing magic
tricks in a desert landscape, projected
across 36 feet of screens over the
rooftops of London. Other projects
have included a three-part programme
of video works by a range of established
and emerging international names
from Sylvie Fleurie and Pipilotti Rist to
Hilary Lloyd and Georgina Starr divided
up into the themes of music, silence
and dialogue.

PRIZES AND EVENTS

PRIZES

The recent proliferation of art prizes,
which are usually commercially spon-
sored, testifies to the profile-raising
power of contemporary art and to an
improvement in the relationship
between new art and money. But, as
everyone knows, this is a volatile and
fragile relationship in which artists
don't necessarily emerge the winners,
even if they pick up the cheque. The
prizes listed below may not award the
largest purse (or indeed any purse at
all), but nor do they blanch at challeng-
ing and problematic art, whilst extend-
ing the opportunities throughout the
UK in which to see it.

Beck's Futures Awards

Details: ICA, The Mall
London SW1 5AH
t 020 7873 0061

This new prize – which sees its remit as being somewhere between the New Contemporaries and the Turner Prize – aims to herald an emerging generation of 'promising, but unknown artists' in all media. A panel of six curators and artists select works and award prizes of £5,000 to a single winner in each category of painting, sculpture, film and video, photography, and art students working in film or video, as well as an overall prize of £20,000, which in 2000 went to Roddy Buchanan. The work of the chosen five goes on display in a special exhibition at the ICA, which then tours to Manchester and Glasgow. Inaugurated in 2000 as part of Beck's celebration of fifteen years of art sponsorship, this award seems set to become a regular event.

The Citibank Private Bank Photography Prize
Details: The Photographers' Gallery
5 & 8 Great Newport Street
London WC2H 7HY
t 020 7831 1772 f 020 7836 9704
email: info@photonet.org.uk
Website: photonet.org.uk

First awarded in 1997, this major prize acknowledges the importance and diversity of the photographic image in contemporary art. The £15,000 prize is awarded to the individual who has made the greatest contribution to the medium through an exhibition or publication in the UK during the previous year. The first winner, in 1997, was Richard Billingham for Ray's a Laugh, a series of affectionate and discomfiting images of his family living in poverty-stricken chaos on an estate near Birmingham. Other prize-winners have included Andreas Gursky (1998), Rineke Dijkstra (1999) and Anna Gaskell (2000).

EAST International and riverside
Details: Norwich Gallery
Norwich School of Art and Design
St George Street, Norwich
Norfolk NR3 1BB
t 01603 610561 f 01603 615728
email: nor.gal@nsad.ac.uk
Website:
www.nsad.ac.uk/gallery/index.htm
Submissions invited early spring.

The largest annual international exhibition of contemporary art held in Britain, EAST International and riverside is organised by the Norwich Gallery. The heavyweight selectors have included Konrad Fischer, Richard Long, Helen Chadwick, Nicholas Logsdail, Giuseppe Penone, Peter Doig and Keith Piper. No rules of age, status, place of residence or media limit those who may enter. Each selected artist installs major works in a space of their own in and around Norwich School of Art and Design, and riverside commissions five temporary site-specific outdoor works. Every year one artist will win the EAST award of £5,000; past winners have included Martin McGinn (1998) and Lucy MacKenzie (1999).

Hamlyn Awards
18 Queen Anne's Gate
London SW1H 9AA
t 020 7227 3500 f 020 7222 0601
email info@phf.org.uk

The Hamlyn Awards constitute the largest sum of prize-money for art in the United Kingdom. Five recipients are selected annually to receive £30,000 each, which is spread over three years rather than awarded in one lump. (After considerable research into artists' needs, it was felt that this way the Awards would have more impact on the recipients' creative processes.) These awards also come with no strings attached in terms of the purchase or exhibition of work and it is left up to each individual to spend their prize money as they choose. In the words of the organisers, they are given 'on the strength of talent, promise and need as well as achievement'. The means by which the candidates are chosen echoes the careful consideration given to this most artist-friendly of prizes – twenty selected nominators from all aspects of the art world are each invited to submit a list of suitable candidates to a panel of six judges, who are also drawn from different areas, whether curatorial, critical or creative.
 Recipients of the 1999 Hamlyn Awards were Zarina Bhimji, Juan Cruz, Anya Gallaccio, Rose English and Simon Starling.

Imaginaria
Details: ICA, The Mall
London SW1Y 5AH
t 020 7873 0055 f 020 7306 0122
email: info@ica.org.uk
Website: www.ica.org.uk
Contacts: Katya García Antón, Susan Copping

Four commissions with an emphasis on the creative use of new technology are awarded annually from the Imaginaria partnership – a consortium of Cap Gemini, the ICA, Arts Council of England and Sun Microsystems. Previous prize-winners invited to make work 'at the frontier between established fine art and new media' include Nina Pope and Karen Guthrie, who made an actual model of a constantly evolving MU (or text-based environment on the Internet) out of model railway materials, and Mark Dean, whose image of computer pioneer Alan Turing evolved into a pixillated cyborg.

Jerwood Painting Prize
PO Box 279, Esher, Surrey KT10 8YZ
t 01372 462190 f 01372 460032

Established in 1993, this prize (part of a private philanthropic foundation set up in 1977 by precious stone magnate John Jerwood) 'celebrates the vitality and excellence of painting in this country' and is the most valuable award for a professional artist in Britain. The prize of £30,000 is open to UK painters of all ages. In the past, the Jerwood has been won by such veterans as Craigie Aitchison (1994), Maggi Hambling and Patrick Caulfield (joint 1995); but increasing numbers of younger artists – Gary Hume, James Rielly, Jason Martin – are now cropping up in its exhibitions of seven or so shortlisted artists – it all depends on who is sitting on the panel of judges.

John Moores Liverpool Exhibition of Contemporary Painting
Details: Walker Art Gallery
William Brown Street, Liverpool L3 8EL
t 0151 478 4615 f 0151 478 4777
email:
public@nmgmepp2.demon.co.uk
Website:
www.merseyworld.com/museums

There are many prizes solely devoted to painting, but the John Moores (named after its founder, the late Sir John Moores of Littlewood's) is the longest-standing and the most forward-looking. Its remit is 'to encourage contemporary artists, especially the young and progressive'. Established in 1957, this biennale of contemporary painting appoints a different panel every time to award a £25,000 prize. Works by the winning artists (David Hockney, Richard Hamilton, Bruce McLean, Lisa Milroy, Peter Doig and Michael Raedecker amongst them) are acquired for the John Moores Collection. Some sixty or so runners-up – such as Peter Blake, Sean Scully, Howard Hodgkin, Gillian Ayres, Chris Ofili – are awarded smaller prizes and/or inclusion in the John Moores exhibition at the Walker Art Gallery, Liverpool.

Sciart

c/o The Wellcome Trust
183 Euston Road, London NW1 2BE
t 020 7611 8538 f 020 7611 8545
email: sciart@wellcome.ac.uk
Website: www.sciart.org

The ever-more prevalent cross fertilisation between science and the visual arts is given a substantial boost by this award of ten research and development grants of up to £10,000 each and two production grants of up to £50,000 each, awarded to collaborative projects between practitioners in the visual arts and any branch of science. Previous recipients have included the fashion designer Helen Storey and Dr Kate Storey, Developmental Biologist at Oxford University, who collaborated to produce a fashion collection based on key events in human embryo development; and artist Humphrey Ocean, who joined forces with physiologists and psychologists in England and America in an examination of the physical processes involved in the translation of the visual to the canvas. As from 1999, Sciart's originators, the Wellcome Trust, have joined forces with the Arts Council of England, the Calouste Gulbenkian Foundation, NESTA and the Scottish Arts Council to increase the resources of this pan-disciplinary set of awards.

Turner Prize

Details: Tate Britain, Millbank
London SW1P 4RG
t 020 7887 8000 f 020 7887 8007
Website: www.channel4.com.

From its debut in 1984, the Turner Prize has gone from being a localised art-world event to one with a high national and international profile. Organised by Tate Britain and sponsored by Channel 4, its rules have changed over the years, but since 1990, the award has gone to 'a British artist under 50 for an outstanding exhibition or other presentation of their work in the twelve months preceding'. The Turner's aim 'to promote public discussion of new developments in British art' has been more than realised in recent years, and every stage is subjected to a media feeding frenzy. From the announcement of the four shortlisted artists, to the opening of the Tate exhibition of their work, and the final presentation of the single £20,000 prize at a gala dinner, broadcast live on national TV, the prize, the artists and Tate itself are all seen as fair game for close scrutiny and criticism from all quarters. Some accuse the prize of promoting novelty at the expense of quality, while an increasing number believe that the media razzmatazz and the first-past-the-post format make this a fundamentally artist-unfriendly event. The jury of five is chaired by Tate Director Nicholas Serota (who has the casting vote) and each year comprises a member of Tate's Patrons of New Art, a curator from overseas, and a writer and a curator from the UK. Past winners include Gilbert and George (1986); Anish Kapoor (1991); Rachel Whiteread (1993); Damien Hirst (1995); Douglas Gordon (1996); Chris Ofili (1998) and Steve McQueen (1999).

EVENTS

The British Art Show

Details: Hayward Gallery, SBC
London SE1 8XX
t 020 7960 4208 f 020 7401 2664

Every five years, National Touring Exhibitions (administered by the Hayward Gallery on behalf of the ACE) organises a survey show of recent developments in British art. Each exhibition features distinctly different selectors, criteria and composition. In 1995-6 it toured to Manchester, Edinburgh and Cardiff and took place in various venues throughout each city, where it presented work in all media but with a particular emphasis on film and video installation. In 2000, *British Art Show* 5 dealt another refreshing sideswipe at the art world's Londoncentricity with over fifty artists occupying a range of venues in Edinburgh, Southampton, Cardiff and Birmingham.

Liverpool Biennial

Gostin House, 32-36 Hanover St
Liverpool L1 4LN
t 0151 709 7444 f 0151 709 7377
email: info@biennial.org.uk
Website: www.biennial.org.uk

In September 1999, Liverpool joined the global roster of cities bi-annually infiltrated by contemporary art when it hosted the UK's first-ever Biennial of International Contemporary Art. This involved every major exhibiting venue in the city, as well as occupying parts of Liverpool that art never usually reaches – from Doris Salcedo's concrete-filled furniture in Liverpool Cathedral, to macabre clothes by Argentina's Nichola Constantino displayed in the window of Lewis' department store. The 1999 Liverpool Biennial consisted of four strands: a specially commissioned international exhibition entitled *Trace*; a more informal set of 'fringe' events that went by the name of *Tracey*; the 21st John Moores exhibition – the UK's largest open exhibition of contemporary painting; and *newcontemporaries* 99 – the annual exhibition of contemporary art by students and recent graduates from fine art colleges throughout the UK. Although *Trace* came in for some severe criticism as an outdated, catch-all trophy show, and the Biennial's format is up for radical revision, there was sufficient enthusiasm both inside Liverpool and elsewhere for the event to be proposed as a regular fixture. In particular, the Biennial is playing a crucial part in Liverpool's bid to become European City of Culture in 2008.

The London Contemporary Art Fair

Business Design Centre
52 Upper Street, London N1 0QH
t 020 7359 3535 f 020 7288 6446
email:
lucyf@business-design-centre-.com
Website: www.art-fair.co.uk
Admission charges

Compared to the art fairs of Europe
(Berlin, Cologne, ARCO in Madrid, FIAC
in Paris and especially the Basel art fair
with its various youthful offshoots) or
America (Chicago, and the young-art
Hotel Fairs in the Gramercy Park, New
York and the Château Marmont in Los
Angeles), Britain's contribution to the
commercial scene is more brantub than
cornucopia. Each January, progressive
galleries cluster anxiously amidst a
welter of nudes, flower paintings and
animal pictures and their works are not
much enhanced by the encounter.

New Contemporaries

Details: Manchester Office
127F Liverpool Road, Castlefield
Manchester M3 4JN
t 0161 839 9453 f 0161 835 1698

New Contemporaries is Britain's most
important annual touring exhibition of
work in all media by students and recent
graduates from UK art schools. It has
consistently given early exposure to
many of the major names in British art,
including Gillian Ayres, Frank Auerbach,
R.B. Kitaj, David Hockney, Allen Jones
and Patrick Caulfield, and more recently,
Tacita Dean, Damien Hirst, Abigail
Lane, Chris Ofili, Gillian Wearing, and
Jane and Louise Wilson. The work is
selected by open submission and
judged by a guest panel of artists, writ-
ers and curators from the international
art world, ranging from established fig-
ures such as Susan Hiller and Adrian
Searle to younger artists such as Keith
Tyson and Gillian Wearing. *New
Contemporaries* has become a must-see
event for anyone interested in the cut-
ting edge of creativity in the UK.

The Lux Biennale

info: Lux 020 7684 2870
Formerly *Pandemonium*, London's bi-
annual festival of the moving image fea-
tures new work by film, video and new

media artists, and is held at a multitude
of venues across London. Works are
obtained through a combination of
open submissions, curated pro-
grammes, new collaborations, and
new commissions including Gillian
Wearing's *The Unholy Three* (1996) and
Tracey Emin's *Riding For a Fall* (1998).

PUBLICATIONS

SPECIALIST PUBLISHERS

Audio Arts

6 Briarwood Road, London SW4 9PX
t/f 020 7720 9129
email: audioarts@aol.com.
Editor: William Furlong

With the increasing use of sound in art-
works, an art magazine that takes the
form of a cassette tape is particularly
appropriate. However, Audio Arts has
been combining interviews, artworks
and historic recordings since its founda-
tion in 1973, its brief being simply the
pursuit of whatever seems interesting to
the magazine's founder-editor William
Furlong. It is Furlong's shifting role as
editor/interviewer/artist and – crucially
– collaborator that helps Audio Arts to
exploit the immediacy and versatility of
sound more creatively than most maga-
zines use text and images – less a vehi-
cle for discussion than 'a space for art
and the critical discourse that sur-
rounds it'.

Not only does Audio Arts deliver the
voices (and therefore the presence) of
Marcel Duchamp, Joseph Beuys, Noam
Chomsky and pretty much every major
artist of the last twenty or so years, it

also allows direct access to artworks,
often specially commissioned. Recent
examples are Georgina Starr's remix of
Mentioning (1997), using lyrics from a
conversation recorded on the London
Underground, and Cornelia Parker's
*Brushes with Fame: or Seven Little
Frictions* (1997), which presented the
sounds of Freud's keys rattling, a record
that belonged to Adolf Hitler, and the
rustling of Vivien Leigh's petticoats.

Book Works

19 Holywell Row, London EC2A 4JB
t 020 7247 2536 f 020 7247 2540
email: jr@bookwks.demon.co.uk
Website: www.bookworks-uk.ltd.uk
Directors: Rob Hadrill/Jane Rolo

Since 1984, Book Works has contrived to
commission and produce new work that
goes beyond the craft-based or illustra-
tive traditions of artists' books. Each
publication represents an exploration
both into the conceptual nature of its
own subject matter and into the scope
of what a book might be. This has
resulted in the production of artists'
books, multiples, videos and CD ROMs,
as well as extending into installations,
mixed-media or time-based work.

Library Relocations (1997), for exam-
ple, took the form of a series of new
commissions and books by artists work-
ing in various libraries throughout the
UK, including Pamela Golden, Pavel
Büchler, David Bonn and Mel Jackson.
Book Works' *Projects/Open House 1998-
2001* invites guest curators working in
partnership with Book Works to com-
mission, develop and promote new
work and attract new audiences. The
first was Matthew Higgs, whose 1998-9

Billy Childish
This Purile Thing
1995
A5 xeroxed booklet
Imprint 93

'residency' resulted in four commissions: Jeremy Deller's *Uses of Literacy*; *Smash this Puny Existence* by the collective, Inventory; sixty-six art-worlders' *Seven Wonders of the World*; and Frances Stark's *The Architect and the Housewife*. For the second, curator Stefan Kalmár has commissioned work by Doug Aitken, Angela Bulloch, Janice Kerbel and Nils Norman, under the name *access/excess*.

Imprint 93

53 Balcombe Street, London NW1 6HD
Director: Matthew Higgs

Imprint 93 was established in September 1993 with the aim of making low-key publications/artists' editions and distributing them by mail. Economy is the only criterion for production: works are all made for virtually no cost, weigh less than 60g (so they can be mailed second class), and run to editions of around 200 copies that eventually go out of print. Describing itself as 'lacking an ideology but not an identity', Imprint 93 is distinguished by the impressive line-up of artists who have produced work for its mail-outs: Martin Creed, with the elliptical torn-up A4 *Work No 140*; Paul Noble, with his *Artist's Books* of drawings and a catalogue of books belonging to himself and his artist friends; Jeremy Deller, who made transcriptions of graffiti from the men's toilets of the British Museum; and Chris Ofili, with *Black*, which reproduced his local newspaper's reports of crimes attributed to black suspects.

Imprint 93 is mailed unsolicited to an audience of artists, writers and curators, and its impact has been such that the Museum of Modern Art in New York has bought an entire run. Annual Imprint 93 exhibitions at such venues as the Cabinet Gallery are not so much presentations of the projects as 'uncurated' shows of recent work.

The Paragon Press

92 Harwood Road, Fulham
London SW6 4QH
t 020 7736 4024 f 020 7371 7229
email: charles.booth-clibborn@paragonpress.co.uk
Website: www.paragonpress.co.uk
Director: Charles Booth-Clibborn

Marc Quinn
Template for my Future Plastic Surgery
4-colour screenprint with varnish, made for the group portfolio **London**
1992
86 × 68 cm
The Paragon Press

Launched in 1986 when the current director was still a student at Edinburgh University (the same year that he also co-organised the ambitious 'New Art New World' charity auction with fellow students Jay Jopling and Greville Worthington), Paragon Press has taken the making and publishing of prints to the heart of contemporary art practice. Most of the artists who have worked with Paragon are internationally known, but few have had much experience of print-making.

Paragon Press has provided an eclectic range of artists with access to the best printing studios and technicians in order to experiment in a multitude of techniques, often for the first time. Its first book/portfolio edition was *The Scottish Bestiary* (1986) where artists including Bruce McLean, John Bellany and Peter Howson worked in print media ranging from screenprint, etching, woodcut and lithography. Since then, projects have been published with a range of artists from very different generations: Richard Deacon, Bill Woodrow, Anish Kapoor, Ian McKeever, Terry Frost and Hamish Fulton, Richard Long, and more recently, Peter Doig, Chris Ofili, Rachel Whiteread and Bill Woodrow. In 1999, Patrick Heron published *Brushworks*, his last set of prints with Paragon.

Because Paragon specialises in portfolios and books, what emerges is not a series of one-offs, but portable shows harnessing the latest in progressive art to older traditions of printing, bookbinding and typography. Nowhere was this more evident than in the Chapman's impressive display of draughtsmanship and printing skills: the *Disasters of War* etchings, published by Paragon in 1999.

The Multiple Store

School of Art, Central St Martin's College of Art & Design
107-109 Charing Cross Road
London WC2H ODU
t 020 7514 7258 f 020 7514 8091
email: multstor@globalnet.co.uk
Website: www.multiplestore.org
By appointment
Contacts: Sally Townsend, Nick Sharp

Not only does this non-profit making organisation showcase new, limited-edition multiples by leading British names, but it is also committed to extending their work with new materials and processes. Examples include Simon Periton's single strand of barbed wire in glass (*Barbiturate*, 1999), Fiona Banner's *Table Stops* (2000), and Keith Coventry's *Inhaler (1999)*, a resin travelling pipe for the urban crack addict.

UK ART MAGAZINES

Art Monthly

Suite 17, 26 Charing Cross Road
London WC2H 0DG
t 020 7240 0389 f 020 7497 0726
email: info@artmonthly.co.uk
Website: www.artmonthly.co.uk
Editor: Patricia Bickers
£3.25

Britain's oldest contemporary art maga-
zine (founded in 1976 by Peter
Townsend and Jack Wendler) is compre-
hensively informative about the many
modes of the British art world. Printed
in black and white, and designed for
clarity, *Art Monthly*'s appearance
reflects its no-nonsense approach.
Major international shows are reviewed,
yet readership is primarily British,
reflected in extensive national exhibition
coverage, monthly columns on artists'
editions, saleroom reports, art law,
news, awards, and exhibition listings.

The Art Newspaper

70 South Lambeth Road
London SW1 1RL
t 020 7735 3331 f 020 7735 3332
email: contact@theartnewspaper.com
Website: www.theartnewspaper.com
Editor: Anna Somers Cocks
£4.50

The Reuters of the art world, this
monthly international paper, devoted to
'Events, Politics and Economics', covers
art in terms of news. It provides useful
information on art scams, scandals and
upcoming projects, as well as compre-
hensive listings and helpful round-ups
of art events across the world and occa-
sional in-depth surveys into particular
art scenes or subjects.

Contemporary Visual Arts

Suite K101, Tower Bridge Business
Complex, 100 Clement's Road
London SE16 4DG
t 020 7740 1704 f 020 7252 3510
email: cva@gbhap.com
Website: www.gbhap.com/cont.visarts
Editor: Keith Patrick
£4.95

In the past, *cva* seemed to be carving
itself a niche with themed issues

devoted to subjects such as 'The
Condition of Painting' or 'Other British
Artists, Beyond the YBAs'. Lately,
however, this bi-monthly, full-colour
publication has contained few surprises
and in an already overcrowded market is
useful, rather than essential reading.

Dazed & Confused

112 Old Street, London EC1V 1BD
t 020 7336 0766 f 020 7336 0966
email: dazed @ confused.co.uk
Website: www.confused.co.uk
Editor: Jefferson Hack
£2.50

Britain's leading style magazine, this is
one of the few non-specialist vehicles to
treat art in terms other than curiosity or
connoisseurship, acknowledging its
place at the centre of contemporary
culture. Each monthly issue carries
interviews and articles on British and
international artists, as well as artists'
projects. It even runs its own art gallery
at 112 Old Street, London EC1V 9BD.

Everything

Unit 126, Camberwell Business Centre,
99 Lomond Grove, London SE5 7HN
t/f 020 7701 7649
email: everything@southspace.org
Editors: Luci Eyers, Vivienne Gaskin
Steve Rushton, John Timberlake
£3.50

Founded in 1992, *Everything* was origi-
nally distributed free and saw itself as a
means for its artist-founders to inter-
vene in, and become engaged with, the
art world. Although it has now become
more businesslike, it continues to avoid
the constraints of topicality and format
– there are no exhibition reviews and
instead it contains artists' projects,
interviews with or between artists, and
pieces on subjects ranging from the
relationship between Adorno and
Gustav Mahler to the spoof newsletter
of the invented borough of Cramley. In
1998, along with the ICA, *Everything*
launched eBC, the world's first net
broadcasting station, which continues
to commission artists' work online.

frieze

21 Denmark Street, London WC2H 8NA
t 020 7379 1533 f 020 7379 1521

email: editors@frieze.co.uk
Website: www.frieze.co.uk
Editor: James Roberts
£4.50

Britain's best-looking art magazine was
founded in 1991 and devoted to the very
latest in 'contemporary art and culture'.
It had a key role in promoting the *Freeze*
generation of artists, along with their
predecessors and successors. The mag-
azine commissions artists' projects for
its pages, and design is a major priority.
Content is international in scope, going
beyond art to encompass zeitgeisty
investigations into music, fashion,
books, movies and TV, written, espe-
cially in the magazine's mid-1990s
heyday, by some of the best writers from
Britain and abroad. Light relief is pro-
vided by such articles as Dave Hickey on
gambling in Las Vegas and Charles Ray
on the history of the kilogramme. Even
the advertisements provide a resumé of
the international art world. But *frieze*
must guard against complacency as the
less showy but consistently solid *Art
Monthly* threatens to eat into its British
readership.

Publishing: The imprint *frieze* was
launched in 1995 with Stuart Morgan's
What the Butler Saw. Its most recent
publication was *An Ideal Syllabus*, an
essential reading list contributed by
artists, critics and curators.

Modern Painters

Universal House
Tottenham Court Road
London W1P 9AD
t 020 7636 6058 f 020 7580 5615
Editor: Karen Wright
£4.95

This glossy 'Quarterly Journal of the
Fine Arts' was founded by the late Peter
Fuller in 1988 as part of a personal quest
to promote figurative and landscape tra-
ditions in British art, and to fend off the
dangerously modernist 'International
Art World Inc.' (Prince Charles was a
contributor to the first issue). Since
Fuller's death, Modern Painters is less
polemical, but is still the mouthpiece for
the conservative camp with an increas-
ingly eccentric list of contributors who
range from such respected elder states-
men of twentieth-century art writing as

Robert Hughes, David Sylvester and Bryan Robertson, to non-art-world celebs like Michael Parkinson and Jeremy Isaacs. *Modern Painters*' special protégé is Sister Wendy Beckett, and David Bowie sits on the editorial board.

Publishing: Although links with *Modern Painters* are vigorously denied, three of the four partners behind '21' Publishing have strong ties with the magazine – editor Karen Wright, gallery owner Bernard Jacobson, and David Bowie. It was launched in 1997 with *Blimey! From Bohemia to Britpop: The London Artworld from Francis Bacon to Damien Hirst*, a personal odyssey through the capital's art world by Matthew Collings.

tate

Avon House, Avonmore Road
Kensington Village, London W14 8TS
t 020 7906 2002 f 020 7906 2004
email: tmarlow@aspenplc.co.uk
Editor: Tim Marlow
£3.50

It is difficult for a magazine named after the Tate and with the majority of its covers devoted to that venue's exhibitions to stress that it is an independent publication with 'its own voice and vision', over which Tate has no control. Since its launch in 1993, however, *tate* has gone a long way towards resolving its identity crisis. The range and depth of its articles, which, unlike most magazines dealing with contemporary art, span throughout art history and across the globe, is helping to dispel the in-house image.

Untitled

29 Poets Road, London N5 2SL
t 020 7354 8659
email: flecha@compuserve.com
Editor: Mario Flecha
£3.50

No glossy design for this low-budget, large-format, black and white mag, which comes out three to four times a year, but well-written and thoughtfully selected reviews, interviews and artists' projects make this a publication that people – especially artists – actually want to read.

Frieze covers

INTERNATIONAL ART MAGAZINES

Artforum

350 Seventh Avenue, New York
NY 10001, USA
t 212 475 4000 f 212 529 1257
email: artforum@aol.com
Website: www.artforum.com
Editor: Jack Bankowsky
£5.95

Not only is this the magazine most read by the international art world, it has been a prominent supporter of the current British art scene, both in exhibition reviews and profiles of individual artists.

Flashart

68 Via Carlo Farini, 20159 Milan, Italy
t: 39 02 668 6150 f 39 02 668 01290
email: politi@interbusiness.it
Website: flashartmagazine.com
Editors: Helena Kontova
Giancarlo Politti
£5.00
Founded in 1967, *Flashart* covers art worldwide – including in-depth reports on art in Africa, Asia and Oceania. In the

1980s, it was required reading, but the declining quality of its editorial content means that it has been overtaken by *Artforum* in the international stakes. Its annual international art directory, which lists artists, events, hotels, galleries, critics in most major cities is handy for art travellers.

Parkett

Quellenstrasse 27, CH 8031 Zurich
t 411 271 8140 f 411 272 4301
email: info@parkettart.com
Website: www.parkettart.com
Editor: Bice Curiger
£19.50

The most prestigious contemporary art publication for those who can afford it, *Parkett* is as much a book as a magazine. Each issue focuses on three artists who contribute special artists' editions and whose work is explored in a range of articles by top writers. If an artist is chosen for this treatment by *Parkett*, they've really made it. Texts are printed both in English and German.

UK VENUES

(Admission to all venues free unless otherwise stated)

ENGLAND

BERWICK UPON TWEED
Berwick Gymnasium Gallery
The Barracks, The Parade
Berwick upon Tweed, TD15 1DF
t/f 01289 303243
Apr – Oct: Daily 10-6
Nov – Mar: Wed – Sun 10-4
Admission charges
Head Custodian: Judith King

Located in a disused gymnasium adjoining Berwick barracks and close to the town ramparts, this gallery offers an annual fellowship for an artist to use the space during the winter months as a studio in which to conceive work for a summer exhibition. Recipients have included Marcus Taylor and Mike Nelson. The gallery also programmes shows and collaborations with other progressive contemporary arts venues.

BIRMINGHAM
Ikon
Oozells Square, Brindley Place
Birmingham B1 2HS
t 0121 248 0708 f 0121 248 0709
email: art@ikon-gallery.co.uk
Website: www.ikon-gallery.co.uk/ikon/
Tues – Sun 11-6
Director: Jonathan Watkins

One of Britain's leading contemporary art galleries, since its foundation in 1963, Ikon has remained the only venue in the Midlands devoted to major exhibitions of contemporary visual art. Early on, it showcased international figures such as Denis Oppenheim and Chris Burden and helped to further the careers of Richard Wilson, Rose Garrard and Susan Hiller. Throughout the 1980s and 1990s it consolidated this commitment to the experimental work of established and emerging artists with the first, large-scale European shows of Adrian Piper, Victor Grippo, Mark Dion, and Martha Rosler, as well as solo exhibitions of British artists including Keith Piper, Zarina Bhimji, Lucia Nogueira, Permindar Kaur, Yinka Shonibare and

Adam Chodzko. A particular concern is the examination of identity and cultural diversity; mixed shows have included *InFusion: New European Art and Distant Relations: A Dialogue Between Chicano, Irish and Mexican Artists.*

In early 1998, Ikon relocated into Oozells Street School, a Victorian, grade II listed building, restored and converted for the purpose by Levitt Bernstein Architects in collaboration with artist Tania Kovats. Not only did she advise the team on all aspects of refurbishment ('de-designing' as she calls it) but she has also made an explicit artistic intervention: the cladding of the wedge-shaped perimeter wall in black slate, creating a form of pedestal that signals the building itself as an object of attention. With shows such as Richard Billingham and Mariele Neudecker, Ikon seems set to continue in the promotion of the most experimental and adventurous work.

BRADFORD
National Museum of Photography Film & Television
Bradford, West Yorks BD1 1NP
t 01274 202030 f 01274 723155
email: initial.surname@nmsi.ac.uk
Website: www.nmpft.org.uk
Tues – Sun 10-6
Head: Amanda Neville

A major expansion to create state-of-the-art galleries dedicated to the new digital media has expanded the museum space by 25 percent, enabling it to tell the developing story of film, photography, television and how these interact with the new media. A major new gallery space will allow the NMPFT to show the largest of international touring shows, or can be subdivided for smaller exhibitions. These range from major retrospectives to solo shows by leading photographers such as Richard Billingham, Nick Waplington and Martin Parr, as well as exhibitions reflecting emerging trends in contemporary photography.

BRIGHTON
Brighton Museum and Art Gallery
Church Street, Brighton BN1 1UE
t 01273 290900 f 01273 292841
email:

nicola.coleby@brighton-hove.gov.uk
Mon – Sat 10-5, Sun 2-5, closed Wed
Head of Exhibitions: Nicola Coleby

Many of Brighton Museum and Art Gallery's temporary exhibitions are devoted to contemporary art. A range of progressive touring shows are accompanied by exhibitions instigated by the gallery, such as Mark Power's photographs of coastlines inspired by BBC radio's shipping forecast (*The Shipping Forecast*, 1997) and shows spanning eras and cultures like their collaborations with SBC *Fetishism: Visualising Power and Desire*, which ranged from African fetish figures to Dorothy Cross' sculptures using cows' udders, or *Carnivalesque* (2000), which looked at carnival imagery in Western art from 1300 to the present.

White Gallery
86/87 Western Road
Hove, Brighton BN3 1JB
t 01273 774870 f 01273 748475
email: artists@whitegallery.co.uk
Opening hours: Tues – Sat, 10-6, Sun & bank hols 11-4
Directors: Simon Owers, Tim Owers

This venue shows a combination of London-based and local artists, many of the former arising out of close working relationships with galleries in the capital such as Alan Cristea, Purdy Hicks and the Marlborough Gallery.

BRISTOL
Arnolfini
16 Narrow Quay, Bristol BS1 4QA
t 0117 929 9191 f 0117 925 3876
email: arnolfini@arnolfini.demon.co.uk
Website: www.arnolfini.demon.co.uk
Galleries: Mon – Sat 10-7, Sun 12-6
Director: Caroline Collier

A former tea warehouse refurbished by architect David Chipperfield and artist Bruce McClean provides an elegant setting for one of Europe's leading centres for contemporary art, which presents touring exhibitions, major initiated shows, collaborations with other institutions, community-based projects and commissions new work. Rachel Whiteread, Vong Phaophanit and Mona Hatoum all received early shows here.

Recent shows include Eija-Liisa Ahtila, Tracey Moffatt, Joachim Koester, Liam Gillick and Michael Snow

CAMBRIDGE
Cambridge Darkroom Gallery
Dales Brewery, Gwydir Street
Cambridge CB1 2LJ
t 01223 566725 f 01223 312188
email: darkroom@dircon.co.uk
Mon – Fri 10-6
Director: Ronnie Simpson

This gallery commissions and exhibits new visual work through exhibition, Internet, publication, broadcasting and public art events. Notable recent shows have included *Postcards on Photography* with work by Jason Brooks, Mark Fairnington, Andrew Grassie, Alex Hartley, Andrew Holmes, John Salt, Paul Winstanley, Chuck Close and Malcolm Morely; *wild goose chase and other journeys* by Louise Short; and Thomson & Craighead's *Decoder*.

Kettle's Yard Gallery
Castle Street, Cambridge CB3 0AQ
t 01223 352124 f 01223 324377
email: kettles-yard-gen@lists.cam.ac.uk
Website: www.kettlesyard.co.uk
Gallery: Tues – Sun 11.30-5
Sun 2-5.30
House: Tues – Sat 2-4
Director: Michael Harrison

This series of eighteenth-century cottages with an extension designed by Sir Leslie Martin contains a unique collection of twentieth-century art, furniture and natural objects gathered over fifty years by HS Ede, assistant curator at the Tate Gallery in the 1920s and 1930s. The selection reflects Ede's friendship with Ben Nicholson and Constantin Brancusi, and includes major holdings of St Ives artists as well as a unique body of sculpture and drawings by Henri Gaudier-Brzeska. The adventurous programme of the adjoining purpose-built galleries distinguishes it as the only venue in East Anglia currently capable of exhibiting important twentieth-century and cutting-edge contemporary exhibitions – these can range from a solo show by Prunella Clough to the digital explorations of *NOISE* (2000).

CANTERBURY
The Herbert Read Gallery
Kent Institute of Art and Design at Canterbury
New Dover Road, Canterbury CT1 3AN
t 01227 769371 f 01227 817500
email: cgist@kiad.ac.uk
Website: www.kiad.ac.uk
Mon – Fri 10-5
Exhibition Curator: Christine Gist

The largest of the three galleries situated in art schools in Canterbury, Maidstone and Rochester, The Herbert Read Gallery reflects in its programme the South East region's links with Northern Europe. *Modi-Operator*, for example, was a first presentation in England of work by the German artist Hermann Pitz. *On the Frac Track* featured works from the international collection of FRAC Nord Pas de Calais.

COLCHESTER
firstsite @ the Minories art gallery
74 High Street, Colchester
Essex CO1 1UE
t 01206 577067 f 01206 577161
email: info@1stsite.keme.co.uk
Mon – Sat
Apr – Oct: 10-5, Nov – Mar: 10-4
Director: Katherine Wood

A programme of touring and self-generated shows of contemporary art by established and emerging figures at local, national and international levels takes place within this historical town house and its gardens as well as a variety of locations throughout the area.

COVENTRY
Mead Gallery
Warwick Arts Centre
University of Warwick
Coventry CV4 7AL
t 02476 524524 f 02476 523883
email: arts.centre@csv.warwick.ac.uk
Website: www.warwick.ac.uk/artscentre
Mon – Sat 12-9 (term-time only)
Director: Sarah Shalgosky

Situated on the campus of Warwick University, the Mead Gallery presents a broad programme of twentieth-century visual culture with one-person and group exhibitions of work in all media. Some shows are conceived by the

gallery itself, including recent work by Permindar Kaur, David Austen and Jo Stockham, while others are drawn from national and international tours.

EASTBOURNE
Towner Art Gallery and Museum
High Street, Old Town, Eastbourne
East Sussex BN20 8BB
t 01323 417961/725112 f 01323 648182
Sun 2-5, Tues – Sat, Apr – Oct: 10-5
Nov – Mar: 10-4,
Curator: Fiona Robertson

The Towner is a participant in the five-year CAS Special Collection Scheme, part-funded by Museums and ACE Lottery. This enables regional galleries to purchase significant contemporary artworks to develop their own collections. It follows a pilot scheme in which works by Tacita Dean, Anya Gallaccio, Callum Innes, Ian Mckeever, Mariele Neudecker, John Virtue and Daphne Wright, amongst others, were purchased. David Nash was commissioned to make a sculpture of reclaimed timber groynes in the gallery grounds. There is also a programme of temporary exhibitions such as *60s/90s – Two Decades of Art and Culture* (1999) and *Donation: Art Given by Charles Saatchi to the Arts Council Collection* (2000).

EXETER
Spacex Gallery
45 Preston Street, Exeter EX1 1DF
t 01392 431786 f 01392 213786
email: mail@spacex.co.uk
Website: www.spacex.co.uk
Tues – Sat 10-5
Artistic Co-Directors: Zoe Shearman
Tom Trevor

The region's main venue for contemporary art boasts an inventive programme alternating work by established figures like Bridget Riley and Richard Long with challenging mixed shows and important solo exhibitions of younger figures. Projects include *The Free Association Series*, marking the centenary of Freud's *The Interpretation of Dreams*, including Christine and Irene Höhenbuchler, Hermione Wiltshire, Bettina Semner and Lois Weinberger. *Home Series*, exploring different cultural attitudes to home includes Gavin Renwick's

residency at Exeter Museum's Inuit collection. New commissions include works by Jayne Parker, and Michael Curran & Imogen Stidworthy.

GATESHEAD
Baltic Centre for Contemporary Art
PO Box 158, Gateshead NE8 1FG
t 0191 478 1810 f 0191 478 1922
email: b4b@balticmill.com
Website:www.balticmill.com
Mon - Sun, hours to be confirmed
Director: Sune Nordgren

A familiar landmark on the banks of the Tyne, the vast brick bulk of the derelict Baltic Flour Mills has already been the temporary site of a number of artworks, whether emblazoned with banners by Bruce McLean and Les Levine, or backdrop to a 2,000-metre light sculpture by Jaume Plensa. Now, with the help of £35 million Lottery money, it will provide the North East with a major, much-needed international centre for the visual arts. In advance of its opening, scheduled for the end of 2001, the Baltic has been running an advance programme of exhibitions, including a show of Kurt Schwitters, organised in collaboration with the Hatton Gallery in Newcastle, and Anish Kapoor's spectacular *Taratantara*, a 35 x 50 metre 'double trumpet' of deep red PVC, which surged through the empty shell of the Baltic in summer 1999.

HALIFAX
Dean Clough Galleries
Halifax, West Yorks HX3 5AX
t 01422 250250 f 01422 341148
email:
linda@design-dimension.co.uk
Website: www.DeanClough.com
Daily 10-5
Gallery Director: Doug Binder

This complex of nineteenth-century mills, which once housed one of the world's largest carpet factories, was purchased by philanthropist Sir Ernest Hall in 1983 to create 'a practical utopia'. Along with some 100 companies and organisations now occupying the site are artists' studios and a network of galleries that show a range of contemporary art and design, giving priority to artists from the region.

Christian Boltanski
The Work People of Halifax 1877
1982
Shoddy, clothing
Dimensions
variable
Installation at The Henry Moore Studio, Dean Clough, Halifax
Photo: Susan Crowe

The Henry Moore Foundation Studio
Gate 1, Dean Clough, Halifax
West Yorks HX3 5AX
Information line: 0113 247 0505
Open during exhibitions
Tues – Sun 12-5 (closed bank hols)

Administered by the Henry Moore Foundation, this 10,000 square feet of stone-flagged, ground-floor space in one of the mills has earned a global reputation for its role as a studio space. Two or three major artists are invited annually to make new work in the studio with as little compromise as possible, which often leads to subsequent installations. These have included Giuseppe Penone (Italy); Richard Long (UK); Bruce McLean (UK); Jannis Kounellis (Italy); Christian Boltanski (France); Tony Cragg (UK); Andrew Sabin (UK); Antonio Messina (Italy); Michaelangelo Pistoletto (Italy). Also notable was *The Cauldron*, selected by Maureen Paley, a mixed show of young British artists including Christine Borland, Gillian Wearing, Jake and Dinos Chapman, Steven Pippin, Georgina Starr and Angela Bulloch.

HULL
Ferens Art Gallery
Queen Victoria Square
Kingston-upon-Hull HU1 3RA
t 01482 613902 f 01482 613710
Mon – Sat 10-5, Sun 1.30-4.30
Curator: Ann Bukantas

An important permanent collection of twentieth-century British art has recently been augmented by a three-year purchasing collaboration (1994-6) with the CAS and ACE that has focused on the collection's strengths in portraiture and extended the theme into new works in a variety of different media dealing with issues of the body and identity. These include Nina Saunders' manipulated furniture, Mark Wallinger's *Passport Control* (1988), video installations by Marty St James and Georgina Starr, and photopieces by Craigie Horsfield and Boyd Webb.

The Ferens is also the home of the Mag Collection – over 200 pieces of British art from the 1980s and 1990s, put together by Paul Wilson. It consists mainly of two-dimensional pieces – paintings, photographs and works on paper – spanning several generations, of which over 75 percent are by women, from Elizabeth Blackadder and Wilhemina Barns-Graham to Cornelia Parker, Gillian Wearing and Tracey Emin.

RED Gallery
19 Osborne Street, Hull HU2 2NL
t 01482 213 169
Wed – Fri 12-4
Gallery Committee: Paul Hughes, Scott Weston, Jayne Jones, Espen Jenson.

The programme of this artist-run space situated in Hull's city centre reflects the diversity of contemporary art practice, and promotes the work of new and emerging artists. Alongside its formal

programme, RED allows undergraduates from Hull School of Art to use the space as an experimental art laboratory.

KENDAL
Abbot Hall Art Gallery
Kendal LA9 5AL
t 01539 722464 f 01539 722494
email: info@abbothall.org.uk
Website: www.abbothall.org.uk
Mon – Sun
Feb, March, Nov, Dec 10.30-4
Apr – Oct 10.30-5
Admission charges
Director: Edward King

An impressive Georgian house with an extensive permanent collection ranging from eighteenth- and nineteenth-century watercolours, modern British paintings and Kurt Schwitters' collages, Abbot Hall Art Gallery has recently put itself on the contemporary art map with a programme aimed to complement the permanent exhibits with, for example, shows of Lucian Freud, Alison Wilding and Bridget Riley.

LEEDS
Henry Moore Institute
74 The Headrow, Leeds LS1 3AH
t 0113 246 7467 f 0113 246 1481
Mon – Sat 10-5.30, Wed 10-9
email: info@henry-moore.ac.uk
Head of Programmes: Penelope Curtis

These three early Victorian wool merchants' houses were dramatically converted in 1993 by architects Jeremy Dixon and Edward Jones into an international centre for the promotion, study and appreciation of sculpture of all periods and nationalities.

The shiny granite entrance looks like a piece of Minimalist sculpture in its own right and the purpose-built galleries serve as a more traditional space to offset the experimental Henry Moore Foundation Studio at Dean Clough in Halifax (see above). The role of the Henry Moore Sculpture Trust, which organised sculpture projects in venues throughout the UK and abroad, has been taken on by Henry Moore Foundation External Programmes. Temporary exhibitions at the HMI, which belongs to the Henry Moore Foundation and receives support from

Leeds City Council, have included *Robert Morris' Recent Felt Pieces and Drawings*, as well as the smaller *In Focus* shows featuring sculptors like Richard Long. *At One Remove*, 1997-8 was a mixed show of contemporary artists from the UK and abroad (for example, Pierre Bismuth, Adam Chodzko, Kathy Prendergast, and Elizabeth Wright) using projections, photos, casts, models and moulds to examine how it is possible for sculpture to function even when it has little or no material substance.

The HMI, with its library, archive and exhibition spaces is connected by bridge to the Leeds City Art Gallery (see below), which displays loan exhibitions of sculpture and selections from the permanent collections such as *Jasper Johns: The Sculptures*, as well as the work of younger figures including David Batchelor's *Polymonochromes*.

Leeds City Art Gallery
The Headrow, Leeds LS1 3AA
t 0113 247 8248 f 0113 244 9689
email: evelyn.silber@leeds.gov.uk
Website: www.leeds.gov.uk
Mon – Tues, Thurs – Sat 10-5
Wed 10-8, Sun 1-5
Director, Leeds Museums and Galleries: Dr Evelyn Silber
Exhibitions Curator: Nigel Walsh

This key permanent collection is strong in English watercolours and twentieth-century British art (particularly Surrealism), and embraces the work of established living artists such as Susan Hiller, Paula Rego and Gillian Ayres, and photographic work by Richard Long, Boyd Webb, Hamish Fulton and Gilbert and George. Thanks to a relationship with the HMF, a strong sculpture collection extends from Rodin through to Alison Wilding and Grenville Davey. Courtesy of the CAS, the gallery will have additional Lottery support to acquire further new works. As well as exhibitions shared with the Henry Moore Institute (which extend into the gallery's mezzanine floor), an annual contemporary show is usually held, such as *Martin Creed Works* (2000).

LIVERPOOL
Bluecoat Gallery
School Lane, Liverpool L1 3BX

t 0151 709 5689 f 0151 709 2777
Tues – Sat 10.30-5
Contact: Catherine Gibson

Part of the arts centre that for most of the twentieth century occupied the eighteenth-century former Bluecoat School – the oldest building in Liverpool's city centre – this gallery boasts a reputation extending well beyond Merseyside for its promotion of innovative art in group and solo shows by local, national and international artists. It is also one of the host spaces for the *Video Positive* biennial of video and electronic art, as well as for the Liverpool Biennial of Contemporary Art.

Static Gallery
23 Roscoe Lane, Liverpool L1 9JD
t/f 0151 707 8090
Tues–Sat 10-5
Director: Paul Sullivan

What began as a raw space for local artists is widening out into a more international perspective with plans to extend into the adjoining building.

Tate Liverpool
Albert Dock, Liverpool L3 4BB
t 0151 702 7400 f 0151 702 7401
email: liverpoolinfo@tate.org.uk
Tues – Sun 10-5.30
Admission charges for temporary exhibitions
Director: Lewis Biggs

In the ten years between its establishment in a nineteenth-century bonded warehouse and its re-opening in May 1998 after further development and the addition of a top floor of galleries, Tate Liverpool has notched up an impressive line-up of contemporary exhibitions. Retrospectives of Rachel Whiteread, Susan Hiller and Paula Rego have alternated with exhibitions of Alison Wilding, Ann Hamilton, Robert Gober, Gary Hill and Andreas Gursky. There have also been significant mixed shows of contemporary Irish, Japanese and African art. An annual artist-in-residence fellowship sponsored by Momart has, over the years, given extra exposure to younger artists including Maud Sulter, Laura Godfrey-Isaacs and Emma Rushton.

LONDON
ARTIST RUN/PROJECT SPACES

Beaconsfield

Newport Street, Vauxhall
London SE11 6AY
t 020 7582 6465 f 020 7582 6486
email: beaconsfield@easynet.co.uk
Website: www.beacons-field.org.uk
Founders: David Crawforth/
Angus Neill/Naomi Siderfin

Beaconsfield's ambition to 'fill a niche between existing public establishments, commercial enterprises and "alternative" ventures' disguises an international outlook (collaborations with artists in Finland, Lithuania and the US for example) and an agenda dedicated to placing strategic spanners in art-world works. Thematic shows held in this Neo-Classical, nineteenth-century, former 'Ragged School' for the poor of Lambeth, including *Cottage Industry* and *Maps Elsewhere* (co-curated with inIVA), have been complemented by performance marathons and an event in cyberspace. Tomoko Takahashi has covered its stepped wooden floor with a maze of dysfunctional appliances (1997) and this was the first European venue for filmmaker Chris Marker's gallery installation *Silent Movie* (1999).

Crawforth and Siderfin are also organisers of Nosepaint, an organisation that curates time-based events in a range of locations, often in collaboration with Beaconsfield. These have included *Nosepaint at the Ministry of Sound*.

Cable St Gallery

566 Cable Street, London E1W 3HB
t 020 7790 1309 f 020 7709 1323
email: csaf.studios@virgin.net
Contact: Michael Cubey
Thurs – Sun, 12-6

This gallery and café is connected to a large studio complex housed in a former Victorian sweet factory.

Chapman FineARTS

39 Fashion Street, London E1 6PX
t 0171 375 3592
Thurs – Sat 10-6, and by appointment
Directors:
Professors Jake and Dinos Chapman

Run by the Chapman brothers and Mark Sanders, of *Dazed & Confused*, this former Halal butcher's shop was inaugurated in a semi-derelict state with David Falconer's mountain of cast-resin mice (*Vermin Death Stack*, 1998), and has played host to the Chapman's A-level art submissions as well as to work by Nigel Buxton, AKA Baad Daad from Channel 4's *Adam and Joe Show*. After a full refurbishment that has also opened up a basement space, the remit of this gallery remains just as broad and idiosyncratic – from showcasing the Chapmans' own work, and their collaborations with others, to shows featuring 'whichever artists and celebrities make the Directors flush'.

Cubitt

2-4 Caledonia Street, London N1 9DZ
t/f 020 7278 8226
Website: www.cubittltd@demon.co.uk
email: admin@cubittltd.deomn.co.uk
Fri – Sun 11-6
Organisers: Artists' Committee
From autumn 2000:
White Lion Street, London N1

A move from Cubitt Street in 1994 to a former laundry in an even dodgier part of King's Cross, and then to Islington in autumn 2000 means that, confusingly, the name of this exhibition space attached to artists' studios no longer reflects its location. However, Cubitt has gained a reputation – and sizeable audiences – as one of the most important artist-run spaces in the UK. Run by an annually changing committee of studio holders, Cubitt has no specific identity or focus, and has made a virtue of its diversity by collaborating with guest curators. Stuart Morgan, Gareth Jones and Antony Wilkinson have all organised shows here; Chris Ofili, John Stezaker and Tacita Dean are among the many artists shown. More recently, the programme has been curated by the gallery committee only, who aim to concentrate on commissioning. A talks and events programme accompanies each exhibition and provides an important platform for art debates.

Decima Gallery

3 Decima Studios, Decima Street,
London SE1 4QR

t 020 7708 2237 f 0870 120 5658
email: art@decima.co.uk
Website: www.decima.co.uk
Contacts: Alex Chappel, David C. West

Decima is 1,200 rough-and-ready square fee, which since 1997 has played host to numerous exhibitions/installations. These include poetry readings, screenings, provocative Situationist-type pieces and media hoaxes, often staged by the gallery organisers. More recently, Decima has been mounting shows in many different locations, It also offers a web-design service. For a minimal fee, Decima offers new and inexperienced artists access to mailing lists and resources, which include a film production unit and inclusion on the web, along with involvement in the gallery's multifarious events and activities. These often seem to involve Diana, the Pantomime Cow.

Delfina

50 Bermondsey Street, London SE1 3UD
Mon – Fri 10-5, Sat – Sun 2-5
t 020 7357 6600 f 020 7357 0250
email: admin@delfina.org.uk
Curator: David Gilmour

Victorian warehouses provide the setting for this studio complex with a gallery space and a surprisingly swanky café. Funded by philanthropist Delfina Entrecanales, the gallery's emphasis is on awarding artists' residencies: foreign artists – such as Karen Kilimnik, Thomas Demand and Vibeke Tandberg – can receive free studio space and accommodation for nine months, while eleven British artists receive a two-year studio residency. The beneficiaries between 1998-2000 include Jane and Louise Wilson, Ceal Floyer, John Frankland, Jaki Irvine, Jemima Stehli, and . There is no obligation for resident artists to show in the gallery space, but many do – and highlights of the Delfina's consistently high-quality programme have included important new shows by Elizabeth Wright, Anya Gallaccio and Susan Hiller.

From summer 2000, the majority of Delfina's shows will be held in the new project space at 51 Southwark Street, London SE1.

Five Years

40 Underwood Street, London N1 7JQ
t 0171 253 6337
Fri – Sun, 1-6
Contacts: Edward Dorrian, Marc
Hulson, Denise Hawrysio, Alex Schady

Founded in July 1998, and expanding
into a 1,000 square-foot space in
November 1999, Five Years is run by a
group of artists who aim to make the
gallery 'the equivalent of an indepen-
dent record label', providing a public
arena for experimentation within which
artists can maintain control over the way
their work is represented. Group shows
including *What is a Photograph?* and *A
Promise of Happiness*, situate practice in
the context of ongoing debates. Others,
such as John Roberts' *Lapsus*, were
organised by guest curators. Non-pro-
ject members to show in the gallery
include Nicholas Bolton, Sally Morfill,
Clio Padovani and Naomi Slaman.

Fordham

20 Fordham Street, London E1
t 020 7247 0410
Tues – Sun 12-5
Contact: Joost Somerlinck

A non-profit project space for under-
exposed British artists, this venue also
gives first-time UK shows to artists from
Europe and the US.

Gasworks

155 Vauxhall Street, London SE11 5RH
t 020 7582 6848 f 020 7582 0159
email: gallery@gasbag.org
Fri – Sun 12-6
Gallery Co-ordinator: Fiona Boundy

This three-storey building provides
rented studio space for London-based
artists attached to its residency pro-
gramme. The gallery shows their work
and also aims to offer a platform to
emerging artists, as well as an experi-
mental space for more established
ones, in all media.

Home

1a Flodden Road, London SE5 9LL
t f 020 7274 3452
email: lgihome@aol.com
Website: www.lgihome.co.uk
Phone for opening times

Contacts: Laura Godfrey-Isaacs
Mimi Cuthbert

A thoughtful programme of projects put
on in Laura Godfrey-Isaacs' Victorian
house sets out both to challenge and to
explore the art-in-domestic-surround-
ings formula. In July 1999, twenty-one
artists – including Bobby Baker and
Gary Stevens – filled all the rooms with a
domestically themed performance fest,
which went out live on the Internet. In
April 2000, Elizabeth Wright, artistic
scale manipulator extraordinaire,
parked a full-sized white Volkswagen
Caddy in the living room. From roof to
basement – spaces to be watched.

LIFT

94 Leonard Street, London EC2A 4RH
t 020 7729 3445 F 020 7729 5375
email: info@liftgallery.co.uk
Website: www.liftgallery.co.uk
Wed – Sun 12-6

Exhibition organiser: Anna Milsom
One of Lift's earliest shows was Tomoko
Takahashi's floor-to-ceiling arrange-
ment of the clutter of discarded equip-
ment she found in the basement (1999).
Another work made especially for this
small space is Angela de la Cruz' giant,
white *One Painting* (1999), smashed,
skewed and strangely elegant.

Mellow Birds

34 Underwood Street, London N1 7JX
t/f 020 7336 7408
Fri – Sun 12-6

Mellow Birds is run by three artists with
studios in the Underwood Street block,
who, until it was redeveloped, had
worked and exhibited in the Curtain
Road artists' studios. It opened with an
exhibition of Martin McGinn's paintings
of light, and is devoted to showing both
established and emerging figures – but
not, as a point of principal, those based
in the surrounding studios.

Milch

2-10 Tinworth Street
London SE11 5EH
t 020 7735 7334
email: milchgallery@yahoo.com
Wed – Sat 12-6
Director: Lisa Panting

Building on its radical reputation gained
under the directorship of the late
Lawren Maben with early shows of
Simon Patterson, Douglas Gordon,
Sarah Staton and Hamad Butt, Milch
moved from its Bloomsbury, Georgian
squat to artists' studios and a three-
room gallery space in London's West
End. Memorable shows have included
Jane and Louise Wilson's *Normapaths*
(1995) and Steve Farrer's *Good night
ladies, good night (1999)*. Now south of
the Thames in a converted 1950s ware-
house in Vauxhall, its primary aim is to
commission new work and organise
first-time exhibitions of artists' work in
all media. Future and recent shows
include Casten Nicolai and new work
from the Baltics.

Museum of Installation

175 Deptford High Street
London SE8 3NU
t 020 8692 8778 f 020 8692 8122
email: moi@dircon.co.uk
Website: moi.dircon.co.uk
Tues – Fri 12-5, Sat 2-5
Directors: Nicola Oxley/Nicolas de
Oliveira/Michael Petry

Founded in 1990, this ironically titled
venue claims to be 'the first and only
museum of its kind in the world'. Its
exhibition spaces, in a rough-edged
former shop premises, are devoted to
projects that explore contemporary
installation (Ron Haselden, Phyllida
Barlow and Carl von Weiler have each
contributed notable pieces). MOI is also
museum-like in its comprehensive
archive of ephemeral projects, and in its
1994 publication of the historical survey,
Installation Art.

The Nunnery

18-3 Bow Road, London E3 2SJ
t 020 8980 7774
Fri – Sun 1-5
Curator: Peter Jones

This studio complex of over seventy
artists with a 2,000-square-foot gallery
converted from an eighteenth-century
Carmelite convent, is situated by St
Mary Atta la Bow, of Bow Bells fame.
Shows in the artist-run gallery have
included *Alice* (1998), which explored
notions of childhood; *Re-grouping*

(2000), which exhibited six new and established contemporary painters, and *Wreck of Hope* (2000), an exhibition of works by 35 contemporary artists in response to Caspar David Friedrich's painting of the same name.

One in the Other

1 Tenter Ground, London E1 7NH
t/f 020 7564 8282
email: oneinthe other.art@virgin.net
Sat – Sun 12-6
Director: Christopher Noraika

One of east London's most atmospheric spaces, this small room on the first storey of an untouched, wooden-floored, early Victorian warehouse hosts a consistently rigorous and progressive programme, which has included work by Dan Coombes, David Shrigley, Ewan Gibbs, Ian Dawson and Paul Noble.

Platform

3 Wilkes Street, London E1 6QF
t/f 020 7375 2973
email: platform@dircon.co.uk
Website: www.platform.dircon.co.uk
Sat – Sun 12-6
Director: Sheila Lawson

A project space that opened on New Year's eve 1998, Platform puts on monthly shows of artists from abroad and the UK, as well as poetry readings, performances and screenings. *From Memory* (1999) included works by Rod Dickinson and James Pyman, and Fiona Banner, while the dystopian theme of another mixed show, *NewBUILD* (1999), was continued in *Les Soldats* (2000), which presented works by John Timberlake and William Burroughs.

Sali Gia

43 Plummer Road, London SW4 8HH
t 020 8671 7147
email: saligia@iname.com
Sat – Sun 2-6
Contact: Michael Klega

A range of artists and curators stage exhibitions in this two-room gallery/flat in a highrise block of flats near Clapham Common, which describes itself as 'a passing guest that comes and goes with the events'. However, with artists such as DJ Simpson, Michael Raedecker,

Gerard Hemsworth, Keith Tyson, Giorgio Sadotti and Mike Silva taking part in its programme, and plans afoot for 'Flying Squad' activities in sites virtual and actual, it seems that although its location may shift, Sali Gia is set to make a lasting impression.

salon3

Unit 318, Elephant and Castle Shopping Centre, London SE1 6ZP
t/f 020 7252 4661
email: salon3@hotmail.com
Mon – Sat 1-6
Trustees: Maria Lind, Rebecca Gordon Nesbitt, Hans Ulrich Obrist

A flexible, mobile project, currently intrepidly based in the brutalist concrete heart of one of London's least-loved landmarks, salon3 is the brainchild of curators Maria Lind, Hans Ulrich Obrist and Rebecca Gordon Nesbitt. It is dedicated to an international approach that addresses the need for 'a more radical trans-disciplinary practice'. Projects so far have included Jeremy Deller's range of t-shirts emblazoned with a phonogram of agnès b's name spoken into a computer, a film of ex-Yugoslavian artist Bojan Sarcevic trailing water through the shopping centre, and a mixed show of figures from all discplines plugging various appliances into the multitude of sockets that still punctuate the walls of this former TV and video store.

Tablet

The Tabernacle, Powis Square
London W11 2AY
t 020 7565 7803 f 020 7565 7810
email: kate@tabernacle.org.uk
Wed – Sat 12-6
Exhibitions Organiser: Kate Macgarry

This project space is situated in a refurbished Victorian church, which also houses a community centre, café and rehearsal rooms. Tablet's inaugural show in 1998 was an installation by Tomoko Takahashi, which utilised the architect's plans and building debris generated by the Tabernacle's Lottery-funded metamorphosis into its current state. Since then, notable shows have included Yinka Shonibare's *Alien Obsessives* (1998), a family of toy aliens made from vivid 'African' fabric, and *48*

Hours (1999), in which artists were invited to collaborate with local individuals and organisations.

30 Underwood St Gallery

30 Underwood Street, London N1 7XJ
t 020 7336 0884 f 020 7250 3045
email: sidust@aol.com
Website:
webspace.netmatters.co.uk/studio23/underwood/index.htm
Fri – Sun, 1-6 or by appointment
Director: Simon Hedges

Attached to a complex of artists' studios, this space focuses particularly on live/multi-disciplinary art and its historical context. It has mounted the first solo UK shows of Fluxus artist Tatsumi Orimoto, and Viennese Actionist Hermann Nitsch. Artists who have shown work in all forms here include Padraig Timoney and Damien Duffy as well as painters Tim Allen and Dan Hayes, photographer Nick Waplington, and Alexander de Cadenet. The gallery also has its own record label, Underwood Audio, which has produced CDs by artists including Martin Creed, Patrick Brill and Angus Fairhurst.

291 Gallery

291 Hackney Road, London E2 8NA
t 020 7613 5676 f 020 7613 5692
Tues – Sat 12-7, Sun 12-6
email: admin@gallery291.demon.co.uk
Director: Edwina Orr

One of London's most spectacular art spaces, this deconsecrated neo-Gothic Victorian church has been meticulously converted into an art gallery, restaurant and bar. Striking architecture has been combined with the latest technology, most notably a 50-foot high projection screen at one end of the 4,700-foot central gallery. So far, the site has tended to dominate 291's mixed programme of shows, which have included life-sized photographs of 168 naked people aged 1-100 by Anthony Noel Kelly and *Porcupines/Arthinking*, a group show of fifteen artists including Cornelia Parker, Martin Creed and Simon Patterson.

The Trade Apartment

404-408 Coldharbour Lane
London SW9 8LF

t/f 020 7733 8181
email: thetradeapart@aol.com
Thurs – Sat 12-6
Contact: Raymund Brinkmann

A former sewing workshop above
Brixton's Market Row Arcade, this 200-
square-metre space was set up in 1997
by an architect and an artist with the
intention of applying a fanzine approach
to the running of an exhibition space. It
has showcased many recently emerging
London-based artists (Dexter Delwood,
Enrico David, Paul Morrison, Luke
Gottelier, Emma Kay, Ulli Knall), organ-
ised a variety of events, produced a
limited-edition CD of art band The Male
Nurse, and hosted several talks.

VOID

511 Hackney Road, London E2 9ED
t/f 020 7729 9976
email: voidgallery@hotmail.com
Website: www.geocities.com.SoHo/
Workshop/4202
Fri – Sun 12-6
Exhibition organisers: Jennifer Mehra,
Yoko Yamashita, Tim Maslen

Originally founded on Brick Lane in
1997, VOID moved to its current
premises, a former shop-front, and
courtyard, in 1999. It shows a wide
range of works in all media by UK and
international artists, including Mark
Bell's aluminium assemblages incor-
porating £15,000 worth of heroin.

VTO

96 Teesdale Street, London E2 6PU
t 020 7729 5629
email: jari@vtogallery.com
Website: www.vtogallery.com
Fri – Sun 11-6
Gallery Director: Jari Lager

This independent space in an East End
warehouse places a strong emphasis on
international artists. *The Soccergette
Firm* (1999), for example, was the first
show in this country for the Danish
group rasmus knud, which explored
British fan culture. The 2000 pro-
gramme includes Myfanwy MacLeod
(Canada), Volker Eichelmann
(Germany), Stefan Nikolaev (Hungary),
and the group show, *Oktoberfest*.

COMMERCIAL GALLERIES

The Agency

35-40 Charlotte Road
London EC2A 3DH
t/f 020 7613 2080
email: theagencyltd@agency-
gallery.demon.co.uk
Tues – Fri 11-6, Sat 11–4
Directors: Bea de Souza,
Charlotte Schepke

Founded in 1992, this gallery maintains
its reputation for the rigorous presenta-
tion of work, particularly Conceptual art
and experimentation with new media.
Shows have included a programme of
films by Paul McCarthy, and large-scale
installations by Ross Sinclair and Kazuo
Katase. International artists Thaddeus
Strode and Ken Lum premiered here,
whilst the gallery continues to focus on
fresh approaches with emerging British
artists such as the photographer
Seamus Nicolson and multi-media
artist Faisal Abdu'Allah.

Alan Cristea Gallery

31 Cork Street, London W1X 2NU
t 020 7439 1866 f 020 7734 1549
email: info@alancristea.com
Website: www.alancristea.com
Director: Alan Cristea

As well as dealing win classic twentieth-
century prints by the likes of Picasso,
Matisse and Braque, the gallery also
publishes original prints and projects by
contemporary artists from Patrick
Caulfield and Michael Craig-Martin to
Mimmo Paladino and Jim Dine, along
with younger artists such as Lisa Milroy
and Langlands & Bell.

Andrew Mummery Gallery

63 Compton Street, London EC1V 0BN
t 020 7251 6265
email: mummerya@aol.com
Website:www.amummery.com
Tues – Sat 11-6
Director: Andrew Mummery

Whether it is the oils of Alexis Harding,
in which the paint seems to assume a
life of its own as it puckers, slides off
and hangs from the canvas, the aerial
landscapes of Carol Rhodes, or Louise
Hopkins' paintings of bleached-out

fabrics, an emphasis on experimental
painting characterises Mummery's pro-
gramme. He has recently moved to this
ground-floor space in a former electric-
ity sub-station, where he continues to
supplement painting with photographic
and film-based work by the likes of John
Goto, or the architectural landscapes of
Ori Gersht.

Annely Juda Fine Art

23 Dering Street, London W1R 9AA
t 020 7629 7578 f 020 7491 2139
email: ajfa@annelyjudafineart.co.uk
Website: www.annelyjudafineart.co.uk
Mon – Fri 10-6, Sat 10-1
Directors: Annely and David Juda,
Ian Barker

This long-established gallery and its
founder Annely Juda are widely admired
throughout the art world. One of
London's most beautiful daylit spaces,
it was designed by the late Max Gordon,
who also converted the Saatchi Gallery.
An abiding concern with the great his-
torical abstract movements – de Stijl,
Russian Constructivism – is comple-
mented by well-established living artists
– Anthony Caro, Hamish Fulton,
Christo, Eduardo Chillida, Leon Kossoff
– and David Hockney. The gallery also
has a long association with the Far East,
regularly exhibiting artists such as
Katsura Funakoshi, Tadashi Kawamata
and Yoshishige Saito.

Anthony d'Offay Gallery

Dering Street, London W1R 9AA
t 020 7499 4100 f 020 7493 4443
Website: www.doffay.com
Mon – Fri 10-5.30, Sat 10-1
Director: Anthony d'Offay
From January 2001:
103 New Bond Street, London W1

Occupying ground and first-floor
spaces in no less than three buildings in
Dering Street, Anthony d'Offay has
ample scope for showing his formidable
stable of international heavyweights,
dead and alive, from Kiefer to De
Kooning, Warhol to Koons. Over the
years, the gallery has functioned like an
institution in its own right, providing
major survey exhibitions of Gerhard
Richter and Ed Ruscha or museum-style
installations of gallery artists Christian

Boltanski, Jannis Kounellis and Joseph Beuys. Anthony d'Offay launched the careers of Gilbert and George and Richard Long, and although he has discontinued the programme of experimental young artists, more youthful additions to the roster are Mexican master of the elliptical Gabriel Orozco; US painter Ellen Gallagher; Richard Patterson, a British painter of hauntingly molten moments; Martin Maloney, known for his studiedly slapdash paintings, and sculptor Rachel Whiteread. In 2001, the gallery transfers its operations to new three-storey premises on New Bond Street.

Anthony Reynolds

5 Dering Street, London W1R 9AB
t 020 7491 0621 f 020 7495 2374
Tues – Sat 10-6
Director: Anthony Reynolds

The diminutive size of this ground-floor space belies the scope, versatility and influence of a gallery that, since its establishment in the mid-1980s, has shown major international figures from all generations as well as demonstrating a consistently sharp eye for some of the UK's most innovative young artists. The stable ranges from vintage radicals such as Nancy Spero, Ian Breakwell and Leon Golub, to important younger artists such as Mark Wallinger, Georgina Starr, Steve McQueen, Richard Billingham, Alain Miller, Paul Graham and Keith Tyson. The impressive back-catalogue of mixed and guest-curated shows that have taken place over the years reads like a 'Who's Who' of the avant garde.

Anthony Wilkinson Gallery

242 Cambridge Heath Road
London E2 9DA
t 020 8980 2662 f 020 8980 0028
email
info@anthonywilkinsongallery.com
Website:
wwwanthonywilkinsongallery.com
Thurs – Sat 11-6, Sun 12-6
or by appointment
Director: Anthony Wilkinson

After several years of putting on shows in a variety of different venues, including his former flat in Great Ormond Street, in 1998 the nomadic Anthony Wilkinson

took over a former East End café, and converted it into three floors of pristine white spaces in which he presents an enterprising programme of mixed and solo shows by artists of all generations and inclinations, whether the idiosyncratic cartoons of Glen Baxter, the looping abstract paintings of Peter Ellis, the beaten-up monochrome canvases of Angela de La Cruz, or the drawings and photograms of Christopher Bucklow. Other gallery artists include Jessica Voorsanger, whose 1998 exhibition continued her investigations into the relationship between celebrity and fan. The 1999 solo show of Bob and Roberta Smith included a multitude of rubber aeroplanes, a multitude of madly misspelt painted signs, and latex cast vegetables mounted on cubes as *Sculptures for the Blind*. Wilkinson is also developing an international programme with shows in 2000 by Silke Schatz, A.K. Dolven and Olav Christopher Jenssen.

The Approach

1st Floor, 47 Approach Road
London E2 9LY
t 020 8983 3878 f 020 8983 3919
Thurs – Fri 1-7, Sat – Sun 12-6
Director: Jake Miller

Located in a former function room on the first floor of a Bethnal Green pub, The Approach started life in 1997 as a non-profit space, mounting shows by emerging and established artists such as Liz Arnold, Jane Simpson and Kerry Stewart, as well as inviting host curators like Tate's youngest artist-trustee, Peter Doig, who selected a show of paintings, and Matthew Higgs, whose 1998 *A–Z* show provided an alphabetical snapshot of artists working with text. Now, after sell-out shows of the likes of Michael Raedecker and Emma Kay, both of whom The Approach represents – along with Daniel Coombs, Martin Westwood, Gary Webb, Enrico David, Tim Stoner and Philip Allen – the gallery has evolved into a more commercial enterprise, but one that manages to maintain its edge as one of the capital's must-see spaces.

asprey jacques

4 Clifford Street, London W1X 1RB
t 020 7287 7675 f 020 7287 7674

email: info@aspreyjacques.com
Website: www.aspreyjacques.com
Tues– Fri 10-6, Sat 11-5
Directors: Charles Asprey,
Alison Jacques

Charles Asprey, founder of the now defunct Ridinghouse Editions, which commissioned multiples and editions from the likes of the Chapmans and Mat Collishaw, has joined forces with Alison Jacques, previously curator at the British School in Rome, in an eighteenth-century building just round the corner from Cork Street. The gallery not only represents artists such as Jane Simpson, Paul Morrison and Peter Davis, it also engages in a number of one-off collaborations with those represented by other galleries. Notable examples have been a Pasolini-inspired film and neon text by Cerith Wyn Evans (1999), and Steven Pippin's 1999 sculptural contraption *Geocentric*, installed to dramatic effect in the gallery's unusual back space, top-lit by a glass rotunda. Other shows of note have been the pairing of works by gallery artist Tania Kovats with Barbara Hepworth's abstract sculpture as part of a series of shows in which the work of a young artist is coupled with a classic figure from contemporary or modern art. This is also the first commercial UK gallery to inaugurate a series of residencies, which have enabled artists from overseas to work in the UK.

Cabinet Gallery

20a Northburgh Street
London EC1V 0EA
t 020 7253 5377 f 020 7608 2414
email: art@cabinetltd.demon.co.uk
Wed – Sat 12-6
Directors: Andrew Wheatley,
Martin McGeown

Since it opened in 1992 in a three-room tenement flat in Brixton, Cabinet has established itself as a leading venue for rigorously curated shows of maverick art from across the globe. Now, the gallery has relocated to a one-storey, cabin-like building in the heart of Clerkenwell, inaugurated by gallery artist Martin Creed's epic balloon installation, *Half the Air in a Given Space* (1998). A more mainstream context has not, however, interrupted the gallery's

taste for art that engages – sometimes subversively – in everyday life and examines its underpinning obsessions. From earlier shows such as that of the US artbomb maker Gregory Green, or of Los Angeles surfer-artist Russell Crotty, who presented biro drawings of waves and constellations, to Cabinet touring shows *Popocultural* and *Lovecraft* (co-curated with Toby Webster of Glasgow's Modern Institute), to Gillian Carnegie's exquisite oils, or the drawings of James Pyman, and the works of Gareth Jones, Elizabeth Peyton and Marc Chaimowicz, Cabinet is a gallery committed to confounding expectations. Nowhere is this more evident than with gallery artist Jeremy Deller, whose collaborations with mainstream youth culture have included drawings by Manic Street Preacher Fans and the performance and CD release of acid-house music played by a traditional brass band.

Conductors Hallway

301 Camberwell New Road
London SE5 0TF
t 020 7274 7474 f 020 7274 1744
email: conductors@cableinet.co.uk
Website:
wkweb5.cableinet.co.uk/ASCstudios

This small but well-proportioned space in an artists' studio block occupying an old bus station puts on a well-curated programme of shows by studio artists and others. Recent exhibitions of note include *Art and Illusion*, which combined Tim Shutter's carved stone crowns and cushions with John Workman's trompe l'oeil wallpaper works.

Corvi-Mora

22 Warren Street, London W1P 5DD
t 020 7383 2419 f 020 7383 2429
email: info@corvi-mora.com
Website: www.corvi-mora.com
Tues – Sat 11-6
Director: Tommaso Corvi Mora

Previously one half of Robert Prime Gallery, Corvi Mora has simply moved across the street. While running an internationally orientated programme of his own – the gallery opened in January 2000 with photographs by Bruce Weber and Larry Clarke, and other shows include new paintings from LA

artist Richard Hawkins – he continues to work with his old partner Gregorio Magnani on specific projects that continue to go under the name Robert Prime. Gallery artists include Liam Gillick and Roger Hiorns (UK), Rachel Feinstein, Jim Isermann, Jason Meadows and Monique Prieto (USA), Eva Marisaldi (Italy) and Glenn Sorensen (Sweden).

Danielle Arnaud

123 Kennington Road, London SE11 6SF
t/f 020 7735 8292
Website: www.daniellearnaud.com
Fri – Sun 2-6
Director: Danielle Arnaud

A large Georgian house in Kennington makes a sympathetic setting for a varied programme of solo and mixed shows in all media, including those of gallery artists such as Georgie Hopton, Simon Granger, John Workman, Marie-France & Patricia Martin, Glauce Cerveira, Sarah Woodfine and Gerry Smith.

Dominic Berning

1 Hoxton Street, London N1 6NL
t 020 7739 4222 f 020 7739 5120
email: dberning@dircon.co.uk
By appointment
Director: Dominic Berning

It may be situated above the fashionable Electricity Showroom bar, overlooking the art ghetto of Shoreditch, but the elegant simplicity of this apartment-gallery belies the trendy grittiness of its location. The work of those represented by Berning – such as the minimal light pieces of Martin Richmann and the glass and fabric sculptures of American Jane Mulfinger – make up part of a changing programme of exhibitions that not only occupy a specially designed gallery, but also infiltrate all the living spaces and sometimes the roof garden, demonstrating that even the most demanding works can be suitable for a home environment.

Emily Tsingou Gallery

10 Charles II Street, London SW1Y 4AA
t 020 7839 5320 f 020 7839 5321
Website: www.emilytsingougallery.com
Tues – Fri 10-6, Sat 10-1
Director: Emily Tsingou

A small but versatile two-storey space with a main viewing wall that extends between the two floors, this gallery has quickly established a reputation for its programme of relatively well-known international names such as US artist Karen Kilimnick – who made a special commission for the gallery's inaugural exhibition in March 1998 – British artist Henry Bond, who mounted a show of snatched images the urban world to launch his book *Cult of the Street* (1998), or the uncanny photographs of Brooklyn-based Gregory Crewdson. This is spliced with the work of younger artists such as the atmospheric images of Britain's Sophy Ricketts.

Entwistle

6 Cork Street, London W1X 2EE
t 020 7734 6440 f 020 7734 7966
Mon – Fri 10-5.30, Sat 11–4.30
Director: Lance Entwistle

Whether through the beetle-encrusted figures of Flemish sculptor Jan Fabre, the arresting surf video and photos of Peter Newman, or the paintings of Dan Hayes, this space is quickly establishing a reputation as a significant showcase for new art from Britain and abroad. In the Summer of 1999, Tomoko Takahashi wreaked her own particular brand of immaculately ordered havoc in the basement, while the paintings of Luke Gottelier were on show upstairs. Shows in 2000 include the paintings of John Moores prize-winner Dan Hays and NatWest prize-winner Jason Brooks.

Flowers East

199-205 Richmond Road
London E8 3NJ
t 020 8985 3333 f 020 8985 0067
email: gallery@flowerseast.co.uk
Website: www.flowerseast.co.uk
Directors: Angela and Matthew Flowers

In 1988, the Angela Flowers gallery made what was then a bold move from the West End to a former fur warehouse in Hackney. The gamble paid off and the gallery, now called Flowers East, which continues to be run by Angela Flowers with her son Matthew as Managing Director, has prospered and expanded with an independent graphics arm as well as a Flowers West in Santa Monica.

While the gallery no longer occupies a place at the forefront of experimental art, it continues to represent many of its original 1970s stable, such as Tom Phillips, Patrick Hughes and Boyd & Evans, and has maintained a solid collector base for the narrative figuration of gallery artists John Keane, Henry Kondracki, John Kirby and Peter Howson. Yet in its mixed theme shows, Flowers East continues to be an eclectic law unto itself, with artists such as Tony Bevan, Jenny Saville and the Chapmans popping up in its 1998 *British Figurative Art,* and the annual unpredictability of its frenetic two-week 'artist of the day' exhibitions, in which younger artists are put forward by an established figure.

Frith Street Gallery

59-60 Frith Street, London W1V 5TA
t 020 7494 1550 f 020 7287 3733
email: frith-st@dircom.co.uk
Website: www.frithstreetgallery.co.uk
Wed – Fri 10-6, Sat 11-4
Director: Jane Hamlyn

A labyrinth-like series of immaculately designed spaces behind the facades of two Georgian houses in Soho provides a conducive setting for a group of gallery artists that combines mid-career heavyweights such as Callum Innes, Craigie Horsfield, Cornelia Parker, Marlene Dumas and Bernard Frize with younger figures working in all media including Dorothy Cross, Fiona Banner, Tacita Dean and Jaki Irvine. The gallery also regularly shows works on paper by major international artists such as Juan Muñoz, Giuseppe Penone and Thomas Schütte. In 1999, Frith Street celebrated its tenth anniversary as one of London's more quietly influential galleries.

Gagosian Gallery

8 Heddon Street, London W1R 7LH
t 0207 292 8222 f 0207 292 8220
email: info-uk@gagosian.com
Opening times: Tues – Sat, 10-6
Directors: Mollie Dent-Brocklehurst, Stefan Ratibor

This new, 3,500 square-foot gallery space, designed by Caruso St John, aims to form 'a vibrant focus of late twentieth-century American and European art'. The European wing of three galleries in

Claire Carter
Untitled
1995
Garden shears, plaster wall
Dimensions variable

Installation at Hales Gallery, London

New York and LA run by Larry Gagosian, who has exhibited the recent work of Damien Hirst along with many other leading contemporary artists, its opening in June 2000 was a double-whammy of Vanessa Beecroft and Chris Burden.

Gallery Westland Place

13 Westland Place, London N1 7LP
t 020 7251 6456 f 020 7251 9339
email: gallery@westlandplace.co.uk
Mon – Sat 10-6
Gallery Director: Michael Chanarin

It's rare for a commercial gallery to incorporate a café, but this converted warehouse space, which opened in September 1999 with a mixed show including works by Peter Doig, Sophy Rickett and John Stezaker, aims to be as much an art centre as a selling space.

Gimpel Fils

30 Davies Street, London W1Y 1LG
t 020 7493 2488 f 020 7629 5732

email: gimpel@compuserve.com
Website: www.gimpelfils.com
Mon – Fri 10-5.50, Sat 10-1
Director: Renée Gimpel, Jackie Haliday

This long-established gallery of modern art is now showing an increasing number of young artists, whether in collaboration with other galleries like Hales in Deptford, or showing the work of artists such as Antoni Malinowski in an exhibition of preparatory pieces for his recent mural works in the Royal Court Theatre and Canary Wharf.

greengrassi

39c Fitzroy Street, London W1P 5HR
t 020 7387 8747 f 020 7388 3555
Tues – Sat 11-6
Director: Cornelia Grassi

This first-floor room in a Fitzrovia townhouse provides a beautifully proportioned space for a programme that mixes talent from Europe and the US

with emerging British artists. In 1998, a show of works on paper by Los Angeleno Lari Pittman complemented his larger paintings at the ICA; other notable exhibitions have included the edgily exquisite abstracts of the UK-based Tomma Abts. The gallery has also played host to such artists as the Italians Stefano Arienti and Alessandro Pessoli, who have received little UK exposure.

Hales Gallery
70 Deptford High Street
London SE8 4RT
t 020 8694 1194 f 020 8692 0471
email: halesgallery@btinternet.com
Mon – Sat 10-4
Director: Paul Hedge, Paul Maslin

It's no mean feat to get major collectors such as Charles Saatchi and Stuart Evans to come and buy from a space in deepest south east London that really is an ace caff with not a bad gallery attached. Profits from the café, which attracts traders from the street market outside, have helped to fund shows in the basement by John Frankland, Claire Carter and Tomoko Takahashi. Gallery artists' shows have ranged from the punched book sculptures of Jonathan Callan, to paintings by Claude Heath and Leo de Goede, and the translucent wax and wood works of Andrew Bick.

Interim Art
21 Herald Street, London E2 6JT
t 020 7729 4112 f 020 7729 4113
Thurs – Sun 11-6
Director: Maureen Paley

In 1984, Maureen Paley opened Interim Art in her small terraced house in Hackney, which went on to become an internationally renowned space. Artists showing in these three modest-sized rooms have included such key international names as Jenny Holzer, Tim Rollins + KOS, Charles Ray, Georg Herold and Helen Chadwick. More recently, the gallery has forged a reputation as a launchpad for many of the younger artists of the late 1990s, with a stable that includes Gillian Wearing, the pristine photographs of Sarah Jones, and the edgy images of Wolfgang Tillmans. Among the painters represented by Interim Art are Mark Francis

and David Rayson, and the uncategorisable Paul Noble, whose dark humour is conveyed through a number of vehicles. In Summer 1999, Interim Art entered a new phase when it expanded into its larger ground-floor factory space in Herald Street.

Laure Genillard
82-84 Clerkenwell Road
London EC1M 5RJ
t 020 7490 8853 f 020 7490 8854
Website: URL:ourworld.compuserve.com.homepages/
Tues – Sat 11-6
Director: Laure Genillard

Works by young artists from the UK and Europe operating in all media find a home here, including Simon Tegala's video projections on metal with burning gas, Elisa Sighicelli's photographic light-boxes of quiet domestic interiors, Dean Hughes punch-hole drawings and Gary Simmonds' decorative paintings. European artists include Sylvie Fleury and Peter Wüthrich. This was also one of the first venues for Sarah Staton's pioneering shop-till-you-drop, art-for-every-income experience, *Art Superstore*.

Laurent Delaye Gallery
11 Saville Row, London W1X 1AE
t 020 7287 1546 f 020 7287 1562
email: delayegallery@clara.net
Mon – Fri 10-6, Sat 10-4
Director: Laurent Delaye

As well as representing a lively group including Chad McCail, Rut Blees Luxemburg, Mark Dean and Grayson Perry, this gallery displays a refreshing attitude to collaboration with a range of artists and organisations. *Dissolution*, for example, was a mixed painting show featuring new work by Keith Tyson, Simon Bill, Gavin Turk, Mark Wallinger and Tracey Emin; *Jam in the Park* was a programme of short, experimental artists' films.

Lisson Gallery
52-54 Bell Street, London NW1 5DA
t 020 7724 2739 f 020 7724 7124
email: contact@lisson.co.uk
Website: www.lisson.co.uk
Mon – Fri 10-6, Sat 10-5
Chairman: Nicholas Logsdail

Not only has the Lisson Gallery launched the careers of sculptors such as Bill Woodrow, Tony Cragg, Richard Deacon, Richard Wentworth, Edward Allington and Anish Kapoor, and later Julian Opie and Grenville Davey, it has also held on to these artists by growing along with them. Now a series of museum-like spaces with a programme that perpetuates the house preference for Minimalist rigour, the Lisson augments its stable of blue-chip elders from home and abroad with more youthful additions. Douglas Gordon's dark, psychological investigations, Christine Borland's forensic experiments, the slyly subversive tweakings at Conceptual and Minimalist traditions of Simon Patterson, and the deceptively low-key pieces of Ceal Floyer can all be found here. In 1999, Jane and Louise Wilson's *Gamma* installation inspired by Greenham Common premiered at the Lisson, winning them their nomination for that year's Turner Prize.

Magnani
60-61 Warren Street, London W1P 5PA
t 020 7916 6366 f 020 7916 6369
Tues – Fri 11-6, Sat 2-6
Director Gregorio Magnani

Continuing on the site of Robert Prime and run by one of its former partners, this space continues to be a valuable showcase for artists from Britain, Europe and the USA, who often enjoy a major international reputation but are rarely seen in the UK.

Michael Hue-Williams Fine Art
21 Cork Street, London W1X 1HB
t 020 7434 1318 f 020 7434 f 434 1321
email: mhw@btinternet.com
Mon – Fri 9.30-5.30, Sat 10-1
Director: Michael Hue-Williams

This gallery presents a programme of surprising exhibitions, many exploring aspects of our environment and surroundings. In 1999, the architectural interventions of Langlands & Bell were appropriately coupled with Hiroshi Sugimoto's photographs of famous buildings in Europe and the US. Hue-Williams represents the striking painter Tony Bevan, photographer of natural processes Susan Derges, the ephemeral

nature artist Andy Goldsworthy, and landscape painter John Virtue, as well as working with American sculptor of light, James Turrell.

Modern Art

73 Redchurch Street, London E2 7DJ
t 020 7739 2081 f 020 7729 2017
email: modernart@easynet.co.uk
Website: www.modernartinc.com
Thurs – Sun 11-6
Directors: Stuart Shave, Detmar Blow

The aim of Stuart Shave – formerly of Entwistle and Victoria Miro Gallery – was to make this two-space gallery in one of Shoreditch's rougher streets a more approachable space to see art. It has swiftly risen to become one of London's leading young galleries. Although small, it has a tardis-like ability to accommodate works of dramatically different scale – Ian Dawson's giant sculptures of melted plastic objects looked quite at home here, as did the small, slyly subversive drawings of Swedish Maria Lindberg. Other gallery artists are Simon Bill, Kenny Hunter, and Webster & Noble, whose *Dirty White Trash*, a silhouetted double portrait made from the shadow cast by a pile of rubbish, inaugurated the gallery in 1998.

Nylon

9 Sinclair Gardens, London W14 0AU
t 020 7602 6061 f 020 7602 2126
email: nylon@btinternet.com
Wed – Sat 12-6 and by appointment
Director: Mary Jane Aladren

Inspired by the example of American galleries who have artists 'on file' but with no exclusive contracts, Nylon has around 100 emerging figures from the UK and the US on its informal books. Operating from a terraced house in Shepherd's Bush, it offers flat-files containing the works on paper of these artists, plus an archive of written and visual material on a further 150. Its programme of shows includes work by Kate Belton, Roger Kelly and Charles Avery from the UK and Ruth Root and Roxy Paine from New York.

Percy Miller Gallery

39 Snowsfields, London SE1 3SU
t 020 7207 4578 f 020 7207 0593
email: percymiller@artserve.net
Tues – Fri 11-6, Sat 11-3
Directors: Bridget Ashley-Miller
Paul Heber-Percy

A relatively new arrival to the catchment area around Tate Modern in Bermondsey, Percy Miller, run by Bridget Ashley-Miller (formerly of Delfina, Gasworks and PS1 Gallery, New York) and Paul Heber-Percy (previously at Richard Salmon Gallery), is committed to showing both established artists and newcomers and working in collaboration with other spaces. The opening show in 1999 consisted of Hadrian Piggott's full-scale replica of a motorbike, vacuum-moulded in plastic, which was accompanied by photographs of deserted country roads.

Purdy Hicks

65 Hopton Street, London SE1 9GZ
t 020 7401 9229 f 020 7401 9595
email: email@purdyhicks.com
Mon, Tues, Thurs, Fri 10-5.30, Wed 10-7, Sat 10-3
Directors: Rebecca Hicks, Frankie Rossi, Nicola Shane

Proximity to the River Thames and a space flooded with natural light are appropriate to this gallery's preference for painting both abstract and figurative, with a stable ranging from the subtle non-figurative works of Estelle Thompson, the haunting paintings of Andrzej Jackowski, or the evocative scenes conjured up by Arturo Di Stefano. It also shows a smattering of artists working with photography, such as David Hiscock and Daro Montag.

Richard Salmon

59 South Edwardes Square
London W8 6HW
t 020 7602 9494 f 020 7371 6617
Tues – Sat 10-5.30
Director: Richard Salmon

A century ago, London's art world revolved around Kensington and Chelsea, and it's good to know that at least one of the area's stunning purpose-built Victorian studios is still being put to creative use. Benefiting from glorious proportions, an abundance of space and northern light is an eclectic programme of solo shows – paintings by Andreas Rüthi, Joan Key or Jonathan Parsons, and the shop signs and bronze cast kebabs of Keith Coventry for example – along with a series of imaginative theme shows such as *Furniture* (1999) *Craft* and *Light* (both 1998), which combined a multitude of approaches and toured to a range of public venues throughout the UK.

Rocket Gallery

13 Old Burlington Street
London W1X 1LA
t 020 7434 3043 f 020 7434 3384
email: js.rocket@btinternet.com
Tues – Sat 11-7
Director: Jonathon Stephenson

Abstract painting, especially from Los Angeles, and shows of contemporary photography dominate the programme of this gallery, which developed out of The Rocket Press, an international publisher of artists' books. It was The Rocket Press that published Martin Parr's photographic portrait of *West Bay* (1997), while his *Common Sense* (1999), a collection of often gross images of global consumerism, premiered at Rocket before touring to forty-three different locations world wide.

Sadie Coles HQ

35 Heddon Street, London W1R 7LL
t 020 7434 2227 f 020 7434 2228
Website: www.sadiecoles.com
Tues – Sat 10-6
Director: Sadie Coles

This first-floor space was opened in 1997 by an ex-Anthony d'Offay Director with a sharp eye for talent and a keen nose for the scene. An inaugural show of richly executed and disquietingly distorted pin-ups by American painter John Currin was followed by two Sarah Lucas exhibitions – one in an appropriately roughed-up warehouse, pointing to a gallery policy of initiating projects in a variety of spaces – and a show of Simon Periton's intricately subversive cut-out 'doily' works. Other UK artists working with Coles include sculptors Don Brown, Angus Fairhurst and Jim Lambie. Coles also focuses on established and emerging figures from the

other side of the Atlantic – recent exhibitions include paintings by LA artist, Laura Owens, multifunctional garments by Andrea Zittel, an important show of Richard Prince's paintings, and new works by Nicola Tyson and Elizabeth Peyton (all from New York).

Stephen Friedman Gallery

25-28 Old Burlington Street
London W1X 1LB
t 0207494 1434 f 020 7494 1431
email: frie@dircon.co.uk
Tues – Fri 10-6, Sat 11-5
Director: Stephen Friedman

This gallery's international programme manages to be both lively and weighty, with younger figures who are already cutting a swathe like British artists Kerry Stewart and Yinka Shonibare, as well as more established names such as Canadian Geneviève Cadieux, Laotian-born sculptor Vong Phaophanit, and German sculptor Stephan Balkenhol. In 1998, Friedman mounted an important two-venue show of the drawings and animated films of South African William Kentridge, and 1999 saw another foray into the biting art of younger South African, Kendell Geers. Amongst the gallery stable is the more gentle subversion of Scottish artist David Shrigley.

Timothy Taylor Gallery

1 Bruton Place, London W1X 7AD
t 020 7409 3344 f 020 7409 1316
email: mail@ttgallery.com
Website: www.ttgallery.com
Mon – Fri 10-6, Sat 11-4
Director: Timothy Taylor

Timothy Taylor presents established names from across the globe, whose lack of exposure in the UK is often at odds with their international reputation. In 1998 he showed new epic paintings by Mallorcan artist Miguel Barcelo. Other notable shows were an impressive display of Philip Guston's late works, and Sean Scully's new paintings.

Victoria Miro Gallery

21 Cork Street, London W1X 1HB
t 020 7734 5082 f 020 7494 1787
Mon – Fri 10-5.30, Sat 11-1
Directors: Victoria Miro/
Glenn Scott-Wright

From late autumn 2000:
16 Wharf Road, London N1

After the recession closed down much of Cork Street in the early 1990s, this was one of the few contemporary art spaces that made the area still worth a visit. Now, the Piccadilly environs are active again, and this gallery continues to lead the field with a selection of artists that includes painters Cecily Brown, Peter Doig and Chris Ofili, filmmaker Isaac Julien and veteran poet-artist Ian Hamilton Finlay. International figures represented by the gallery are Doug Aitken, Thomas Demand and Andreas Gursky. However, such a small space can no longer meet the needs of its impressive line-up, and in autumn 2000 it moves to a spacious canal-side warehouse, just off City Road.

Vilma Gold Gallery

62 Rivington Street, London EC2A 3AY
t 020 7613 1609 f 020 7256 1242
email: vilma.gold@telinco.co.uk
Thurs – Sun 12-6
Contacts: Steve Pippet, Rachel Williams

Although work is for sale in this first-floor gallery in the heart of Shoreditch, it is administered along the lines of an artist-run space with a mixture of group and solo shows. In order to keep the programme flexible, exhibitions are planned no more than three months ahead, and artists are often invited to curate shows, such as Brian Griffiths' *These Epic Islands* (2000).

Waddington Galleries

11, 12 & 34 Cork Street, London W1X 2LT
t 020 7437 8611/439 6262
f 020 7734 4146
Mon – Fri 10-5.30, Sat 10-1
Director: Leslie Waddington

Although it has shed a few spaces since the boomtime years, this is still *the* blue-chip gallery of Cork Street where it is possible to view museum-quality works by a roster of modernist masters. These are augmented by such elder statesmen as Patrick Caulfield and Michael Craig-Martin, and, under the aegis of Hester van Roijen, a smattering of younger painters such as Lisa Milroy, Ian Davenport and Zebedee Jones.

White Cube

44 Duke Street St James's
London SW1Y 6DD

White Cube²

48 Hoxton Square, London N1 6PB
t 020 7930 5373 f 020 7930 9973
email: jjopling@whitecube.com
Website: www.whitecube.com
Tues – Sat 10-6
Director: Jay Jopling

White Cube was set up in 1993 as a 'temporary project space for contemporary art'. But these modestly impermanent beginnings and 4 square metres of exhibition space have not prevented it from staying put in its quirky first-floor site for over six years while evolving into a wide-reaching operation that played a crucial role in the 1990s British art boom. Now, with the opening of an extensive new spaces in Hoxton Square, the gallery has greater scope for showing its impressive stable of British artists: Tracey Emin, Damien Hirst, Angus Fairhurst, Antony Gormley, Mona Hatoum, Marc Quinn and Sam Taylor-Wood. It also continues its ongoing relationship with major international names – Lari Pittman, Nobuyoshi Araki, Gary Hill, Sean Landers, Jeff Wall – as well as working on a one-off basis with others – Richard Prince, Brian Eno, Karen Kilimnik.

Wigmore Fine Art

104 Wigmore Street, London W1H 9DR
t 020 7224 1962 f 020 7224 1965
Website: www.wigmore-fine-art.co.uk
Tues – Fri 10-6, Sat 11-5
Exhibitions Director: Sotiris Kyriacou

An early bias towards contemporary Greek art remains, but has widened to a mixed international programme that has included the work of Susan Hiller, Sharon Kivland, and installations of text and collaged photographs by Sonia Boyce and Hermione Wiltshire.

Zwemmer Gallery

24 Litchfield Street, London WC2H 9NJ
t 010 7240 4158 f 020 7836 7049
email: zwemmer.co@btinternet.com
Website: www.zwemmer.com
Mon–Wed 10-6.30
Thurs–Fri 10-7.30, Sat 10-6
Gallery Manager: David Risley

This new gallery in the historic art book-shop has already entered into fruitful collaborations with progressive commercial galleries such as The Approach (Dan Coombes) and Modern Art (Richard Woods).

PUBLIC GALLERIES

Barbican Art Gallery

Level 3/Concourse Gallery, Barbican Centre, Silk Street, London EC2 8DS
t: 020 7382 7105 020 7920 9648
Website: www.barbican.org.uk
Mon – Tues, Thurs – Sat 10-6, Wed 10-8, Sun and bank hols 12-6
Art Galleries Director: John Hoole

Housed in an unwelcoming two-tier space in London's most difficult-to-negotiate arts centre, the Barbican has produced a notoriously uneven programme, only alleviated by an emphasis on strong historical photographic exhibitions such as *Picasso & Photography*. Exhibitions have ranged from *Malevich's Vision of the Avant-Garde,* to *The Art of the Harley*, and *Shaker: the Art of Carpentry*. Until recently, contemporary fine art has only received an occasional airing in the problematically shaped concourse gallery, The Curve, or in the Foyer Gallery, where Helen Chadwick's *Stilled Lives* had their debut in 1996. In 2000, The Curve accommodated *Sleuth*, a mixed show of artists whose work evokes film *noir*. The amalgamation of Barbican spaces under a team of curators including Mark Sladen, formerly of the Whitechapel Gallery and Entwistle, promises a more experimental future.

Camden Arts Centre

Arkwright Road, London NW3 6DG
t 020 7435 5224/2643 f 020 7794 3371
Tues – Thurs 11-7, Fri – Sun 11-5.30
Director: Jenni Lomax

Having to find funding for every show it mounts has not deterred Camden Arts Centre's ambitious and thoughtful programme, whose dedication to innovative works by established and emerging artists can encompass huge new canvases by St Ives painter Patrick Heron, Mat Collishaw's ventures into the phenomenological, or the architectural

sculptures of Dan Graham. Mixed shows have contrasted works by Ad Reinhardt, Felix Gonzalez-Torres and Joseph Kosuth, or looked at the multi-cultural range of artists working in Paris (*Parisiennes*, 1997). Recent shows of international figures such as Marlene Dumas (Netherlands), Jim Isermann (USA) and Sophie Calle (France) continue to make this a must-see space, while Martin Creed, Rachel Lowe, Simon Starling and Mike Nelson are among the young artists who have benefited from Camden's policy of accompanying exhibitions with artists' residencies. Overall, the Centre's judicious splicing of the influential older generation with rising youth, its global outlook, and its light-footed but resolute dedication to raising issues in art and disseminating them through an intelligent education programme, has won it universal respect from audiences across the world, as well as within its local community.

Chisenhale Gallery

64 Chisenhale Road, London E3 5QZ
t 020 8981 4518 f 020 8980 7169
email: mail@chisenhale.org.uk
Website: www.chisenhale.org.uk
Wed – Sun 1-6
Director: Sue Jones

This 2,500-square-foot space in a former factory for Spitfire propellers has become established as an influential testing ground and launch-pad for younger artists to achieve international reputations. Rachel Whiteread had her first solo show at Chisenhale, which commissioned *Ghost* (1990), the cast of a room that preceded her famous *House* (1993). Cornelia Parker's exploded and reconstituted shed, *Cold Dark Matter: an Exploded View* (1991), was also a Chisenhale commission, and Simon Patterson and Cathy de Monchaux both held their debut major solo shows in its one large room. Chisenhale is also known for giving international artists such as Pipilotti Rist (1996) and Wolfgang Tillmans (1997) their initial major UK showing. Recently, it has confirmed the importance of video for a generation of artists by commissioning new video installations from Jane and Louise Wilson, Sam Taylor-Wood, Gillian Wearing and Hilary Lloyd.

Hayward Gallery

SBC, London SE1 8XX
t 020 7960 4208 f 020 7401 2664
Advance booking: 020 7960 4242
Website: www.hayward-gallery.org.uk
Thurs – Mon 10-6, Tues – Wed 10-8
Admission charges
Director: Susan Ferleger Brades
Head of Exhibitions:
Martin Caiger-Smith

This purpose-built gallery, opened in 1968, is both loved and loathed as a classic example of 1960s 'brutalist' architecture, but its large spaces have proved surprisingly adaptable for presenting a wide range of ground-breaking exhibitions over thirty years. Examples of living artists who have received shows here are Bridget Riley, Jasper Johns, James Turrell, Julian Opie, Patrick Caulfield, Bruce Nauman, Chuck Close and Panamarenko. Key survey exhibitions have been *Doubletake* (1992); *Unbound: Possibilities in Painting* (1994); *Spellbound: Art and Film* (1996) and the sculpture exhibition *Material Culture: The Object in British Art of the 1980s and 90s* (1997). These complement other shows in the programme devoted to historical themes and artistic movements and to non-Western cultures, whether *Art and Power: Europe Under the Dictators 1930-45* (1995) or the epic *Cities on the Move: Urban Chaos and Global Change, East Asian Art, Architecture and Film Now* (1999). Overall, the Hayward provides a bridge between the experimental and the established in the visual arts – and even between shows, its 'turnaround' projects encourage artists such as Simon Periton, Gary Hume and Gillian Wearing to make site-specific work on and around the building.

Managed by the Hayward Gallery on behalf of the Arts Council of England, National Touring Exhibitions present a varied programme of around twenty shows a year. Available to venues across the UK, these range from the five-yearly *British Art Show,* to an exhibition devoted to *Fetishism*, or *Drawing the Line* – artists' drawings from the Renaissance to the contemporary, selected and provocatively juxtaposed by Michael Craig-Martin. National Touring Exhibitions also draw on the holdings of the Arts Council Collection.

Institute of Contemporary Arts (ICA)

The Mall, London SW1Y 5AH
t 020 7930 3647 f 020 7306 0122
email: info@ica.org.uk
Website: www.ica.org.uk
Mon – Sun 12-7.30
Admission charge for non-members
Associate Directors of exhibitions:
Matthew Higgs, Cristina Ricupero,
Martijn van Nieuwenhuyzen,
Toby Webster

Described by one of its founders, the writer Herbert Read, as 'an adult play centre' that would unite the arts internationally and provide a meeting place for poets, artists, actors, musicians, scientists and the public, the ICA has, since its establishment in 1947, been a crucible for experimental, avant-garde work in all art forms. Its first exhibition, *40 Years of Modern Art* included early work by Bacon, Freud, Picasso and Balthus, and it was also the headquarters of the Independent Group who invented British Pop Art.

More recently, however, it has seen energetic newcomers in all disciplines threaten to steal its revolutionary thunder and has been criticised for responding to trends rather than initiating them. Nevertheless, it has mounted important shows of artists from the UK and internationally, from the first major solo shows of Damien Hirst (1991), Jake and Dinos Chapman (1996) and Steve McQueen (1999), to Darren Almond's live satellite link-up to a Pentonville prison cell (1997), along with such boundary-testing mixed shows as *The Institute of Cultural Anxiety* (1994**)**, curated by writer-artist Jeremy Millar, and *Stealing Beauty*, a major show of current British design held in 1999. With an increasing number of metropolitan art spaces providing innumerable opportunities for adult play, the ICA is currently focusing its programme on the introduction to UK audiences of emerging artists from Britain and abroad, and the exploration of the complex relationships between fine art, design, architecture, music, fashion and the digital. The appointment of four new Associate Directors may signal a new direction for the exhibition programme.

Jerwood Space

171 Union Street, London SE1 0LN
t 020 7654 0173 f 020 7654 0176
email: gallery@jerwoodsapce.co.uk
Website: www.jerwoodspace.co.uk
Mon – Sat 10-6 Sun and bank hols 12-6
Director: Stephen Hepworth

The Jerwood Foundation has converted this former Victorian school building into a complex of rehearsal studios, commercial spaces, a café, three large interconnecting gallery spaces and an external sculpture court. As well as playing host to the £30,000 Jerwood Painting Prize, since it opened in 1998 the gallery has demonstrated a commitment to promoting and supporting young artists with a programme that mixes solo shows – Sarah Jones or Glenn Brown, for example – with group exhibitions such as the 1998 *Dumbpop*; the three-person *Formerly*, in which D.J. Simpson, Ana Prada and Mark Cannon all made different responses to painterly traditions; or *Natural Dependency*, in which ten artists – including Anya Gallaccio, Simon Periton and Bridget Smith, explored the notion of excess.

The Lux

The Lux Centre, 2-4 Hoxton Square
London N1 6NU
t 020 7684 0101 f 020 7684 1111
email: lux@lux.org.uk
Website: www.lux.org.uk
Gallery: Wed – Sun 12-7
Director: Michael Mazière

Formerly London Electronic Arts and London Film Makers' Co-op, the Lux not only makes its thirty-year archive of artists' films and videos available to galleries, museums, broadcasters and international festivals, but it also facilitates the production of new ones by commissioning projects and providing high-tech facilities. Some of these, by Gillian Wearing, Jaki Irvine, Keith Tyson and Mark Wallinger, have been seen in the *Lux Biennale,* formerly known as *Pandemonium*, a festival of the moving image held in sites throughout London. The Lux also presents exhibitions by contemporary artists using film and electronic technology in its purpose-built gallery within the Lux Centre, which opened in 1997 with the Wilson Twins'

Stasi City (1997), as well as works by Angela Bulloch and Graham Wood. Other Lux commissions have included 'curated' compilations of new video work, which tour to other venues, such as *Speaking of Sofas* (1995), video works by young British artists; or *A Small Shifting Sphere of Serious Culture* (1996), both compiled by Gregor Muir, who is now curator of the Lux Gallery.

Matt's Gallery

42-44 Copperfield Road London E3 4RR
t 020 8983 1771 f 020 8983 1435
Wed – Sun 12-6
Director: Robin Klassnik

Perhaps the only gallery to be named after a dog, this two-space, East End venue is run by two people and a computer but still manages to maintain a uniquely experimental profile. Its policy of allowing artists the scope and time to develop new ideas while making work specifically for the space has been much imitated, but the status of the artists and quality of the projects that continue to emerge from this collaboration, including Richard Wilson's oil piece *20:50* (1987), Susan Hiller's *An Entertainment* (1990), Juan Cruz's *Sancti Petri* (1998) and important new works by Willie Doherty, Jimmie Durham, Lucy Gunning, Mike Nelson, Matthew Tickle and Kate Smith show that, so far, few do it better.

The Photographers' Gallery

5 & 8 Newport Street
London WC2H 7HY
t 020 7831 1772 f 020 7836 9704
minicom 020 7379 6057
email: info@photonet.org.uk
Website: www.photonet.org.uk
Mon – Sat 11-6, Sun 12-6
Director: Paul Wombell

Britain's first independent gallery to be devoted to photography, this space has maintained its reputation as a primary venue for contemporary photographic work, both initiating exhibitions and commissioning new work. It has been instrumental in encouraging the inclusion of photography in the programmes of leading galleries and museums, and its recent exhibitions have reflected the interchangeable relationship between

photography and contemporary art. Although it has outgrown its current site and is set to move as soon as it finds a suitable new home, the Photographers' Gallery continues to present a lively programme of group and mixed exhibitions from artists working with photographic media world wide. Recent and upcoming shows include artists such as Hellen Van Meene (Netherlands), Ulf Lundin (Sweden), Jean-Luc Mylayne (France), solo retrospectives of Catherine Opie and the Ukrainian photographer Boris Mikhailov, and Garry Winogrand's street photographs.

Royal Academy of Arts
Piccadilly, London W1V 0DS
t 020 7300 8000 f 020 7300 8001
Advance booking: 020 7300 5959
Website: www.royalacademy.org.uk
Sat – Thurs 10-6, Fri 10-8.30
Admission charges
Exhibitions Secretary:
Norman Rosenthal

Since its foundation in 1768, the RA has been the symbolic centre of the British art establishment, situated bang in the middle of Piccadilly, with a statue of founder Sir Joshua Reynolds in the courtyard. Yet, with the appointment of the inimitable Norman Rosenthal as Exhibitions Secretary in 1977, the Academy has become as synonymous with the blockbuster exhibition as with the pick 'n' mix gentility of its annual Summer Show. Rosenthal's exhibitions have included *The Art of Photography* (1989), *The Glory of Venice: Art in the Eighteenth Century* (1994) *Africa: the Art of a Continent* (1995-6) as well as the *Twentieth Century* series (German, 1985; British, 1987; Italian 1989 and American 1993) However, it was *Sensation* (1997), which featured some 150 works by many of the more flamboyant young British artists from the Saatchi Collection, that really rocked the Academy (and the Brooklyn Museum when it toured to the US). With *Apocalypse* (2000), which mixed young contemporaries such as the Chapmans and Darren Almond with international heavyweights such as Mike Kelley, Richard Prince and Jeff Koons, effectively providing them with miniature one-person shows, Rosenthal has confirmed his ability to think big.

Young British Artists VI
1996
Installation at Saatchi Gallery, London (foreground John Isaacs, background Nina Saunders)

Saatchi Gallery
98a Boundary Road, London NW8 0RH
t 020 7624 8299 f 020 7624 3798
Thurs – Sun 12-6
Admission charges
Curator: Jenny Blyth

The vast dimensions and stunning impact of this series of dazzling white spaces, as well as its programme, which has spanned the grandest of American High Modernism (Cy Twombly, Richard Serra, Andy Warhol, Frank Stella) and the most daring of the contemporary (Damien Hirst, Marc Quinn, Sarah Lucas), as well as Saatchi's stab at inventing a new school of 'Neurotic Realism', make it hard to remember that this is a privately run gallery and not an official institution. Almost everything looks good in this pristine setting, conjured out of a derelict paint factory in 1985 by the architect Max Gordon, especially the kind of large-scale, spectacular young art that Saatchi seems to favour. Recent exhibitions of new art from America, Germany and from across Europe show that Saatchi has not yet kicked his buying habit. Richard Wilson's *20:50* installation (1987), remains on semi-permanent view.

Serpentine Gallery
Kensington Gardens, London W2 3XA
t 020 7402 6075 f 020 7402 4103
email: serpentinegallery.org
Website: www.serpentinegallery.org
Daily 10-6
Director: Julia Peyton-Jones
Chief Curator: Lisa Corrin

Few galleries forced to close for refurbishment were as creative as the Serpentine during the year of its Lottery-funded redevelopment: artists from Richard Wilson to Anya Gallaccio were invited to make work, around the site. By opening its revamped building in 1998 with an exhibition of Piero Manzoni, the avant-garde pioneer of Conceptual art and Performance, whose enduring influence can be felt on many of the young British artists who have exhibited in the gallery (Damien Hirst, Simon Patterson and Rachel Whiteread among them), the Serpentine confirmed its commitment to the experimental in both old and new art. Memorable shows were Brian Catling's *The Blindings* (1994) and the famous collaboration between Cornelia Parker and Tilda Swinton, *The Maybe* (1995). Major solo exhibitions have included Richard Wentworth, Mark Wallinger, Richard Wilson, Andreas Gursky, Chris Ofili, Jane and Louise Wilson (all 1999), Yayoi Kusama and Felix Gonzalez Torres (2000).

The Showroom
44 Bonner Road, London E2 9JS
t 020 8983 4115 f 020 8981 4112
Wed – Sun 1-6
Director: Kirsty Ogg

This venue increasingly lives up to its name by commissioning important and often ambitious new work by young artists at a crucial stage of their careers. Sam Taylor-Wood's four-part projection *Killing Time* (1994) was initiated here, as were the two video projections *Sustain* (1995) by Stephanie Smith and Edward

Stewart, and Elizabeth Wright's life-size reconstruction of a 1950s bungalow inside the gallery space (*Untitled* 1996). Other recent commissions are a trippy, geometric floorpiece by Scottish artist Jim Lambie *(Zobop* 1999) and *Andrea and Phillipe Present Philippe Bradshaw* (1999), a residency that turned the space into a cross between boudoir, techno nightclub and dungeon.

South London Gallery

65 Peckham Road, London SE5 8UH
t 020 7703 6120 f 020 7252 4730
Recorded information: 020 7703 9799
email: mail@southlondonart.com
Website: www.southlondonart.com
Tues, Wed, Fri 11-6, Thurs 11-7
Sat – Sun 2-6
Director: David Thorp

Purpose-built in 1891 to introduce an impoverished area of London to the improving qualities of art, this gallery has fulfilled its remit with interest by metamorphosing from a shabby local arts centre into a uniquely versatile venue for major shows of contemporary art. The wraparound *Naked Shit Pictures* of Gilbert and George (1994), Tracey Emin's reliquary of personal memorabilia (1997), the giant projected face of Brian Catling (1996), and the epic, seed-encrusted images of Anselm Kiefer (1997) have all been shown here, as well as a number of guest-curated mixed exhibitions of the hottest work from across the world (Carl Freedman's *Minky Manky* 1995, the Cabinet Gallery's *Popocultural* 1996 and *Some Kind of Heaven* 1996, organised by Sadie Coles and Eva Meyer-Hermann). Whether Julian Schnabel's sail-like canvases (1999), or Mimmo Paladino's hewn sculptures (1999) all works look (and are sometimes worth) a million dollars in this perfectly proportioned, top-lit Victorian gallery.

Whitechapel Art Gallery

Whitechapel High Street
London E1 7QX
t 020 7522 7878 f 020 7377 1685
recorded information: 020 7522 7878
email:
programming.wag@dialpipex.com
Website: www.whitechapel.org
Tues – Sun 11-5, Wed 11-8

Director: Catherine Lampert
Head of Programming: Judith Nesbitt

The result of a turn-of-the-century attempt to bring the local community into contact with major works of art, the Whitechapel boasts an auspicious history that embraces the exhibition of Picasso's *Guernica* in 1939, major shows of US and UK abstract art in the 1960s and 1970s, and a programme of international heavyweights throughout the 1980s. Now, it is established as an important venue for worldwide contemporary art with shows of Bill Viola, Christian Boltanski and Marie-Jo Lafontaine. There has also been a special emphasis on artists from outside Britain and the US such as Frida Kahlo, Tina Modotti, Lygia Clark, and more recently, Tunga (1989) and Francis Alys (1997). Leading British artists presented here – Tony Bevan, Lucian Freud, Tony Cragg, Peter Doig and Gary Hume – show that this gallery also has its roots in home ground.

PUBLIC MUSEUMS

British Museum

Great Russell Street, London WC1B 3DG
t 020 7636 1555 f 020 7 323 8855
Mon – Sat, 10-5, Sun 12 - 6
Website: www.british-museum.ac.uk
Contemporary Arts and Culture
Programmer: James Putnam

Founded in 1753, the British Museum was the world's first great public museum, and although it is best known for its collection of artefacts from ancient human civilisations, it also boasts extensive modern collections, which include contemporary art – the Chapman's *Disasters of War* etchings being a recent purchase. There have already been a number of innovative projects involving living artists at the British Museum, most notably Eduardo Paolozzi's *Lost Magic Kingdoms* (1987) and *Time Machine* (1984-5), in which the works of twelve contemporary artists including Andy Goldsworthy, Stephen Cox and Marc Quinn were integrated with the permanent collection in the Egyptian Sculpture Gallery. A fresh initiative is being developed to coincide

with the unveiling of Norman Foster's Great Court Scheme in late 2000. In the new Clore Centre for Education, there will be an ongoing series of contemporary art projects, lectures and conferences aimed to bridge the gap between past and present. The Contemporary Arts and Culture programme is run by James Putnam who has also established a reputation as an independent curator.

Freud Museum

20 Maresfield Gardens
London NW3 5SX
t 020 7435 2002 f 431 5452
email: freud@gn.apc.org
Website: www.freud.org.uk
Wed – Sun 12-5
Director: Erica Davies

A superb monument to the Great Man – he lived here for the last year of his life and his consulting room remains unchanged – The Freud Museum opened in 1986 and has played an increasingly important role in contemporary art. Artists of all tendencies and generations are attracted to its evocative environment, with its famous, carpet-draped couch and collection of antiquities. Among those who have made direct interventions are Cornelia Parker, whose *Freudian Abstracts* have magnified and transformed feathers from his cushions and fluff from his couch, and Susan Hiller, who continues to work with the exhibits in her ongoing installation *At the Freud Museum*. In 1999, to coincide with her exhibition at the Camden Arts Centre, French artist Sophie Calle intervened in Freud's rooms and his possessions to blend fact, fiction and personal history in a series of dramatic scenarios, and in the Museum provided an effective context for Sarah Lucas' suggestive sculptures. Louise Bourgeois is another major artist planning to work within this psychologically charged setting.

Natural History Museum

Cromwell Road, London SW7 5BD
t 020 7942 5000
Website: www.nhm.ac.uk
Mon – Sat 10-5.50, Sun 11-5.50
Admission charges
Director: Dr Neil Chalmers

A newly restored and refurbished gallery, funded through a grant from the Jerwood Foundation and opened in 1999, ushered in a programme that combines the museum's historical collections with contemporary art-led shows. This began in January 2000 with an installation by Belgian artist Jan Fabre, which infiltrated a public space of the museum. Called *A Consilience*, it incorporated a film shot in the vast scientific collections with Fabre's elaborate insect costumes, worn by the Museum's insect experts (the Head of Entomology as a butterfly, a Collections Manager as a beetle).

National Maritime Museum

Park Row, Greenwich
London SE10 9NF
t 020 8858 4422 f 020 8312 6632
Website: www.nmm.ac.uk
Daily 10-5
Admission charges for adults
Contact: Rebecca Carnihan

As part of the Museum's Lottery-funded refurbishment, Lucy Blakstad, Tacita Dean, Stefan Gec, Bill Fontana, Rosie Leventon, Kasia Morawska and Humphrey Ocean were invited to take part in an initiative entitled *New Visions of the Sea*. Their works have become part of the permanent collection, exhibited amongst the maritime objects and displays. A commitment to contemporary art continues with a series of temporary exhibitions and interventions extending to the Royal Observatory, in which 1999 Turner Prize nominee Steven Pippin installed two of his solar-system machines, and into the museum's new galleries with a show of wall sculptures by the Boyle Family.

Science Museum

Exhibition Road, London SW7 2DD
t 020 7938 8000 f 020 7938 8118
Website: www.nmsi.ac.uk
Daily 10–6
Admission charges
Director: Sir Neil Cossons

The Science Museum's progressive attitude towards contemporary art has resulted in a commitment to incorporating artists' work into every major capital project. Commissions come about

through the artists' research into the collection. The new Wellcome Wing houses thirteen permanent contemporary works in a variety of media, sited throughout the exhibits. Artists include Marc Quinn, Yinka Shonibare, Darrell Viner and Scanner. Previous projects have involved Cornelia Parker, Tim Head and Jordan Baseman.

Tate Britain

Millbank, London SW1P 4RG
t 020 7887 8008 f 020 7887 8007
email: information@tate.org.uk
Website: www.tate.org.uk
Daily 10-5.50
Admission charges for exhibitions
Director: Stephen Deuchar

The Tate Gallery was established in 1897 on the site of Millbank Penitentiary to house the collection of the Liverpool-born sugar magnate and philanthropist, Henry Tate. In March 2000, this original Millbank site was relaunched as Tate Britain, a new national gallery devoted to presenting the Tate's world-class collection of British art from the sixteenth century to the present day. This has involved a radical re-jig of the Tate's historic holdings into in-focus galleries, single-artist displays and groups of thematically linked rooms, and has also given the Tate a chance to show that it has acquired some significant pieces of new British art over the last decade. As part of its desire to be seen as a nimble, time-travelling counterpart to its twentieth-century-only counterpart across the Thames at Bankside, in July 2000 Tate Britain launched *Intelligence: New British Art 2000*, the first in a series of major triannual exhibitions of recent and emerging British art. It also continues to keep the contemporary flag flying by hosting the annual bunfight that is the Turner Prize; along with a commitment to expanding the scope of the bi-monthly *Art Now* programme of British (Georgina Starr, Tacita Dean, Marc Quinn and Paul Graham) and international artists (Matthew Barney, Geneviève Cadieux and Mark Dion), housed in a special-projects room based on that of the Museum of Modern Art, New York, but on a smaller scale. Let's hope *Art Now* is one of the strands that will benefit from the £32.3 million

programme of building works scheduled for completion in 2001, which will create a 35 percent increase in gallery space and generally upgrade the building inside and out.

Tate Modern

Bankside, London SE1 9TG
tel: 020 7887 8008
email: information @tate.org.uk
Website: www.tate.org.uk
Sun –Thurs 10-6, Fri–Sat 10-10
Admission charges for exhibitions
Director: Lars Nittve
Head of Exhibition Planning:
Iwona Blazwick

One of Britain's few millennium projects to be completed on time and on budget (£134 million) has been the transformation of Sir Giles Gilbert Scott's 1947 Bankside Power Station into Tate Modern, Britain's national museum of modern art. Grouped parallel to the epic space of the Turbine Hall – 100 feet high and 500 feet long – are three floors of galleries, two devoted to Tate Modern's permanent collection displays, which consist of international art dating from 1900 to the present. The other, sandwiched between them, shows a changing programme of temporary exhibitions. Tate has substantial holdings in classic modern and contemporary art, and has acquired – often with the help of its increasingly active Patrons – some significant pieces by younger British artists such as Rachel Whiteread, Cathy de Monchaux and Michael Landy, and in 1997 its representation of recent artists was massively boosted by the gift to the gallery of fifty-six works by British and American artists collected by Tate Trustee Janet de Botton between the late 1970s and early 1990s, valued at around £2.3 million. There are paintings by Sean Scully, Robert Ryman, Julian Schnabel, Francesco Clemente, Frank Stella and Andy Warhol, photographic works by Cindy Sherman and Gilbert and George, and pieces tracing the redefinition of sculpture, begun in the 1960s by Carl Andre, Donald Judd and Sol LeWitt, and continued by Richard Long, Richard Wentworth, Bill Woodrow and Grenville Davey. Another boost to Bankside's spaces has been various long-term loan arrangements

with the extensive Froehlich Foundation collection of German and American art.

So far, so in keeping with the classic format of a major museum of modern art – albeit one in an industrial hangar, pierced by a giant chimney. However, where Tate Modern has departed from the established codes of museum procedure is in its decision to display its collections not chronologically or by school, but grouped around four themes – History, Memory, Society; Nude, Action, Body; Landscape, Matter, Environment; Still Life, Object, Real Life. These break away from previous presentations of modern art while being rooted in traditional genres and the way in which these have been reinterpreted throughout the twentieth- and into the twenty-first century.

Lymington
ArtSway
Station Road, Sway, Near Lymington
Hampshire SO41 6BA
t 01590 682260 f 01590 681989
email: info@artsway.demon.co.uk
Website: www.artsway.demon.co.uk
Tues – Sun 11-5
Director: Mark Segal

A converted coach house at the back of a hotel in the middle of the New Forest is an unlikely venue for contemporary art, but there's nothing quaint about this small gallery, which opened in 1997 and was designed by Tony Fretton – the architect of the Lisson Gallery, London. Its remit to show challenging work has resulted in exhibitions of drawings by Antony Gormley and Alison Wilding, and a survey of past Turner Prize winners. *The World of Our Landscape*, a Lottery funded three-year programme of commissions, residencies and exhibitions, has included a sonic installation by Hywel Davies, a video work by Tony Sinden and residencies with a number of international artists. Recent exhibiting artists have included Melanie Manchot, Brian Catling and Anna Best.

MANCHESTER
Castlefield Gallery
5 Campfield Avenue Arcade
Off Deansgate, Manchester M3 4FN
t 0161 832 8034 f 0161 819 2295
Tues– Sun 12-5

One of the oldest artist-run initiatives in the UK, the Castlefield Gallery gives solo exhibitions to newcomers and shows artists from the region alongside more major names including Bridget Riley, Antony Caro, and Anya Gallaccio.

Cornerhouse
70 Oxford Road, Manchester M1 5NH
t 0161 2228 7621 f 0161 200 1506
email: exhibitions@cornerhouse.org
Website: www.cornerhouse.org
Tues – Sat 11-6, Sun 2-6
Exhibitions Director: Paul Bayley

Cornerhouse is among the key venues for contemporary art in the UK. Its remit is to juxtapose UK artists such as Peter Greenaway with major international figures like Americans John Baldessari (1996) and Lari Pittman (1998), all of whom received their first UK retrospectives here. Other major shows were Archigram (1998), Eric Bainbridge (1997) and Sonia Boyce (1998). Commissions have included Damien Hirst's *Isolated Elements all Swimming in the Same Direction* (1991) – his first work made for a public space – and Bruce McLean's 1996 film *Urban Turban*.

the international 3
8 Fairfield Street, Manchester M1 3GF
t/f 0161 281 0122
email: info@theannualprogram.com
Website: www.theannualprogram.com
Thurs–Sun 12-5
Contact: Martin Vincent

A new joint venture by Live Arts organisation Work & Leisure International and the exhibition and commissions agency The Annual Programme, this space aims to provide a 'porous and flexible forum for diverse practice'.

Manchester City Art Gallery
Mosley Street, Manchester M2 3JL
t 0161 236 5244 f 0161 236 7369
email: cityart@mcrl.poptel.org.uk
Website: www.cityartgalleries.org.ukl
Closed until late 2001
Director: Virginia Tandy

A complex of fine Victorian buildings designed in Greek-revival style by Charles Barry – architect of the Houses of Parliament – Manchester City Art

Gallery is currently being refurbished and extended in a £25 million scheme by Sir Michael Hopkins Partners. The transformed gallery will re-open in late 2001 with twice as much display space, a large new exhibition hall and much-improved visitor facilities. The gallery's permanent collection of British and continental old masters extends to the twentieth century. A programme of contemporary exhibitions, often generated by the gallery, has showcased the work of Cindy Sherman, Tony Oursler and Sean Scully, among others.

Whitworth Art Gallery
Oxford Road, Manchester M15 6ER
t 0161 275 7450 f 0161 275 7451
email: whitworth@man.ac.uk
Website: www.whitworth.man.ac.uk
Mon – Sat 10-5, Sun 2-5
Director: Alistair Smith

Changing displays from the extensive permanent collection of historic and modern British works on paper, textiles and wallpapers, are accompanied at the Whitworth by regular shows including modern and contemporary sculpture in the recently opened Mezzanine Court sculpture galleries.

MILTON KEYNES
Milton Keynes Gallery
900 Midsummer Boulevard
Central Milton Keynes, MK9 3QA
t 01908 676 900 f 01908 558 308
email: HYPERLINK
mailto:mkgallery@mktgc.co.uk
Website: www.mkgc.co.uk
Tues – Sat 11-6, Sun 12-4
Director: Stephen Snoddy

Part of the city's new £32 million gallery and theatre complex inaugurated in October 1999, MKG consists of 300 square metres of gallery space arranged in three rooms, and presents up to ten exhibitions a year. The gallery opened with Gilbert and George's *THE RUDIMENTARY PICTURES*; other shows have included new paintings by Mark Francis, displayed along with the artist's extensive collection of objects and artefacts; and *Richard Hamilton: New Technology and Printmaking*. Contemporary art plays a prominent role throughout the building.

NAILSWORTH, GLOUCS
Cairn Gallery
The Old Stamp Office, George Street
Nailsworth, Gloucestershire GL6 0AG
t 01453 832483
Wed – Sat 10-1, 2-5
Directors: Laurie and Tom Clark

Since its foundation in 1986, this non-profit-making gallery run by an artist and a poet has mounted over 100 shows, roughly divided between established artists (Hamish Fulton, Roger Ackling, Kate Whiteford, Richard Long, Ian Hamilton Finlay), and lesser-known figures, all of whom reflect an interest in Land, Minimal and Conceptual art. A priority is to give artists a space in which to try out new ideas, and to provide audiences with a contemplative environment.

NORWICH
Norwich Gallery
Norwich School of Art and Design
St George Street, Norwich NR3 1BB
t 01603 610561 f 01603 615728
email: nor.gal@nsad.ac.uk
Website:
www.nsad.ac.uk/gallery/index.htm
Mon – Sat 10-5
Curator: Lynda Morris

With a higher profile than many galleries attached to art schools, Norwich Gallery is probably more recognised internationally than locally. This is not only because it acts as host gallery for the prestigious annual EAST International and riverside competition, but is also due to its adventurous programme, which can range from an exhibition of drawings featuring Rachel Evans, Graham Gussin and Thomas Schütte, to *One Night Stands*, two weeks of twenty-four-hour events with contributions from Jeremy Deller, Haley Newman and Ross Sinclair.

Sainsbury Centre for Visual Arts, University of East Anglia
Norwich, Norfolk NR4 7TJ
t 01603 593199 f 01603 259401
email: scva@uea.ac.uk
Tues – Sun 11-5
Admission charges
Curator of Collections and Exhibitions:
Amanda Daly

Norman Foster's metallic structure houses a significant permanent collection of modernist greats such as Bacon, Epstein and Giacometti as well as a large group of Ancient and non-Western artworks. Temporary exhibitions of current art have spanned a retrospective of Derek Jarman, photographs by Hiroshi Sugimoto and the first full-scale show for Zoran Music in the UK.

NOTTINGHAM
Angel Row Gallery
Central Library Building, 3 Angel Row
Nottingham NG1 6HP
t 0115 915 2869 f 0115 915 2860
Mon – Sat 11-6, Wed 11-7
Director: Deborah Dean

Although inauspiciously based on the first floor of the Central Library Building, since its establishment in 1991, with a specific remit to show contemporary visual art, this gallery is now regarded as a leading art space. It was the first showcase for Helen Chadwick's *Piss Flowers* (1991-2); more recent exhibitions have included Roger Ackling and Katrine Herian, and a site-specific commission from Judith Cowan.

Nottingham Castle Museum & Art Gallery
Nottingham NG1 6EL
t 0115 915 3700 f 0115 915 3653
Daily 10-5 (closed Fris in winter)
Admission charges weekends and bank holidays
Keeper of Fine Art: Clare van Loenen

An adventurous acquisitions policy for the Castle Museum's permanent collection ensures that old masters are accompanied by works from the 1980s and 1990s including pieces by Ron Haselden, Tony Bevan, Helen Chadwick, Lisa Milroy, Nick Waplington and Mat Collishaw. A temporary exhibitions programme combines significant touring shows of contemporary art with those initiated by the gallery, such as Nick Waplington's photographs, *Living Room,* and commissions by John Newling and Permindar Kaur.

OXFORD
Museum of Modern Art (MOMA)
30 Pembroke Street, Oxford OX1 1BP

t 01865 722733 f 01865 722573
recorded information: 01865 813830
email: feedback@moma.demon.co.uk
Website: www.moma.org.uk
Tues, Wed, Fri – Sun 11-6, Thurs 11-9
Admission charges
(free Wed 11-1, Thurs 6-9)
Director: Kerry Brougher

Since its foundation in 1965, MOMA has gained a worldwide reputation for presenting the work of up-and-coming British artists and for introducing internationally known figures to the UK – Joseph Beuys, Carl Andre, Donald Judd, Richard Wilson and, more recently, Sol LeWitt and Gary Hill. *About Vision: New British Painting in the 1990s* (1997) assembled leading young artists such as Gary Hume, Chris Ofili, Ian Davenport, Lisa Milroy, Damien Hirst and Fiona Rae. MOMA is also one of the main providers of touring contemporary exhibitions in Britain outside London. Recent shows are *Yoko Ono: Have you seen the horizon lately?; Willie Doherty: Somewhere Else; Notorious: Alfred Hitchcock and Contemporary Art.*

PENZANCE
Newlyn Art Gallery
New Road, Newlyn, Penzance TR18 5PZ
t 01736 363715 f 01736 331578
Mon – Sat 10-5
Director: Elizabeth Knowles

Newlyn Art Gallery is one of the South West's leading contemporary art galleries, presenting exhibitions of work from the UK and abroad and collaborating with other organisations. In 1999 it showed works by James Turrell and Tacita Dean in response to the total eclipse, as part of St Ives International.

PORTSMOUTH
Aspex Gallery
27 Brougham Road, Southsea
Portsmouth, Hants PO5 4PA
t 02392 812121 f 02392 874523
email: aspexgallery@compuserve.com
Tues – Fri 12-6, Sat 12-4
Director: Joanne Bushnell

The Aspex Gallery's policy is to show younger or emerging artists in solo, group or themed exhibitions. Artists whose early work was shown here

include Richard Wilson, Helen Chadwick and Cornelia Parker.

PRESTON
Harris Museum and Art Gallery
Market Square, Preston PR1 2PP
t 01772 258248 f 01772 886764
email: harris@pbch.demon.co.uk
Mon – Sat 10-5
Museum and Art Officer:
Alexandra Walker

This imposing nineteenth-century temple of art is raised on its own plinth above the market-place and emblazoned with friezes, reliefs, stained glass and even a Foucault's pendulum. Alongside a fine collection of Victorian paintings, which extends to living artists, the gallery is also committed to showing the most progressive of contemporary art and craft. It is currently embarking on a programme of high-profile temporary commissions for non-gallery areas of the building, including sound works by Shirley McWilliam and projects by Keith Wilson, Matthew Thompson and Simon Starling. It is also developing programmes that reflect the cultural diversity of the town.

READING
Open Hand, Open Space
571 Oxford Road, Reading
Berkshire RG30 1HL
t/f 0118 9597752
email: info@ohos.org.uk
Website: www.ohos.org.uk
Sat1 – Sun 12–6 and by appointment
Organisers: Artists' committee

These artist-led studios and gallery in a former Victorian army barracks pursue an ambitious exhibitions and education programme and provide much-needed exposure to contemporary art in the Reading area.

ST IVES
Tate St Ives
Porthmeor Beach, St Ives
Cornwall TK26 1TG
t 01736 796226 f 01736 794480
Apr – Sept: Mon – Sat 11-7, Sun 11-5
Oct – Mar: Tues – Sun 11-5
Website: www.tate.org.uk
Admission charges
Curator: Susan Daniel-McElroy

Tate St Ives
Photo: Marcus Leith

Designed in 1993 by Eldred Evans and David Shalev, Tate St Ives is dramatically sited in the cliff above Porthmeor Beach. Its changing exhibitions of twentieth-century art associated with Cornwall are presented both in the displays, which focus especially on the modern tradition with which St Ives is closely identified, and in the fabric of the building itself – there is a dramatic stained-glass window by Patrick Heron. Works by Barbara Hepworth, Ben Nicholson, Naum Gabo *et al* are drawn from Tate's collection and supplemented by long-term loans from private collections, and collaborations with other institutions.

The aim is to provide an introduction to the principal St Ives artists and their work, as well as a programme of themed exhibitions and artists' projects related to the collection and its surroundings. The most ambitious of these to date has been the first St Ives International, *A Quality of Light* (1997), in partnership with Newlyn Art Gallery, Falmouth College of Arts, South West Arts and inIVA, in which fourteen internationally recognised artists, including Bridget Riley, Mona Hatoum and David Medalla, were commissioned to make new work inspired by the Cornish landscape at venues around the Penwith Peninsula.

SALISBURY
New Art Centre Sculpture Park & Gallery
Roche Court, East Winterslow
Salisbury, Wiltshire SP5 1BG
t 01980 862244 f 01980 862447
email: nac@globalnet.co.uk
Daily 11-4
Director: Madeleine Bessborough

Munkenbeck + Marshall's new RIBA award-winning gallery in glass and steel links the existing Georgian house to its orangery of the same period, providing an appealing context for modern and contemporary painting and sculpture. In addition, 20 acres of park, gardens and woodlands are the setting for 100 sculptures ranging from the works of Tony Cragg, Antony Gormley, Lynn Chadwick, Philip King and Barbara Hepworth, whose estate the New Art Centre represents. The galleries were inaugurated in spring 1999, with paintings by Paul Huxley followed by new works from Tania Kovats. Exhibitions for 2000 include Bill Woodrow, Alison Wilding, Susan Derges and Hideo Furuta.

SHEFFIELD
Mappin Art Gallery
Weston Park, Sheffield S10 2TP

t 0114 276 8588 f 0114 275 0957
Tues – Sat 10-5, Sun 11-5
Curator of Contemporary Art:
Julie Milne

The Mappin's programme of contemporary art exhibitions encompasses solo shows to large-scale group shows either initiated or hired. The Mappin Open Solo Shows is a new initiative that seeks to encourage emerging talent. Four artists will be selected annually.

Site Gallery
1 Brown Street, Sheffield S1 2BS
t 0114 281 2077 f 0114 281 2078
email: gallery@site-map.u-net.com
Website: www. site-map.u-net.com
Tues–Fri, Sat 11-5.30, Sun 1-5
Director: Carol Maund

Site's gallery space was extended and refurbished in 1998. It offers an important showcase and facilities for film, video and installation by national and international figures – with an emphasis on originating solo and mixed shows and special artists' commissions. Examples are *Traffic*, a group show of work by Augusto Alves da Silva, Dryden Goodwin, Julian Opie, Mabel Palacin, Nick Waplington; Sophie Calle's *Double Games*, and Susan Hiller's *PSI Girls*.

SOUTHAMPTON
John Hansard Gallery
University of Southampton, Highfield
Southampton SO17 1BJ
t 023 80592158 f 023 80594192
email: handsard@soton.ac.uk
Tues – Fri 11-5, Sat 11-4
Director: Stephen Foster

The John Hansard Gallery is a converted engineering laboratory in the middle of a University campus, and still retains an experimental feel. It commissions important new work from young British artists such as Judith Goddard, Hamad Butt and Juan Cruz, as well as from older international artists, whose work is also shown in historical reviews. These include Richard Nonas, Haim Steinbach and the first British exhibition of Gina Pane's work. Influential thematic shows such as *Refusing to Surface*, *Small Truths* and *Lie of the Land* bring together these differing areas of interest. The gallery

also has an ambitious programme of conferences setting contemporary art in a wider cultural context.

Southampton City Art Gallery
Civic Centre, Southampton SO14 7LP
t 02380 832277/632601 f 02380 832153
email: artgallery@southampton.gov.uk
Tues –Sat 10-5, Sun 1-4
Director: Godfrey Worsdale

In addition to an extensive historical collection, this venue houses the most important group of British contemporary artworks in a public gallery outside London, with strong pieces by Helen Chadwick, Peter Doig, Antony Gormley, Rachel Whiteread, Richard Patterson, Gillian Wearing, Douglas Gordon and Ian Davenport. (Southampton's curators have an uncanny ability to snap up the work of Turner Prize nominees just before they are recognised by the jury and their prices rise accordingly.) This progressive collecting is complemented by a policy of initiating challenging exhibitions, including the first major solo shows of Martin Creed and Chris Ofili in a public gallery in Britain; a significant solo exhibition of Rachel Lowe; *Real Art: A New Modernism*, an exhibition of young painters in the 1990s; and *Co-operators*, a tribute to the importance of collaborations in the current art scene involving Henry Bond and Liam Gillick, Andrea and Phillippe, Jane and Louise Wilson, Jake and Dinos Chapman, and Langlands and Bell.

SOUTHEND-ON-SEA
Focal Point Gallery
Southend Central Library
Victoria Avenue, Southend-on-Sea
Essex SS2 6EX
t 01702 612621 f 01702 469241
email: admin@focalpoint.org.uk
Mon – Fri 9-7, Sat 9-5
Director: Lesley Farrell

Focal Point Gallery is committed to providing access to, and promoting an understanding of, photography, video and new media with self-initiated shows like David Mabb's *Mapping the Movie*, Les Bicknell's *Opening Landscapes* and mixed shows such as *Later*, with work by Dan Holdsworth, Rut Bles Luxemburg, Neville Smith and Hainsley Brown.

STOKE ON TRENT
The Potteries Museum & Art Gallery
Bethesda Street
Hanley, Stoke-on-Trent ST1 3DE
t 01782 232323 f 01782 232500
email: museums@stoke.gov.uk
Website: www.stoke.gov.uk/museums
Mon – Sat 10-5, Sun 2-5
Keeper of Art: Sarah MacDonald

Mixed and solo shows by artists who may be local or from elsewhere in the UK or abroad have included Laura Godfrey-Isaacs' obsessional installation of fabric and yarn, *There's a Mad Woman in the Attic*, as well as touring exhibitions such as the Arts Council's *Sublime: The Darkness and the Light*.

SUNDERLAND
Northern Gallery for Contemporary Art
City Library and Arts Centre
Fawcett Street, Sunderland SR1 1RE
t 0191 514 1235 f 0191 514 8444
Mon, Wed 9.30-7.30, Tues, Thurs, Fri, 9.30-5, Sat 9.30-4
Exhibitions Officer: Louise Wirz

This gallery presents innovative exhibitions of established and emerging artists, plus a residency programme. Shows in 2000 include the group show *Paint: Too*, including Tanya Axford, D.J. Simpson, Richard Forster, Natalie Frost, Graham Little and Simon Lewandowski; a solo exhibition of Simon Jones; Kathryn Boehm & Staffan Saffer; and off-site projects with Graham Gussin, who has also curated *Nothing – Exploring Invisibilities* with Ele Carpenter.

WALSALL
The New Art Gallery
Gallery Square, Walsall
West Midlands WS2 8LG
t 01922 654400 f 01922 654401
email: info@artatwalsall.org.uk
Website: www.artatwalsall.org.uk
Tues – Sat 10-5, Sun and banks hols 12-5
Director: Peter Jenkinson

A new £21 million art gallery in a stunning building designed by Caruso St John architects has given the West Midlands a world-class gallery, which was attracting plaudits two years before

its opening in February 2000. Contemporary artist Richard Wentworth has created a square surrounding the gallery, which demarcates the area between the canal path and the gallery with alternate stripes of tarmac. At the core of the gallery is the Garman Ryan Collection of 150 works, including pieces by Sir Jacob Epstein. This is complemented by an adventurous contemporary art programme.

WOLVERHAMPTON
Wolverhampton Art Gallery
Litchfield Street
Wolverhampton WV1 1DU
t 01902 552055 f 01902 552054
email: info@wolverhamptonart.org.uk
Mon – Sat 10-5. Closed Jan – Aug 2001
Head of Arts and Museums:
Nicholas Dodd

The policy of Wolverhampton Art Gallery, which won an award for Best Museum of Fine Art, is to promote access, involvement and understanding in the visual arts. A programme of temporary exhibitions features adventurous new work. The contemporary art in the permanent collection, strong in Pop art and work with socio-economic themes, has been greatly expanded thanks to the Contemporary Art Society and the Arts Council of England.

YORK
Impressions Gallery
29 Castlegate, York YO1 9RN
t 01904 654724 f 01904 651509
email: info@impressions-gallery.com
Mon – Sat 9.30-5.30, Sun 11-5.30
Director: Anne McNeill

Since opening in 1972 as one of the first photography galleries in Europe, Impressions Gallery is among the leading spaces for photography and digital media in the north of England. The gallery supports work by artists who extend the boundaries of contemporary creative and innovative exhibitions, some of which tour internationally.

NORTHERN IRELAND

BELFAST
Catalyst Arts

New Art Gallery, Walsall
Photo: Hélène Binet

5 Exchange Place, Belfast BT1 2NA
t 02890 313303 f 02890 312737
email: info@catalystarts.org
Tues – Fri 11-6, Sat 12-5
Directors: Stella d'Ailly, Phil Collins, Joanna Fursman, Stephen Hackett, Alan Hughes

This artist-run organisation was established in 1993 to provide a platform within Northern Ireland for all aspects of the visual arts and to set Northern Irish art within an international context. It offers a multipurpose centre where local and international artists can work experimentally, and provides space and support for one-off projects from a broad range of practice.

Ormeau Baths Gallery
18a Ormeau Avenue, Belfast BT2 8HQ
t 02890 321402 f 02890 312232
Tues – Sat 10-6
Director: Hugh Mulholland

Opened in 1995 on the site of a disused Victorian swimming baths, this gallery is dedicated to presenting innovative contemporary work by artists of national and international standing, including Bill Viola, Gilbert and George and Yoko Ono. The gallery is also committed to the promotion of Northern Irish art in a wider international context, showing leading Irish figures such as Rita Duffy, Barbara Freeman, Brian Kennedy and David Crone, as well as offering a platform to younger emerging artists through *Perspective*, its annual open submission exhibition.

Proposition Gallery
Unit 22, North Street Arcade
Belfast BT2 8HQ
t 02890 234072
email:
info@proposition.freeserve.co.uk
Website:
www.proposition.freeserve.co.uk
Thurs – Sat 1-5
Director: Ian Charlesworth

A non-profit-making, artist-run space, Proposition Gallery exhibits work in all media by Belfast artists and international figures as well as offering a number of residencies for artists to live in Belfast whilst producing work for

shows. Past exhibitions have show-cased German artist Kathrin Boehm, Canadians Mitch Robertson and Kelly Mark, Scott Barden's large Cibachrome prints of mocked-up Napoleonic war scenes, and New York sculptor Michael Buckland's work with sponges and playing cards. The gallery also has access to five vacant shop units for providing more flexible shows.

DERRY
Context Gallery
5 Artillery Street, Derry BT48 6RG
t 028 7137 3538 f 028 7126 1884
email: context.cbn@artservicesire-land.com
Mon – Sat 10-5.30
Director: James Kerr

Context Gallery is devoted to providing a platform for emerging Irish artists and to supporting their work on an international level with solo and mixed theme shows and international touring exhibitions. These take place in the gallery itself and at the nearby McLoone's Factory, and have included *Goal*, which brought together Irish artists with international figures such as Carles Guerra from Spain and London-based Simon Patterson. A quarterly publication, *inContext*, provides an outlet for young art critics to develop their style and to voice opinions about issues relating to international contemporary art practice.

Orchard Gallery
Orchard Street, Derry BT48 6EG
t 01504 269675 f 01504 267273
Tues – Sat 10-6
Contact: Brendan McMenamin

Since it opened in 1978, Orchard has established itself as one of Ireland's key contemporary galleries. Leading Irish artists such as Nigel Rolfe and Willie Doherty, and international figures including Richard Long (UK), and Nancy Spero and Ida Applebroog (USA), present work in all media both within the gallery and in sites across Derry in an active liaison programme with the city's communities. Orchard Gallery also regularly curates thematic and issue-based shows at international venues, such as *Mapping and Power*, Paris, 1996.

SCOTLAND

ABERDEEN
Aberdeen Art Gallery and Museums
Schoolhill, Aberdeen AB10 1FQ
t 01224 523700 f 01224 632133
Website: www.aagm.co.uk
Mon – Sat 10-5, Sun 2-5
Exhibitions officer: Abigail Juett

Aberdeen Art Gallery houses an important fine art collection with particularly good examples of nineteenth- and twentieth-century works plus recent art by young Scots. The gallery seeks to provide a platform for emerging artists and hosts an active programme of special exhibitions throughout the year.

Peacock Gallery
21 Castle Street, Aberdeen AB11 5BQ
t 01224 639539 f 01224 627094
email: peacockprint.co.uk@virgin.net
Tues–Thurs 9.30-8, Fri – Sat 9.30-5.30
Exhibitions: Colin Greenslade

Peacock provides printmaking, video, photography and digital imaging facilities for artists, whose activities are reflected in two exhibition spaces and an extensive art education programme.

AYR
Maclaurin Art Gallery
Rozelle Park, Monument Road
Ayr KA7 4NQ
t 01292 443708 f 01292 442065
Mon – Sat 10-5 (April – Oct 2-5 Sun)

Maclaurin offers a collection containing the work of established figures from

Scotland and the UK including John Bellany and Bridget Riley.

DUNDEE
Dundee Contemporary Arts
152 Nethergate, Dundee DD1
t 01382 434000 f 01382 432294
Tues – Sun 10.30 - 5.30
Thurs – Fri 10.30-8
Director: Andrew Nairne

This £9 million centre for contemporary art and film opened in 1999 in a former car showroom overlooking the river Tay. A pair of spacious galleries, extensive artists' production facilities, two cinemas and a lively café in the heart of the building are all managed in partnership with the University of Dundee's Faculty of Art and Design. The gallery's determination to put itself on the international map was demonstrated by its inaugural show, *Prime*, which presented work in all media by artists ranging from Anya Gallaccio, Catherine Yass, Tatsuo Miyajima and Anish Kapoor to more historical figures such as Joseph Beuys and Andy Warhol. Since then, exhibitions have included new work by Tacita Dean, Olafaur Eliasson, and Ian Davenport (all 1999) and, in 1999-2000, Christine Borland's first exhibition in her native Scotland since 1994.

Generator Projects
Mid-Wynd Industrial Estate
25/26 Mid-Wynd, Dundee DD1
t/f 01382 225982
email:
generator@arts.fsbusiness.co.uk
Phone for opening hours
Contact: Tony Nolan

Philip Napier
Guage
1997
Mixed media
Installation at Orchard Gallery, Derry

Established in 1996 by a group of graduates from Duncan of Jordanstone College of Art to redress the lack of opportunities for artists to show in the area, Generator has blossomed into a group of over 100 artist-members, some of whom occupy the Generator studios at 143c Nethergate. Generator mounts a variety of exhibitions and events including *Radar*, which put artists from Vienna, Rome and Los Angeles alongside young artists from Dundee in a warehouse space in the city centre; and *Fade Away and Radiate*, an exhibition of public art in and around the city centre. In early 2000, Generator inaugurated a permanent exhibition/projects space with *An Invitation to Kiss*, curated by Prunella Spence and Beverley Hood, which utilised new technology and was based on the kiss.

EDINBURGH
Collective Gallery
22-28 Cockburn Street
Edinburgh EH1 1NY
t/f 0131 220 1260
email: smunrocoll@aol.com
Tues – Sat 11-6, Sun 1-5
Director: Sarah Munro

One of Scotland's leading spaces for launching up-and-coming artists working in all media, this gallery shows local, national and international artists including Lyn Lowenstein, Clara Ursitti and Mike Nelson.

The Fruitmarket Gallery
45 Market Street, Edinburgh EH1 1DF
t 0131 225 2383 f 0131 220 3130
email: info@fruitmarket.co.uk
Mon – Sat 11-6, Sun 12-5
Director: Graeme Murray

Amongst the UK's major contemporary art galleries, the Fruitmarket has a worldwide reputation for bringing to Scotland the work of leading artists – whether Sol Lewitt, Lisa Milroy or Nobuyoshi Araki – and for presenting new work from Scottish artists like Ross Sinclair and Graeme Todd in an international context.

Inverleith House, Royal Botanic Garden
20a Inverleith Row, Edinburgh EH3 9LR

t 0131 248 2943 f 013128 2901
email: s.dunn@rbge.org.uk
Website: www.rbge.org.uk/inverleith-house/index.html
Wed – Sun 10-5 (times vary seasonally)
Director of Exhibitions: Paul Nesbitt

This eighteenth-century house, set within seventy-three acres of a Botanic Garden and founded in 1670, contains seven galleries. These present a programme of exhibitions by major international contemporary artists with the wider aim of furthering appreciation of the natural world through art and science. Exhibited artists include Carl Andre, Lothar Baumgarten, Melissa Kretschmer, Agnes Martin, Tina Modotti, Philip Taaffe, Callum Innes, Laura Owens, Lawrence Weiner and Stanley Kubrick. Botanical drawing and photography show are also originated.

Portfolio Gallery
43 Candlemaker Row
Edinburgh EH1 2QB
t 0131 220 1911 f 0131 226 4287
Tues – Sat 12-5.30
email: portfolio@ednet.co.uk
Director: Gloria Chalmers

Small but perfectly formed, the Portfolio showcases the very latest in British and international photographic work by the likes of Andres Serrano, Orlan and Helen Chadwick. The gallery also maintains ongoing relationships with artists such as Calum Colvin and Catherine Yass, who are given an additional showcase in the form of *Portfolio*, a bi-annual photographic periodical that reflects and extends the gallery's programme.

Scottish National Gallery of Modern Art
Belford Road
Edinburgh EH4 3DR
t 0131 624 6200 f 0131 343 3250
Mon – Sat 10-5, Sun 12-5
(during Edinburgh Festival Sun 11-5)
Admission charges for some exhibitions
Keeper: Richard Calvocoressi

Although it accommodates a number of living artists, the main strength of the permanent collection is in the big names of modern British painting and sculpture and its world-class holdings

of Dada and Surrealist art and literature. However, exhibitions such as a retrospective of the innovative Paragon Press or the first Scottish showing of *Endlessly* (1997), an installation by Dalziel & Scullion, confirm a policy of exhibiting imaginatively selected examples of the latest art being made in Scotland and the UK. The opening of the Dean Gallery in 1999 has doubled the size of the GMA and provided a space devoted solely to twentieth-century art. Not only does it house a large collection of work by Eduardo Paolozzi and the GMA's Dada and Surrealist collections, it also has a gallery fitted out as a library for the display of artists' books and a suite of air-conditioned galleries for temporary exhibitions, which have included self portraits by John Coplans and new paintings by Gary Hume.

Talbot Rice Gallery
The University of Edinburgh
Old College, South Bridge
Edinburgh EH8 9YL
t 0131 650 2211 f 0131 650 2213
email: pat.fisher@ed.ac.uk
Tues – Sat, 10-5
Curator: Professor Duncan Macmillan

A department of the University of Edinburgh, the Talbot Rice Gallery was established as a community asset in 1975 to show the permanent art collection and to house a contemporary gallery presenting the work of Scottish and international artists. There have been solo shows of Anslie Yule (1999), Bruce McLean (2000), Alistair Maclennan (2000) and Kerry Stewart (2001). All exhibitions are accompanied by a full education programme. In 2000, the Talbot Rice was one of the host galleries for *British Art Show 5*.

Stills
23 Cockburn Street
Edinburgh EH1 1BP
t 0131 622 6200 f 0131 622 6201
email: info@stills.org
Website: www.stills.org
Tues – Sat 10-5
Director: Kate Tregaskis

Stills was established as a photography gallery in 1977 and relaunched in 1997 after an extensive Lottery-funded

refurbishment. Now showing a diverse programme of photography, digital imaging and video work, Stills has exhibited work by Barbara Ess, Tomoko Takahashi, Wolfgang Tillmans and Hermione Wiltshire. In 1999, Stills launched the Richard Hough Resource. This contains a project space, a digital imaging lab, and a large suite of photography darkrooms for use by individuals, artists, community groups and schools. It also supports ongoing residencies for Scottish-based artists.

GLASGOW
Bulkhead

264 High Street, Glasgow G4 0QT
t 0141 572 0161 f 0141 572 0160
email bulkhead.info@virgin.net
Creative Director:
Nicola Atkinson-Griffith

Established in 1997, when it put visual art on 1,200 buses running throughout Glasgow, Bulkhead has since moved to its permanent premises in a former funeral parlour. In addition to a programme of contemporary art from the UK and abroad, the Bulkhead Gallery also provides artists with an exhibition space in the form of the 24HR Window and an interior space that operates on an open-submission basis and by invitation. In 1999, Bulkhead, in collaboration with Glasgow City Council, Fairway Forklifts Ltd and others in the business community, launched The Bulkhead Prize, a contemporary art award of £3,000, which invites 'ambitious proposals for new public artwork of any medium in unusual and interesting sites within the city boundary'. The first prizewinner was Lisa Gallacher, whose *Sewing Machine* was installed on the wall of the semi-derelict British Linen Corporation Bank.

CCA

270 Sauchiehall Street, Glasgow G2 3EH
t 0141 332 7521 f 0141 332 3226
email: gen@cca-glasgow.com
Website: www.cca-glasgow.com
Mon – Sat 10-6, Sun 11-6
Director: Graham McKenzie

Currently at temporary premises in McLellan Galleries, Glasgow, CCA will reopen in its original building, following a £10.5 million refurbishment in 2001. Shows at this well-established venue for up-coming and well-known international and national figures have spanned a survey of sculpture by Kerry Stewart, and a re-creation of a slice of Scottish mountainside by Glasgow-based Ross Sinclair. Shows for 2000 include *Continuum 001* curated by Rebecca Gordon Nesbitt and *IF I RULED THE WORLD*, a group show of Glasgow-based artists including Simon Starling, Ross Sinclair, Rose Thomas and Bryndis Snaebjornsdottir.

fly

322 Duke Street, Glasgow G3 1QT
t 0141 550 1185, f 0141 556 1745
Tues – Fri 12-6, Sat 10-4, Sun 12-4
Working Group: Luci Ransome,
Nicola Cooper

fly emerged in 1997 as one of many projects initiated by Fuse Ltd, an umbrella organisation set up by Patricia Fleming, which secured three empty shop units for a venue, and studio spaces in Glasgow's East End. *fly* soon extended its scope to present four to five shows/ events a year, including work from Martin Boyce, Dene Happell and Lucy McKenzie, as well as guest-curated shows by Justin Carter, Will Bradley and Caroline Woodley, aka Stop-Stop. Since December 1999, *fly* has been undergoing redirection by a new group of artists who are co-ordinating projects in and outside the venue. Projects for 2000/1 include a season of short-run DIY shows, *G31 Open*, and *Plano XX1*, a city-wide exhibition of Portuguese art.

Fringe Gallery

18 Castlemilk Avenue
Castlemilk, Glasgow G45 9AA
t 0141 631 2267/634 2603 f 0141 631 1484
email: info.castlemilk-arts@virgin.net
Wesbsite: www.fringmedia.co.uk
Mon – Sat 10-1.30, 2.30-5
Arts Officer: John Ferry

Situated in the heart of Castlemilk Shopping Centre, Fringe combines a policy of working with local artists and a schedule of touring national and international exhibitions. Shows for 2000 include photographs by Kathleen Little, and the paintings of Steven Walker.

Gallery of Modern Art Glasgow

Queen Street, Glasgow G1 1DT
t 0141 229 1996 f 0141 204 5316
Website: www.goma.gov.uk
Mon–Thurs, Sat 10-5, Fri & Sun 11-5
Curators: Victoria Hollows
Sean McGlashan

Art-world lips curled in unison when GoMA opened in 1996 with a collection devoted to the work of living – and especially Scottish – artists under the remit of 'Art For People'. GoMA is the only modern art gallery to give a prominent place to Beryl Cook, and the director's idiosyncratic definition of 'genuinely popular, not narrowly elitist' resulted in an abundance of muscular Scottish figuration fashionable in the 1980s, and an eclectic selection of works by established figures – Bridget Riley, David Hockney, Anthony Caro and Andy Goldsworthy – as well as Mexican, Ethiopian, Russian and Australian aboriginal art and photographs by Henri Cartier-Bresson. As of early 1999, however, a new regime has been in place and although the collection is still arranged over four floors, perplexingly devoted to the themes of fire, earth, water and air, there is now a commitment in both purchasing and programming to represent new tendencies in contemporary art – as was shown by the 1999 exhibition of works from the Frank Cohen Collection.

Glasgow Print Studio

22 King Street, Glasgow G1 5QP
t 0141 552 0704 f 0141 552 2919
email: gallery@gpsart.co.uk
Website: www.gpsart.co.uk
Mon – Sat 10-5.30
Director: John Mackechnie

Since its establishment in 1972, the print studio has extended its scope both within and beyond Scotland with a programme that ranges from graphic work by legendary American Pop artist Jim Dine, to the best of current Scottish printmaking, painting and sculpture. Notable is *Habitat* (1999), a portfolio of prints by Christine Borland, Carol Rhodes and Adrian Wisznewski. Exhibitions are presented in three galleries, Gallery III being the showcase for Glasgow Print Studio publications and Scottish-based printmakers.

Street Level Photoworks

26 King Street, Glasgow G1 5QP
t 0141 552 2151 f 0141 552 2323
email:
info@sl-photoworks.demon.co.uk
Tues – Sat 10-5.30
Director: Malcolm Dickson

This showcase for the latest in new media, whether photography, video, or sound installation, also provides facilities for the production of new work. Recent shows of emerging and established artists have included specially commissioned work by Ian Breakwell and Elizabeth Worndl.

The Modern Institute

See Organisations

Tramway

25 Albert Drive, Glasgow G41 2PE
t 0141 422 2023 f 0141 287 5533
email: firstname.surname@dpav.glasgow.gov.uk
Website: www.glasgow.gov.uk/pav/
Wed – Sun 12-6
Director: Robert Palmer

Since its establishment in 1990, this cavernous former tram depot has acquired a formidable international reputation as one of Britain's most innovative venues for contemporary art. Tramway's commitment to inviting young Scottish artists to make works in response to the space has led to the commission of 24 Hour Psycho by Douglas Gordon (1993), Christine Borland's From Life (1994), and Sustain by Stephanie Smith and Edward Stewart (1995). Established international and British artists are also invited to make or show work, including Niek Kemps (Netherlands) and Bruce McLean (Scotland), whose video The Complete Contempt (1997) received its premiere here. Stephen Hur-rel's 1999 audio boat trip along the River Clyde (Zones) confirms that not all Tramway's commissions are restricted to its building.

Transmission Gallery

28 King Street, Trongate
Glasgow G1 5QP
t 0141 552 4813 f 0141 552 1577
email: 101346.422@compuserve.com
Tues – Sat 11-5
Organisers: Changing committee

Founded in 1983 by four ex-art students in response to the then moribund local situation, Transmission is still run by an unpaid committee of practising artists who each work at the gallery for a maximum of two years. It attracts more than local attention, however, with exhibitions and events involving artists from Glasgow and around the world as well as exchange projects in Barcelona, Antwerp, Belfast, Toronto, London, Malmö and Chicago. Artists who have worked with this seedbed for the thriving artistic scene in Glasgow are Christine Borland, Nathan Coley, Jacqueline Donachie, Douglas Gordon and Roddy Buchanan.

INVERNESS
art.tm

20 Bank Street, Inverness IV1 1QU
t 01463712240 f 01463 239991
email: info@attm.org.uk
Website: www.arttm.org.uk
Opening hours: Tues – Sat 11-6
Contact: Astrid Shearer

Originally established as Highland Printmakers Workshop and Gallery in 1986 by a group of local artists, art.tm now functions as a multi-purpose visual arts organisation in a refurbished building that was created with architects Sutherland Hussey and a number of artists and designers. The aim to represent a range of arts practices is reflected in a programme spanning Michele Lazenby's specially commissioned photographs of the Scottish highlands, and Baa, in which artists and designers including Michael Malig, 1999 Jerwood Prize nominee Mary Little, and Precious McBane with Gary Hume, each made work exploring the qualities of wool.

SKYE
An Tuireann Arts Centre

Struan Road, Portree
Isle of Skye IV51 9EG
t 01478 613306 f 01478 613156
email: norah@antuireann.demon co.uk
Mon – Sat 10-5
Director: Norah Campbell

This former hospital on the outskirts of Portree was completely refurbished in 1998 as three independent exhibition spaces devoted to the latest in contemporary arts and crafts. The inaugural show, The Island Earth, curated by Iain Irving, included work by Scotland's top names, including Dalziel & Scullion, David Shrigley, Douglas Gordon and Ross Sinclair. Since then, shows have included an installation by Les Bicknell, and Vapour Trails Paper Tales, contemporary photography by Neville Blask, Shauna McMullan and Alex Hamilton.

STORNOWAY
An Lanntair

Town Hall, South Beach, Stornoway
Isle of Lewis, HS1 2BX
t/f 01851 703307
email: lanntair@sol.co.uk
Website: www.lanntair.com
Mon – Sat 10-5.30
Director: Roddy Murray

An Lanntair opened in 1985 and is the premier public arts facility in the Western Isles. Although culturally rooted in Gaelic, it provides a broad forum for innovative local, national and international touring exhibitions.

David Mach
Here to Stay
1990
Newspapers
Sculpture in progress at
Tramway, Glasgow
Photo: Alan Wylie

Among these have been *As an Fhearann: From the Land*, on the Centenary of the 1886 Crofting Act; *Acts of Faith* by Steve Dilworth, created from the avian and marine detritus of the Isle of Harris, and *Calanais: the Atlantic Stones*, an award-winning show on megalithic culture in Northern Europe. An Lanntair moves to a major new development in 2001.

STROMNESS
The Pier Arts Centre
Victoria Street, Stromness
Orkney KW16 3AA
t 01856 850 209 f 01856 851 462
Director: Neil Firth

Former fishermen's sheds provide an appropriately maritime backdrop for an important collection of twentieth-century paintings from St Ives artists donated by founder Margaret Gardiner, a friend of Ben Nicholson and Barbara Hepworth. Shows in the Pier Gallery and The House Gallery (an adjoining eighteenth-century merchant's residence) complement the permanent collection, often with the presentation of major contemporary figures – Sol LeWitt, Richard Long and Anthony Caro as well as Scottish and Orcadian artists.

WALES

CARDIFF
Centre for Visual Arts
Working Street, The Hayes
Cardiff CF10 1GG
t 02920 394040 f 02920 388924
email: ad@cva.org.uk
Website: www.cva.org.uk
Tues – Sun 11-5
Admission charges
Exhibitions Director: Alex Farquharson

The largest venue in Wales for national and international exhibitions of new and historical art, the centre opened in 1999 in the former Cardiff Central library building with a vast, specially commissioned piece by Jessica Stockholder, her first solo UK show in a public venue. There is also a commitment to Welsh art and culture – often presented in unexpected ways, as in Jeremy Deller's *Unconvention*, which brought together artists, war photographers, musicians,

The Pier Arts Centre, Stromness

poets and an eclectic range of organisations, all of which feature in the work of the band The Manic Street Preachers.

Chapter Arts Centre
Market Road, Canton, Cardiff CF5 1QE
t 02920 304400 f 02920 313431
email: enquiry@chapter.org
Website: www.chapter.org
Tues – Sun 12-5, 6-9
Exhibitions programmer:
Karen MacKinnon

Wales' centre for innovative and challenging contemporary art, Chapter has gained a reputation for introducing major figures from the British and international art world to a Welsh audience. Exhibitions often arise from residencies – Cornelia Parker's *Avoided Object* (1996) was a notable example – and Chapter also commissions a series of new, on-site installations by figures who have included Mona Hatoum (1992) and Max Fenton (1996). Chapter encourages programming across its three spaces – cinema, theatre and gallery – as in *Body Radicals* (1997), which featured Orlan, Stelarc, Franco B, Annie Sprinkle and Ron Athey.

Ffotogallery
31 Charles Street, Cardiff CF10 2GA
t 02920 341667 f 02920 341672
Tues – Sat 10.30-5.30
Director: Christopher Coppock

Founded in 1978, Ffotogallery is the only venue in Wales solely devoted to the exhibition and promotion of photo-based art. It features the work of leading artists including Catherine Yass, Josef Koudelka, Elisa Sighicelli and Martin

Parr. Examples of exhibitions originated by the gallery are Ian Breakwell's *Death's Dance Floor* (1998), a specially commissioned body of new digital work; and *Intimate Distance* (2000) by Melanie Manchot, which includes a series of large-scale colour works of her mother.

Llandudno
Oriel Mostyn Gallery
12 Vaughan Street, Llandudno LL30 1AB
t 01492 879201 f 01492 878869
email: post@mostyn.org
Website: ww.mostyn.org
Mon – Sat 10-5
Contact: Martin Barlow

Oriel Mostyn is the main space for contemporary art in North Wales, initiating, taking touring exhibitions, or collaborating on shows of major figures ranging from Bethan Huws to Yinka Shonibare. *Artworkers* (2000) used works by artists such as Carl Andre, Mary Kelly, Tomoko Takahashi, Rirkrit Tiravanija and Lois Williams to investigate art-making rooted in the materials and rituals of manual labour and daily routine.

NEWTOWN
Oriel 31
Davies Memorial Gallery, The Park,
Newtown, Powys SY16 2NZ
t 01686 625041 f 01686 623633
email: enquiries@oriel31.org
Website: www.oriel31.org
Mon – Sat 10-5
Director: Amanda Farr

Oriel 31's varied programme is devoted to both contemporary and historical shows. Self-originated exhibitions in 2000-1 include Lily Markiewicz and

David Nash. Light sculpture by Marion Kalmus and Dalziel & Scullion shows outside the gallery during 2000.

SWANSEA
Glynn Vivian Art Gallery
Alexandra Road, Swansea SA1 5DZ
t 01792 655006 f 01792 651713 email: glynn.vivian.gallery@business.ntl.com
Website: www.swansea.gov.uk
Tues – Sun 10-5
Curator: Jenni Spencer-Davies

Purpose-built in 1911, but with a 'white cube' space added in the 1970s, this gallery's remit is to show the work of Wales-based artists such as Tim Davies (1997). These exhibitions are augmented by received and initiated shows – like *Some Organising Principles* (1993), at the time Peter Greenaway's only major solo exhibition in the UK.

Mission Gallery
Gloucester Place, Maritime Quarter
Swansea SA1 1TY
t/f 01792 652016
Daily 11-5
Gallery Co-Ordinator: Jane Phillips

An independent public gallery situated in the Maritime quarter of Swansea, this converted nineteenth-century seaman's chapel is one of Wales' premier venues for contemporary art. The gallery has a commitment to showing contemporary work and site-specific installations produced by artists with a national and international profile.

WREXHAM
Wrexham Arts Centre
Rhosddu Road, Wrexham LL11 1AU
t 01978 292093 f 01978 361876
email: gallery@wrexhamlib.u-net.com
Mon – Fri 9.30 -6.45
Sat 9.30-5
Visual Arts Officer: Tracy Simpson

A diverse programme of self-initiated and touring exhibitions displays a commitment to international and local artists, as well as a remit to reflect cultural diversity that has exposed Lesley Sanderson's *These Colours Run* (1994), Lubaina Himid's *Beach House* (1995), and contemporary art from South Africa (1996) to Welsh audiences.

OUTDOOR GALLERIES

Forest of Dean Sculpture Trail
c/o Forest Enterprise, Bank House, Bank Street
Coleford, Gloucs GL16 8BA
t 01594 833057 f 01594 833908
Daily 8–dusk
Chairman: Martin Orrom

In the mid-1980s a number of artists, including Magdalena Jetalova, Ian Hamilton Finlay and Cornelia Parker were invited to create a series of sculptural works for and inspired by the Forest of Dean. These remain on site, along with a changing selection of other projects and works in progress, either in a state of production or sometimes, of natural disintegration.

The Grizedale Society
Grizedale, Hawkshead, Ambleside, Cumbria LA22 0QJ
t 01229 860291 f 01229 860050
email: info@grizedale.org
Website: www.grizedale.org
Sculpture in the Forest: permanently open to the public
Gallery: daily, Easter – Nov 11-5
Director: Adam Sutherland

This working forest doubles up as an external project-space for local, national and international sculptors. Since 1977, artists have worked in the forest on a series of residencies, mostly with found materials. Works in progress can be seen alongside site-specific sculptures by established environmental artists like Andy Goldsworthy, David Nash, Sally Matthews, Shigeo Toya and Richard Harris. The result is the largest collection (over eighty) of site-specific works in the UK, on display on the society's two trails, as well as in its gallery (converted from a sawmill), which includes works by resident artists and drawings, maquettes and prints relating to the art outside. Artists in residence for 2000-1 include Jordan Baseman, Sarah Staton, Graham Gussin and Louise K. Wilson, with an emphasis on new media.

Sculpture at Goodwood
Goodwood, West Sussex PO18 0QP
t 01243 538449 f 01243 531853
email: w@sculpture.org.uk
Website: www.sculpture.org.uk
Mar – Nov, Thurs – Sat 10.30-4.30
Admission charges
Administrator: Marian Witcomb

Founded and privately endowed by Wilfred and Jeanette Cass in 1994, Sculpture at Goodwood is a charitable foundation dedicated to promoting and selling contemporary British sculpture both nationally and internationally. In its first five years, it realised over 100 sculptures. Goodwood both forms partnerships with artists, and works with other organisations to assist projects outside its own boundaries. Recent collaborations have included the Sculpture at Goodwood Commission Prize with the London Contemporary Art Fair and the joint initiation of the Fourth Plinth project with the Royal Society of Art. Situated fifty miles south of London, Goodwood's twenty acres of woodland walks and glades provide an idyllic venue for a changing display of contemporary sculpture by emerging and established artists.

Yorkshire Sculpture Park
Bretton Hall, West Bretton
Wakefield WF4 4LG
t 01924 830302 f 01924 830044
email: office@ysp.co.uk
Daily
Summer: grounds 10-6, galleries 10-5
Winter: grounds 10-4, galleries 11-4
Director: Peter Murray

As Britain's first sculpture park, situated in the eighteenth-century estate of Bretton Hall, Yorkshire Sculpture Park has pioneered the curating and promoting of open-air exhibitions and related events, often in close partnership with the Henry Moore Foundation. In addition to a loan collection that embraces Henry Moore, Barbara Hepworth, Anthony Caro, Richard Serra, Sol LeWitt, Richard Wentworth and Grenville Davey, there is also a changing programme of exhibitions and projects by established international figures. These have featured Barry Flanagan's bronze hares and works by Christo, Magdalena Abakanowicz and Joel Shapiro as well as by comparative newcomers like Kerry Stewart and Joel Shapiro.

INDEX

Page numbers in **bold** type denote main entries

Abakanowicz, Magadalena
272
Abbot Hall Art Gallery **246**
Abdu'Allah, Faisal 250
Aberdeen Art Gallery and
Museums **267**
Abromavic, Marina 180
Abts, Tomma 254
Acconci, Vito 158
ACE see Arts Council of
England
Ackling, Roger 263
aFoundation 195
Agency, The **250**
Ahtila, Eija-Liisa 184, 244
Aitchison, Craigie 237
Aitken, Doug 179, 240, 256
Alan Cristea Gallery 243, **250**
Albers, Josef 35, 141
Allen, Philip 251
Allen, Tim 249
Allington, Edward 149, 191,
213, 214, 254
Allthorpe-Guyton, Marjorie
228, 229
Almond, Darren 7, **111-113**,
166, 173, 258, 259
Alves da Silva, Augusto 265
Alys, Francis 260
Anderson, Laurie 187
Andre, Carl 41, 62, 176, 198,
202, 261, 263, 268, 271
Andrea and Phillippe 265
Andrew Mummery Gallery **250**
Andrews, Michael 181
Angel Row Gallery **263**
An Lanntair **270-1**
Annely Juda Fine Art **250**
Annual Programme **232**, 262
Anthony d'Offay Gallery 181-2,
250-1
Anthony Reynolds Gallery
184-5, **251**
Anthony Wilkinson Gallery
247, **251**
Antoni, Janine 170
An Tuireann Arts Centre **270**
Applebroog, Ida 267
Approach, The 178-9, 234, **251**,
257
Araki, Nobuyoshi 256, 268
Archigram 262
Architectural Association **226**
Arienti, Stefano 144, 254
Arman 189
Armitage, Kenneth 189
Arnaud, Danielle **252**
Arnold, Liz 251
Arnolfini **243-4**

Art Monthly 224-5, **241**
Art Newspaper, The **241**
art.tm **270**
Artangel 149-50, 187, 207, **232**
Artaud, Antonin 49
Artforum **242**
Artlab **233**
Arts Catalyst, The **233**
Arts Council of England (ACE)
200, **227-8**, 238, 245, 257,
266
Arts Council of England (ACE)
Collection **229**
Arts Council of Northern
Ireland (ACNI) **227-8, 229**
Arts Council of Wales (ACW)
227-8, 230
Artsadmin **233**
ArtSway **262**
Artwise **233**
Aspex Gallery **263-4**
asprey jacques **251**
Athey, Ron 271
Audio Arts **239**
Auerbach, Frank 188, 239
Austen, David 244
Avery, Charles 255
Axford, Tanya 265
AXIS **230**
Ayres, Gillian 190, 209, 238,
239, 246

B, Franco 233, 271
Bacon, Francis 7, 28, **10-12**, 28,
123, 146, 218
Bainbridge, Eric 262
Baker, Bobby 233, 248
Baldessari, John 262
Balkenhol, Stephan 256
Baltic Centre for Contemporary
Art 9, 230, **245**
Bank 232
Banner, Fiona **114-15**, 146, 153,
240, 249, 253
Barbican Art Gallery **257**
Barcelo, Miguel 256
Barden, Scott 267
Barlow, Phyllida 248
Barney, Matthew 149, 193, 232,
261
Barns-Graham, Wilhemina
245
Baseman, Jordan 261, 272
Basquiat, Jean-Michel 174,
199
Bataille, Georges 49, 177
Batchelor, David 246
Baumgarten, Lothar 268

Baxter, Glen 251
Beaconsfield 224, 235, **247**
Bean, Anne 233
Becher, Bernd and Hilla 151
Beck's Futures Awards **236**-7
Beecroft, Vanessa 253
Bell, Mark 250
Bell, Nicki see Langlands and
Bell
Bellany, John 240, 267
Bellmer, Hans 49
Belton, Kate 169, 255
Bendon, Helen 232
Bening, Sadie 152
Berwick Gymnasium Gallery
243
Best, Anna 262
Beuys, Joseph 46, 141, 181,
239, 251, 263, 267
Bevan, Tony 253, 255, 260, 263
Bhimji, Zarina 227, 233, 237,
243
Bick, Andrew 188, 254
Bickerton, Ashley 200, 202
Bicknell, Les 265, 270
Bill, Simon **115-17**, 188, 254,
255
Billingham, Richard 97, 185,
190, 215, 232, 237, 243, 251
Bismuth, Pierre 246
Blackadder, Elizabeth 245
Blacker, Karen 191
Blake, Peter 211, 238
Blakstad, Iona 261
Blaswick, Iwona **140-2**, 157
Blask, Neville 270
Blease, Gillian 235
Bluecoat Gallery 234, **246**
Boehm, Kathryn 265, 267
Boggs, J.S.G. 210
Boltanski, Christian 56, 199,
245, 250-1, 260
Bolton, Erica **204-5**
Bolton, Nicholas 248
Bomberg, David 188
Bond, Henry 252, 265
Bonn, David 239
Book Works **239-40**
Borland, Christine 7, **43-5**, 158,
203, 229, 245, 254, 269, 270
Bourgeois, Louise 141, 222,
234, 260
Bowie, David **186-8**, 242
Boyce, Martin 269
Boyce, Sonia 256, 262
Boyd and Evans (Fionnuala
Boyd and Leslie Evans) 253
Boyle Family 261
Bradley, Will 235, 269
Brancusi, Constantin 244
Breakwell, Ian 233, 251, 270,
271
Brennan-Wood, Michael 233
Brighton Museum and Art
Gallery **243**
Brill, Patrick (Bob and Robert
Smith) 249, 272
British Art Show **238**

British Council 145-6, 152, 222,
230
British Council Collection **230**
British Museum **260**
Brook, Minetta 236
Brooks, Jason 188, 244, 252
Brown, Cecily 179, 199, 256
Brown, Don 152, 255
Brown, Gavin 171
Brown, Glenn 158, 179, 258
Brown, Hainsley 265
Buchanan, Roddy 237, 270
Büchler, Pavel 239
Buckland, Michael 267
Bucklow, Christopher 251
Bulkhead **269**
Bulloch, Angela 122, 186,
193, 197, 203, 236, 240, 245,
258
Burden, Chris 243, 253
Burki, Marie José 236
Burra, Edward 189
Burroughs, William 249
Butt, Hamad 248, 265
Buxton, Nigel 247
Byam Shaw School of Art **226**

Cabinet Gallery 177-8, **251-2**,
260
Cable St Gallery **247**
Cadenet, Alexander de 249
Cadieux, Geneviève 256, 261
Cairn Gallery **263**
Callan, Jonathan 254
Calle, Sophie 151, 257, 260,
265
Calouste Gulbenkian
Foundation 238
Calvocoressi, Richard 230
Camberwell College of Arts
227
Cambridge Darkroom Gallery
244
Camden Arts Centre 150-2,
257
Cannon, Mark 258
Cardiff, Janet 232, 233
Carnegie, Gillian 178, 252
Caro, Anthony 37, 250, 262,
269, 271, 272
Carter, Claire 253, 254
Carter, Justin 269
Caspersen, Dana 232
Castlefield Gallery **262**
Catalyst Arts **266**
Catling, Brian **45-7**, 259, 260,
262
Caulfield, Patrick **12-15**, 237,
239, 250, 256, 257
CCA 230, **269**
Central St Martins College of
Art & Design **227**
Centre for Contemporary Arts
see CCA
Centre for Visual Arts 144-5,
271
Cerveira, Glauce 252
Cesar 189

Chadwick, Helen 7, **15-17**, 21, 45, 52, 62, 167, 213, 214, 231, 233, 237, 254, 257, 263, 264, 265, 268
Chadwick, Lynn 264
Chaimowicz, Marc 252
Chamberlain, John 200
Chapman, Jake and Dinos **47-50**, 152, 153, 163, 166, 171, 173, 180, 199, 201, 231, 240, 245, 247, 251, 253, 258, 259, 260, 265
Chapman FineARTS 171, **247**
Chapter Arts Centre **271**
Chelsea College of Art & Design **227**
Chia, Sandro 194
Childish, Billy 239
Chillida, Eduardo 250
Chisenhale Gallery 257
Chodzko, Adam 146, 151, 153, 158, 223, 243, 246
Chomsky, Noam 239
Christo 202, 220, 250, 272
Citibank Private Bank Photography Prize **237**
City Racing 224, 232
Clark, Lygia 260
Clarke, Larry 252
Clemente, Francesco 261
Close, Chuck 244, 257
Clough, Prunella 151, 244
Coates, Nigel 191
Coburn, Jason 236
Cocker, Jarvis 186
Cohen, Frank 172, **188-9**
Coldstream, William 181
Coles, Alan **170-2**, 197, 235, 255-6, 260
Coley, Nathan 270
Collective Gallery 229, **268**
Collings, Matthew 186, **216-17**, 242
Collins, Cecil 181
Collins, Hannah 214
Collishaw, Mat 7, 25, **50-2**, 151, 164, 190, 196, 196, 230, 251, 257, 263
Colvin, Calum 268
Commissions East **233**
Condon, George 179
Conductors Hallway **252**
Constantino, Nichola 238
Contemporary Art Society (CAS) **230**, 245, 246, 266
Contemporary Visual Arts **241**
Context Gallery **267**
Cook, Beryl 269
Coombes, Dan 179, 249
Coplans, John 268
Cork, Richard **217-18**
Cornerhouse **262**
Corvi-Mora **252**
Counsell, Melanie **52-54**, 148
Coventry, Keith 240, 255
Cowan, Judith 263
Cox, Stephen 260

Cragg, Tony 37, 77, 175, 218, 245, 254, 260, 264
Craig-Martin, Michael **142-4**, 178, 250, 256
Creed, Martin 8, **118-19**, 122, 151, 146, 147, 178, 180, 186, 203, 212, 230, 235, 240, 246, 249, 251, 257, 265
Crewdson, Gregory 252
Crone, David 266
Cross, Dorothy 232, 243, 253
Crotty, Russell 252
Cruz, Angela de La 8, **120-1**, 188, 248, 251
Cruz, Juan 237, 258, 265
Cubitt **247**
Curran, Michael 245
Currie, Ken 188
Currin, John 170, 194, 197, 255
Cuss, John 177
Cutts, Simon 179

Dalí, Savador 4, 49
Dalziel and Scullion (Matthew Dalziel and Louise Scullion) 153, 268, 270, 272
Dalwood, Dexter (Dick Witts) 220
Daly, Pauline 171
Dane, Thomas 190
Darbyshire, Mark **205-6**
Davenport, Ian 91, 144, 189, 256, 263, 265, 267,
Davey, Grenville 37, 246, 254, 261
David, Enrico 133, 151, 179, 250, 251
Davie, Alan 190
Davies, Hywel 262
Davies, John 227
Davies, Tim 272
Davis, Peter 36, 163, 251
Dawson, Ian 135, 169, 249, 255
Dazed & Confused 241
Deacon, Richard 37, 77, 150, 175, 183, 191, 213, 231, 240, 254
Deakin, John 195
Dean, Mark 237, 254
Dean, Tacita 146, 167, 220, 239, 244, 247, 253, 261, 263, 267
Dean Clough Galleries **245**
Deblonde, Gautier 168
Decima Gallery **247**
de Jong, Constance 236
De Kooning, Willem 123
Delfina **247**
Deller, Jeremy **122-4**, 145, 147, 158, 178, 186, 240, 249, 252, 263, 271
Delwood, Dexter 250
Demand, Thomas 180, 199, 247, 256
Derges, Susan 255, 264
Dickinson, Rod 249
Dijkstra, Rineke 237
Dilworth, Steve 271

Dine, Jim 189, 250, 269
Dion, Mark 141, 243, 261
Dix, Otto 48
Dobai, Sarah 232
d'Offay, Anne 181, 182
d'Offay, Anthony **181-2**, 250-1
Doherty, Willie 44, **54-56**, 148, 167, 190, 193, 230, 258, 263, 267
Doig, Peter **57-59**, 134, 146, 147, 180, 237, 238, 240, 251, 253, 256, 260, 265
Dolven, A.K. 251
Dominic Berning **252**
Donachie, Jacqueline 235, 270
Donachie, Kaye 59
Donagh, Rita 151
Doron, Itai 174
Doyle, Sarah 232
Dubuffet, Jean 189
Duchamp, Marcel 18, 23, 24, 29, 38, 45, 100, 103, 135, 141, 239
Duffy, Damien 249
Duffy, Rita 266
Dumas, Marlene 194, 253, 257
Duncan of Jordanstone College of Art & Design, School of Fine Art **226**
Dundee Contemporary Arts 230, **267**
Durham, Jimmie 148, 258

Eagle Gallery 224
EAST International and river-side **237**, 263
East Midlands Arts Board **228**
Eastern Arts Board **228**
Edmier, Keith 171
Egbert, Ann 152
Elephant Trust **231**
Eliasson, Olafaur 267
Ellis, Peter 251
Emily Tsingou Gallery **252**
Emin, Tracey 22, **59-61**, 129, 153, 161, 173, 190, 193, 194, 196, 198, 205, 220, 232, 239, 245, 254, 256, 260
Engle, Vanessa 215
English, Rose 237
Eno, Brian 187, 256
Entrecanales, Delfina 247
Entwistle **252**
Esche, Charles 235
Ess, Barbara 269
Evans, Geraint 188
Evans, Rachel 223, 263
Evans, Stuart **189-90**, 254
Everything **241**

Fabre, Jan 233, 252, 261
Fairhurst, Angus 166, 171, 186, 190, 196, 249, 255, 256
Fairnington, Mark 244
Falconer, David 171, 247
Falmouth College of Arts 264
Farquharson, Alex **144-5**
Fawcett, Anthony **206-7**

Fawns Watt, Jane 235
Feinstein, Rachel 252
Fenton, Max 271
Ferens Art Gallery **245**
Ffotogallery 230, **271**
fig-1 **233**
Finlay, Ian Hamilton 179, 256, 263, 272
firststite @ the Minories art gallery 244
Fischer, Konrad 179, 237
Fischli-Weiss (Peter Fischli and David Weiss) 135, 141, 194
Five Years **248**
Flanagan, Barry 189, 225, 272
Flashart **242**
Flavin, Dan 176, 200, 202
Fleming, Patricia 269
Fleissig, Peter **191-2**
Fleury, Sylvie 254
Flowers East **252-3**
Floyer, Ceal 153, 247, 254
fly **269**
Focal Point Gallery **265**
Fontana, Bill 261
Fordham **248**
Forest of Dean Sculpture Trail **272**
Forster, Richard 265
Forsyth, William 232
Foundation for Art & Creative Technology (FACT) **234**
Francis, Mark 189, 233, 254, 262
Frankland, John 173, 247, 254
Freedman, Carl 153, **160-1**, 260
Freeman, Barbara 266
Freud, Lucian **17-19**, 181, 182, 187, 246, 260
Freud Museum **260**
frieze 222-3, **241**, 242
Fringe Gallery **269**
Fritsch, Katharina 141
Frith Street Gallery **253**
Frize, Bernard 253
Frost, Natalie 265
Frost, Terry 240
Fruitmarket Gallery 229, **268**
Fry, Robin 211
Fryer, Paul 236
Fulton, Hamish 56, 167, 240, 246, 250, 263
Funakoshi, Katsura 250
Furlong, William 239
Furness, David 187
Furuta, Hideo 264

Gabo, Naum 264
Gabriel Orozco 251
Gagosian Gallery **253**
Gallaccio, Anya 16, **62-3**, 211, 213, 218, 220, 231, 235, 237, 244, 247, 258, 259, 262, 267
Gallacher, Lisa 269
Gallagher, Ann **145-6**
Gallagher, Ellen 251
Gallery of Modern Art Glasgow **269**

Gallery Westland Place **253**
Galli, Letizia 233
Garrard, Rose 243
Gaskell, Anna 237
Gasworks **248**
Gaudier-Brzeska, Henri 244
Gec, Stefan 227, 234, 236, 261
Geers, Kendell 256
Geesin, Ron 233
General Assembly 211-12
Generator Projects **267-8**
Gersht, Ori 250
Gibbs, Ewan 249
Gibson, Lloyd 234, 235
Gibson, Rick 210
Gidley, Thomas 122, 153, 186, 223
Gilbert and George **19-22**, 47, 83, 128, 161, 182, 188, 194, 199, 207, 238, 246, 251, 260, 261, 262, 266
Gillick, Liam **161-2**, 203, 233, 244, 252, 265
Gimpel Fils **253**
Glasgow Print Studio **269**
Glasgow School of Art **226**
Glendinning, Hugo 213
Glynn Vivian Art Gallery **272**
Goede, Leo de 254
Gober, Robert 193, 194, 199, 200, 246
Goddard, Judith 265
Godfrey-Isaacs, Laura 246, 248, 265
Goetz, Ingvild **192-3**
Golden, Pamela 239
Goldin, Nan 61, 97, 215
Goldsmiths College 142-4, **227**
Goldsworthy, Andy 255, 260, 269, 272
Golub, Leon 185, 251
Gontanski, Steven 133 174
Gonzalez-Torres, Felix 151, 257, 259
Gooding, Mel **218-19**
Goodwin, Dryden 265
Gordon Nesbitt, Rebecca 249, 269
Gordon, Douglas 30, **63-6**, 149, 153, 158, 167, 175, 191, 193, 196, 203, 219, 223, 229, 231, 232, 238, 248, 254, 265, 270
Gormley, Antony **66-8**, 149, 167, 173, 213, 227, 256, 262, 264, 265
Goto, John 250
Gottelier, Luke 250, 252
Graham, Dan 151, 176, 257
Graham, Paul 97, 146, 251, 261
Granger, Simon 252
Grassie, Andrew 244
Green, Gregory 158, 252
Greenaway, Peter 262, 272
greengrassi **253-4**
Griffiths, Brian 256
Grigely, Joseph 141
Griffiths, Michelle 169

Grippo, Victor 243
Grisoni, Tony 46
Grizedale Society **272**
Guardian 223-4
Guerra, Carles 267
Gunning, Lucy 220, 258
Gursky, Andreas 180, 197, 237, 246, 256, 259
Gussin, Graham 146, 227, 233, 263, 265, 272
Guston, Philip 194, 256
Guthrie, Karen 237

Haacke, Hans 164, 180
Habitat 210-11
Hales Gallery 172-3, 253, **254**
Hambling, Maggi 237
Hamilton, Alex 270
Hamilton, Ann 246
Hamilton, Richard **22-4**, 233, 238, 262
Hamlyn Awards **237**
Hapaska, Siobhán **68-70**, 146
Happell, Dene 269
Harding, Alexis 121, 144, 250
Haring, Keith 86, 174, 199
Harper, Edward 188
Harris, Richard 272
Harris Museum and Art Gallery **264**
Hartley, Alex 210, 231, 244
Hasagawa, Jun 163
Haselden, Ron 213, 248, 263
Hatoum, Mona 21, **71-73**, 150, 173, 193, 209, 229, 231, 243, 256, 264, 271
Hatton Gallery 245
Hawkins, Richard 252
Hayes, Dan 163, 249, 252
Hayward Gallery 229, 238, **257**
Head, Tim 187, 233, 261
Heath, Claude 188, 254
Hedge, Paul **172-3**
Hemsworth, Gerard 249
Henderson, Ferguson 196
Henderson, Margot 196
Henry Moore Foundation **231**, 272
Henry Moore Foundation External Programmes 231, 246
Henry Moore Foundation Studio 231, **245**, 246
Henry Moore Institute 231, **246**
Henry Moore Sculpture Trust 141
Hepworth, Barbara 251, 264, 272
Herbert Read Gallery **244**
Herian, Katrine 263
Herold, Georg 183, 254
Heron, Patrick 151, 240, 257, 264
Hertzsch, Eva 232
Hesse-Honegger, Cornelia 234

Higgs, Matthew 8, 9, **146-8**, 239, 251
Hill, Gary 174, 246, 256, 263
Hiller, Susan 7, **24-6**, 141, 227, 239, 243, 246, 247, 256, 258, 260, 265,
Hilty, Greg 229
Himid, Lubaina 272
Hiorns, Roger 252
Hirshhorn, Thomas 154
Hirst, Damien 7, 11, 16, 20, 22, 23, **26-9**, 35, 40, 50, 62, 141, 153, 160, 167, 173, 174, 175, 186, 187, 188, 190, 191, 196, 199, 200-1, 206, 208, 209, 210, 213, 220, 238, 239, 253, 256, 258, 262, 263
Hiscock, David 255
Hoberman, Nicky 188
Hockney, David 12, 20, 238, 239, 250, 269
Hodgkin, Howard 238
Höhenbuchler, Christine and Irene 244
Holdsworth, Dan 265
Holmes, Andrew 244
Holzer, Jenny 56, 86, 141, 183, 184, 197, 254
Home **248**
Hood, Beverley 268
Hopkins, Louise 250
Hopton, Georgie 252
Horn, Roni 236
Horsfield, Craigie 245, 253
Houshiary, Shirazeh 229
Howson, Peter 187, 240, 253
Hughes, Dean 254
Hughes, Patrick 253
Hughes, Stephen 233
Hume, Gary 14, 19, **73-6**, 84, 90, 144, 152, 153, 154, 171, 186, 211, 237, 257, 260, 263, 268, 270
Hunter, Alexis 220
Hunter, Kenny 188, 255
Hurrel, Stephen 270
Huws, Bethan 231, 232, 271
Huxley, Paul 264

Ikon 230, **243**
Illuminations Group 214-15
Imaginaria **237**
Impressions Gallery **266**
Imprint 93 9, 141, 146-8, **240**
Innes, Callum 91, 189, 190, 191, 253, 268
Institute of Contemporary Arts (ICA) 146-8, 158-9, 237, 241, **258**
Institute of International Visual Arts (inIVA) **234**, 247, 164
Interim Art 183-4, **254**
international 3 **262**
Inventory 147, 179, **234**, 240
Inverleith House, Royal Botanic Garden **268**
Irvine, Jaki 153, 247, 253, 258

Isaacs, John 233
Isermann, Jim 252, 257

Jackowski, Andrzej 255
Jackson, Mel 239
Jacobson, Bernard 187, 242
Jacques, Alison 251
Jarman, Derek 176, 263
Jarre, Jean-Michel 164
Jenssen, Olav Christopher 251
Jerwood Foundation 261
Jerwood Painting Prize **237**
Jerwood Space **258**
Jetalova, Magdalena 272
Joachimides, Christos 166
Joffe, Chantal 179
John, Elton 187
John Hansard Gallery **265**
John Moores Liverpool Exhibition of Contemporary Painting 195, **237-8**
Johns, Jasper 23, 181, 257
Johnston, Robert 235
Johnstone, Isobel 229
Jones, Allen 12, 220, 239
Jones, Gareth 247, 252
Jones, Sarah 173, 254, 258
Jones, Simon 265
Jones, Zebedee 256
Jopling, Jay **173-5**, 196, 233
Judd, Donald 28, 62, 176, 202, 261, 263
Julien, Isaac 180, 256

Kahlo, Frida 61, 260
Kalmár, Stefan 240
Kalmus, Marion 233, 272
Kapoor, Anish 86, 167, 175, 203, 213, 218, 238, 240, 245, 254, 267
Katase, Kazuo 250
Kaur, Permindar 243, 244, 263
Kawamata, Tadashi 250
Kay, Emma 179, 250, 251
Keane, John 253
Kelley, Mike 83, 158, 166, 179, 193, 259
Kelly, Anthony Noel 211, 249
Kelly, Ellsworth 35
Kelly, Mary 141, 271
Kelly, Roger 255
Kemps, Niek 270
Kennedy, Brian 266
Kent, Sarah 129, **219-20**
Kentridge, William 199, 256
Kerbel, Janice 240
Kettle's Yard Gallery **244**
Key, Joan 255
Kiefer, Anselm 202, 260
Kienholz, Ed 60
Kilimnik, Karen 247, 256
King, Philip 264
Kippenberger, Martin 154
Kirby, John 253
Kirkup, Wendy 234
Kitaj, R.B. 12, 239
Kivland, Sharon 256
Klassnik, Robin **148-9**

Knall, Ulli 250
Koester, Joachim 244
Kondracki, Henry 253
Koons, Jeff 28, 166, 181, 194, 199, 200, 202, 259
Kossoff, Leon 250
Kosuth, Joseph 151, 257
Koudelka, Josef 271
Kounellis, Jannis 245, 251
Kovats, Tania 188, 243, 251, 264
Kretschmer, Melissa 268
Krisanamis, Udomsak 180
Kruger, Barbara 56
Kuhn, Hans Peter 149
Kusama, Yayoi 259
Lafontaine, Marie-Jo 260

Lambie, Jim 64, 159, 186, 188, 235, 255, 260
Landau, Sigalit 232
Landers, Sean 256
Landy, Michael 154, 160, 161, 199, 210, 214, 232, 261
Lane, Abigail 190, 193, 231, 236, 239
Langlands and Bell 196, 250, 255, 265
Langlands, Ben see Langlands and Bell
Lansley, Jo 232
Lanyon, Peter 188
Laure Genillard 254
Laurent Delaye Gallery 254
Lazenby, Michele 270
Lee, Edward and Agnes 194
Leeds City Art Gallery 246
Leventon, Rosie 261
Levine, Les 245
Levine, Sherrie 193, 199
Lewandowski, Simon 265
LeWitt, Sol 175, 200, 201, 202, 261, 263, 268, 271, 272
LIFT 248
Lim, Kim 151
Lind, Maria 249
Lindberg, Maria 255
Lingwood, James 149-50
Linke, Simon 222
Lisson Gallery 175-7, 254
Little, Graham 265
Little, Kathleen 269
Little, Mary 270
Liverpool Biennial 238
Lloyd, Hilary 236, 257
Locus+ 234, 235
Logsdail, Nicholas 9, 175-7, 237
Lomax, Jenni 150-2
London, Barbara 165
London Arts Board 228
London Contemporary Art Fair 239
London Institute 227
Long, Richard 56, 191, 237, 240, 244, 245, 246, 251, 261, 263, 267, 271

Lowe, Rachel 124-6, 151, 169, 257, 265
Lowenstein, Lyn 268
Lowry, L.S. 189
Lucas, Sarah 22, 61, 76-8, 129, 153, 170, 187, 190, 193, 196, 201, 205, 206, 212, 214, 215, 220, 255, 260
Lum, Ken 250
Lundin, Ulf 259
Lusby Taylor, Louise 235
Lux 152-3, 258
Lux Biennale 239
Luxemburg, Rut Bles 254, 265
Lydiate, Henry 211

Mabb, David 265
McBane, Precious 270
McBride, Riat 167
McCail, Chad 254
McCarthy, Paul 199, 250
McCullin, Don 123
McGeown, Martin 158, 177-8
McGinn, Martin 237, 248
Mach, David 270
McKeever, Ian 231, 240, 244
McKenzie, Craig 64
MacKenzie, Lucy 237, 269
McLaren, Malcolm 187
Maclaurin Art Gallery 267
McLean, Bruce 29-31, 209, 219, 238, 240, 243, 245, 262, 268, 270
Maclennan, Alistair 268
MacLeod, Myfanwy 250
Macmillan, Ian 215
McMullan, Shauna 270
McQueen, Steve 78-81, 184, 191, 193, 234, 238, 251, 258
McWilliam, Shirley 264
Magnani 254
Magnani, Gregorio 252
Magritte, René 21-2, 49, 76
Malig, Michael 270
Malinowski, Antoni 253
Maloney, Martin 8, 128, 163-4, 211, 220, 251
Malraux, André 191
Manchester City Art Gallery 262
Manchot, Melanie 262, 271
Manzoni, Piero 83, 100, 259
Mappin Art Gallery 264-5
Mapston, Tim 225
Marden, Brice 202
Maria, Walter de 108
Marie-France & Patricia Martin 252
Marisaldi, Eva 252
Mark, Kelly 267
Marker, Chris 235, 247
Markiewicz, Lily 271
Marlborough Gallery 243
Martin, Agnes 35, 268
Martin, Jason 91, 121, 144, 176, 237
Maslin, Paul 172-3
Matisse, Henri 90

Matt's Gallery 148-9, 172, 258
Matta-Clark, Gordon 110
Matthews, Sally 272
Maybury, John 215
Mead Gallery 244
Meadows, Bernard 189
Meadows, Jason 252
Medalla, David 176, 195, 264
Mednikoff, Rueben 225
Medway, Jim 232
Mellow Birds 248
Messina, Antonio 245
Metzger, Gustav 145, 225
Meyer-Hermann, Eva 260
Michael Hue-Williams Fine Art 254-5
Mikhailov, Boris 259
Milch 248
Millar, Jeremy 164-5, 162, 258
Miller, Alain 251
Miller, Jake 178-9
Miller, Lee 158
Milroy, Lisa 238, 250, 256, 263, 268
Milton Keynes Gallery 9, 262
Miró, Joan 90, 189
Miro, Victoria 179-80
Miro, Warren 180
Mission Gallery 272
Miyajima, Tatsuo 196, 198, 232, 267
Modern Art 255, 257
Modern Institute 158-9, 171, 234, 235
Modern Painters 187, 217, 241-2
Modotti, Tina 260, 268
Moffatt, Tracey 180, 244
Molinier, Pierre 158, 177
Möller, Regina 141
Monchaux, Cathy de 7, 81-3, 210, 257, 261
Montag, Daro 255
Moore, Henry 37, 69, 231, 272
Moores, James 195
Morawska, Kasia 261
Morfill, Sally 248
Morgan, Stuart 221-2, 241, 247
Mori, Mariko 196
Morris, Frances 141, 157
Morris, Robert 100
Morrison, Paul 14, 36, 188, 191, 199 250, 251
Morreau, Jacqueline 220
Moyes, Jim 208-9
Muir, Gregor 152-3, 258
Mulfinger, Jane 252
Multiple Store, The 240
Muñoz, Juan 150, 199, 253
Murphy, Stephen 146
Museum of Installation 248
Museum of Mankind 234
Museum of Modern Art (MOMA) 231, 263
Music, Zoran 263
Mylayne, Jean-Luc 259

Nairne, Sandy 214

Naldi, Pat 234
Napier, Philip 267
Nash, David 244, 272
National Art Collections Fund 230
National Lottery 230
National Maritime Museum 261
National Museum of Photography Film & Television 243
NATØ 141, 191
Natural History Museum 260-1
Nauman, Bruce 18, 41, 96, 141, 192, 200, 234, 257
Neill, Angus 247
Nelson, Mike 135, 148, 151, 169, 243, 257, 258, 268
Nesbitt, Judith 153-5
NESTA 238
Neudecker, Mariele 243, 244
New Art Centre Sculpture Park & Gallery 264
New Art Gallery 230, 265-6
New Contemporaries 239
Newling, John 263
Newlyn Art Gallery 263, 264
Newman, Barnett 151
Newman, Haley 263
Newman, Peter 203, 252
Nicholson, Ben 244, 264
Nicolai, Casten 248
Nikolaev, Stefan 250
Nimarkoh, Virginia 232
Nitsch, Hermann 249
Nittve, Lars 157
Noble, Paul 8, 126-8, 147, 154, 184, 240, 249, 254
Noble, Tim and Sue Webster 128-30, 144, 135, 154, 187, 188, 196, 255
Nogueira, Lucia 243
Noland, Cady 135, 146, 193
Nonas, Richard 265
Nordenstaad, Thomas 235
Norman, Maia 196
Norman, Nils 240
North West Arts Board 228
Northern Arts Board 228
Northern Gallery for Contemporary Art 265
Norwich Gallery 263
Norwich School of Art and Design 237
Nosepaint 247
Nottingham Castle Museum & Art Gallery 263
Nunnery, The 248-9
nvisible Museum 190-1
Nylon 255

Obrist, Hans Ulrich 165, 205, 249
Ocean, Humphrey 261
Ofili, Chris 83-5, 141, 146, 193, 199, 233, 238, 238, 239, 240, 247, 256, 259, 263, 265

Oldenburg, Claes 28
Oliver, Anthony 213
One in the Other **249**
O'Neill, Lorca 168
Ono, Yoko 176, 234, 263, 266
Open Hand, Open Space **264**
Opie, Catherine 259
Opie, Julian 14, 37, **85-7,** 158, 175, 188, 222, 223, 254, 257, 265
Oppenheim, Denis 243
Orchard Gallery 229, **267**
Oriel Mostyn Gallery 230, 231, **271**
Oriel 31 **271-2**
Orimoto, Tatsumi 249
Orlan 268, 271
Ormeau Baths Gallery 229, **266**
Orozco, Gabriel 149
Oursler, Tony 234, 262
Owens, Laura 256, 268

Padovani, Clio 248
Page, Adam 232
Pailthorpe, Grace 225
Paine, Roxy 255
Palacin, Mabel 265
Paladino, Mimmo 189, 231, 250, 260
Paley, Maureen 9, **183-4,** 172, 206, 245, 254
Pane, Gina 265
Paolozzi, Eduardo 189, 190, 211, 260, 268
Paragon Press **240,** 268
Parker, Cornelia **87-9,** 214, 218, 227, 231, 232, 239, 245, 249, 253, 257, 259, 260, 261, 264, 271, 272
Parker, Jayne 245
Parkett **242**
Parr, Martin 243, 255, 271
Parsons, Jonathan 255
Patrons of New Art **231-2**
Patterson, Richard 251, 265
Patterson, Simon 37, 191, 223, 248, 249, 254, 257, 259, 267
Peacock Gallery **267**
Peer Trust **235**
Penone, Giuseppe 237, 245, 253
Percy Miller Gallery **255**
Perkins, Gary 169
Periton, Simon 133, 151, 158, 170, 211, 240, 255, 257, 258
Perry, Grayson 8, 128, **130-2,** 133, 170, 188, 254
Pessoli, Alessandro 254
Peyton, Elizabeth 146, 171, 252, 256
Peyton, Oliver 171, 172, **196-7**
Phaophanit, Vong 229, 243, 268
Phillips, Tom 253
Photographers' Gallery 164-5, **258-9**
Picasso, Pablo 49, 123

Pier Art Centre 229, **271**
Piggott, Hadrian 255
Piper, Adrian 243
Piper, Keith 234, 237, 243
Pippin, Steven 23, 141, 161, 231, 245, 251, 261
Pistoletto, Michaelangelo 151, 245
Pittman, Lari 144, 174, 254, 256, 262
Pitz, Hermann 244
Platform **249**
Plensa, Jaume 245
Pollock, Jacson 117, 123
Pope, Nina 237
Portfolio Gallery **268**
Potteries Museum & Art Gallery **265**
Power, Mark 243
Prada, Ana 258
Prendergast, Kathy 246
Prieto, Monique 252
Prince, Nigel 169
Prince, Richard 166, 171, 172, 174, 197, 193, 256, 259
Proposition Gallery **266-7**
Pruit, Rob 178
Public Art Commissions and Exhibitions (PACE) 235
Public Art Development Trust **236**
Purdy Hicks 243, **255**
Putnam, James 260
Pyman, James 249, 252

Quinn, Jane **204-5**
Quinn, Marc 173, 174, 187, 191, 201, 240, 259, 260, 261

Rae, Fiona 14, 41, **90-1,** 263
Raedecker, Michael 7, 8, 59, **132-4,** 133, 178, 190, 199, 238, 249, 251
Rauschenberg, Robert 60, 135
Rawlinson, Ian 232
Ray, Charles 49, 183, 199, 241, 254
Rayson, David 59, 188, 190, 199, 254
RED Gallery **245-6**
Reed, Mark **198**
Regional Arts Boards (RABs) **228**
Rego, Paula 7, 17, **31-4,** 246
Reinhardt, Ad 151, 257
Renwick, Gavin 244
Reynolds, Anthony **184-5,** 251
Reynolds, Richard 169
Rhoades, Jason 135
Rhodes, Carol 250, 269
Richard Salmon **255**
Richmann, Martin 198, 252
Richter, Gerhard 56, 57, 141, 150, 233, 250
Ricketts, Sophy 252, 253
Rielly, James 237

Riley, Bridget **34- 6,** 144, 244, 246, 257, 262, 264, 267, 269
Rist, Pipilotti 154, 236, 257
Robert Prime Gallery 252, 254
Roberts, James 152, **222-3**
Roberts, John 248
Roberts, William 189
Robertshaw, Simon 234
Robertson, Mitch 267
Rocket Gallery **255**
Rodley, Chris 215
Rodney, Donald 229, 233, 234
Roijen, Hester van 256
Rolfe, Nigel 267
Rollins, Tim + KOS 184, 254
Root, Ruth 255
Rosen, Andrea 171
Rosenthal, Norman **165-6,** 168, 259
Rosler, Martha 243
Royal Academy of Arts 165-6, **259**
Royal Academy of Arts Schools **227**
Royal College of Art **227,** 233
Royse, Julia 175
Rubell, Don and Mera **199**
Rückreim, Ulrich 167
Ruscha, Ed 181, 250
Rushton, Emma 246
Ruskin School of Drawing and Fine Art **227**
Russolo, Luigi 122
Rüthi, Andreas 255
Ryan, Joel 232
Ryman, Robert 176, 202, 261

Saatchi, Charles 27, 73, 108, 161, 163, 164, 166, 172, 175, 192, **200-2,** 220, 254, 259
Saatchi Gallery **259**
Sabin, Andrew 245
Sadie Coles HQ 170-2, 235, **255-6**
Sadotti, Giorgio 147, 249
Saffer, Staffan 265
Sainsbury, Timothy 187
Sainsbury Centre for Visual Arts, University of East Anglia **263**
St James, Marty 245
Saito, Yoshishige 250
Salcedo, Doris 238
Sali Gia **249**
Salle, David 199
salon3 **249**
Salt, John 244
Samba, Chérie 141
Sanders, Mark 247
Sanderson, Lesley 272
Sarcevic, Bojan 249
Saunders, Nina 245
Savvas, Nike 211, 212
Saville, Jenny 18, 123, 253
Scanner 261
Schatz, Silke 251
Schlieker, Andrea **167**

Schnabel, Julian 199, 174, 202, 260, 261
Schubert, Karsten 180
Schütte, Thomas 150, 253
Schwitters, Kurt 29, 135, 245, 246
Sciart **238**
Science Museum **261**
Scott Wright, Glenn 180
Scottish Arts Council (SAC) 227-8, **229-30,** 238
Scottish National Gallery of Modern Art **268**
Scullion, Louise *see* Dalziel and Scullion
Scully, Sean 238, 256, 261, 262
Sculpture at Goodwood **272**
Searle, Adrian 221, **223-4,** 229, 239
Seator, Glen 206
Seawright, Paul 190
Sellman, Billee 160
Semner, Bettina 244
Serota, Nicholas **155-7,** 166, 238
Serpentine Gallery 88, 154-5, 231, **259**
Serra, Richard 67, 200, 208, 259, 272
Serrano, Andres 268
Sewell, Brian 218
Shand Kydd, Johnnie **168**
Shapiro, Joel 272
Shaw, George 59, 190
Sherman, Cindy 49, 193, 261, 262
Shonibare, Yinka 231, 234, 243, 249, 256, 261, 271
Short, Louise 244
Showroom, The **259-60**
Shrigley, David 64, 165, 249, 256, 270
Shutter, Tim 252
Siderfin, Naomi 247
Sighicelli, Elisa 254, 271
Signer, Roman 165
Silva, Mike 249
Simmonds, Gary 254
Simpson, D.J. 188, 249, 258, 265
Simpson, Jane 251
Sinclair, Ross 164, 250, 263, 268, 269, 269, 270
Sinden, Tony 262
Site Gallery **265**
Skrynka, Stephen 235
Slade School of Fine Art **227**
Sladen, Mark 257
Slaman, Naomi 248
Smith, Bob and Roberta *see* Patrick Brill
Smith, Bridget 190, 258
Smith, Gerry 252
Smith, Kate 258
Smith, Michael **209-10**
Smith, Neville 265
Smith, Stephanie 141, 259, 270
Smithson, Robert 150

Snaebjornsdottir, Bryndis 269
Snow, Michael 244
Sorensen, Glenn 252
South East Arts Board **228**
South London Gallery 231,
 260
South West Arts Board **228**,
 264
Southampton City Art Gallery
 265
Southern Arts Board **228**
Space Explorations **236**
Spacex Gallery **244-5**
Spence, Prunella 258
Spero, Nancy 141, 150, 185,
 251, 267
Sprinkle, Annie 271
Stark, Frances 147, 240
Starkey, Hannah 190
Starkmann, Bernhard **202-3**
Starling, Simon 64, 146, 159,
 235, 237, 257, 264, 269
Starr, Georgina 31, **92-3**, 122,
 146, 161, 184, 186, 191, 203,
 223, 236, 239, 245, 251, 261
Static Gallery **246**
Staton, Sarah 248, 254, 272
Stefano, Arturo Di 255
Stehli, Jemima 247
Steinbach, Haim 265
Stelarc 268
Stella, Frank 259, 261
Stephen Friedman Gallery **256**
Stephens, Mark **210-11**
Stevens, Gary 233, 248
Stewart, Dave 29, 31, 187
Stewart, Edward 141, 259-60,
 270
Stewart, Kerry 251, 256, 268,
 269, 272
Stezaker, John 247, 253
Stidworthy, Imogen 245
Stills **268-9**
Stockham, Jo 244
Stockholder, Jessica 145
Stoner, Tim 251
Street Level Photoworks **270**
Strode, Thaddeus 250
Sugimoto, Hiroshi 255, 263
Sulter, Maud 246
Sylvester, David 146, 181

Taaffe, Philip 268
Tablet **249**
Tait, Neal 174
Takahashi, Tomoko 8, **135-7**,
 169, 173, 190, 227, 247, 248,
 249, 252, 254, 269, 271,
Talbot Rice Gallery **268**
Tandberg, Vibeke 247
Tanning, Dorothea 151
Tate 155-7, 231, **242**
Tate Britain **261**
Tate Liverpool 141, 231, **246**
Tate Modern 9, 140-2, **261**
Tate St Ives **264**
Taylor, Marcus 235, 243
Taylor, Timothy 189

Taylor-Wood, Sam 31,
 94–6, 105, 152, 154, 171, 173,
 187, 193, 196, 197, 205, 212,
 231, 236, 256, 257, 259
Tegala, Simon 254
Tennant, Neil 187
30 Underwood St Gallery **249**
Thomas, Rose 269
Thompson, Estelle 255
Thompson, Matthew 264
Thomson & Craighead 244
Thorpe, David 14, 184, 188
Three Month Gallery 232
Tickle, Matthew 236, 258
Tillmans, Wolfgang **96-8,** 154,
 190, 197, 254, 257, 269
Tilson, Jake 227
Timberlake, John 249
Time Out 219-20
Times 217-18
Timoney, Padraig 249
Timothy Taylor Gallery 256
Tiravanija, Rirkrit 195, 235, 271
Titchner, Mark 169
Todd, Graeme 190, 268
Toren, Amikam 146
Towner Art-Gallery and
 Museum **244**
Toya, Shigeo 272
Trade Apartment, The **249-50**
Tramway 230, 231, **270**
Transmission Gallery 229,
 232, **270**
(Trans)position **236**
Tunga 260
Turk, Gavin 25, **99-100,** 145,
 174, 195, 211, 212, 224, 231,
 233, 254
Turnbull, William 189
Turner Prize 232, **238**
Turrell, James 108-9, 255, 257,
 263
291 Gallery **249**
Twombly, Cy 200, 259
Tyson, Keith 7, **137-9,** 146, 165,
 179, 185, 198, 239, 249, 251,
 254, 258
Tyson, Nicola 171, 256

University College London *see*
 Slade School of Fine Art
University of Oxford *see* Ruskin
 School of Drawing and Fine
 Art **227**
Untitled **242**
Ursitti, Clara 268

Van der Stokker, Lily 178
Van Meene, Hellen 259
Vasarely, Victor 35
Victoria Miro Gallery 179-80,
 256
Vilma Gold Gallery **256**
Viner, Darrell 261
Viola, Bill 96, 198, 232, 260,
 266
Virtue, John 244, 255
VOID **250**

Voorsanger, Jessica 146, 251
VTO **250**

Waddington Galleries **256**
Wade, Gavin **169**
Walker, Steven 269
Wall, Jeff 256
Wallinger, Mark 22, **101-103,**
 184, 185, 190, 191, 224, 227,
 229, 230, 231, 235, 245, 251,
 254, 258, 259
Waplington, Nick 243, 249,
 263, 265
Warhol, Andy 20, 28, 34, 48,
 96, 99, 123, 174, 181, 200,
 220, 259, 261, 267
Warren, Rebecca 179
Wearing, Gillian 31, 34, 129,
 103-5, 154, 161, 184, 211, 220,
 231, 239, 245, 254, 257, 258,
 265
Weaver, Ben **211-12**
Weiler, Carl von 248
Webb, Boyd 245, 246
Webb, Gary 179, 251
Weber, Bruce 252
Webster, Sue *see* Tim Noble
 and Sue Webster
Webster, Toby **158-9,** 235, 252
Wegee 158
Weinberger, Lois 244
Weiner, Lawrence 123, 268
Wentworth, Richard **36-9,** 77,
 167, 175, 221, 222, 227, 235,
 254, 259, 261, 266, 272
West Midlands Arts Board
 228-9
Westwood, Martin 179, 251
Wheatley, Andrew **177-8**
White, James 152
White, Stephen 213
White Cube 173-5, 187, **256**
White Cube[2] 174, **256**
White Gallery **243**
Whitechapel Art Gallery 153-4,
 260
Whiteford, Kate 263
Whiteread, Rachel 7, **39-42,**
 62, 77, 149, 167, 181, 188,
 190, 191, 193, 207, 210, 218,
 211, 227, 231, 232, 238, 240,
 243, 246, 251, 257, 259, 261,
 265
Whitworth Art Gallery **262**
Wigmore Fine Art **256**
Wilding, Alison 246, 262, 264
Willats, Stephen 147
Williams, Lois 271
Wilson, Andrew **224-5**
Wilson, Jane and Louise 25,
 106-8, 146, 148, 149, 152,
 153, 167, 176, 201, 208, 213,
 220, 223, 224, 231, 239,
 247, 248, 254, 257, 258, 259,
 265
Wilson, Keith 169, 236, 264
Wilson, Louise K. 272
Wilson, Paul 245

Wilson, Richard 54, **108-110,**
 148, 149, 243, 258, 259, 263,
 264
Wiltshire, Hermione 235, 244,
 256, 269
Winogrand, Garry 259
Winstanley, Paul 244
Wiszniewski, Adrian 269
Wohlen, Anita 235
Wolverhampton Art Gallery
 266
Wood, Craig 203
Wood, Graham 258
Woodfine, Sarah 252
Woodley, Caroline 269
Woodman, Edward **213-14**
Woodrow, Bill 37, 77, 213, 218,
 240, 254, 261, 264
Work & Leisure International
 232, 262
Workman, John 252
Worndl, Elizabeth 270
Wrexham Arts Centre **272**
Wright, Elizabeth 163, 246,
 247, 248, 260
Wright, Daphne 244
Wright, Karen 187, 242
Wright, Richard 64, 235
Wüthrich, Peter 254
Wyver, John **214-15**
Wyn Evans, Cerith 122, 152,
 153, 186, 198, 205, 251

Yass, Catherine 220, 229, 267,
 268, 271
Yorkshire Arts **229**
Yorkshire Sculpture Park **272**
Young, Gordon 235
Yule, Anslie 268

Ziranek, Sylvia 184
Zittel, Andrea 170, 171, 256
Zwemmer Gallery **256-7**